Figure Drawing

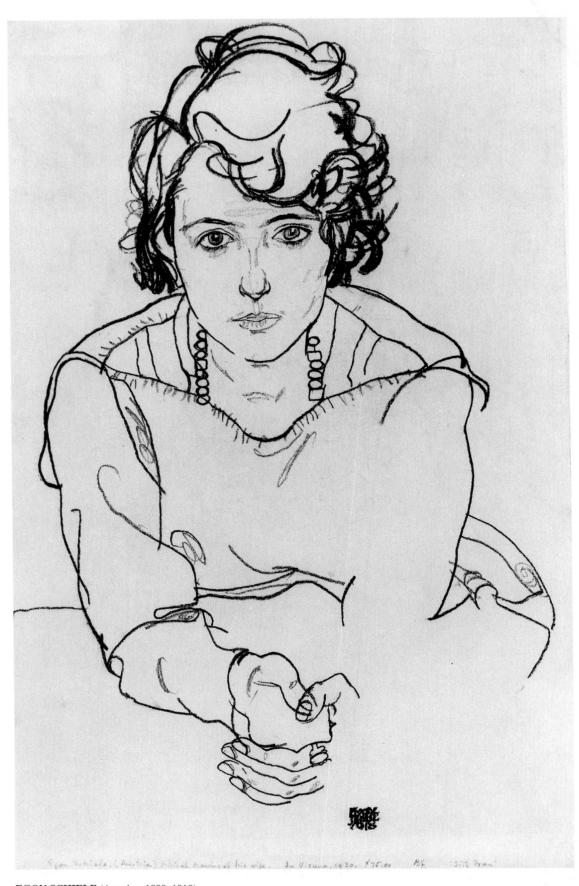

EGON SCHIELE (Austrian, 1890–1918) Seated Woman (Sitzende Frau) (1918) Black crayon, $18^{11}/_{16} \times 11^{13}/_{16}$ in. $(47.5 \times 30.0 \text{ cm})$. The Ackland Art Museum, The University of Carolina at Chapel Hill, Burton Emmett Collection. 58.1.252.

Figure Drawing

The Structure, Anatomy, and Expressive Design of Human Form

FIFTH EDITION

Nathan Goldstein

FOREWORD by Jack Beal

Library of Congress Cataloging-in-Publication Data

Goldstein, Nathan.

Figure drawing: the structure, anatomy, and expressive design of human form / Nathan Goldstein. — 5th ed.

cm.

Includes bibliographical references and index.

ISBN 0-13-923863-8

1. Human figure in art. 2. Anatomy, Artistic. 3. Drawing-

–Technique. I. Title.

NC765.G64 1999

743'.4—dc21

98-33623

CIP

Acquisitions Editor: Bud Therien Assistant Editor: Marion Gottlieb Production Editor: Jean Lapidus Manufacturing Buyer: Bob Anderson Photo Research Supervisor: Melinda Reo Photo Researcher: Francelle Carapetyan Photo Permissions Supervisor: Kay Dellosa Photo Permissions Coordinator: Carolyn Gauntt Photo Permissions Specialist: Irene Hess Copy Editor: Frank Hubert

Indexer: Murray Fisher

Artists: Maria Piper & Mirella Signoretto Marketing Manager: Sheryl Adams

Cover Design: Bruce Kenselaar Cover Art: Hilaire-Germain-Edgar Degas (1834-1917) Russian Dancer. Pastel over charcoal on tracing paper, H.: 243/8 in., W.: 18 in. $(61.9 \times 45.7 \text{ cm.})$ Signed (lower left): Degas. The Metropolitan Museum of Art, H. O. Havemeyer Collection, Bequest of Mrs. H. O. Havemeyer, 1929 (29.100.556). Photograph © The Metropolitan Museum of Art.

This book was set in 10.5/11.5 Times Roman by ElectraGraphics, Inc. and was printed and bound by Banta Company. The cover was printed by Banta Company.

© 1999, 1993, 1987, 1981 and 1976 by Prentice-Hall, Inc. Simon & Schuster/A Viacom Company Upper Saddle River, New Jersey 07458

All rights reserved. No part of this book may be reproduced, in any form or by any means, without permission in writing from the publisher.

Printed in the United States of America

10 9 8 7 6 5 4 3 2 1

12BN 0-13-923863-8

PRENTICE-HALL INTERNATIONAL (UK) LIMITED, London PRENTICE-HALL OF AUSTRALIA PTY. LIMITED, Sydney PRENTICE-HALL CANADA INC., Toronto PRENTICE-HALL HISPANOAMERICANA, S.A., Mexico PRENTICE-HALL OF INDIA PRIVATE LIMITED, New Delhi PRENTICE-HALL OF JAPAN, INC., Tokyo SIMON & SCHUSTER ASIA PTE. LTD., Singapore EDITORA PRENTICE-HALL DO BRASIL, LTDA., Rio de Janeiro In Memory
of My Father
Who First Noticed and Cared,
and for Harriet,
Who Lights It All Up.

Contents

	Foreword xi	The Interjoining of Planes and Masses 45
1	THE EVOLUTION OF INTENT: Major Factors and Concepts	Structure and Value 49
	in Figure Drawing 1 Some Common Denominators 1	Structural Supports and Suspensions in the Figure 51
	The Emergence of Interpretive Figure Drawing 8	Structural Aspects of Foreshortening 54
2	THE STRUCTURAL FACTOR: The Figure As a Structure 35	Seeing Shape, Direction, and Edge 61
	Some General Observations 35 A Planar Approach to Human Form 40	Structural Aspects of the Draped Figure and Its Environment 64
		Suggested Exercises 75

3	THE ANATOMICAL FACTOR: Part One: The Skeleton	79	Further Observations on Surface Forms 172
	Some General Observations	79	Suggested Exercises 191
	Bones of the Skull 80	5	THE DESIGN FACTOR: The Relational Content of Figure Drawing 197
	Bones of the Spinal Column	84	
	Bones of the Rib Cage 86		2 2 101 105
	Bones of the Shoulder Girdle	86	Some General Observations 197
	Bones of the Pelvis 89		The Visual Elements 203
	Bones of the Arm 91		Line 203
	Dolles of the 7 time 31		Value 209
	Bones of the Leg 98		Shape 213 Volume 220
	Skeletal Proportions 101		Texture 224
	The Skeleton in Figure Drawing 105		The Elements in Action 228
	Suggested Exercises 113		Direction 230 Rhythm 232
4	THE ANATOMICAL FACTOR: Part Two: The Muscles	123	Handling or Character 232 Location and Proximity 232 Subdivision 232
	Some General Observations	123	Visual Weight 233 Tension 234
	Muscles of the Head 124		Figurative Influences 235
	Surface Forms of the Head	126	Examples of Relational Activities in the Figure 236
	Muscles of the Neck 131		
	Muscles of the Torso 134		Anatomy As an Agent of Design 243
	Muscles of the Arm 143		The Figure and the Environment 248
	Muscles of the Leg 154		
	Skin and Fat 172		Suggested Exercises 255

6 THE EXPRESSIVE FACTOR:
The Emotive Content of Figure
Drawing 259

Some General Observations 259

The Inherent Expression of the Elements 264

Distortion 270

The Expressive Role of the Medium 271

Examples of Expression in Figure Drawing 273

Suggested Exercises 287

7 THE FACTORS INTERACTING: Some Examples 291

Differing Formulas 291

The Pathologies of Figure Drawing 312

Perceptual Defects 315
Organizational Defects 317
Expressive Defects 318

The Role of Media in Expression 319

In Conclusion 321

8 A GALLERY OF VISUAL RESOURCES 331

BIBLIOGRAPHY 351

INDEX 353

Foreword

It gives me great pleasure to write an introduction to Nathan Goldstein's book FIGURE DRAWING which, in itself, is both a lucid introduction to the subject and a wonderful compendium. Its major strength lies in the fact that it covers the discipline completely, including aspects of the subject not dealt with elsewhere. From the most basic knowledge and instruction, to the most advanced understanding and concepts, this book covers it all. Because of my admiration for the book (and its author) I have been recommending it for years to my own students, be they beginners, advanced, or professional artists. Now I am pleased to enthusiastically recommend this book (and Nathan's other works) to a wider audience.

The first chapter, *The Evolution of Intent*, discusses subjects found in few other works. It is an in-depth look at the philosophy of the human figure and figure drawing, and is invaluable in helping to reach an informed opinion about the subject, the artists discussed, and, obviously, self-realization.

As Western Civilization developed, certain of the Greek philosophers theorized that the concepts of beauty and proportion were based on the human body. In that we each own a body, it clearly occupies a singular importance to each person. Nathan's book reinforces this fact and, further, clarifies the concept with comprehensive measured illustrations.

Another of the most important aspects of the book is the vast number of reproductions of master drawings and the author's comments regarding them. By including so many illustrations, the book offers a wide range of compare/contrast possibilities, from exacting Realism to Expressionism, and the reader begins to make choices almost without realizing it. I am a true believer in the value of making copies of drawings by others, and this book certainly satisfies my needs and desires in that area.

Each chapter ends with a set of suggested exercises, which increase the book's educational value. These are as comprehensive and well-thought-out

as the other aspects of the book itself, and provide the basis for lesson plans for teaching a variety of students, from amateur to advanced.

From time-to-time, younger artists call or write to me saying that they have obtained a job teaching figure drawing and are unprepared since they have not had an intense course of study in the discipline. When they ask for help in learning to teach the subject, I always recommend this book.

Jack Beal

Preface

That the three later incarnations of Figure Drawing, like the first edition, met with immediate and substantial acceptance among artists and students alike is a matter of personal gratification and a dependable sign that something about the book's overall presentation and character struck a responsive chord among those who want to reinforce their evident interest in figure drawing with more facts and options. This new edition tries to serve those interests with even greater clarity and effect.

The earlier editions—expanded in some places, simplified in others, and strengthening the original text further throughout—were shaped by the opportunities I had, in the intervening years, of examining the book's effect on countless readers, by the good counsel of colleagues and students, and by the insights and experiences that time provides. The thing about time, though, is that it keeps on providing new notions. Although I was satisfied with the book's essential form and content, it occurred to me recently that yet another revision was in order.

I am, however, a staunch believer in the old adage, "if it ain't broke, don't fix it." Consequently, this fifth edition continues in the same vein as its predecessors, with a few useful additions and

changes. Again, I have included a number of colorplates to show how "the queen of the visual elements" can amplify our creative purposes. Most of the works new to this edition are by contemporary artists, and each strongly amplifies various matters of importance in the text. Additionally, I have included a new chapter (Chapter 8) with 38 photographs showing the figure's forms in ways I hope the reader will find useful as a source of study and practice. As for the text, the change I am proudest of is that rarest of all occurrences: a reversal of the usual tendency for new editions to gain weight. This edition's slightly reduced text is, I believe, clearer and stronger than its predecessors', and contains a few useful adjustments in presenting the relative importance of the book's several themes.

If some of these additions and changes originated with me, many came from readers and colleagues too numerous to list here, and I want to thank them in this public way for helping me more closely realize my goals on this fifth time around. Always the optimist, I have high hopes for this latest revision. But also always the artist and teacher, I know in my bones that it is the quality and quantity of good figure drawings reproduced in the text that

will give this book its ultimate worth. For that important reason, I have tried to reproduce figure drawings that represent a wide range of styles, themes, and eras, though less concerned with when they were done than with what they say and how well they say it.

As before, this edition is designed to assist the art student, the amateur, the art teacher, and the practicing artist in developing a more extensive understanding of the figurative and abstract considerations of drawing observed or envisioned human forms.

I continue to hold the single assumption that the artist-reader's interest in expanding his or her understanding is motivated by a wish to comprehend those universal elements present in the best examples of figure drawing by old and contemporary masters alike, rather than by a wish for readymade formulas and techniques. Although five of the eight chapters provide suggested exercises, these exercises are intended to clarify and reinforce the particulars and potentialities of the chapter's subject, not to suggest canons of figure drawing. The exercises may be simplified, embellished, otherwise varied, or even be bypassed without interrupting the flow of the text.

The term *figure drawing* as used here refers to drawings of the draped as well as nude figure, and drawings of parts of the figure or drawings in which the figure represents only a small part of the configuration. Very often, the beginner is too much in awe of the figure to bring to bear those skills he or she does possess, and which are more readily applied to still life and landscape subjects. This broader view, in regarding the figure in its context among the multitude of things that make up our physical world, helps us to recognize that many of the concepts and skills we call on in responding to the things around us apply just as much to the figure's spirit and form.

For the same reason, I have abandoned the traditional approach to anatomy, which is isolated from the figure's dynamic and humanistic qualities and often seems clinical and remote from living individuals. Instead, I have tried to integrate with master drawings creative applications of the various parts of anatomy under discussion and to show anatomy's role as both servant and source of structural and dynamic inventions.

In this volume, anatomy is regarded as only

one of the four basic factors of figure drawing. The best figure drawings always reveal a congenial interaction among the factors of *structure*, *anatomy*, *design*, and *expression*. The best teachers, sensitive to this interplay, try to show students the mutually reinforcing behavior of these factors, both in their teaching and in their own creative work.

To my knowledge, no one has previously written a comprehensive discussion of the ways in which the four factors assist and govern each other. If this formulation of the concepts at work (and at play) in the figure helps the reader to better focus on the options and obstacles of figure drawing, or even if in contesting aspects of this presentation the reader is aided in forming a pattern of issues more suited to his or her views, I will have achieved my goal.

I would like to acknowledge my debt to the writings of Rudolf Arnheim, whose important contributions to the psychology of perception frequently clarified and occasionally confirmed my views on various aspects of perception as they apply to figure drawing.

I wish to express my gratitude and thanks to the many students, artists, and friends whose needs, advice, and interest helped to shape and test the views presented in earlier editions of this book and in its present revised form. I wish also to thank the many museums and individuals who granted permission to reproduce works from their collections; Charles D. Wise of Medical Plastics Laboratory, Gatesville, Texas, for his cooperation in providing the skeleton replica reproduced in Chapter Three; David Yawnick, Don Hirsh, and Gabrielle Keller for their excellent photographic skills; the late Walter R. Welch for his help with the book's first edition; and Bud Therien of Prentice Hall, whose cooperation and generosity in numerous ways have made this a better book.

The author also thanks the following reviewers for their helpful suggestions: Diane Banks, East Carolina University; Joyce Ricci Fuller, Fayetteville Technical Community College; and Robert Morton, Plymouth State College.

My deepest gratitude to Harriet and Jessica for their practical assistance, care, and understanding, and to my daughter Sarah, herself a writer, whose interest, affection, and patience are always there.

Figure Drawing

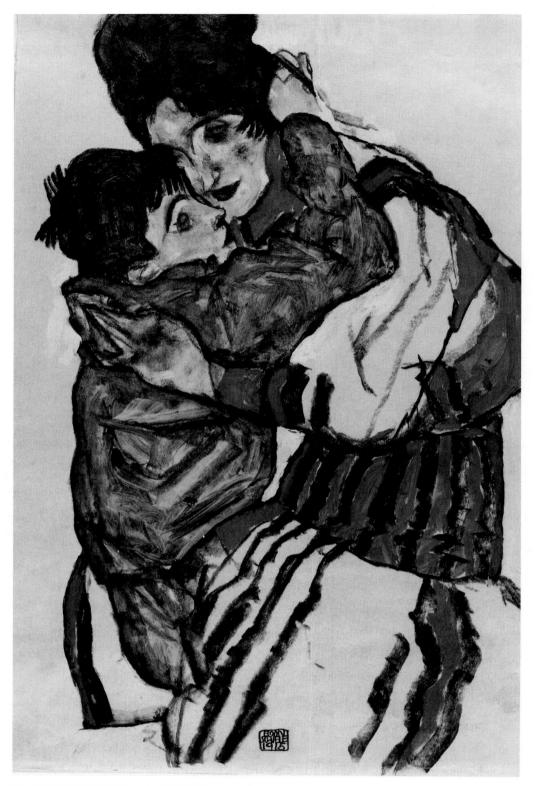

1.1 EGON SCHIELE (Austria, 1890–1918) Schiele's Wife with Her Little Nephew (1915) Charcoal, opaque and transparent watercolor on paper, $19 \times 12^1/2$ in. (483 × 318 mm). Edwin E. Jack Fund. Courtesy, Museum of Fine Arts, Boston. #65.1322.

The Evolution of Intent

Major Factors and Concepts in Figure Drawing

SOME COMMON DENOMINATORS

The main interest of people everywhere has always been people. Images of the human figure have always held a special fascination for artists and the public alike. Of the several means by which the figure is represented, drawings often seem to possess a greater sense of vitality and expressive eloquence than do many paintings, sculptures, and photographs. To most artists and connoisseurs, the skill with which the figure is drawn remains a telling standard for evaluating an artist's ability to draw. The psychological and philosophical nature of people, and the ways we establish these qualities through the act of drawing, can evoke powerful expressive meanings. By losing ourselves in an intense visual encounter with another's living nature, we benefit our selves: We have the satisfaction of better apprehending our own creative and human nature and of achieving important insights about the people around us.

An ability to draw the figure well is important not only to the representationally oriented artist. Something of the figure's spirit and form can be sensed in many of the finest examples of abstract and nonobjective painting and sculpture, and of pottery, ornament, and architecture. As the noted art historian Kenneth Clark observed, "The nude does not simply represent the body, but relates it, by analogy, to all

structures that have become part of our imaginative experience." It is no coincidence that many of the best abstract artists of the twentieth century—for example, Picasso, de Kooning, and Diebenkorn—are gifted exponents of figure drawing. Perhaps it is the visual analogies to human form and character—some inflections of shape, line, and color that set off human associations in our minds—that give their more subjective works a special meaning for us.

But mere facility in drawing the figure is not enough to hold the interest of the gifted artist *or* the sensitive viewer. Something else is necessary. Some figure drawings have the power to affect and involve us deeply. The reasons for this have little to do with the artist's facility or objective accuracy. All compelling figure drawings seem to possess certain extraordinary energies and metaphors that make them important creative expressions for all of us. Other figure drawings, though deftly stated and inviting in subject matter, seem to lack the vitality and, consequently, the lasting power of master figure drawings. They hold little interest beyond their descriptive content. Drawings preoccupied with facility, accuracy, or "storytelling" are bound to be limited to these creatively dubious goals.

¹ Kenneth Clark, *The Nude: A Study in Ideal Form* (New York: Pantheon Books, Bollingen Foundation, 1953), p. 370.

2 CHAPTER 1 / The Evolution of Intent

What is it about the figure drawings of Rembrandt, Matisse, Kollwitz, and other old and contemporary masters that attracts and engages us so? It is certainly not their success as faithful documents of observed individuals and situations, for many are drastically altered or wholly invented images. Nor are they the most thoroughly precise or objectively detailed accounts. Sometimes, as in Schiele's Schiele's Wife with Her Little Nephew (Fig. 1.1), such works are strikingly inventive interpretations. Often, they are boldly concise, as in Kollwitz's Woman Weeping (Fig. 1.2). It is not that the best figure drawings exemplify some cultural standard of beauty, for many do not meet even minimal standards of attractive human proportion. Still, no matter how plain or misshapen the forms, the best figure drawings always

impart some kind of psychological or spiritual attraction (Fig. 1.3). Finally, the appeal of master drawings often does not depend on their compositional inventiveness. Many are private preparatory studies, as are Figures 1.4 and 1.5, and as such, often concentrate on investigating a subject's structure, contour, proportions, and the like.

It seems, then, that the vitality and expressive impact of the best drawings cannot be explained solely in terms of facility, cultural ideals, accuracy, design, or narrative theme. To understand why certain drawings have the power to please, provoke, and inspire us, we must begin by recognizing that each of us responds to far more than their representational or *figurative* content. All such works possess a *dynamic* "life"—a network of visual relationships and energies

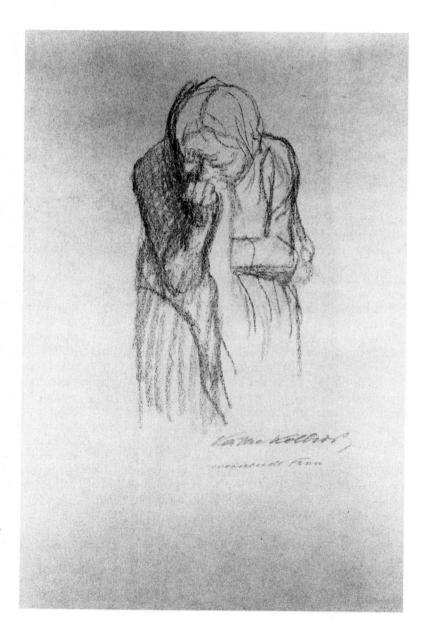

1.2 KATHE KOLLWITZ (1867–1945) Weinende Frau (Woman Weeping) (1918) Charcoal on gray-blue laid paper, .478 × .322 (18⁷/₈ × 12¹¹/₁₆ in.).
Rosenwald Collection, Photograph © 1998 B.

Rosenwald Collection, Photograph © 1998 Board of Trustees, National Gallery of Art, Washington, D.C. 1943.3.5221.

1.3 MATTHIAS GRUNEWALD (1470?–1528) Portrait de Margarethe Prelewitz Black chalk, $8^7/8$ in. \times $11^1/4$ in. Photo R.M.N./Musee du Louvre, Paris.

1.4 ANDREA DEL SARTO (1486–1530) Red Chalk Drawing Red Chalk, $14^7/8 \times 8$ in. © The British Museum.

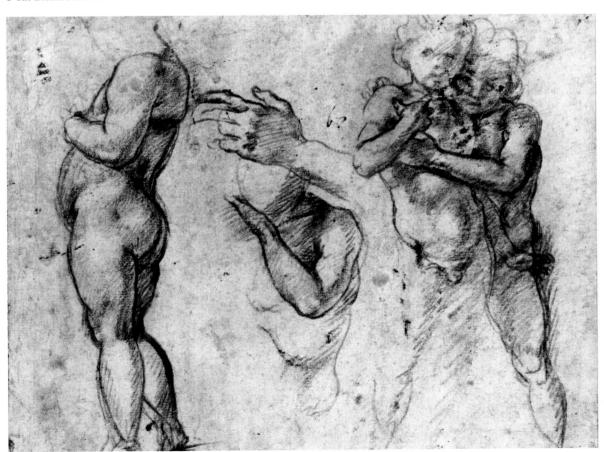

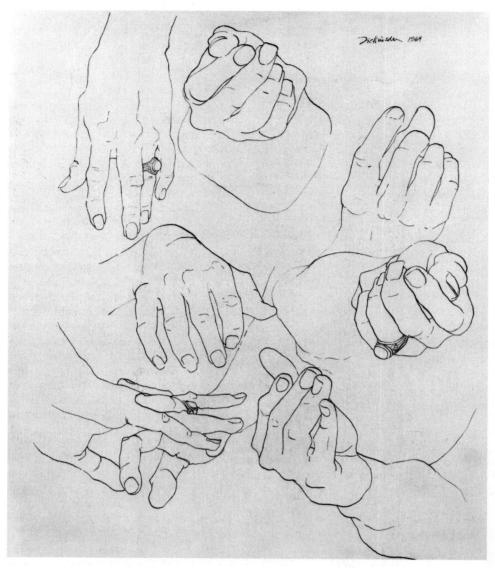

1.5 ELEANOR DICKINSON (1931–) Study of Hands (1964)
Pen and ink, $13^{1/4}$ in. \times $10^{1/4}$ in.
Stanford University Museum of Art, 1968.13.
Gift of Dr. and Mrs. Louis J. Rattner.

between the marks used and between the forms they produce. This network of activities—the sense of movements, rhythms, and tensions, of similarities and contrasts among a drawing's parts—produces sensations that affect the way we respond to a drawing. As we shall see in Chapter 5, these visual energies are inherent in the very nature of the drawing's marks and resonate through the work. We respond to these dynamic actions partly because of our *kinetic* sensibili-

ties—our ability to identify, through our bodily senses, with the thrusts, pulsations, and rhythms that animate the things we see around us. And everything we see suggests energy of some kind. The curve of an arm or a drawn line, the thrust of a church spire or a drawn wedge, and the undulation of a tree branch or a brush stoke express, through their form, actions we can sense. These inherent actions in the things we draw are an ever present part of how we see a subject

and must be taken into account when we draw. Artists, it seems, are able to sense such "movement" in things that aren't moving.

In drawings, such movements, issuing from the actions (and interactions) of the lines and tones themselves, carry the drawing's *abstract* character, and those actions inherent in a drawing's recognizable forms carry its *figurative* or *depictive* character. These actions are mutually interacting aspects of a drawing's dynamic and organizational life.

These interacting actions also convey expressive meanings. In the best drawings, expression can be found at both the figurative and abstract levels. To illustrate this point, let us again turn to Figure 1.2. Both the woman and the lines and tones that shape her reveal similar expressive qualities. Notice that the downward flow of the lines, like the lines of a weeping willow tree, intensify the figure's expressive mood. Such lines do not flow from conscious choice alone. Rather, their emotive character reflects the artist's intuitive as well as emphatic response to the subject's state. Kollwitz feels as well as sees her subject. The best figure drawings are never merely descriptive. They evolve out of the negotiations between the subject's measurable, figurative actualities and the artist's sympathetic interests in those actualities—his or her interpretation of the subject's human and abstract energies.

The figure's measurable features—its differing masses and their various shapes, planes, values, textures, sizes, and locations in space—can be reduced to two fundamental considerations: its general constructional nature and its specific anatomical one. We will refer to these as the *structural factor* and the *anatomical factor*. Although these factors are always interdependent aspects of a figure's draped or undraped forms, in the next three chapters we will consider them separately to better examine the nature of each and to see how they interact.

Similarly, for discussion purposes, we will divide the figure's dynamic properties—those directional and relational energies that give a drawing its order and impact—into the *design factor* and *expressive factor*. These two factors are also interdependent, but by separating them (in Chapters 5 and 6), we can explore each more fully. Because we make these arbitrary divisions, it is important to bear in mind that artists understand a drawing's design and expression as parts of the same phenomenon in the subject: its allusions to emotive order. Furthermore, in practice, all four factors are interrelated. One of the major themes of this book is to call attention to the high degree of interdependence of the measurable and dynamic factors.

In the best figure drawings, then, representational content not only coexists but interacts with a system of dynamic and expressive content. A drawing's figurative and abstract content stems from the way artists use the visual elements—the seven basic tools of visual communication. These elements are line, shape, value, volume, color, space, and texture. Chapters 5 and 6 examine these visual tools and the energies they release. Here, it is important to recognize that this first universal common denominator of creative figure drawing-the interacting of abstract and figurative meaning—is a given fundamental condition. All marks relate in some way. Left unregarded, the abstract behavior of a drawing's elements will produce confusing discords and inconsistencies-a kind of visual noise that obscures representational meanings. The best exponents of figure drawing have always understood that the organizational and emotive powers of the visual elements affect the clarity and meaning of the figurative forms they denote, that the dynamic nature of the marks and of the recognizable forms they produce are interdependent considerations. In creative figure drawings, then, the marks not only define, but they also enact and evoke the character of the subject, bringing the image to life.

And master drawings are always "alive." In Rembrandt's Bearded Oriental in a Turban, Half Length (Fig. 1.6), the animated behavior of the figure and of the lines and tones expresses vigorous life. The man's confident stance is intensified by swift but certain strokes. The fanlike eruption of rhythmic lines emerging from the arms and waist further heightens the figure's barely contained energy. Even the more specifically drawn forms of the head are developed with a graceful authority. Despite the small scale of these forms, the lines and tones that comprise them are powerfully alive.

But aliveness in drawing does not always depend on graceful harmonies. The goal in Hokusai's Wrestlers (Fig. 1.7) seems to be the ruggedly potent, even awkward character of the two struggling figures. Their gnarled and straining forms contrast with the more supple forms of the man who is observing on the right. He serves as an expressive counterpoint against which the tensions and stresses of the struggling wrestlers gain greater impact. Note that the wrestlers are drawn with lines that are deliberate, even crabbed, suggesting the tension and strain of the fighting figures, while the forms of the third figure are drawn in a more flowing manner. This contrast can even be seen in the difference between the shapes of the wrestlers' feet (and the lines that form them) and the feet of the onlooker. Likewise, the more complicated and "lumpy" shapes of the wrestlers' bodies are

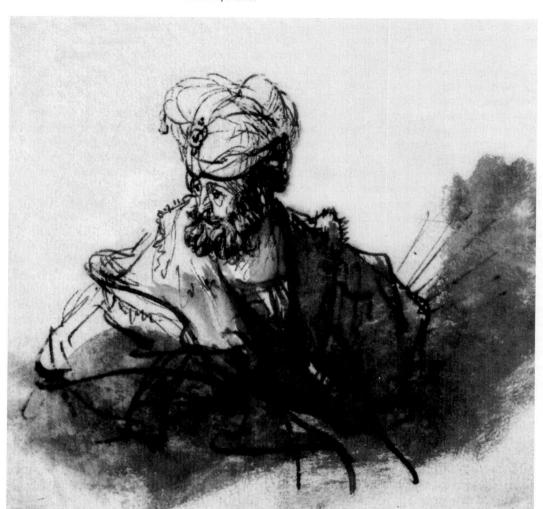

1.6 REMBRANDT VAN RIJN (1606–1669) **Bearded Oriental in a Turban, Half Length**Pen and wash 117 × 114 mm. (4³/₄ × 4¹/₂ in.).
Photograph by Walter Steinkopf. Staatliche Museen
Preussischer Kulturbesitz Kupferstichkabinett, Berlin.

in clear contrast to the simpler, more rhythmic shapes of the third figure. Hokusai even managers to extract a heightened sense of drama (while simultaneously balancing the masses of the entire drawing within the picture plane) by emphasizing the leftward lurching of the wrestlers with the opposing tilt in the figure on the right.

Note that Hokusai, like Rembrandt, has altered anatomical fact to strengthen expressive meaning. The best exponents of figure drawing *utilize* rather than eulogize anatomical facts because their purpose is to *express*, not to record, *precisely*. For the same reason, artists often take liberties with laws of perspective and illumination and the "rules" of composition, or those

that refer to the ways various media should be used, when such laws and rules interfere with their creative intentions. Freedom of inquiry and of interpretation must always overrule conformity to any convention or system.

Another common denominator in the best figure drawings is the economy and directness with which the artist establishes the drawing. Invariably, master drawings are as concise and straightforward as the artist's theme and tools permit. Indeed, the best artists tell their truth plainly. One of the most engaging qualities of master drawings is the great amount of figurative and abstract content in an economically conceived image. Choosing a medium that permits such a

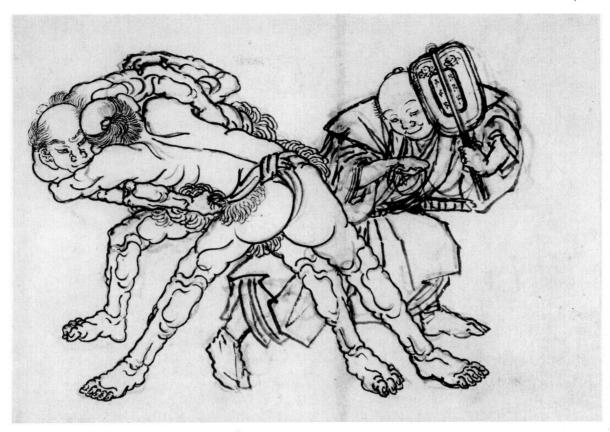

1.7 KATSUSHIKA HOKUSAI (1760–1849) Wrestlers
Brush and ink, 12 in. × 16¹/₂ in.

© The British Museum.

concise graphic statement is important. All master drawings demonstrate a sensitive interaction between the meanings and the means used.

Still another important common denominator is that the best drawings show a unique temperament and attitude. As Edgar Degas put it, "Drawing is a way of looking at form." This quality stems partly from the nature of what is drawn and partly from the artist's overall temperament—his or her general likes and dislikes—both as an artist and as an individual. A discussion of the psychological and social forces that shape an artist's point of view—how we arrive at our particular aesthetic and temperamental persuasion—is beyond the scope of this book, but we should recognize that an artist's temperament determines his or her perceptions and responses. Perhaps less obvious is that the artist's ability to assert his or her attitude clearly is crucial to the drawing's success as a work of art. Genuine creative invention demands genuinely personal interpretations, deflected as little by outside influences as possible. The best figure drawings always show an unwavering declaration of judgments and interests. Such works are always eloquent in the clarity of their intent. They are either keenly bold or delicate, schematic or sensual, animated or stilled. In other words, great figure drawings always incisively affirm the artist's convictions about what are the important human and dynamic conditions of a subject.

The best figure drawings, even when they are highly subjective images, also reveal the artist's knowledge of the structural and anatomical factors. However, as noted earlier, in master drawings, it is always evident that these matters serve, but never dominate, the artist. Some artists, such as Michelangelo (Fig. 1.14), are even able to elevate their private anatomical studies to the level of art. Such drawings show an interplay between facts and feelings, between the figure's measurable matters and the expressive power implicit in its forms. Structure and anatomy are essential as liberating, not restricting, factors. And even when we subdue their role in our

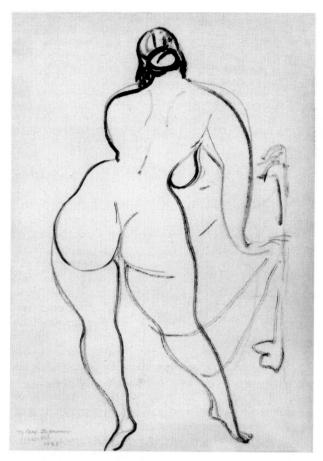

1.8 GASTON LACHAISE (1882–1935)

Back of a Nude Woman (1929)

Pencil, quill pen, India ink and brush wash, 17³/₄ × 12 in.

Brooklyn Museum of Art, Gift of Carl Zogrosser. 38.183.

drawings, we must do so with an authority that only a genuine understanding of these factors makes possible.

One of the most important realizations of such understanding is that structural and anatomical considerations can add to a drawing's dynamic interest; they can both stimulate and strengthen relational and emotive ideas. In Lachaise's *Back of a Nude Woman* (Fig. 1.8), the "beat" of ovoid shapes and the rhythmic undulations of contour lines are abstract expressions of the character of the figure's pose and forms. It is impossible to view Lachaise's drawing without responding to the moving energy of the lines and shapes that express in abstract terms his interests in the subject's action and form.

The structural aspects of Lachaise's drawing, as shown in the solid interlocking masses and his knowledge of anatomy to simplify some forms and amplify others, are the product of sound understanding, so that they interrelate with the drawing's design and expression. Here, all four factors—structure, anatomy, design, and expression—interact to advance the same theme.

This leads us to the last common denominator. Great figure drawings reveal an authoritative and personal solution to the governance among the factors of structure, anatomy, design, and expression inherent in human form. Although the degree to which each factor participates in a drawing's creation is determined by what we see and what we want, all four must be successfully integrated in forming the image. Because these four elements are given conditions in figure drawing, and each is dependent on the others, none can be disregarded without weakening the quality and meaning of the rest.

THE EMERGENCE OF INTERPRETIVE FIGURE DRAWING

Interpretive figure drawing, in the sense described earlier as conveying the felt convictions of an individual temperament, was a relatively late arrival in the history of art. But when it did arrive, structure, anatomy, design, and expression were all interacting properties of the best drawings. Perhaps figure drawing's main strength, namely its ability to function as a direct means of personal inquiry and interpretation—its power as a tool for quickly finding and stating—is the reason for its delayed appearance as a major category of creative expression. Earlier creative modes had little to do with *personal* expression.

Visual imagery from the dawn of history to the late Middle Ages (if such a sweep of time can be summarized) was largely determined by highly formalized, collective conventions. Representations of human and animal figures conformed to these rigid schemas. The earliest depictions of the human figure are few and rather crude when compared to the cave paintings of bison and other animal figures of the period, which show a sensitivity to rhythmic line. By the Neolithic era, humans had begun to leave a visual record of their activities conveying a sprightly charm (Fig. 1.9), but these pictures conformed strictly to formula and were simple in concept. With the emergence of the Egyptian civilization and the civilizations of the Tigris-Euphrates Valley, far more sophisticated but still rigidly stylized conventions developed for representing human form (Fig. 1.10).

Although impressive humanistic developments occurred in many aspects of Greek civilization, in early Greek art, formula solutions for depicting the figure showed only slight allowances for objective investigation. Not until about 550 B.C. did Greek art be-

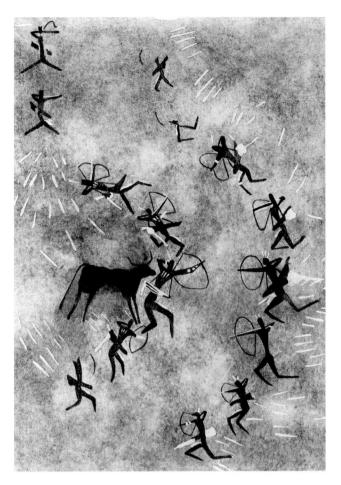

1.9 Facsimile of rock painting: A fight apparently for possession of a bull. Khargur Tahle, Libyan Desert.
Collection, Frobenius-Institut, Frankfurt am Main, Germany.

gin to develop its grand aesthetic concepts based on objective visual inquiry and a collective ideal that saw humans as physically and spiritually perfected according to Greek cultural and religious standards. This fertile convention was flexible enough to permit a modest degree of personal interpretation, and the first individuals of outstanding mastery begin now to be known to us by name. Sculptors such as Phidias and Praxiteles and vase painters such as Epictetus and Douris leave their imprint on later Greek art. This classic style was to have a profound impact on Renaissance artists and, periodically, on many artists throughout the world, especially in the West. But despite the great heights that idealized representations of the figure—owing much to a sensitive understanding of human form—attained in later Greek sculpture and painting, drawings of the figure (done almost exclusively as vase decorations) generally show a still markedly conventionalized treatment (Fig. 1.11). This is not to suggest that these drawings are less aesthetically valid or pleasing; indeed, many are of outstanding artistic merit. But they are less the result of inquiry and response than of a collective system, or formula, for depicting human forms. Virtually no drawings on flat bounded surfaces emerged from Greek or, still later, Roman art. And with the exception of a small number of sculptors and painters, no tradition of art done in a spirit of personal interpretation developed from these cultures.

During the Middle Ages, a highly symbolic convention arose in the art of manuscript illumination, which became somewhat more observational

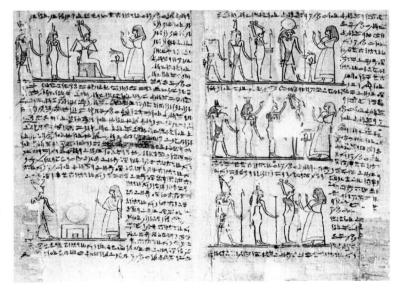

1.10 Book of the Dead of Ta-Amen, Chantress of Amen, Daughter of Disyast. Egypt, from Sakkara, Ptolemic Period.
Papyrus, L: 28.0 cm, W: 36.5 cm.
Gift of Martin Brimmer. Courtesy,
Museum of Fine Arts, Boston. 92.2582.

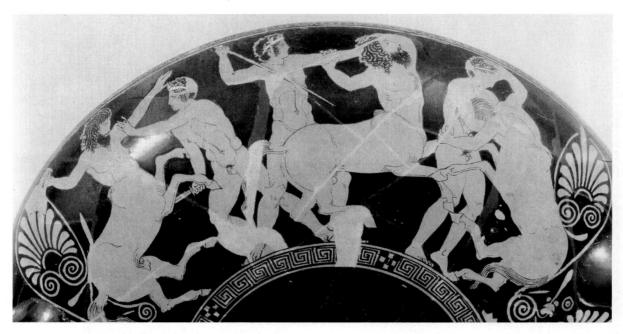

1.11 Kylix, View: exterior. Battle of Centaurs & Lapiths, Aristophanes, Greece (Attica). Red-figure vase. Henry Lillie Pierce Fund. Courtesy, Museum of Fine Arts, Boston. 00.344.

and interpretive with time. Occasionally, as in Figure 1.12, such manuscript art reached some degree of freedom from convention, but such works were the exception.

Drawing, and especially figure drawing, resulting from an investigative, humanistic, and personally interpretive attitude did not begin to appear as a serious creative activity until the Renaissance. With the emergence of a sense of individuality, a thirst for scientific and philosophical knowledge, and a desire to understand the nature of the world and of humanity, drawing became an efficient and even necessary mode of exploration and expression. In this climate of inquiry, earlier collective conventions of art quickly gave way to individual interpretation, and a powerful interest in drawing emerged. Not only did this emancipation from the restrictions of formula solutions dramatically alter the motives and meanings of works in painting and sculpture, but the spirit of the Renaissance can also be credited with the birth of interpretive drawing-especially figure drawing-as a serious form of creative expression.

The engraving *Battle of Nudes* (Fig. 1.13) by the fifteenth-century Italian sculptor Pollaiuolo provides an example of the emerging interest in human form during the early Renaissance period. The artist's unflagging attention to anatomical facts and his sensitiv-

1.12 *Portrait of St. Gregory*, Carolingian Illumination. Title leaf of the Manuscript of St. Gregory's Moralia in Job in Trier. 10th century, Western German or Flemish. Manuscript on vellum, Matted: $10^3/4 \times 8^1/4$ in. William Francis Warden Fund. Courtesy, Museum of Fine Arts, Boston. 49.492.

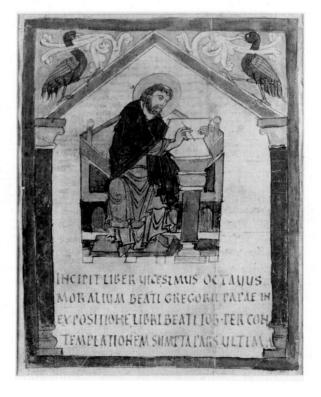

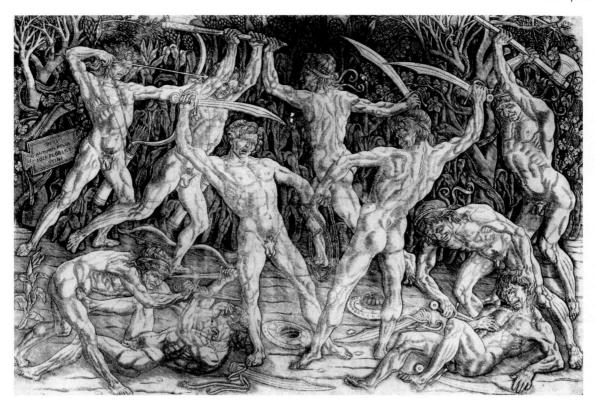

1.13 ANTONIO DEL POLLAIUOLO (1429–1498) Battle of the Nudes (ca. 1470–75) Engraving, 40 cm. \times 57.9 cm. (15 1 /2 \times 22 1 /4 in.) sheet Courtesy of the Fogg Art Museum, Harvard University Art Museums. Bequest of Francis Bullard in memory of his uncle Charles Eliot Norton M377.

ity to the supple, rhythmic nature of human forms represent a new level of attraction and understanding in the art of figure drawing. Although the drawing's overall style is one of deliberate, refined delineation—characteristics which typify earlier artistic attitudes—the almost sculptural modeling and the expressive force of the drawing's curvilinear and diagonal movements show an integration of structure, anatomy, design, and expression.

By the sixteenth century, the tendency toward a calculated elegance in figure drawing had been largely replaced by more personal attitudes of inquiry and response. This change resulted from a number of conditions: a growing visual sophistication nurtured by cross-influences among artists, the value that patrons of the arts now placed on original concepts, and the ready market for major projects in painting and sculpture that required many preparatory drawings.

Furthermore, sixteenth-century art, especially in Italy, often dealt with religious or mythological themes of a monumental kind, often requiring large

numbers of figures in complex settings, conditions that prompted bolder and more economical approaches to the act of drawing. Renaissance drawings continued to reflect an attraction for the humanism and grandeur of Greek and Roman art in ever more forceful terms. A comparison of Pollaiuolo's drawing of male figures with Michelangelo's treatment of the figure (Fig. 1.14) shows the high degree of understanding of, and feeling for, human form that developed in later Renaissance drawing. Although both artists demonstrate their outstanding knowledge of anatomy and sculpt the forms with great clarity, Pollaiuolo's treatment is more deliberate and precise, whereas Michelangelo's is more dramatic and rugged. This shift in the way drawings were conceived is due in part to the growing regard among later Renaissance artists for more intuitional and spontaneous responses.

Throughout the Renaissance, especially in Italy and Northern Europe, an interest in drawing the human figure flourished. Like Michelangelo's drawing, many of these drawings represent preparatory

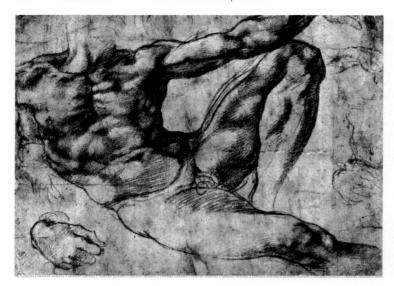

1.14 MICHELANGELO BUONARROTI (1475–1564)

Study of Adam in the "Creation of Adam"

in the Sistene Chapel

Chalk on tan paper, 95/8 × 15 in.

© The British Museum.

sketches for works in painting and sculpture. Many other drawings, like da Vinci's study of the shoulder region of a male (Fig. 1.15), resulted from the intense investigatory spirit of the time. Some, such as Portrait of Anna Meyer, the Daughter of Jacob Meyer (Fig. 1.16), by the Northern Renaissance artist Holbein, were intended as final graphic statements. In Holbein's drawing, the precise and subtle fluctuations of volume-revealing edges and surfaces and his sympathetic attitude toward the young woman are conveyed by lines and tones as gentle as the subject and the design. In color (see Plate 1), the cool gray of the background recedes to create the spatial depth needed to give the figure's lighter or warmer-toned forms greater solidity. Holbein's drawing provides a striking contrast with Michelangelo's dramatic and rugged modeling of human form. Seen together, these drawings suggest the range of interpretation made possible by the liberating spirit of the Renaissance.

A sensitive interest in the figure's structure and anatomy as capable of conveying powerful dynamic meanings continued to flourish in the seventeenth century. Often, drawings showed a more daring search for the figure's expressive essentials than a thorough exploration of its parts. Rosa's Nearly Full-Length Figure of a Youth Pulling off His Shirt (Fig. 1.17) and Canuti's Study of a Dead or Sleeping Man (Fig. 1.18) illustrate this more interpretive concept. It is immediately apparent that these artists have intensified the flow of the figure's forms into fluid ripples, creating a sense of animation and vitality. Such movement and energy demand more than an understanding of anatomical and structural facts. They demand a sensitivity to the underlying abstract and expressive energy of human forms. Whether these artists

1.15 LEONARDO DA VINCI (1452–1519)

Myology of the Shoulder Region

Pen and ink, some gray washes, 73/8 × 93/8 in.

The Royal Collection © Her Majesty Queen Elizabeth II.

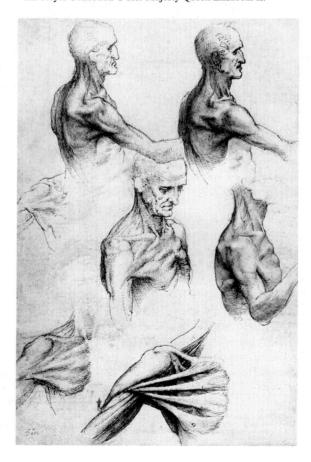

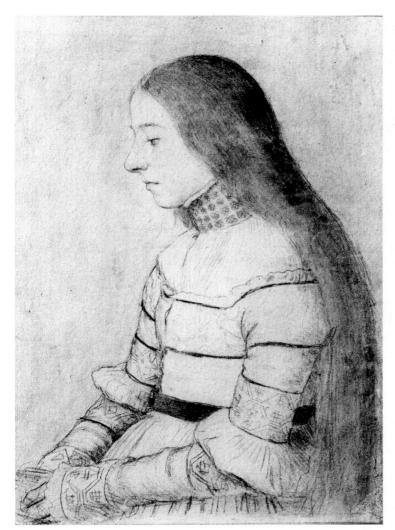

1.16 HANS HOLBEIN the Younger (1497-1543) Portrait of Anna Meyer, the Daughter of Jacob Meyer Colored chalks, $15^{1}/4 \times 10^{5}/8$ in. Basel, Kupferstichkabinett. Museum Faesch, 1823.

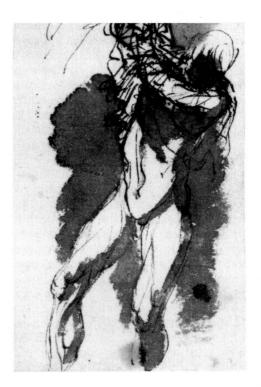

1.17 SALVATOR ROSA, Italian (1615–1673) Nearly Full-Length Figure of a Youth Pulling off His Shirt Pen, brown and dark brown ink and brown wash, $9.8\times6.4~\mathrm{cm}$. The Art Museum, Princeton University. Bequest of Dan Fellows Platt, Class of 1895. 1948–1274.

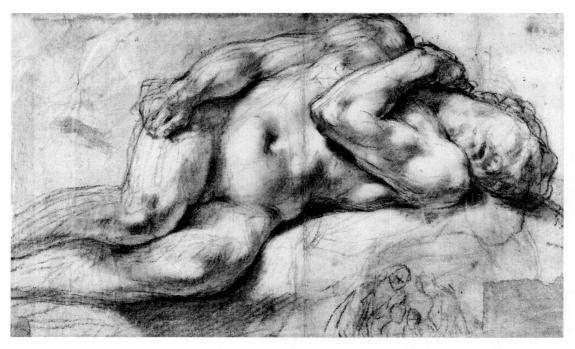

1.18 DOMENICO MARIA CANUTI (1620–1684)

Study of a Dead or Sleeping Man

Red and white chalks.

The Pierpont Morgan Library, NY. (1975.2)/Art Resource, NY.

observed or imagined their subjects, they had to *feel* the weight and tension of the limbs, the fullness and hollows of the forms, the physical situation of the figure, as if it were their own. Only a strong identification with the figure's physical behavior could have led to the judgments and handling that express this behavior with such economy, clarity, and impact.

Another seventeenth-century artist, the great Flemish painter Rubens, was an enthusiastic student of Renaissance attitudes and techniques but brought to them an individual stamp of vigor and tactile sensitivity. In his *Study for the Figure of Christ on the Cross* (Fig. 1.19), there is the same high degree of knowledge about, and empathy with, human form that we see in the Michelangelo drawing. Rubens's emphasis on the figure's action, masses, design, and character, rather than on finished surfaces, reveals the artist's identity with the figure's situation. Rubens feels as well as visualizes the situation he depicts.

If the Renaissance artists were attracted to the idealized forms of antiquity, seventeenth-century artists were usually more impelled toward encounters with human forms as they found them. And as Figures 1.17, 1.18, and 1.19 show, they often drew them with more tumultuous energy. But if some traces of the

Renaissance interest in an idealized, heroic interpretation of humans lingered (as in the Rubens drawing), this influence is wholly absent in the drawings of perhaps the greatest seventeenth-century artist, Rembrandt.

Although Rembrandt's drawings depict people realistically, they possess moving visual metaphors that allude to psychological and spiritual meanings. That is, they seek to evoke humanistic meanings through accurately observed or envisioned subjects stated in dynamic terms that amplify such meanings. No one, until Rembrandt, focused as intensively or with such penetrating clarity on the introspective nature of ordinary people, and few have ever expressed such insights more engagingly, economically, and forcefully. While drawings in a realistic manner and with a sensitivity to psychological subtleties had appeared earlier (Fig. 1.16), few approach the power in Rembrandt's drawings to transcend narrative content and to imply universally understood feelings and states. In Rembrandt's works, even simple domestic scenes are transformed into moments that suggest deeper significance. A drawing by Rembrandt, whether of a child, a beggar, or a wealthy burgher, is at once a penetrating human observation and a daring system of dynamic actions.

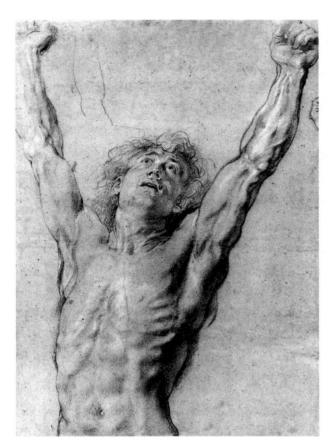

1.19 PETER PAUL RUBENS (1577–1640) Study for the Figure of Christ on the Cross Charcoal, heightened by white, $15^{1}/2 \times 20^{1}/4$ in. © The British Museum.

Rembrandt's figure drawings do more than integrate abstract and psychological expressions with figurative material. There is instead a fusion of these qualities. In Femme Couchee (Fig. 1.20), the lines and tones are simultaneously engaged in creating the design and the mood as well as the forms and space. Each mark is engaged in all of these functions. Consider, for instance, how the value, shape, and overall activity of the broader strokes of the background complement the value, shape, and activity of the blanket, and how, by their airy nature, they reinforce the figure's solidity. Additionally, these strokes, representing a large cast shadow, explain the light source and, by their agitated nature, serve to deepen the figure's stillness. The figure's hand is at once an expression of relaxation and a reflection of the fingerlike curved lines, large and small, that appear in the clothing and surrounding bedding. On the far left, the large dark tone acts as a necessary "containing wall" for the vigorous undulations that course through the foreground, and by its texture and dark tone, this "wall" calls attention to similar passages on the bedding.

For Rembrandt, even a drawing of an old woman bathing is transformed into an expression of dignity and grace. In the etching *Woman Bathing Her Feet at a Brook* (Fig. 1.21), Rembrandt approaches his subject with empathy, not pity, and with respect, not sentimentality. The depictive and dynamic factors merge to form an affirmation of human strength and nobility and to tell of spiritual, not physical, beauty.

In the eighteenth century, a growing interest in design and expression and a deepening need to make drawings reflect a more personal viewpoint continued to spur exploration of new approaches to figure drawing. An example of this trend can be seen in the *Study for "Jupiter et Antioche"* (Fig. 1.22) by the eighteenth-century artist Watteau. The artist utilizes his sensitivity to inflections of movement and modeling, revealed by the confident supple lines and by his emphasis on the gestural nature of the figure. Rhythmic, searching lines often weave through large segments of

1.20 REMBRANDT VAN RIJN (1606–1669) Femme Couchee (Saskia Sick in Bed)
Pen, washes of tone, 6¹/₂ × 5¹/₄ in.
Ville de Paris, Musee du Petit Palais, Paris.
© Phototheque des musees de la Ville de Paris.

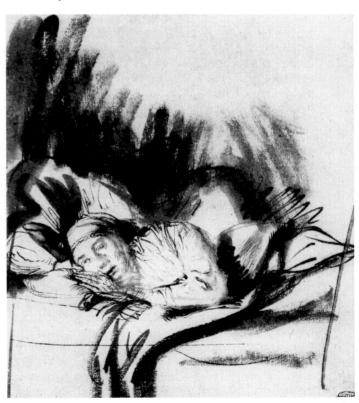

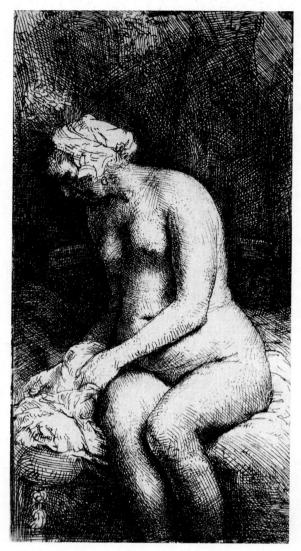

1.21 REMBRANDT VAN RIJN (1606-1669) Woman Bathing Her Feet at a Brook (1658) Etching, drypoint, and burin, Sheet: $175 \times 102 \text{ mm}$ ($6^{7/8} \times 4 \text{ in.}$): Plate: $159 \times 80 \text{ mm} (6^{1}/4 \times 3^{1}/8 \text{ in.}).$ Harvey D. Parker Collection. Courtesy, Museum of Fine Arts, Boston. P584.

the figure, their action relating even distant parts to each other. For example, some of the lines in the right arm move along its entire length and appear to continue down the left arm, giving evidence of the relatedness of the two limbs. (How often, in student drawings, are limbs drawn without reference to each other!) Note how these tactile lines grow thicker and thinner as they ride on the forms, suggesting volume, interjoinings, muscular tensions among parts, and even the presence of a light source. As they do this, the lines establish a design theme—a discernible pat-

tern of light and heavy stresses-of the line itself and of curving actions. These stresses and curves, in addition to the activities already noted, give the drawing an animated energy at both the depictive and abstract level. Here, as in the drawings discussed earlier, the marks that form the image simultaneously depict, organize, and express. In other words, the abstract behavior of the lines is compatible with the nature of the figure's action; the vigorous dynamic and representational expressions reinforce each other. To draw such spontaneous actions slowly and deliberately would tend to diminish their force and, consequently, our belief in them (compare Fig. 1.13).

Yet another example of the trend toward more personal modes of expression in drawing is Tiepolo's Seated River God, Nymph with an Oar, and Putto (Fig. 1.23). By assuming that a brilliant light source illuminates his subject, Tiepolo is able to model the forms broadly in three values: the white of the page, a tan tone, and a dark brown tone. The economy and clarity with which these imagined forms are drawn demonstrate the artist's knowledge of structure. anatomy, and perspective. The rhythmic and calligraphic behavior of the lines and shapes of tone attest to this sensitivity to the role of abstract energies in enhancing expressive meanings. Note, for instance, how most forms are interpreted as made up of egglike components. The pattern of such ovoids, like the pattern of dark shapes that punctuates the configuration, does much to unify the image and give it a suppleness and vigor that a more cautious and "correct" treatment could not achieve.

Another eighteenth-century artist, Goya, in his etching Not [in this case] either (Fig. 1.24), effectively communicates his outrage through a powerful system of abstract strategies. The atrocity depicted relies for its impact on more than recollections of the grim event. Goya has feelingly devised dynamic activities that intensify our reaction to the scene.

The entire configuration describes a large triangular shape interrupted only by the "softer" shape of the lounging French officer, a wry visual counterpoint to the severe vertical lines of the hanged man. Goya's knowledge of structure and anatomy, and of the expressive power of directed movement, helps him emphasize the weight of the hanged man. The awful forward thrust of the head is emphasized even more by the heavy mass of dark hair sloping downward. Fast-moving verticals add to the victim's weight. Even his long shirt is simplified, its edges drawn severely vertical. Although Goya gives us only a few suggestions of the body's presence beneath the shirt. we are convinced it is there: We can even guess that the hanged man's body is stocky. The fallen leggings, even the fast fall of the cast shadow below the vic-

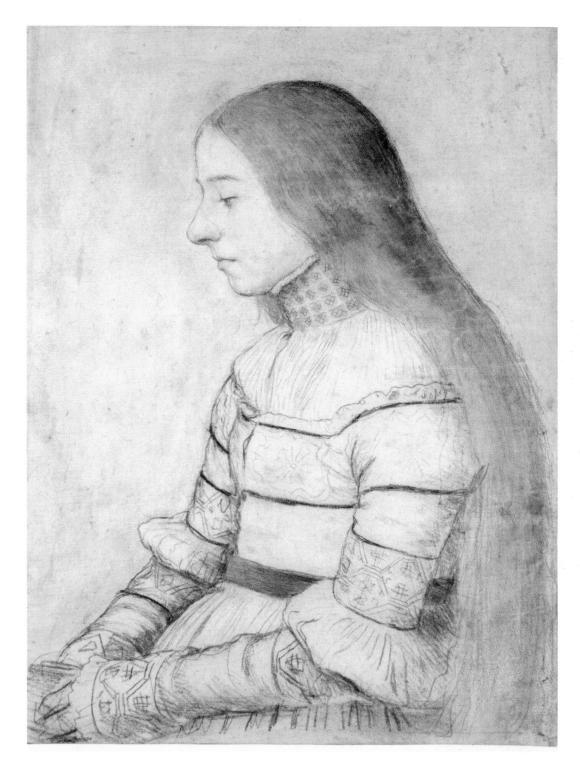

Plate 1 HANS HOLBEIN the Younger (1497-1543) Portrait of Anna Meyer Colored chalks, 39.1×27.5 cm ($5^1/4 \times 10^5/8$ in.). Photo by Martin Buhler. Oeffentliche Kunstsammlung Basel, Kupferstichkabinett. 1823.142.

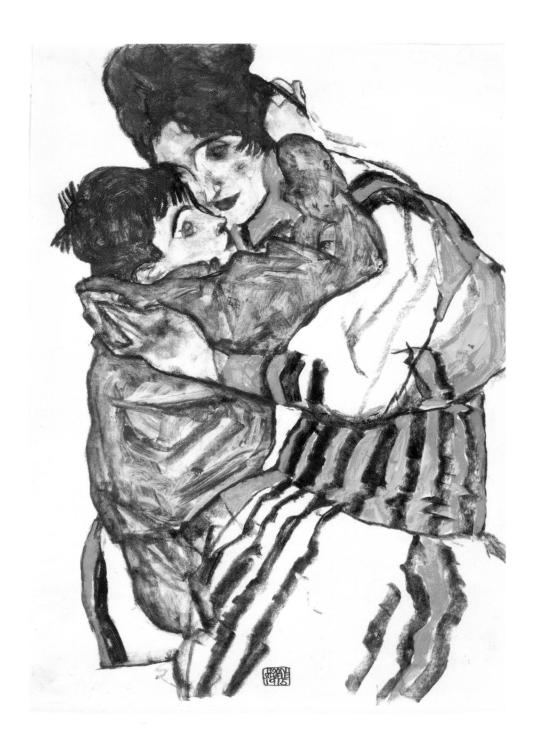

Plate 2 EGON SCHIELE (AUSTRIA, 1890–1918) Schiele's Wife with Her Little Nephew (1915) Charcoal, opaque and transparent watercolor on paper, $19 \times 12^{1}/2$ in. (483 × 318 mm). Edwin E. Jack Fund. Courtesy, Museum of Fine Arts, Boston. 65.1322.

Plate 3 WILLEM DE KOONING (American, 1904–)

Two Women III (1952)

Pastel, charcoal, and graphite pencils on heavy white machine-made paper, 451×561 mm. Signed in pencil I.I.: "de Kooning."

Allen Memorial Art Museum, Oberlin College, Oberlin, Ohio. Friends of Art Fund, 1957/
© 1999 Willem de Kooning Revocable Trust/Artists Rights Society (ARS), New York.

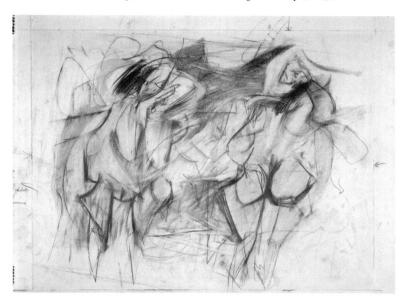

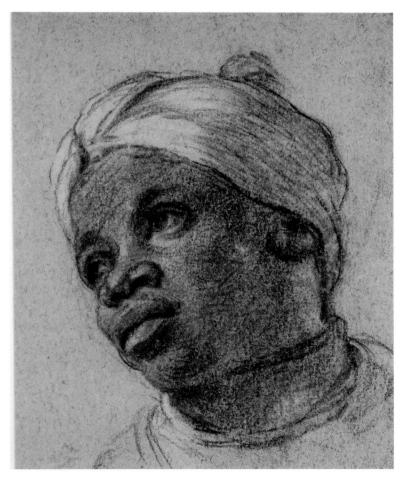

Plate 4 CHARLES DE LA FOSSE Head of a Young Negro, Inclined to Left Reproduced by Courtesy of the Trustees of the British Museum.

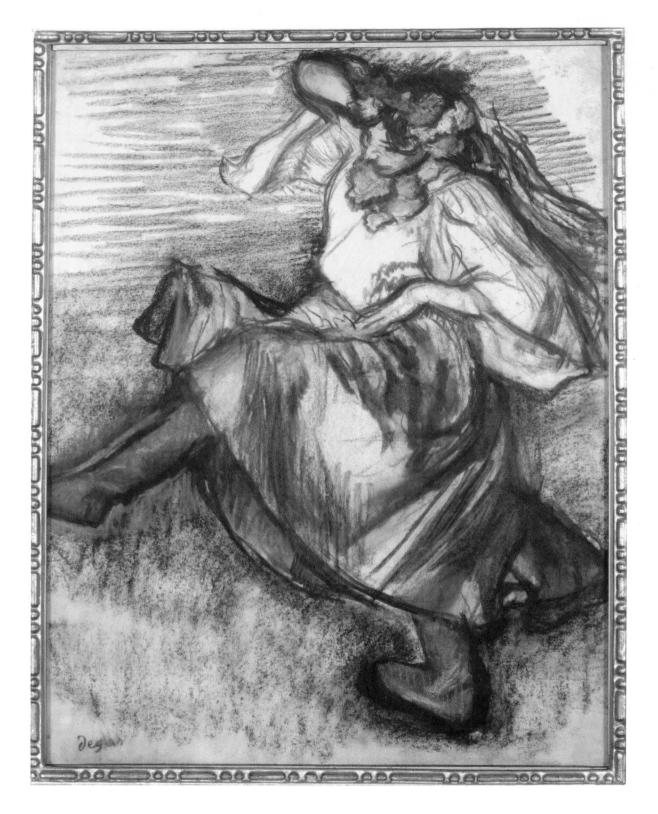

 $\textbf{Plate 5} \quad \textbf{HILAIRE-GERMAIN-EDGAR DEGAS} \ (1834-1917)$

Russian Dancer

Pastel over charcoal on tracing paper, H. $24^3/s$ in. \times W. 18 in. (61.9 \times 45.7 cm). Signed (lower left): Degas.

The Metropolitan Museum of Art, H. O. Havemeyer Collection,

Bequest of Mrs. H. O. Havemeyer, 1929 (29.100.556).

Photograph © 1992 The Metropolitan Museum of Art.

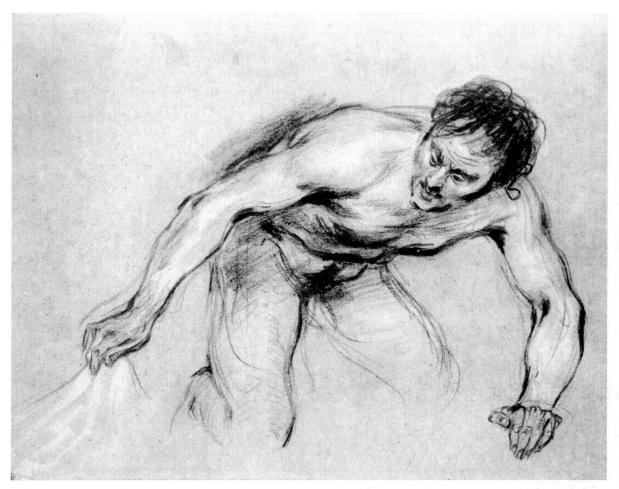

1.22 ANTOINE WATTEAU (1684–1721) Study for "Jupiter et Antioche"
Conte crayon on toned paper, 95/8 × 115/8 in. Photo R.M.N./Musee du Louvre, Paris/
Reunion des Musees Nationaux.

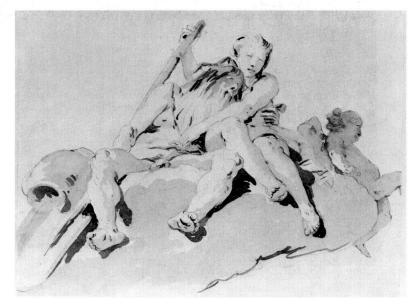

1.23 GIOVANNI BATTISTA TIEPOLO, Italian $(1696\hbox{--}1770)$

Seated River God, Nymph with an Oar, and Putto Pen and brown ink, brown wash, over black chalk, H: 23.5 cm, W: 31.3 cm. $(9^1/4 \times 12^5/16$ in.). The Metropolitan Museum of Art, Rogers Fund, 1937 (37.165.32).

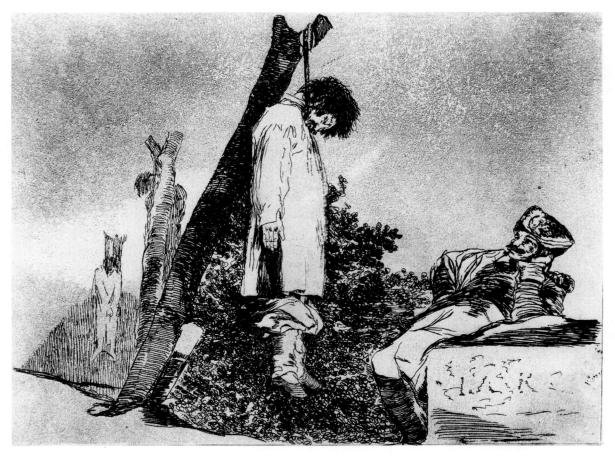

1.24 FRANCESCO JOSE DE GOYA Y LUCIENTES, Spanish (Fuente de Todos [Aragon], 1746–1828, Bordeaux), Not [in this case] either (one of a series of etchings from "The Disasters of War") Etching and aquatint, 15.6 x 20 cm. (7¹/4 × 5¹/2 in.). plate.

Courtesy of the Fogg Art Museum, Harvard University Art Museums, Gray Collection of Engravings Fund G8545.

tim's arm, help us feel as well as see what has happened here. Goya further strengthens the sense of falling weight by the repetition of the vertical lines of the foliage in the distance and by the strong vertical edge of the block against which the officer relaxes. Goya increases our initial shock of recognition by harshly contrasting the stark white of the victim's shirt with the dark tones that surround him. Note that the only lines suggesting animation are those more gestural ones of the lounging officer. In this way, too, Goya heightens the tragic stillness of the hanged man.

Despite the deepening interest in more subjectively interpreted figure drawings, there were some who held to a more objective reportorial approach to the figure's actualities and to an interest in the aesthetics of earlier periods. The nineteenth-century artists Ingres (Fig. 1.25) and Delacroix (Fig. 1.26)

represent two extremes of aesthetic persuasion that occupied the attention of many artists of that time.

Ingres, the older of the two, held that "the simpler the lines and forms, the more effectively they reveal beauty and power." Figure 1.25 shows his dedication to the volume-informing delineation of forms as the desired means by which to draw. This drawing reveals Ingres's attraction to the forms of ancient Greek and Roman art. The figures are shaped by the same concern for the classic standards of beauty that attracted such Renaissance masters as Raphael (Fig. 1.27). In both works, elegant and precise contours create figures of somewhat idealized proportions. In both, general structural facts and specific anatomical ones are important in the overall design of the forms. Ingres's lines, like Raphael's, are easy-paced and serenely harmonious. They express a graceful order among even the smallest surface details.

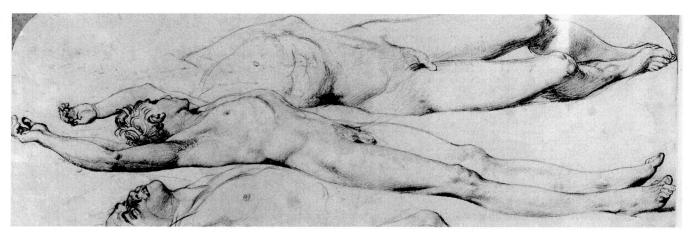

1.25 JEAN AUGUSTE DOMINIQUE INGRES, French (1780–1867) *Three Studies of a Male Nude*Lead pencil on paper, H: 7³/4 in., W: 14³/8 in.
The Metropolitan Museum of Art, Rogers Fund, 1919. (19.125.2).

1.26 EUGENE DELACROIX (1798–1863) *Two Nude Studies*Pen and ink, washes of color, 190 × 148 mm. Photo R.M.N./Musee du Louvre, Paris.

1.27 RAPHAEL (1483–1520)

Combat of Nude Men (detail)

Red chalk over preliminary stylus work, 14³/₄ × 11¹/₈ in. (entire work)

Ashmolean Museum, Oxford.

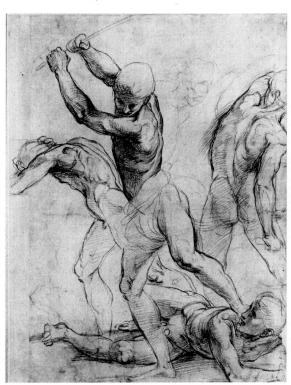

20

By contrast, Delacroix abhorred the idea of patient and deliberate contour drawing, although he, too, valued the impression of convincing volumes in space. But for Delacroix, emphasizing a volume's edges by contour lines only serves to weaken the sense of mass by calling forward those most distant parts of forms-their outlines. Instead, he advised that volumes should be grasped "by their centers, not by their lines of contour." Nor did Delacroix possess the temperament that could devote itself to explicit nuances and little harmonies. His interest lay in capturing fleeting actions by direct means. One of the boldest Romantics of nineteenth-century art, he sought the gestural, sensual qualities of the figure. In René Huyghe's view, "It is not form he studies, but rather its animating principle, its living essence that he transcribes." That a passionate interest in essentials was an important theme in Delacroix's drawings is borne out by his advice to a student: "If you are not skillful enough to sketch a man jumping out of a window in the time it takes him to fall from the fourth story to the ground, you will never be able to produce great works."

These opposing attitudes—a deliberate delineation versus a spontaneous gestural attack—have continued to contest with each other to this day. Indeed, these differing views about the act and purpose of drawing existed long before the 1800s. They are, after all, as much determined by individual temperament as by the stylistic trends of a particular period or country. We have only to compare the drawing by Veronese (Fig. 1.28) with that of another Italian Renaissance artist, Primaticcio (Fig. 1.29), to recognize the fundamental differences between an explicit and a gestural approach—between the wish to explain and the wish to seize.

Other artists, however, saw the desirable qualities of the two approaches not as opposing but actually as complementing each other. In fact, embracing both ideas, these artists emphasized at times the letter and at times the spirit of their subjects. Michelangelo, Rubens, and Rembrandt are among the few artists for whom the seeming conflicts between the prose of delineation and the poetry of evocation are not only resolved but become necessary interworking concepts that allow for a more encompassing view of human

1.28 PAOLO VERONESE (1528–1588)

Peter of Amiens before the Doge Vitale Michele (1576–7)

Pen and wash, 190 × 273 mm.

Szepmuveszeti Museum, Budapest. Collection Poggi Estethary.

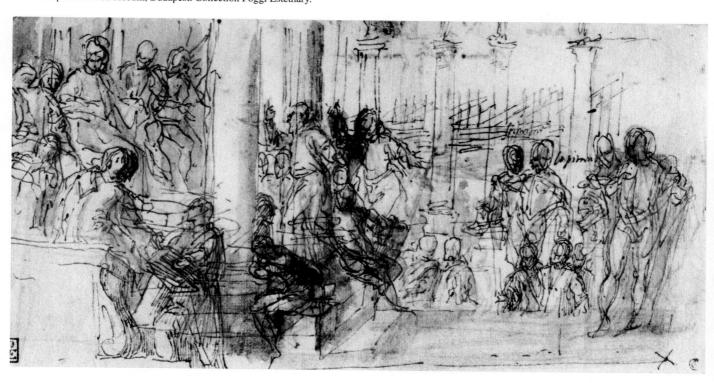

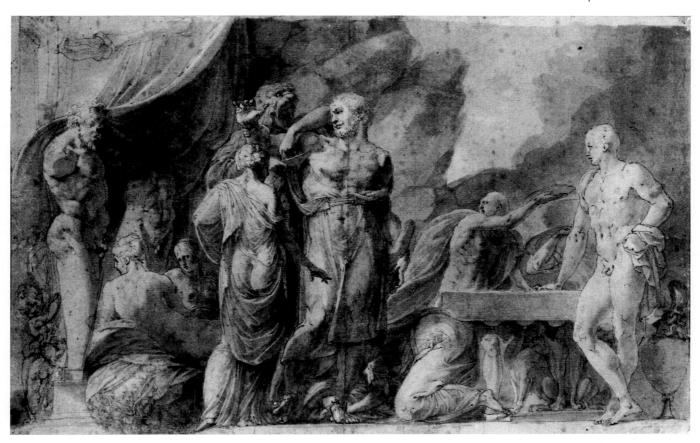

1.29 FRANCESCO PRIMATICCIO (1504–1570) Hercules and Omphale Pen and ink with bistre wash, $11^{1}/2 \times 17^{7}/8$ in. Fonds Albertina/Bildarchiv der Oesterreichische Nationalbibliothek.

form and spirit. Such artists cannot accept the restrictions of either precision or suggestion. For them, the freedom to range between exactitude and impression is an essential condition of creativity (Figs. 1.16, 1.21, and 1.22).

Figure drawings by the French artist Degas, regarded by many as one of the greatest figure draftsmen of the nineteenth century, offer an interesting example of an artist's shift, over the years, from a deliberate linear mode to a strongly animated and painterly one. Early Degas drawings show his interest in precise images influenced by an envisioned ideal. The later drawings show his attraction to a more direct and rugged style. As Degas's drawings became less calculated, their abstract activities grew bolder. This, in turn, led to drastic changes in the expressive content of his work. It is impossible to say whether a change in his aesthetic interests, perhaps influenced by the work of his Impressionist fellow artists, led

him from refined, quiet images to more direct, turbulent ones. Perhaps a more philosophical change toward the figure (and life) led him from idealized to more stormy conceptions. But whatever stimulus triggered the change, both his abstract and figurative interests changed together and were always well suited to each other.

As a young man, Degas was attracted to the classical view, as exemplified by Raphael and Ingres. These influences are evident in an early drawing, Study of a Nude for "The Sorrows of the Town of Orleans" (Fig. 1.30). But there are already some clues to the direction that Degas's drawings would take. Note the more objectively drawn passages in the left arm, the head, and the legs. These seem to depart from the drawing's main theme of idealized form. There is a hint of conflict between the desire to refine every nuance of edge, every dip and rise of the terrain, and an urge to simplify what is observed. The

1.30 EDGAR DEGAS (1834–1917)

Study of a Nude for "The Sorrows of the Town of Orleans"

Charcoal, 13⁷/8 × 9 in.

Photo R.M.N./Musee du Louvre, Paris.

more direct treatment of the right arm and hand; the frequent gestural accents, especially in the arms and along the figure's lower left side; the heavy accents of charcoal along the raised arm; and the fast, more calligraphic lines occurring throughout the drawing—all these suggest a wish to come to grips with issues concerning figurative and abstract essentials. The result is a work in which an idealized concept of Woman and the felt perceptions of a woman coexist in a tenuous alliance.

Comparing this drawing with a later lithograph by Degas, *Nude Woman Standing, Drying Herself* (Fig. 1.31), we see the release of the energies hinted at in the previous drawing. There is still something of a vision—a personal convention for human form and proportion. But in place of the lithe and sensuous ideal of the early drawings, there is a treatment of the figure simplified to suggest more weighty and geometrically pure forms. The drawing's dominant visual theme is movement. The hair, the curving torso, the

wedge shape of the towel, and even the pattern of the background all exhibit motion. There is a kind of frozen moment in what we feel is a continuing sequence of movements. Catching the woman in the act of drying herself, Degas suggests what her prior actions were and foretells the action to come. Notice how much stronger the abstract activities become when Degas shifts from an emphasis on denotation, as in Figure 1.30, to an emphasis on the figure's essential structure and spirit. In these two Degas drawings, the four factors interact differently, but in each, they succeed in shaping forms that live.

Nineteenth-century artists frequently brought more intensive subjective interpretations to drawing. Sometimes creative crosscurrents pointed to new concepts. Cassatt's *The Coiffure* (Fig. 1.32), for example, shows the influence of Japanese prints on the artist. Often, the passions of the artist, finding encouragement and inspiration in the ever-expanding themes and styles of art, especially in France, were able to hit

1.31 HILAIRE-GERMAIN-EDGAR DEGAS, French (1834–1917, Paris)

Nude Woman Standing, Drying Herself (ca. 1891–1892). Lithograph, 50×28.5 cm. $(14^3/4 \times 11$ in.) design. Courtesy of the Fogg Art Museum, Harvard University Art Museums. Gray Collection of Engravings Fund G8830.

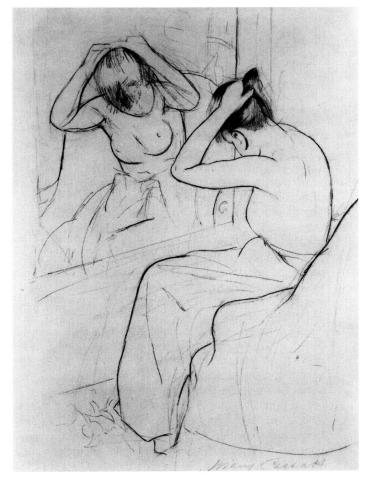

1.32 MARY CASSATT (1844–1926)

The Coiffure (1891)

Black crayon and graphite, $.383 \times .277 \ (15^1/8 \times 10^7/8 \ in.)$ Rosenwald Collection, Photograph © 1998 Board of Trustees, The National Gallery of Art, Washington, D.C. 1948.11.50.

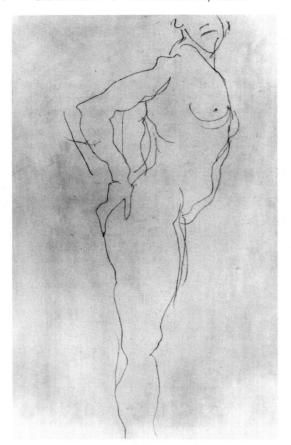

1.33 AUGUSTE RODIN (1840–1917) Study of a Standing Nude Pencil, $9^1/4 \times 6^1/2$ in. National Gallery, Prague.

on more daring expressive modes. The drawing by Rodin (Fig. 1.33) shows something of the tempo that graphic expression can attain when it is driven by strong abstract and sensory forces.

So far, in broadly tracing the emergence of interpretive approaches to figure drawing, we have seen fluctuations in emphasis between the depictive and the dynamic. During the early Renaissance, emphasis focused on depiction. By the nineteenth century, some artists continued to favor depictive imagery, but most showed a growing interest in a subject's underlying abstract condition. But as we have seen, for some artists both qualities were (or as in the case of Degas, became) compelling and interdependent themes. Much twentieth-century figure drawing continues to move in the direction of amplifying subjective meanings by concentrating on abstract rather than representational strategies. But as in earlier periods, the strongest drawings, both in creative and human terms, seem to be those which reveal a sensitive interaction among the four basic factors and between the figurative and abstract meanings they generate. The best exponents of figure drawing have always understood that each factor inevitably affects—and is affected by—the other three.

It should not be inferred that artists who favor representational imagery are necessarily less sensitive to dynamic matters or that artists who emphasize abstract and emotive matters are less concerned with depictive ones. In either mode, artists must regard both aspects. When they do not, the drawings that result, however realistic or abstract they may be, usually lack the impact of works in which the "what" and the "how" reinforce one another. Although Goya's etching (Fig. 1.24) emphasizes the figurative whereas Lachaise's drawing (Fig. 1.8) stresses the abstract, both are integrated systems of these two themes. Their differences in emphasis tell in different creative purposes and attitudes.

Later nineteenth-century figure drawings and those of the twentieth century are characterized by their general tendency toward more daring, inventive, and ever more subjective points of view and by their broad range of interests and goals, which now often includes color as a consideration. In Schiele's drawing (Fig. 1.1; also see Plate 2), the animated, swirling

figures and the bold abstract life of the elements that produce them are strong intensifications of both considerations. Notice, though, in Plate 2, how the orange stripes of the mother's dress help animate the drawing's swirling motion, intensifying the figures' bonding gestures. In Figure 1.1, however, the absence of color's dynamic force greatly reduces the sense of action.

This more personal and inventive approach to figure drawing encouraged artists to explore new ways of interpreting the human figure and of communicating ideas and feelings. For the German artist Kollwitz, the figure became a vehicle for expressing her (and everyone's) anguish at the pain and bereavement that war brings. As noted earlier, her drawing of a weeping woman (Fig. 1.2) is a deeply moving expression of sorrow. The wavering flow that envelopes the fig-

ure suggests the movements we associate with weeping. In contrast to the soft fall of the lines of the drapery and kerchief, the angular arms, the action of the fist pressed to the face, the sudden tonal contrast between the right shoulder and head, and even the figure's scale and placement on the page all add to our understanding of the drawing's message of grief.

Some artists have always been motivated by the need to convey a moving, provocative, or perhaps amusing message. It might be compassion, as in the drawing by the Northern Renaissance artists Grünewald (Fig. 1.3); it might be sensuality, as in the drawing by the late nineteenth-century sculptor Rodin (Fig. 1.33); or it might be rage and protest, as in the drawings by the twentieth-century artists de Kooning (Fig. 1.34) and Rothbein (Fig. 1.35).

1.34 WILLEM DE KOONING (1904–)

Two Women III (1952)

Pastel, charcoal, and graphite pencils on paper, H: 14³/₄ in., W: 18¹/₂ in. Allen Memorial Art Museum, Oberlin College, Ohio. Friends of Art Fund, 1957.57.11/© 1999. Willem de Kooning Revocable Trust/Artists Rights Society (ARS), New York.

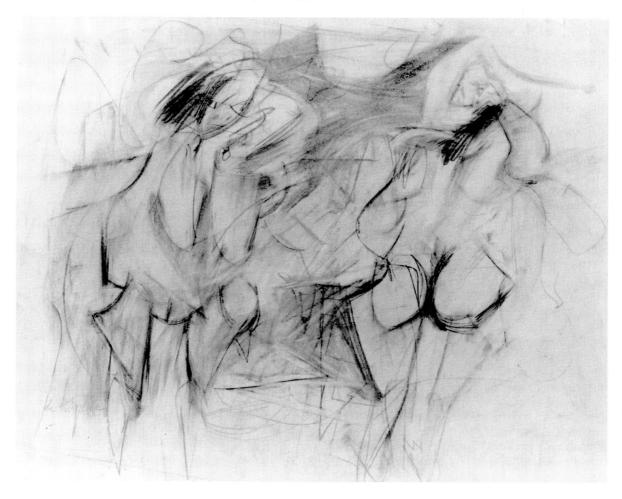

1.35 **RENEE ROTHBEIN** (1924—) Study for the Nazi Holocaust Series Pen and ink, $5 \times 7^{1/2}$ in. Courtesy of the artist.

Such artists are impelled as much by psychological as by visual themes. Unlike artists for whom figure drawing is first of all an act of inquiry and analysis, artists oriented toward human commentary are motivated by the need to tell as well as to find. Note how, in de Kooning's drawing (Plate 3), strong color notations add to the work's expressive power.

In the twentieth century, the factor of design in figure drawing has become increasingly important. This interest in the formal, relational ordering of the elements and of the figurative forms they produce has led to a notable characteristic of many contemporary artists: emphasis on the two-dimensional aspects of

the figure and its environment. Although the best artists have always been sensitive to a drawing's two-dimensional design—to the relational interactions of the visual elements within the bounded area of the page, or *picture plane*—such relational activities were generally subordinated to those of the third dimension. This should not suggest that the two-dimensional conditions of earlier drawings are necessarily less fully considered or sophisticated; rather, their impact—their ability to dominate our attention—is intentionally reduced to avoid muffling the drawing's volumetric and spatial order.

For many recent and contemporary artists, expanding the abstract activities on the picture plane has permitted new graphic ideas and experiences. In Matisse's *Seated Nude with Tulle Blouse* (lithograph) (Fig. 1.36), bold systems of straight and curved lines, textural and tonal contrasts, and shape and pattern variations call our attention to the drawing's surface state. There are equally strong clues to these forms as volumes in space, but these structural and spatial statements share in, rather than dominate, the drawing's overall design. This enables

1.36 HENRI MATISSE (1869–1954)

Seated Nude with Tulle Blouse
(Nu assis a la chemise de tulle) (1925)

Lithograph, 12 × 16 in.

Rosenwald Collection, Photograph © 1998 Board of Trustees,
National Gallery of Art, Washington, D.C. 1943.3.5867/© 1999

Succession H. Matisse, Paris/Artists Rights Society (ARS), New York.

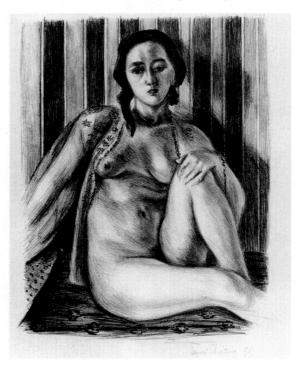

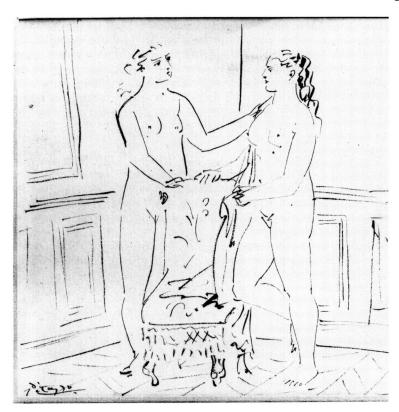

1.37 PABLO RUIZ PICASSO Spanish (1881–1973)

Two Nudes (1923)
Pen and ink, 8¹/₄ × 7³/₁₆ in.

Museum of Art, Rhode Island School of Design.
Gift of Paul Rosenberg/© 1999 Estate of Pablo
Picasso/Artists Rights Society (ARS), New York.

us to "read" the drawing in two compatible and satisfying ways. No sooner do we experience an ordering of two-dimensional conditions than volumes emerge to reveal an ordering of masses in space. This impression, in turn, subsides into the matrix of picture-plane activities to start the cycle over again. This creates a pulsation between flat and deep space, where the contrasts between geometric and organic areas and among the variously patterned textures take on different visual meanings.

Picasso's *Two Nudes* (Fig. 1.37) is an example of a somewhat more two-dimensionally oriented drawing. In contrast to the Matisse, which relies for its design strategy on strong patterns and strongly defined enclosed shapes, Picasso's theme is based on subtle tensions. There is tension in the broken lines that strongly suggest but never actually enclose shapes, in the lines and shapes that suggest vertical and horizontal directions but are themselves always diagonal, and in the overall fluctuation between the depictive and the abstract function of the lines. Additionally, small bursts of textural activity in the hair of both figures, the chair, and the floor contrast with the austere character of the two figures and their surroundings.

In Close's Phil/Fingerprint II (Fig. 1.38), there is

a barely contained standoff between the second and third dimensions. The representation is plain enough, but the pronounced means of depicting it—by a pattern of finger daubs—returns us to the picture plane and to the realization that these daubs are the reality and the young man's head is the illusion.

In the three previous drawings, the visual activities of the second and third dimensions are roughly equal. This is not the case in de Kooning's *Two Women III* (Fig. 1.34; also see Plate 3), which is conceived in a way that sharply reduces the sense of volumes in space. Here, the tempestuous life of the elements, occasionally breaking free of any depictive role, accomplishes two things: It creates a predominantly two-dimensional drawing, and it conveys a powerfully aggressive statement about the subject. De Kooning relies on the expressive nature of the elements' dynamic behavior to carry the message; here, evocation largely replaces denotation.²

² For a thorough discussion of the concepts of evocation and denotation, see Nelson Goodman, *Language of Art* (New York and Indianapolis: Bobbs-Merrill, 1968), chap. 1.

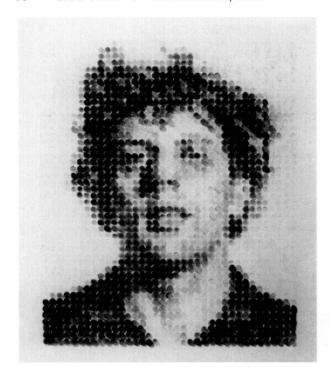

1.38 CHUCK CLOSE (1940—)

Phil/Fingerprint II (1978)

Stamp-pad, ink, and graphite on paper, 29³/4 × 22¹/4 in. (75.6 × 56.5 cm.)

Collection of the Whitney Museum of American Art, New York.

Purchase, with funds from Peggy and Richard Danziger 78.55.

Photograph by Geoffrey Clements. Copyright © 1998:

Whitney Museum of American Art.

We have seen that a concern with abstract considerations is not new in figure drawing. We have also seen that a sound understanding of structure and anatomy has always informed and influenced the best figure drawings. Whether it is a dominant theme, as in Figure 1.14, a spur to gestural activity, as in Figures 1.17 and 1.26, or a guide to expressive summaries of human forms, as in Figure 1.34, it is apparent that structural and anatomical knowledge participated in the choices and judgments that shaped these images.

Sometimes structural issues and the visual metaphors of strength and energy they suggest are prominent ideas in figure drawings, as in Figures 1.14 and 1.23, where the figure's constructional, often planar, aspects are strongly in evidence. Sometimes, as in Figure 1.39, they are only felt rather than seen; they are gentle nuances instead of bold carvings.

For many artists, structural considerations are important in the early stages of developing their figure drawings. In Rubens's "Presentation in the Temple" (Fig. 1.39), we can follow the artist's thinking about

the placement and general character of the volumes. Many lines, especially in the three standing figures, are preliminary probes to establish masses. Note that some of these lines are drawn through forms, as if the figures were transparent, enabling Rubens to understand the masses in more sculptural terms. Some pale washes are broadly applied to define the large planes and the general behavior of the light. In the kneeling figure, massed lines have been placed over the washed tones, further developing the big masses. Most artists agree that such inquiries about the structural essentials of a subject, whether actually drawn or only observed in the mind's eye, are crucial to an understanding of their subject's expressive character.

Similarly, Papo's *Standing Figure* (Fig. 1.40) uses ranks of schematic lines to establish the subject's

1.39 PETER PAUL RUBENS Flemish (1577–1640) *Presentation in the Temple* Brown ink and wash on paper, H: 8³/₈ in., W: 5³/₄ in. The Metropolitan Museum of Art. Gift of Mr. and Mrs. Janos Scholz, 1952 (52.214.3).

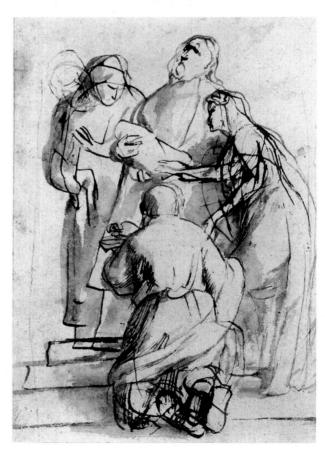

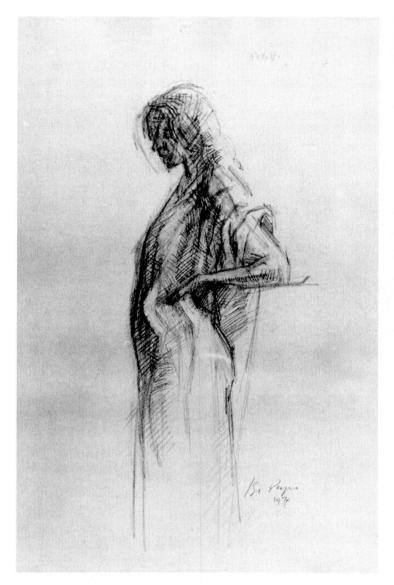

1.40 ISO PAPO (1925-) Standing Figure
Pencil, 13 × 18 in.
Collection of Susan Butler, Brookline, Massachusetts.

major planes and masses. Papo's interest in understanding the architectural nature of these forms can be seen in the way the lines measure them, how lines are drawn through some forms to locate their far sides and connect them, and how the lines are made to explore the forms' terrain. Note the surprisingly curvilinear movements among these incisively summarized and mainly angular masses. In Chapter 2, we will examine this analytic, planar approach to the figure's forms. Although such structural considerations are only sometimes a dominant theme, as here, many good figure drawings show them in evidence, however subtly, interacting with the other factors.

Yet another useful example of structural consider-

ations is Giacometti's *Trois Femmes Nues* (Fig. 1.41), where the figures are formed by a coming together of flat and curved planes that abut and interlock in various ways. Contrary to the beginner's tendency to rely heavily on contours, Giacometti fits together facets of the figure, only some of which form the figure's silhouette, thus reducing attention to the subject's outer boundaries. For Giacometti, the purpose is to define mass more than their collective shape. This is especially evident in the left and central figures, where, once the drawing is under way, the emphasis shifts from the tentative sketching of outer edges (as in the figure on the right) to the construction of the figure's planar condition. As these structurally dominant

1.41 ALBERTO GIACOMETTI (1901–1966)

Trois Femmes Nues (1923–24)

Bleistift, H: 44.5 cm × W: 28 cm.

Photo by Walter Drayer. © 1999 Artists Rights Society (ARS),
New York/ADAGP, Paris.

1.42 MICHAEL PLATT

Sketchbook (1990–91)

Charcoal on wooden cutouts, 72 in. × 288 in.

Photograph by Harlee Little. Courtesy of the artist.

1.43 RUDY AUTIO (1929–) Girl with Dog (1981) Ink on paper, $30\times23^{1/4}$ in. The Arkansas Arts Center Foundation Collection, 1987.87.29.

1.44 KENT BELLOWS (1949–) Four Figure Set Piece (1988) Graphite pencil on paper, $17^{1/4} \times 30^{1/2}$ in. The Arkansas Arts Center Foundation Collection: Purchased with a gift from Virginia Bailey, Curtis and Jackye Finch and Director's Collectors, 1989. Accession #89.22.

drawings show, conceiving the figure as an architectural event holds important creative potential.

Every age redefines humankind. The artists of the twentieth century, creating with a sense of limitless freedom to inquire and interpret, have come forward with a multitude of definitions. These differing approaches to figure drawing, whether they tend toward an expressionistic (Fig. 1.42), design-oriented (Fig. 1.43), or realistic persuasion (Fig. 1.44), have to contend with the same forms that confronted Michelangelo, Rembrandt, Degas, Picasso, and all the other great exponents of the figure. And this common challenge—the figure—has imposed *its* conditions on artists of every age, as they have imposed their modes of order and expression on it.

In this broad review, anatomy and the underlying factor of structure have been only briefly commented on; these considerations will be discussed more fully in the following chapters. Their importance in figure drawing cannot be overemphasized. But it should again be noted that structure and anatomy are tools to

be utilized, not concepts to be worshiped to the exclusion of the figure's dynamic aspects or to be regarded as obliging the artist to draw in a naturalistic mode. Our purpose in understanding these systems is to broaden, not restrict, choice; to enhance, not diminish, expressive meanings. This is the case even when anatomical forms are themselves the subject, as in Rothbein's *Study for the Nazi Holocaust Series* (Fig. 1.35). In this drawing, both the skulls *and* the eruptive fury of the dynamic forces cry out a warning. To lose sight of anatomy's function as both a source and an agent of visually expressive inventions is to replace felt perceptions and insights with unselective scrutiny. Such an attitude tends toward taxidermy, not life.

Art is not science. Young artists today who wish to draw the figure cannot pick up the trail where Degas or Matisse stopped. They cannot begin by building on the achievements of these artists, not only because beginning artists lack the vast factual knowledge about human form that masters acquire, but also

because they lack the penetrating perceptual comprehension and informed intuition that all great artists evolve over a lifetime of encountering human form and spirit. In any case, we cannot (and should not want to) adopt another's sensibility.

We must "draw our own conclusions" through a dedicated study of the basic factors involved in figure drawing and by a searching examination of what these factors demand of us as artists and as members of the human family.

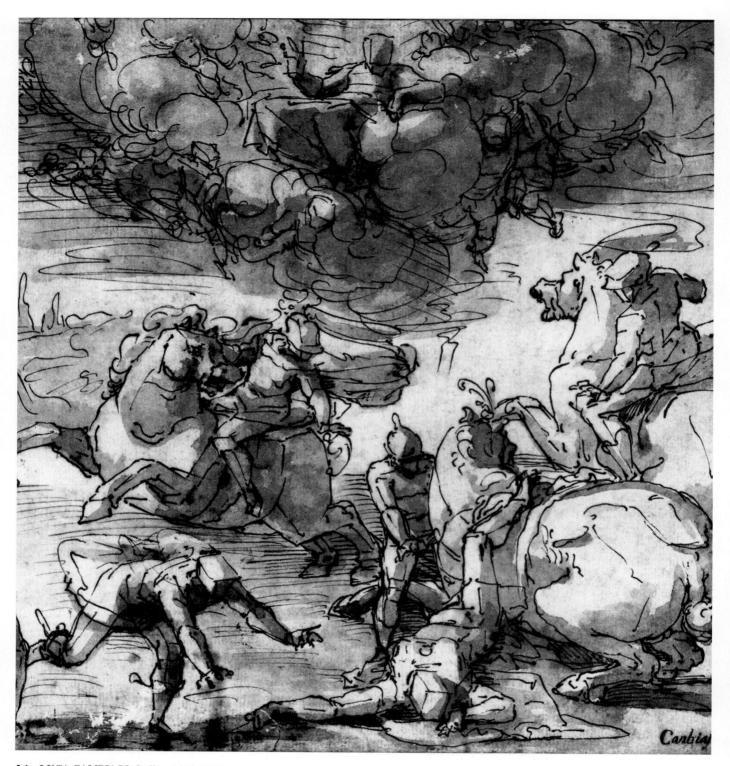

2.1 LUCA CAMBIASO, Italian (1527–1585)

The Conversion of St. Paul (detail)

Pen and brown and iron gall ink and brown wash, 27.7 × 40.7 cm.

The Art Museum, Princeton University. Bequest of Dan Fellows Platt, Class of 1895. 1948-617.

The Structural Factor

The Figure As a Structure

SOME GENERAL OBSERVATIONS

The child who draws a tree as a vertical shaft topped by a ball of leaves may not be able (or wish) to drape this basic structure in more realistic trappings, but at least the tree's essential form and character have been understood and established. If our drawings are to show convincing volumes in space, we, too, must determine the basic constructional nature of our subjects' forms. Paul Cézanne, the great French painter, put it this way: "Treat nature by the cylinder, the sphere, the cone." In other words, discover the basic geometric volumes that underlie all forms. This is easy to do with many subjects: We recognize the cylindrical form of a silo or a cigar and can readily see a Christmas tree as conical or a barn as blocklike. But we may at first have difficulty seeing these and other kinds of geometric solids as underlying human forms.

There are several reasons for this. The beginner, reacting to the figure's imposing presence, usually tries to capture it by concentrating on contours, on surface textures, and on various interesting but minor details. A preoccupation with such surface conditions

Seen this way, human forms can be reduced to such geometric solutions as shown in Figure 2.2. As this illustration shows, the figure's forms yield to more than one kind of geometric interpretation. Some artists, such as Cambiaso (Figs. 2.1, 2.5, and 2.35), favor blocklike solutions; others, such as Picasso (Fig. 2.8) and Tintoretto (Fig. 2.19), often reduce the figure to cylinders, spheres, and ovoids. As Figure 2.2 shows, some form summaries are not, strictly speaking, purely geometric. So we must expand on Cézanne's list of simple forms. In the human figure, we can find underlying masses that suggest the pyra-

blinds the student to the figure's underlying geometric forms. Moreover, the beginner's awe of the figure, which is quite rightly regarded as complex, important, and beautiful, and the subtlety with which the figure suggests its substructure of simple, pure forms, make an analytic search for them difficult. Then, too, the beginner's tendency to assemble the image in a sequence of mostly unrelated segments makes a search for the figure's action, form character, and proportions nearly impossible. As with the traveler who cannot see the forest for the trees, the beginner, in concentrating on a sequence of details, misses the figure's fundamental movements and masses. One of the primary insights of sound figure drawing, then, is the need to understand the figure's forms as reducible to arrangements of simple geometric summaries.

¹ Paul Cézanne: Letters, ed. John Rewald (London: Cassirer, 1941).

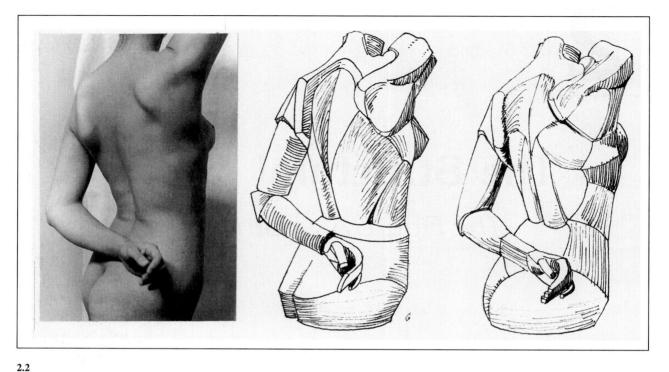

mid, egglike or ovoid forms, the wedge, and the bent or twisted block as well as several variants and combinations of these simple forms (Fig. 2.3). Practice drawings of masses such as these and other similar ones are useful in helping us better understand the structural nature of the figure.

Such simple solids can also be understood as *emerging from* human forms. In Figure 2.2, the figure on the left is seen as reduced to the more geometric forms in the analyses, but in Figure 2.4, we sense the figure to contain these pure forms within it; the forms, forcing their way to the surface, simplify the figure's surface terrain, their various joinings explaining the passages between them.

Once we understand the figure as both reducible to and emerging from simple geometric volumes, we have the reciprocal concepts that help us understand the figure's forms in more manageable visual terms. As we can see, in *The Conversion of St. Paul* (Fig. 2.5), Cambiaso relies on just such simple masses to clarify the structure and positions in space of complex human and animal forms. In this preparatory sketch, the artist is exploring the structure and lighting of a proposed painting project. Logically enough, he reduces the subject matter to its volumetric essentials, enabling him to arrange the main building blocks of the form and composition quickly and easily. Notice how in this envisioned scene Cambiaso calls on his

store of anatomical knowledge to help shape the simple volume summaries. As the detail in Figure 2.1 clearly demonstrates, the foreshortened upper and lower segments of the fallen rider's torso, despite their blocky simplifications, strongly suggest the rib cage and pelvis.

Cambiaso's use of a light source also helps clarify the subject's main masses. Light coming from a single source illuminates most strongly those flat or curved surface segments, or *planes*, directly facing it, leaving those planes turned away from the light source darker. Cambiaso's consistency in illuminating all the planes facing the light, which here falls from a point just over our left shoulder, provides an additional means for understanding the structure and placement of these forms. By this simplified means, the artist is also better able to establish quickly the tonal design of the work.

But this emphasis on structural clarity is often present in works intended for more than exploratory study. For many artists, the figure's architectural aspects are important matters, as Michelangelo's drawing *Adam* (Fig. 1.14) clearly shows. Some artists emphasize the figure's constructional aspects by frankly stressing the geometric solids that human forms hint at. In Dürer's etching *Desperate Man* (Fig. 2.6), we find strong suggestions of cylinders, cones, ovoids, and only slightly less evident hints of block forms, as

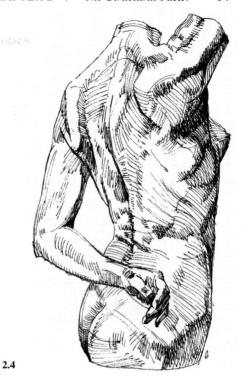

2.3

in the left arm and leg of the central figure. Cézanne's restatement of the figure in the simple masses he wrote of expresses a monumental solidity (Fig. 2.7). In Picasso's *Woman Seated and Woman Standing* (Fig 2.8), the forms boldly show their geometric origins and create powerful figures resembling a sculpture.

Other artists, such as Whistler (Fig. 2.9) and Bishop (Fig. 2.10), although they hold these form simplifications in mind, emphasize instead the figure's pliant, serpentine character. For such artists, structural conclusions are still necessary (though largely unseen) guides in suggesting volume in simple, spontaneous figure drawings primarily concerned with rhythm and movement.

Although the need to see the structural aspects of mass is fundamental to good figure drawing, perception does not begin or end with the noting of planes and values. We must respond to the abstract possibilities in our subject matter and in the emerging drawing—the directed movements, tensions, and contrasts that constitute the dynamics of perception. Once we do, these qualities become as visually evident as the measurable aspects of the things we see. In analyzing the structural nature of our model, we can no more disregard the energies that play among the parts than we can concentrate on such dynamic actions to the exclusion of seeing the figure's structural essentials. Neither aspect of the model's forms can be usefully

understood unless they are seen as acting on each other. It is when we recognize the interdependence of the measurable and dynamic components of perception that we fertilize our constructions in ways that turn them into living graphic inventions.

Although accentuating either a subject's structure or its abstract life is, of course, a personal creative matter, many artists—for example, Rubens, Rembrandt, G. B. Tiepolo, and Degas—consider structural and dynamic factors to be equally important. Their drawings show a more or less evenhanded concern with both matters; they reflect the view that a subject's structure is an important key to its dynamics, and its dynamics a key to its structure. They realize that the expression in a figure's abstract character clarifies important structural traits. For, in any pose, the effects of weight, the tensions and pressures among the parts, and the sense of forms being strained or limp are all *felt* as well as observed realities.

To experience these dual realities, the artist needs to negotiate between fact and feeling. Rembrandt does this in *Female Nude Asleep* (Fig. 2.11). Limp weight is expressed by simple blocky forms that are, considering the urgent spontaneity of Rembrandt's handling, remarkably convincing volumes. How much we know about the structure of the figure's torso, left arm, and legs, and how few lines and tones are used to construct them!

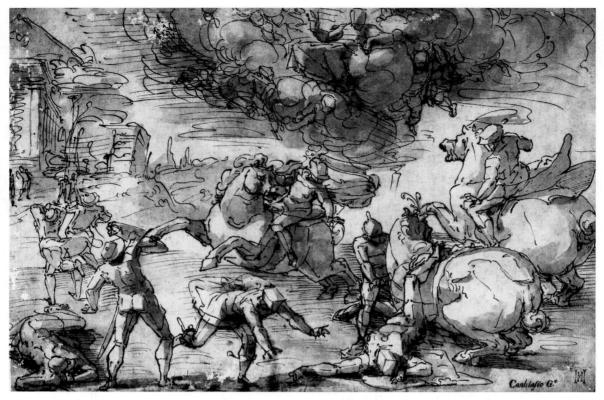

2.5 LUCA CAMBIASO, Italian (1527–1585)
The Conversion of St. Paul
Pen and brown and iron gall ink and brown wash,
27.7 × 40.7 cm.
The Art Museum, Princeton University. Bequest of
Dan Fellows Platt, Class of 1895. 1948-617.

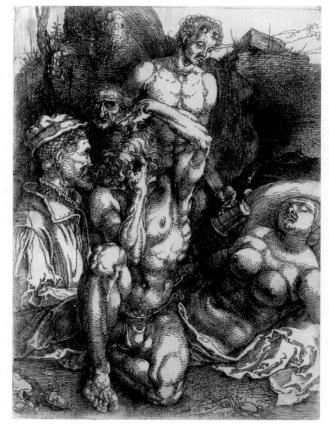

2.6 ALBRECHT DÜRER (1471–1528) *Desperate Man* (ca. 1514/1515)

Etching, $7^3/8 \times 5^3/8$ in.

Rosenwald Collection, Photograph © 1998 Board of Trustees, National Gallery of Art, Washington, D.C. 1943.3.3531.

2.7 PAUL CÉZANNE, French (1839–1906)

Allegorical Figure of a River God (ca. 1875–1886)
(after Eugene Delacroix, French, 1798–1863),
Graphite on cream wove paper, 12.5 × 21.6 cm.
Arthur Heun Fund. 1951.1 page 4 recto. Photograph
© The Art Institute of Chicago. All Rights Reserved.

But these forms do much more than convey structural essentials. By their weight and pliancy, their emphatic overlappings, and their rhythmic harmony, they enact as well as describe the pose. They do still more. Note how Rembrandt draws the billowing forms of the bedding to emphasize the design's "crescendo": a great burst of dynamic force at the head. Note, too, that Rembrandt further underscores this center of activity by placing the drawing's largest tones on and below the head, by the scale of the pillows, and by the bold lines that radiate from them. The design builds in weight and tension to the left, echoing the buildup of the figure's forms on that side. By their similarity of handling and direction, the lines that move around the figure's forms and those that express the bedding's mass and the weight of the figure on it serve both structural and dynamic functions. These alternately thick and thin lines act as a kind of visual meter—a beat—that unites forms as it defines them.

This fusion of analytic and emphatic interests is also apparent in Kokoschka's *Trudl Wearing a Straw Hat* (Fig. 2.12). As in Rembrandt's drawing, we sense that Kokoschka perceives his world in active, not

2.8 PABLO RUIZ PICASSO (1881–1973)
Woman Seated and Woman Standing (1906)
Charcoal on paper, 24¹/8 × 18¹/4 in.
Philadelphia Museum of Art, Louise and Walter Arensberg
Collection/© 1999 Estate of Pablo Picasso/
Artists Rights Society (ARS), New York.

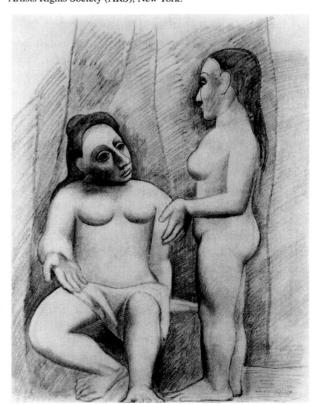

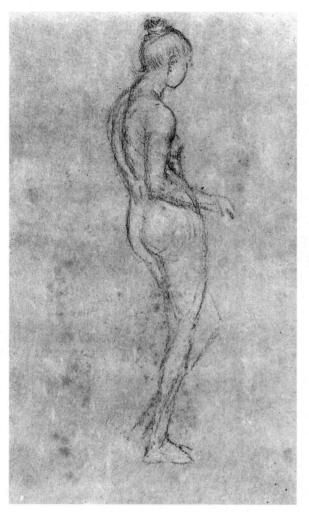

2.9 JAMES ABBOTT McNEILL WHISTLER (Lowell, MA, 1834–1903, London, England)
Nude Model (1872–1875).
Pastel on brown paper, 28.6 × 17.8 cm. actual.
Courtesy of the Fogg Art Museum, Harvard University Art Museums.
Bequest of Grenville L. Winthrop 1943.621.

static, terms. Not only do lines produce directed energies in the hair, hat, and background, but even the shapes and planes that construct the young woman's forms possess an animated drive. In the same way, the artist's responses to the subject's rhythmic character provide him with motives for emphasizing the structure in some areas and subduing it in others. Here, as mentioned earlier, structural discoveries stimulate dynamic ones, and vice versa.

These general remarks about structure point to two reasons for artists regarding this factor highly. First, it leads to important insights about a subject's underlying mass character, and second, it leads to reasons (and techniques) for endowing drawings with the abstract energies that make them come alive. To understand better how artists extract the structural essentials from the raw material of the figure—often obscured by conflicting light sources and always somewhat camouflaged by color, texture, and minor surface effects—we now turn to those issues that help them do so.

A PLANAR APPROACH TO HUMAN FORM

For the artist, the basic structural unit is the plane. Planes can be defined as flat or curved surfaces or facets of a surface whose boundaries can be described by lines. These boundaries, then, represent changes in the terrain of a form's surface. For example, in Figure 2.13, the three planes in (a) represent three separate surfaces, which by their shape and position collectively suggest a cube. But in (b), the six upper planes are more readily seen as changes in the direction of a single rooflike surface. When planes group together to form solids, they can suggest other unseen planes, as in (c).

Planes always define changes in a form's surface. In nature, we always see planes as separated from each other by changes in direction, color, texture, or value. The use of lines to separate adjacent planes is a convenient graphic convention, but lines rarely exist in nature and not at all in the figure. In human forms, even the finest "lines" are actually narrow hills or valleys, as, for example, in the folds and creases of your hand.

Examining your hand from several angles will show that very few planes are easily visible as neat bounded facets. Most of the planes of the hand, like those of the rest of the human figure, are small, often curved, and gradually blend into each other. In analyzing or inventing a figure's masses, artists must see the large, or major, planes first. They must train themselves to see groups of small planes as forming larger ones when they are roughly alike in their direction in relation to other groups of small planes. For example, examining our hand held in a fist, as in Figure 2.14, we see that the four fingers suggest a blocklike mass and that the thumb and palm also offer similar blocklike masses. But to see these blocky forms, we must disregard the little planar surface changes that each part of the fist is composed of. They obscure our recognition of the large planes they collectively form. In other words, we must analyze a form's structure not by recording every plane we see, but by first making a conscious search for the form's larger planes.

Not until the shape, scale, and direction of these major planes are established can we, with any certainty, draw those smaller facets that comprise them. For in constructing the major planes, we set up an ac-

2.10 ISABEL BISHOP *Nude Bending* (1949) Ink and inkwash on paper, $5^3/4 \times 5^1/2$ in. Courtesy DC Moore Gallery, NYC.

curate "scaffold" to receive the small planes. To reverse the process and arrive at the major planes by accumulating small ones usually results in a flood of details that makes for fussy drawing and a weak sense of masses. Such drawings tend to drown forms in a sea of details.

Like the major planes of the fist, large planes exist throughout the figure, as we saw in Cambiaso's drawing. Examining these major planes, we find that

they subdivide into somewhat smaller ones—the *sec-ondary* planes. Secondary planes modify the major planes to provide more specific, but still simplified, versions of the subject's actual surface state, as in the drawing on the far right in Figure 2.14. These major and secondary planes are well illustrated in Cretara's *Seated Figure, Back View* (Fig. 2.15). The artist clarifies the planes by grouping them into three tonal divisions: white (the tone of the paper), light gray, and

2.11 REMBRANDT VAN RIJN (1606–1669)

Female Nude Asleep

Pen and brush in bistre ink, $5^{1}/4 \times 11^{1}/8$ in.

Rijksmuseum, Amsterdam.

2.12 OSKAR KOKOSCHKA (1886–1980)

Trudl Wearing a Straw Hat

Black crayon, $13 \times 18^5/8$ in.

Rijksmuseum, Amsterdam/© 1999 Artists Rights Society (ARS),

New York/Pro Litteris, Zurich.

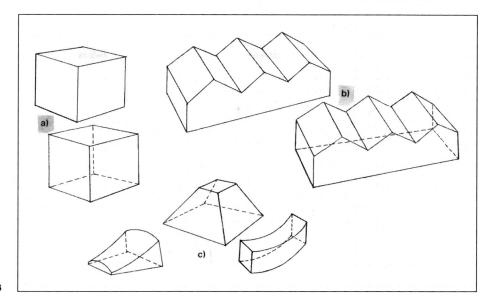

2.13

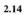

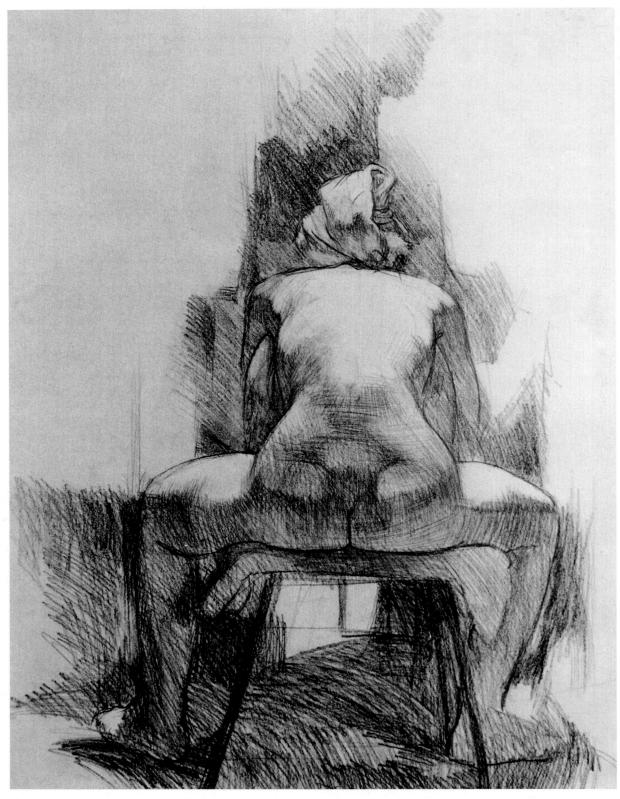

2.15 DOMENIC CRETARA (1946–) *Seated Figure, Back View* Pencil, 18 × 24 in. Courtesy of the artist.

dark gray. Note that the crosshatched lines creating these planes are often drawn in the direction of a plane's *short* axis. That is, the lines move around a form rather than run in the direction of the form's longer axis. These massed lines show the flat or curved nature of each plane by "riding" on it. Such lines look as if they were actually drawn on the forms themselves. Even in the headdress, these groups of structural lines can be seen to turn with the form.

Cretara is sensitive to the abstract behavior of such line groups. He unifies those of the figure with a network of similar but darker lines in the background, simultaneously creating a field of spatial depth and an attractive design of tonal patches. As this drawing demonstrates, an analytic approach to the figure's planar construction can result in compelling dynamic conditions. But to discover such large planes, we must make a disciplined search for them and not merely record everything we see.

All of the figure's forms, large and small, can be reduced to simpler, more manageable masses. Looking again at our fist, we see that each of the four clenched fingers is, in each segment, as blocklike as the fist they collectively produce. In examining any of the major planes of these smaller forms, we find they subdivide into their secondary and still smaller planes. It seems that the closer we look, the more aware we become of these tiny variations and the less aware we are of a form's major planes. As noted earlier, seeing the larger planes that the groups of smaller planes belong to is basic to understanding any form's structure. Overlooking this constructional aspect of form is one of the common pitfalls of the beginner, who strives instead to produce volume by repeated rubbing and smudging of the drawing. But such blendings not only destroy the freshness of a drawing's forms, they destroy the forms themselves. In analyzing the figure's masses, we should avoid confusing the blending of surface characteristics with form clarity, and in establishing the figure's planes, we should avoid drifting too far from the mainstreams of its major and secondary planes down the tributaries of superficial detail.

Comparing the female figure in Dürer's etching (Fig. 2.6) with Rembrandt's drawing of a woman in a similar pose (Fig. 2.11) shows that although Dürer has gone further in explaining the figure's structure, he does not go much beyond the secondary planes in doing so. Where he does become engrossed with surface niceties—as in the side view of the head on the left, the head just above it, and though to a lesser extent, the right foot of the central figure—the structural character of the forms is actually less clearly stated.

The aesthetic benefits gained from analyzing the figure in planar terms are highly regarded by many

2.16 JACQUES VILLON French (1875–1963)

Portrait of Felix Barré

Black chalk over slight traces of blue pencil,
H: 14³/4, W: 13¹⁵/16 in. (37.5 × 33.8 cm.).

The Metropolitan Museum of Art, Rogers Fund 1963 (63.4)

© 1999 Artists Rights Society (ARS), New York/ADAGP, Paris.

artists. Such artists intend to draw the figure in these prismatic units not for purposes of study, as Cambiaso does, but for creative purposes. In Villon's *Portrait of Felix Barré* (Fig. 2.16), the artist's theme seems to be the realization of the sitter's psychological as well as structural character through the emotive and explanatory power of the strong masses that planar modeling provides. Planar analysis, then, is more than a tool for understanding a subject's constructional aspects; it can be a source of creative insight and expression.

THE INTERJOINING OF PLANES AND MASSES

Some parts of the figure appear to interlock; others appear to fuse. Again, our hands provide a useful example for study. Looking at your partially open hand, palm side up, notice that the thumb and its fleshy heel seem to be deeply rooted in the palm and wrist. As you bring the thumb and fingers together a bit more, each segment of the fingers—the fleshy pads of the palm and the thumb—show more strongly these embedding, interlocking, and overlapping characteristics. Opening

the hand wide, with each finger stretched to its limits, greatly reduces this type of structural condition. In this position, the fingers seem fused with the palm, a five-lane continuation of the major plane of the palm.

In analyzing the figure's forms, we must decide when parts seem to interlock and when they seem to fuse. Here, the term *form* defines the figure's major segments (arm, head, foot, etc.) and the smaller segments of which they are composed. For example, the features of the head (eyes, nose, lips, ears) and the often overlooked features that separate them (chin, cheek, forehead, temple, etc.) can all be regarded as interjoinings and fusions of small *form units*.

A form unit, then, is any large or small part of the figure whose mass is seen as a more or less self-contained component—a building block—in the figure's structural state. The way each of these parts appears to interjoin is, of course, largely determined by our anatomy and, as we have seen, by the figure's particular pose. But there remains a considerable degree of freedom to interpret the interjoining of form units according to personal preference. Some artists em-

phasize the wedging, overlapping, and embedding characteristics; others focus on the gentle flow of the forms; and still others strike a balance between these two general kinds of unions.

Matisse, in *Nude Study* (Fig. 2.17), drives parts together with great force. Form units grasp and overlap resolutely, even aggressively. The upper part of each leg holds the lower part as if by pincers. At the neck and waist, bold lines express the weight and tension of overlapped forms strongly pressed together. How different is Ingres's interpretation of a standing female figure! In the *Studies of a Man and a Woman for "The Golden Age"* (Fig. 2.18), Ingres's interpretation relies on precise delineation and subtle fusions of form units rather than on rugged interlockings.

Tintoretto merges the concepts of strong and subtle joinings by forceful interlockings of graceful form units. His powerful *Study of a Model for the* "Guiliano de Medici" of Michelangelo (Fig. 2.19) is a rhythmic system of exaggerated interjoinings made of ovoid rather than blocklike segments. This study of a work by Michelangelo, itself a heightened interpre-

2.17 HENRI MATISSE (1869–1954) Nude Study India ink with quill pen, 10¹/₄ × 7⁷/₈ in. National Gallery Prague/© 1999 Succession H. Matisse, Paris/ Artists Rights Society (ARS), New York.

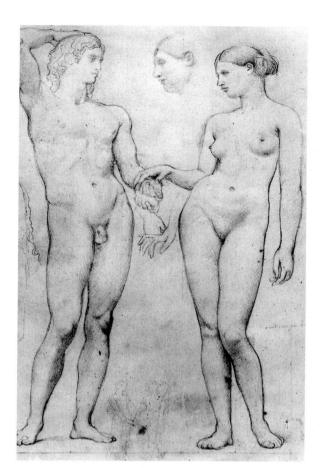

2.18 JEAN-AUGUSTE-DOMINIQUE INGRES, French (Montauban, 1780–1867, Paris)

Studies of a Man and a Woman for The Golden Age (ca. 1842). Graphite on cream wove paper, 41.6 × 31.5 cm. actual. Courtesy of the Fogg Art Museum, Harvard University Art Museums. Bequest of Grenville L. Winthrop 1943.861.

tation of idealized forms boldly interjoined, conveys a strong sense of aliveness through the energetic way these richly modeled forms interact. Their almost serpentine ripple implies pulsating movement and great strength. It is worth noting that Tintoretto's drawing is an excellent example of structural and anatomical matters serving the factors of design and expression. Note the abstract and emotive energies of the forms and the sense of barely contained energy.

Segantini's *Male Torso* (Fig. 2.20) shows a more tactile interpretation of human forms as emerging from rounded rather than blocklike solids. But there is an impressive clarity in the way these form units interjoin. Note how insistently the lines ride on the changing directions and levels of the surface. They rise and fall with the terrain, explaining the depth of every hollow, the height of every rise, and the degree

of abruptness or flow in the union between the parts. A sculptor using Segantini's drawing as a guide could model these forms and never be in doubt about the subject's volumes.

As Segantini's and Tintoretto's, drawings demonstrate, the impression of the rising and falling of the figure's terrain owes much to the way the lines used to model the forms move on the surface. Such surface-probing lines, usually drawn close together, are sometimes called *cross-contour* or cage lines. Moving in "schools," they collectively chart a volume's surface structure in visual terms that are easy to understand. Sometimes, as in Figures 2.7 and 2.17, these volume-seeking lines are used to indicate only the

2.19 JACOPO TINTORETTO (1518–1594)
Study of a Model for the "Giuliano de Medici" of Michelangelo Black and white chalk.
By kind permission of The Governing Body, Christ Church, Oxford.

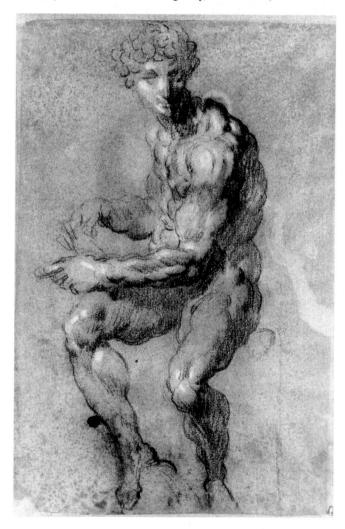

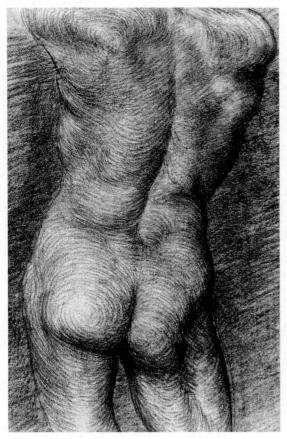

2.20 GIOVANNI SEGANTINI (1858-1899) Male Torso Black crayon and charcoal, fixed, on buff wove paper, 31.1×19.6 cm. actual. Courtesy of the Fogg Art Museum, Harvard University Art Museums. Bequest of Grenville L. Winthrop. 1943.542.

secondary planes, allowing the white of the page to create the figure's major planes. This often has the effect of suggesting a light source striking the forms. Usually, these straight or curved hatched lines move around the body of a long form such as an arm or leg. On flat planes, they more frequently repeat the plane's short axis. However, such line groups may run in the direction of the long axis of a plane or a form and still define surface conditions by the varying distance between lines or by their differing thicknesses. Something of this can be seen in Figure 2.16. Less frequently, such inner contour lines are made to describe circular levels of terrain, much in the manner of the cartographer (see Fig. 2.20). Such a schema can be utilized for medical purposes by a computer, as in Figure 2.21.

Cross-contour lines, when they succeed in explaining the terrain of the forms they move upon, seem not to intrude on our sensibilities as textures no matter how bold (Fig. 2.17). Our first impression is of their volume-revealing nature. Only when lines fail to explain the terrain do they strike us as strong patterns that rise to the surface of the page. Notice that the lines in Figure 2.21, although they are exact registrations of levels of terrain, do seem to rise to the level of the picture plane in a decorative manner. This is because of their mechanical, unchanging nature. A convincing realization of form that keeps the crosscontour lines "glued" to the form requires the artist's feel for the changing surface as well as acute visual judgments (Fig. 2.20).

All gifted artists, of whatever period or style, have, in their formative years, fully explored the structural nature of the forms around them. This has

2.21 (a) DR. R. E. HERRON **Back View of Male Figure**

Computer drawing.

Courtesy, The Institute for Rehabilitation and Research, The Texas Medical Center, Houston, Texas.

2.21 (b) DR. R. E. HERRON Front View of Female Figure

Computer drawing.

Courtesy, The Institute for Rehabilitation and Research, The Texas Medical Center, Houston, Texas.

been so even when their mature work was of a severely nonobjective kind, as in the case of Josef Albers, whose investigations into form, color, and space phenomena reveal the same sensitivity we find in his early *Self Portrait* (Fig. 2.22), a brilliant demonstration of the creative role structural considerations may play.

Whether artists emphasize or subdue the joining of planes and form units, whether they favor a block-like or egglike schema, they need to understand the figure's forms as reducible to simpler masses that interjoin in various ways. Held in the mind's eye, unions such as those in Figure 2.2 help artists understand and explain the forms they draw.

STRUCTURE AND VALUE

Most volumetrically convincing drawings rely on values to help clarify the figure's structural nature. The structure-seeking hatchings, as they establish the tilt of flat planes, show the turnings of curved ones, or explain how planes and masses interjoin, usually suggest light playing upon the subject. This is the case in Figures 1.40 and 2.20 where structural issues, and not illumination, are the dominant theme. But when these hatchings produce values that are accented on one side of a form and only lightly indicated, or even omitted, on the other side, we sense more strongly the presence of light on the form. Michelangelo's Studies of a Madonna and Child (Fig. 2.23) does this, as do Figures 2.15 and 2.16. Although it is clear in Michelangelo's page of sketches that form realization is the artist's main motive, he suggests a gentle light falling from the upper left side. Michelangelo does this by only lightly modeling the planes facing to the left, while darkening the hatchings on the planes turned toward the right. On the Madonna's face and neck, the changing directions and values of the lines that constitute the planes explain how these facets abut and blend to form the surface terrain of those parts. Figures 2.15 and 2.16 show that even stronger light sources needn't intrude on structural clarity. The structurally sensitive artist is not primarily concerned with value for the purpose of illumination. Drawings that only imitate the existing light and dark areas of a subject—as photographs do—are merely records of light's accidental behavior. Light is indifferent. It strikes any object in its path, sometimes explaining structure, sometimes camouflaging or even destroying it.

Imagine a zebra standing before a fence made of diagonally crossed lattice which is casting strong shadows on the animal. Simply copying the shadows and stripes would result in a richly patterned zebra

whose structure would be lost in the visual confusion of so many crisscrossed ribbons of tone. Or imagine a figure illuminated from several sources at once, as occurs when overhead lights are spaced across a ceiling or when daylight enters through windows facing several directions. The figure will be brightly lit, but most of the forms will appear flat, showing little volume-revealing value change. When artists desire a sense of light-bathed forms, most will nevertheless subordinate the effects of illumination to structural interests, as Stevens does in his Two Studies of a Standing Figure, Back View (Fig. 2.24). Here, light falls from a point high on the left side, but the illuminating role of value is secondary to its volumeinforming role. The figure's right leg is in shadow, but the hatched lines that produce the leg's shadowed state are concerned first with modeling the form. Again, in Erlebacher's Male Back (Fig. 2.25), volume clarity is the artist's first concern. Although a gentle light falling from the left plays across the forms, it never intrudes on the realization of the subject's surface forms.

Such form-revealing information is, of course, not possible in contour drawing alone. Although contour lines can be highly informing about the nature of the masses they enclose (Figs. 1.5 and 1.6), values are necessary to describe the figure's topography. While few artists go to the opposite extreme of explaining every facet of a subject's terrain, it is extremely useful for the student to make some drawings in which no "deserts" of empty, unexplained terrain exist.

Value, then, is able to model form and convey light. It can also distinguish among the inherent values of a subject's parts. For example, values can show the dark tone of the hair against the lighter tone of a head or hat. The inherent lightness or darkness of a form or any of its segments, apart from the effects of light on it, is called its *local tone*. Artists intending to convey the local tones of their subject matter will generally simplify them to keep from weakening value's structural role. In Watteau's Study of a Young Negro (Fig. 2.26), the light tone of the headdress and the darker tone of the head are indicated by simple flat values: Watteau unifies these areas by a band of dark tone that suggests the presence of light as it models the face, headdress, and hair. Note that in modeling these three areas, the artist emphasizes major and secondary planes. Comparing Watteau's drawing to the similar view of the Madonna's head in the Michelangelo drawing, we see that Watteau's providing of information about the local tones of the young black is in addition to, not in place of, structural clarity.

In a similar drawing, Watteau's use of color adds to the drawing's clarity of volume and space (Plate 4).

2.22 **JOSEF ALBERS** (1888–1976)

Self Portrait (ca. 1917)

Transfer lithograph, printed in black, composition: $18^1/8 \times 12$ in. $(46.1 \times 30.5 \text{ cm})$. The Museum of Modern Art, New York. John B. Turner Fund. Photograph © 1999 The Museum of Modern Art, New York/© 1999 The Josef and Anni Albers Foundation/ Artists Rights Society (ARS), New York.

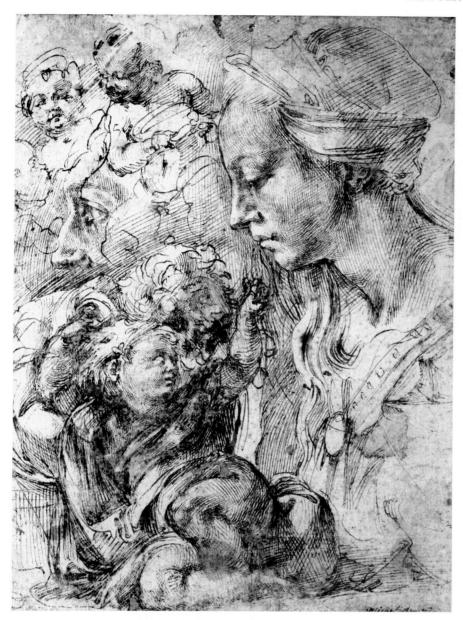

2.23 MICHELANGELO BUONARROTI (1475–1564)
 Studies of a Madonna and Child
 Pen and brown ink, 11¹/4 × 8¹/4 in.
 Staatliche Museen Preussischer Kulturbesitz
 Kupferstichkabinett, Berlin.

The use of red, white, and black chalk (often on a cool-colored sheet) was a popular device, especially in France, of seventeenth- and eighteenth-century European drawing. Just these few colors (and their optical mixtures) are capable of imparting a strong impression of solidity and space as well as pleasant color harmonies.

STRUCTURAL SUPPORTS AND SUSPENSIONS IN THE FIGURE

The skeleton provides a firm, armaturelike system of support for the figure's more plaint muscular and fatty tissues. In Chapter 3, we will examine the skeleton in some detail, but here we must add to our understand-

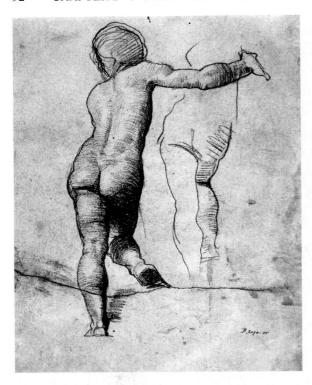

2.24 ALFRED STEVENS (1817–1875)
Two Studies of a Standing Figure, Back View
Red chalk, 18³/₈ × 6¹/₄ in.
V & A Picture Library.

ing of the figure's structural nature a sensitivity to the supporting role of the skeleton beneath the drapery of muscle, fat, and skin. To understand better those rigid forms that hold and the behavior of those more flexible forms that are held, we can temporarily envision the skeleton as reduced to a simple, manikinlike system of bony masses connected by spheres, cylinders, and wedges (Fig. 2.27).

The three large masses of the skeleton are the skull, the rib cage, and the pelvis (Fig. 2.27). Of the three, the skull is the most visible in the living figure, influencing surface forms throughout the head. Reduced to its simplest geometric state, the skull can be represented by an ovoid upper segment which extends downward in front into a blocky lower segment, not unlike a referee's whistle (a). The rib cage is reducible to a large egglike mass, small end up, with a pie-slice opening in its curved front plane that extends upward from the base of the egg to about its middle (b). Somewhat less visible in the figure than the skull, the rib cage is still a prominent mass, especially in the area of the wedgelike opening; it strongly influences the shaping of the upper torso. The pelvis is more

deeply buried in the figure. A complex form, it can be reduced to several simple masses: a half sphere; a block or keystone; a winged and slightly tapered, hollowed block; or the forms shown in the manikins in Figure 2.27c. Note that the manikinlike figures (d) in the illustration show ball joints at the shoulder, elbow, knee, wrist, and ankle. These roughly correspond to the bony prominences found throughout the skeleton, occurring at the ends of the long shaftlike bones of the limbs or resulting from small projecting bones, as at the knee. Most of these protuberances are visible to some degree in most poses, for example, in de Gheyn's *Studies of Four Women at Their Toilet* (Fig. 2.28). Additionally, the ball joints shown in Figure 2.27d suggest the figure's mobility at these sites.

Imagining the manikinlike scaffold inside the figure on the far left of de Gheyn's drawing (Fig. 2.28)

2.25 MARTHA MAYER ERLEBACHER (1937–) Male Back (1980) Pencil on paper, 11⁷/8 × 8⁷/8 in. The Arkansas Arts Center Foundation Collection: Purchased with Gallery Contributions, 1982. accession #82.31.1.

2.26 ANTOINE WATTEAU (1684–1721)
Study of a Young Negro
Red and black chalk, heightened with white on gray paper, 7¹/₈ × 5³/₄ in.
Reproduced by Courtesy of the Trustees of the British Museum. © The British Museum.

suggests how the muscular and fatty tissues are draped on the skeleton; it also helps explain why the "container" of skin is stretched taut in some places, as at the knees and hips, and why it is slack in other places, as in the chest and abdomen. Note how de Gheyn, in drawing the figure's fleshy forms, suggests the inner armature of the skeleton and how he integrates firm and supple passages everywhere, avoiding form solutions that are wooden or rubbery. He does this not only at the joints, where the bones come to the surface, but throughout the length of the limbs and in the torso, where (especially in the figure on the left) we sense the rib cage and pelvis through the heavily fleshed forms. Note, too, the clarity of the cross-contour lines which de Gheyn uses to convey the abrupt and flowing unions between form units.

Likewise, in Boucher's Seated Nude (Fig. 2.29), we sense the presence of an inner supporting system. Although this figure is rather heavily proportioned, even plump, the forms are not inflated or rubbery. As in de Gheyn's drawing, they show alternating firm and pliant passages that suggest the skeletal and mus-

cular substructure. Comparing Boucher's drawing with its schematic counterpart in Figure 2.27(d) helps explain what holds and what is held.

Naturally, the skeleton's influence is more apparent in lean figures. Géricault's study for one of the figures in his painting *Study for one of the figures in "The Raft of the Medusa"* (Fig. 2.30) reveals a keen understanding of the skeleton's effect on the figure's outer casing. The rib cage and the wings of the pelvis are quite distinct. Throughout the figure, the taut sheath of the skin hints at the forms below, suggesting the firm inner structures pressing outward. Note that the head, only roughed in, looks something like the schematic skull in Figure 2.27a.

Although developed much further, the head in Guercino's St. Joseph with His Flowering Staff (Fig. 2.31) is still modeled chiefly by large planes that do not surrender their dominance to the smaller details. In fact, notice that in all the structurally sensitive drawings we have been looking at in this chapter, simple form concepts underlie the modeling of forms in values. Both Géricault's depiction of small but pro-

2.27

nounced surface changes and Boucher's modeling of large but subtly turning ones are enhanced by the artist's appreciation of the figure's underlying cubes, cylinders, ovoids, and so forth, shaped in part by the bony substructure. Something rings true in drawings that show the skeleton's role in forming and affecting the figure's surface forms. Such works express truths about the figure's construction and character that the mere collecting of surface data cannot achieve.

STRUCTURAL ASPECTS OF FORESHORTENING

As with all forms in nature, those of the figure are subject to the laws of perspective. Although an examination of perspective is not within the scope of this book, it is necessary to comment briefly on some of its basic principles.²

A basic concept of linear perspective holds that any view of any solid mass involves the foreshortening of some of its surfaces. For example, looking directly at one plane of a cube must necessarily show its other planes to be severely foreshortened. In some forms, we cannot see the foreshortened planes—for example, when our line of sight is centered on the bottom plane of a cone or pyramid. More often, and especially in the forms of the figure, any view of a form, large or small, shows some of its surfaces turned away from our line of sight.

Although the beginner may not be aware of it, any "easy" pose, such as a front view of a figure standing at attention, contains a great deal of foreshortening. Such a pose consists of a severely foreshortened view of the sides of the head, torso, and limbs. Depending on our eye level in relation to the model, this pose will also show foreshortened views of the top or underside of various forms. For example, if we are seated in front of the standing figure, we see a foreshortened view of the *underside* of the model's nose and jaw and a foreshortened view of

² For a fuller discussion of linear and aerial perspective, see Nathan Goldstein, *The Art of Responsive Drawing*, 5th ed. (Upper Saddle River, N.J.: Prentice Hall, 1998), chap. 5.

2.28 JACOB DE GHEYN II (1565–1629) Studies of Four Women at Their Toilet Pen and ink, some black chalk, on gray paper, $10^{1}/8 \times 13^{1}/8$ in. Musees Royaux des Beaux Arts, Brussels.

2.29 FRANCOIS BOUCHER (1703–1770) *Seated Nude* Red and white chalk on gray paper, $11^3/4 \times 15^1/4$ in. Rijksmuseum, Amsterdam.

2.30 THEODORE GERICAULT (1791–1824)

Study for one of the figures in "The Raft of the Medusa"

Charcoal on white paper, 11¹/4 × 8 in.

Musee des Beaux-Arts et d'Archeologie, Besancon, France.

2.31 SCHOOL OF GUERCINO (GIOVANNI FRANCESCO BARBIERI), Italian (1591–1666) St. Joseph with His Flowering Staff Pen, iron gall ink and wash, 16.0 × 20.7 cm. The Art Museum, Princeton University. Bequest of Dan Fellows Platt, Class of 1895. 1949-40.

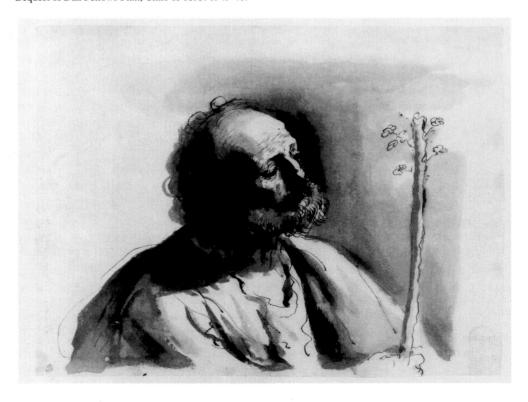

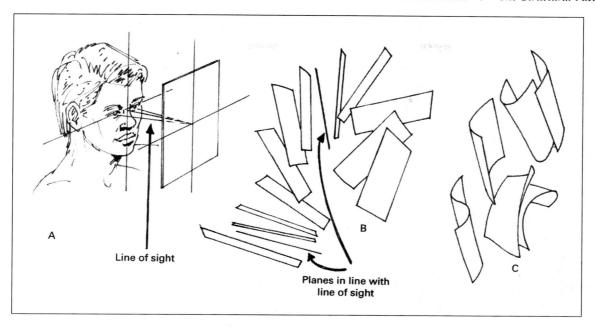

2.32

the *top* surfaces of the model's feet, as in Figures 2.8 and 2.18.

The greater the degree of foreshortening, the less we will see of a plane's surface. *All* planes except those at a right angle to and centered in the viewer's line of sight are seen as foreshortened, as in Figure 2.32a. The more a plane's position parallels the viewer's line of sight, the less can be seen of its surface. When a plane is exactly in line with the viewer's line of sight, only its near edge is visible, as in Figure 2.32b. Curved planes, by their nature, are always seen as foreshortened (Fig. 2.32c).

Naturally, what is true for a single plane holds true for the flat and curved planes of any solid mass. The variously positioned forms of the figure in any pose are better understood by first determining their location in space in relation to your line of sight and your eye level, that is, the height of your eyes from the ground plane on which you are standing, seated, or even lying. For the artist, the terms eve level and horizon line are synonymous. Our eye level determines the high or low position of the horizon line in our field of vision. If we lie on the sand, looking at the sea, the horizon line is low; if we stand up, it is higher; and if we climb the lifeguard's tower, the horizon line is higher still. In Cambiaso's Resurrection and Ascension (Fig. 2.33), it is evident that the artist has envisioned a scene occurring mainly above his (and consequently, our) eye level. Because the horizon line is low, we look down on only those few

forms located below it, namely the feet and lower limbs of the three figures standing on the ground plane. All other forms in the drawing, regardless of their angle and degree of foreshortening, appear positioned above our eye level. This is so even though we do see the top planes of some of the forms, because we understand the overall location of the figures to be above our eye level.

We have all learned, or instinctively know, that parallel lines on a ground plane, when they are going back in the spatial field, appear to incline toward each other and will meet at an imaginary point on the horizon line. We have all noted this apparent converging of lines when walking down a corridor or street. It is equally true that any group of parallel lines projecting back into space, that is, away from the viewer at any angle, will appear to converge, as in Figure 2.34. Thus, the width of any form possessing parallel lines (edges), such as a block or cylinder, appears to diminish as it projects back toward the horizon line or toward any imaginary point above or below it. Such forms appear, then, to taper. Forms that actually taper, as many of the figure's forms do, will appear to do so to a greater degree than blocks or cylinders when projecting away from the viewer.

Note in Figure 2.35 that the positions of the head and neck, the torso, and the upper and lower limbs are made easier to locate in relation to each other by the device of the near form always overlapping the form beyond it. The edges of the throat are overlapped and

2.33 LUCA CAMBIASO (1527–1585)

Resurrection and Ascension

Pen, ink, and brown wash, $13^1/8 \times 9^3/8$ in. Gabinetto Nazionale della Stampe, Istituto Nazionale per la Grafica, Rome. Photo by Oscar Savio. Per gentile concessione del Ministere per i Beni Culturali e Ambientali.

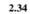

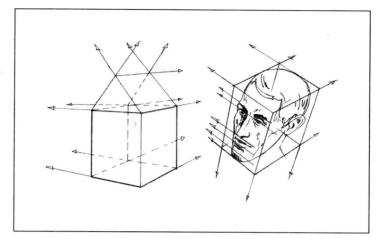

2.35 NATHAN GOLDSTEIN (1927–) Reclining Figure, Foreshortened View Red chalk, $10^3/4 \times 11^1/2$ in. Collection of the artist.

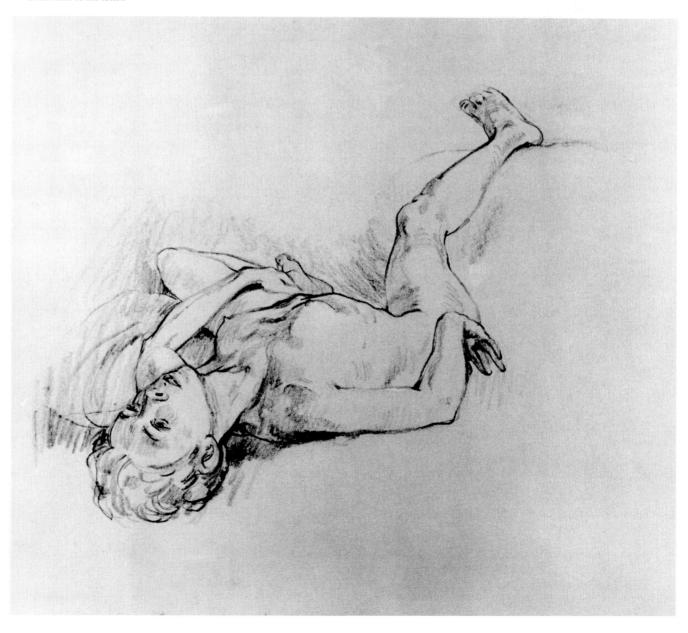

set into the torso, which in turn asserts its dominance over the upper right leg by a single line; the upper right leg does the same to the lower leg, which overlaps the foot.

This dominance of the near over the far form holds true in the figure when the same foreshortened forms are viewed from either end. In Michelangelo's *Studies for the Crucified Haman* (Fig. 2.36), a right arm projecting back and a left arm thrust *i*orward both show this principle at work. Comparing the two hands in the upper part of the drawing again reveals how these overlappings clarify the position of forms in relation to each other.

The ability to reduce the figure's masses to geometric forms (whether these forms are actually drawn in as a preliminary substructure or are only held in the mind's eye as the work proceeds) is of particular importance in drawing views of drastically foreshortened forms, as in Figures 2.35 and 2.36. But as we

have seen, foreshortening is an ever-present phenomenon, even with forms only slightly turned away. In Cretara's *Sheet of Studies of the Female Figure* (Fig. 2.37), the forms are located both above and below our eye level. This impression is conveyed by the artist's sensitive tapering of the forms, by the direction of the lines that model them, and by his appreciation of the geometric core that underlies each one.

For most beginners, drawing any human form in severe foreshortening is difficult. Often, the student begins to draw a foreshortened form as he or she actually sees it, but in the completed drawing, the part looks as though it had been viewed from an overhead position. What began as an objective study of a foreshortened view of, say, a leg, ends in a drawing that combines some of the student's observations with some of his or her *prior knowledge* about legs: that they are long forms with certain familiar outlines and some important characteristics such as the knee and

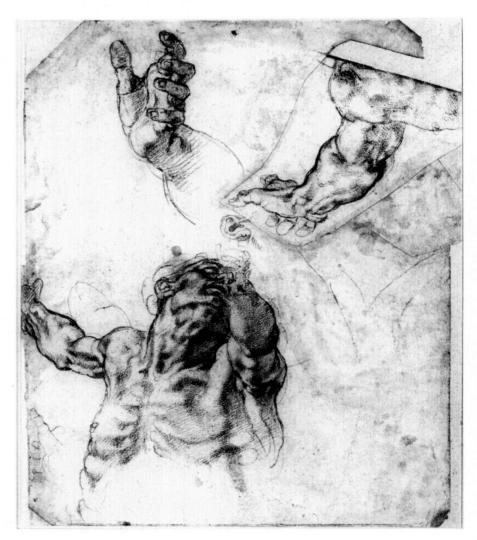

2.36 MICHELANGELO BUONARROTI (1475–1564)

Studies for the Crucified Haman

Black chalk, 13 × 8⁷/s in.

Teylers Museum, Haarlem.

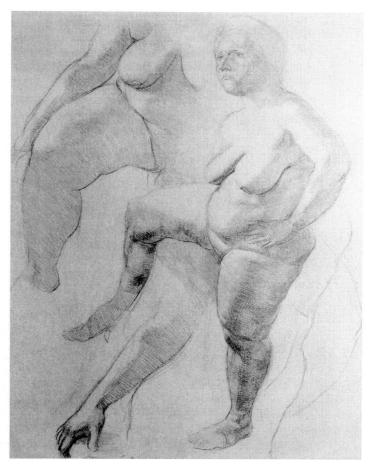

the ankle. Under the stress of analyzing the actualities before them, some beginning students fall back on remembered notions about the figure's forms.

Yet the same students can probably draw severely foreshortened blocks, cylinders, and cones accurately. Indeed, if the students and the instructor of an introductory life-drawing class were each to draw a foreshortened cylinder, it would be difficult to tell which drawing was the instructor's. But if the students and the instructor drew a finger in the same position as the cylinder, the instructor's drawing would be immediately identifiable. What has changed? Essentially, little. The finger can be understood as a modified cylinder with a number of abrupt and gradual planar changes, but still conforming to a tapering, tubular core. The instructor's drawing is the one most likely to have benefited from a grasp of the subject's essential mass, on which the variations—the major and secondary planes—can be modeled, the resulting forms overlapped and interjoined, and the firm and supple characteristics of the finger conveyed.

The instructor can call on another observable fact

that serves structural interests. He or she knows that every volume has its definable limits—its outline, or *shape state*. By noting the shape state of a foreshortened volume, one can more easily establish its position in space. The shape of a form—its silhouette—defines the form's position in space and conveys important clues about its structure; it represents a form's totally foreshortened planes, which is what edges are largely composed of. The beginner who tries to draw the foreshortened leg but draws instead an overhead view has failed to observe the leg's shape configuration. The ability to see the shape of a form or a plane as if it were a flat puzzle piece is an essential perceptual skill.

SEEING SHAPE, DIRECTION, AND EDGE

A helpful exercise for more objectively seeing parts as flat puzzle pieces is to hold a sheet of Plexiglas® before you and, using a wax crayon, carefully trace on it the outlines of the figure's forms, as in Figure 2.38.

2.38

Such an experiment underscores two important facts: (1) the shapes of most human forms, even when only moderately foreshortened, appear "misshapen" and (2) most outlines of human forms are more complex and contain more subtle turnings than you may have supposed.

A useful procedure for more objectively drawing the shape state of any form or form unit before you is what might be called drawing in straight line segments. All artists realize that the freely drawn gestural lines which usually begin a drawing, although necessary to establish the arrangement of the figure's parts, tensions, and moving energies, only weakly reflect the shape actualities of the figure's parts. To denote these shapes more accurately, many artists will then redraw each shape's edges, restricting their drawing to straight lines. They know that many poor shape judgments are hidden among the sweeping curves of the drawing's first lines and that by translating a shape's curving edges into a series of straightline segments that collectively describe these curves, they can far more accurately define the shape's actual boundaries.

Such straight-line drawing can be seen in Rubens's *Bathsheba Receiving David's Letter* (Fig. 2.39). The mainly angular lines on the left side, intended as an underdrawing, can be seen to underlie the rest of the drawing. Note especially the drawing of the originally intended position of Bathsheba's left leg. Angular-edge drawing is, of course, a major factor in constructing the masses in Cambiaso's draw-

ings (Figs. 2.5 and 2.33) and in Papo's drawing (Fig. 1.40). Picasso's *Study for the Painting, "Pipes of Pan"* (Fig. 2.40) provides a very clear demonstration of seeing curved edges as if they were composed of straight lines.

Even a simple, freely drawn curving line is almost impossible to duplicate *exactly* by again trying to draw it freely. Try it and you will see. Restating such a line by first reducing it to the straight lines it can be broken down to, as in Figure 2.41b, will promote more accurate results. Even a circle can be implied by straight lines. Once this is done, the lines can be reworked to soften the angles (Fig. 2.41a).

Giacometti's drawing (Fig. 1.41) shows this evolution from straight to curved edges. His drawing also illustrates the point that the abutments between the figure's planes, when likewise treated in this angular way, more clearly define the figure's masses. Such abutments seldom occur with the clarity we find in Giacometti's or Papo's drawings. To see them, we must search for the subtle ridges and crests that mark changes in the direction of the figure's surfaces. As with the outer contours, once the figure's inner contours have been noted, they can be modified to any degree, if desired.

Such straight-line segments, in restating complex organic forms in simpler, more concrete terms, help us better judge the location, relative scale, and design of the forms as well as their constructional nature. Furthermore, these schematic straight-line inquiries, in reducing forms to temporarily simpler states, create

2.39 PETER PAUL RUBENS (1577–1640) Bathsheba Receiving David's Letter Pen and ink, $7^{1/2} \times 10^{3/8}$ in. Photo by Walter Steinkopf. Staatliche Museen Preussischer Kulturbesitz Kupferstichkabinett, Berlin.

just those important lines of perspective that show how forms arrange themselves and recede in a spatial field. One of the most important (and first) responses to an observed (or envisioned) form is its direction in both two- and three-dimensional space. Unless we note the particular tilt of a part and whether it advances toward us or recedes, we have overlooked the most fundamental fact of its existence in space.

A form's two-dimensional orientation is easily recognized by the simple device of imagining a clock-face on it. This helps us judge whether an arm, head, torso, or a segment of a form's edge is at, say, two o'clock or three o'clock, as in Figure 2.41c. Analyzing a part's location in three-dimensional space can be done in the same way, provided we imagine the clockface to encircle the part at the angle that aligns the part's long axis with the line running from six to twelve o'clock, as in Figure 2.41d. When we are establishing these two- and three-dimensional

directions, it is important to recognize the difference between the direction of a part's long axis and the several directions of that part's edges because they may differ widely. For example, in contrast to the vertical long axis of a front view of an upright torso, its edges are inclined outward in a V-shaped manner, as in Figure 2.41e.

Related to these perspective considerations is a less evident but nevertheless important one, namely, the direction, or angle, at which cross-contour lines intersect a form in modeling it. A cross-contour line appearing at eye level will be seen as a straight line, as illustrated in Figure 2.42. Such a line will show nothing of a form's surface changes; in fact, it tends to deny them. However, lines drawn above and below it, because they occupy inclined planes (shown by dotted lines in our illustration) *are* form-revealing. Cross-contour lines, then, tell most about a form's volumetric nature when the direction in which they

2.40 PABLO PICASSO (1881–1973)

Study for the Painting "Pipes of Pan" (1923)

Charcoal, 640 × 490 mm.

The Art Institute of Chicago. Bequest of Joseph Winterbotham/© 1998 Estate of Pablo Picasso/Artists Rights Society (ARS), New York.

are drawn is at any angle other than the eye-level angles seen in Figure 2.42. This avoidance can be seen in Figure 2.39, where cross-contour lines strike the forms at various angles.

The universality of this graphic strategy can be appreciated when we see the same process at work in a contemporary drawing (Fig. 2.43). Notice that Bloom integrates form realization and expressive intent by modeling the forms with lines that suggest wrinkles as well as mass. Indeed, Bloom's use of line, in showing the artist's sensitivity to anatomical and design considerations, shows a fine integration of all four factors of figure drawing.

STRUCTURAL ASPECTS OF THE DRAPED FIGURE AND ITS ENVIRONMENT

Successful figure drawings show a sensitivity to the nature of the anatomical forms beneath the "drapery" of the skin—the tensions, weight, rhythms, and

masses of the bone, muscle, and fatty tissue that affect the figure's surface forms. The skin, then, can usefully be thought of as a kind of drapery. Tight-fitting for the most part, the skin still shows draperylike folds and wrinkles and the taut and slack behavior of cloth, especially in older people (Fig. 2.43). Most master figure drawings also suggest something of the general action and structural character of the figure beneath the drapery of clothed figures. In such drawings, the gestures and general structure of the limbs and torso are often clearly evident, even when the figure is voluminously draped, as in Rubens's drawing (Fig. 2.39). Here, there is little doubt about the position, weight, and robust character of the servant's forms. Not only does Rubens show the figure's action and structural essentials; in some areas, such as the servant's left upper arm and left leg, he actually "draws through" the drapery to reveal the general contours of the forms beneath.

Conversely, then, clothing can be thought of as a kind of loose second skin. And like skin, it requires a

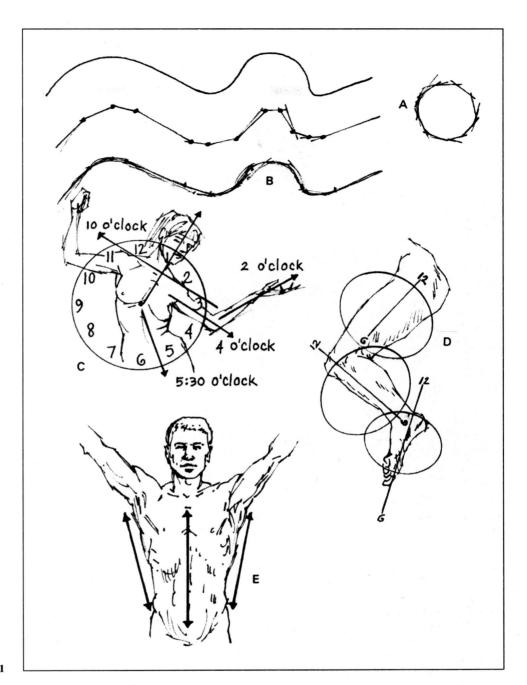

2.41

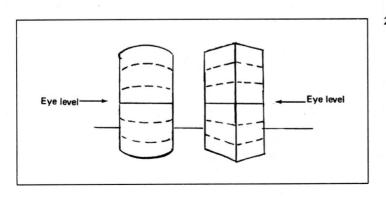

2.42

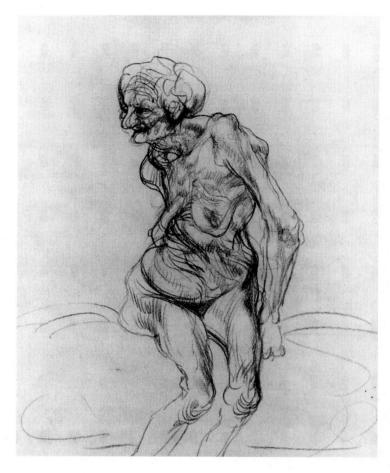

2.43 HYMAN BLOOM (1913–) Nude Old Woman (1945) Brown crayon, 9¹/₂ × 7⁷/₈ in. Grunwald Center for the Graphic Arts, University of California, Los Angeles. Gift of Mr. and Mrs. Robert Robles.

firm armature to hold it up, yielding to the pull of gravity wherever it is free of support. Occasionally, drapery will be as taut as skin usually is. When this is the case, it will reveal almost as much about the forms it covers as skin does. Even a loose garment will reveal something about the nature of the forms beneath; for instance, this occurs where forms interrupt the fall of a fold, or create folds where they press against the drapery, or where, because of gravitational pull, the drapery clings to the top surfaces of forms. These conditions can be seen in Rubens's drawing (Fig. 2.39) and in da Vinci's *Study of Drapery* (Fig. 2.44).

Beginners should be as attentive to the ways in which drapery reveals the body's action and masses as they are to the ways in which the body's surfaces reveal deeper anatomical forms. This search for the forms below provides a useful basis for selecting among the many folds and creases in a subject's drapery. Beginners can, as Rubens does, emphasize those folds that reveal the figure's gesture and form and omit or subordinate those folds that obscure or confuse such actions and masses. Note that Rubens ex-

plains the drapery's intricate topography by the same means with which he models the servant's (and Bathsheba's) forms; namely, by reducing forms to their major and secondary planes, by the direction of the hatchings on the planes, and by clarifying the way form units interconnect.

Every drawing teacher has seen student works in which an interest in structural analysis, design, perspective, and proportion diminished sharply when the student turned from drawing the figure's forms to drawing the drapery on it. Often, there is an even greater loss of visual involvement when the student goes on to draw the indoor or outdoor matter surrounding the draped figure. These drawings reveal the student's declining interest in forms other than human ones. But it is fundamental to good figure drawing to recognize the structural and dynamic opportunities in drapery and in the masses and spaces that make up the figure's environment. Indeed, no sensitivity to the figure's architectural or expressive character is possible without a comparable sensitivity to these matters in all other forms in nature. Although we may prefer

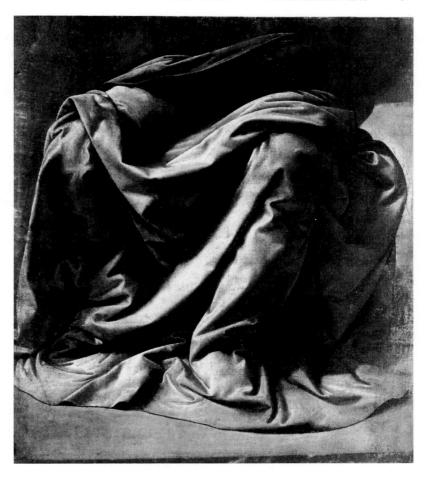

2.44 LEONARDO DA VINCI (1452–1519) *Study of Drapery* Brush, gray wash, heightened with white,

on linen, $10^3/8 \times 9^1/8$ in. Photo R.M.N./Musee du Louvre, Paris.

one kind of subject matter to another, until we can appreciate the visual potential of all kinds of subject matter, we do not fully understand the possibilities of one in particular.

An analysis of the folds in any draped material shows that they conform to a few characteristic masses and movements (Fig. 2.45). Usually, a fold can be reduced to three planes: an ascending plane, a flat or curved top plane, and a descending plane (a). Sometimes the ascending and descending planes are overlapped by the top plane, as in (b). Sometimes the valleys separating folds are broad and flat; sometimes they are narrow and concave, as in (c). When the latter is the case, the folds appear to roll in a wavelike manner. Unless interrupted by other forms or folds, the folds will radiate from a point at which a form interrupts their fall (d). When drapery is held at two points, both sets of radiating folds will dovetail as the individual folds intercept each other (e). Tubular drapery, such as sleeves or pant legs, tends to fall in circular dovetail patterns, a series of zigzags, or in opposing V-shaped folds, as in (f). Occasionally, especially when drapery is somewhat loose, Y-shaped folds occur (g). When tightly stretched, valleys disappear as folds push together (h). When tubular drapery is bent, or when any material is "caught" in the bending of the figure's forms, folds rush away from the point of tension (i). All other fold arrangements are variants of the foregoing kinds, and the folds in soft materials such as silk show more rhythmic, wavelike movements, whereas harder materials such as cotton show a more angular, faceted behavior.

In master drawings, the drapery—whether of silk, fur, lace, or skin—shows the artist's understanding of its structure, pliance, weight, and gestural behavior (Fig. 2.46). Although the figure is often more fully realized than some of the drapery and surrounding environment, in the best drawings nothing is drawn indifferently.

This is well illustrated by Rembrandt's An Actor in His Dressing Room (Fig. 2.47). In addition to his remarkable grasp of the measurable matters of direction, shape, scale, and value, Rembrandt always feels the structural forces and moving energy of his sub-

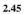

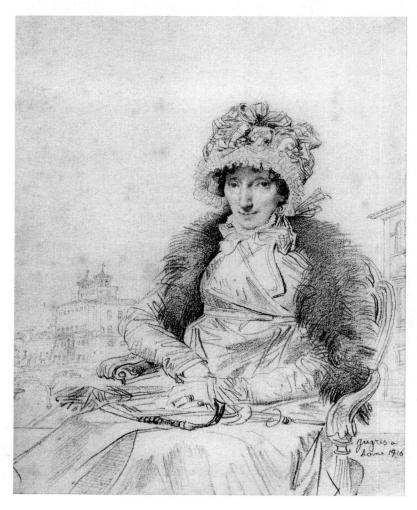

2.46 JEAN AUGUSTE DOMINIQUE INGRES (1789–1867)
Portrait of Mrs. John Mackie (1816)
Pencil, $6^5/8 \times 6^{1/2}$ in.
V & A Picture Library, London.

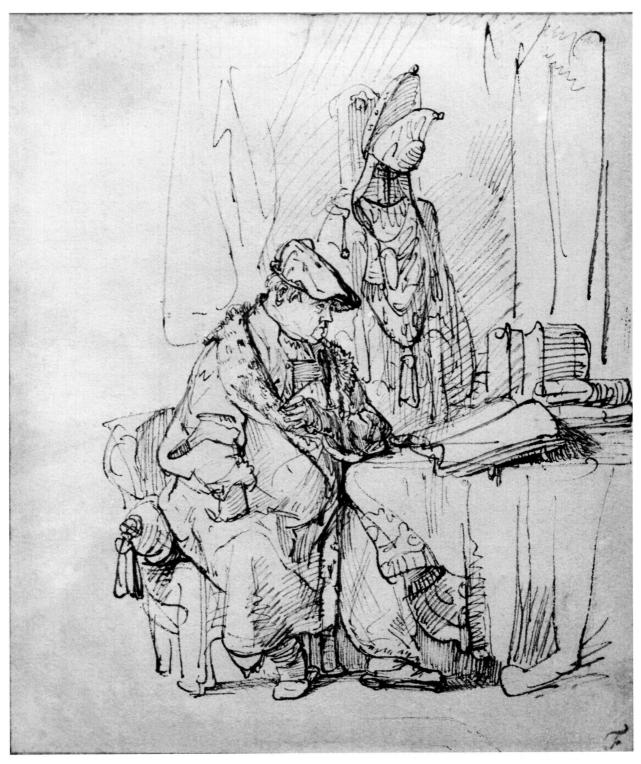

2.47 REMBRANDT VAN RIJN (1606–1669)

An Actor in His Dressing Room

Quill and reed pens and ink, 7¹/₈ × 5⁷/₈ in.

Devonshire Collection, Chatsworth. Reproduced by permission of the Trustees of the Chatsworth Settlement.

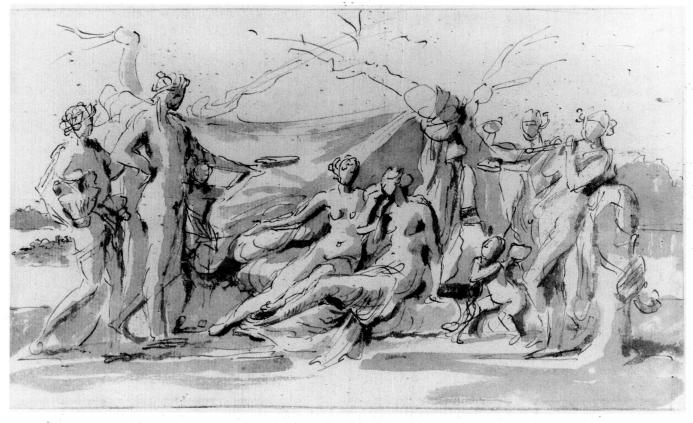

2.48 NICOLAS POUSSIN (1594–1665) Bacchus and Ariadne Pen, bistre ink washes, on pinkish paper, $6^{1}/8 \times 9^{3}/4$ in.

Pen, bistre ink washes, on pinkish paper, 6¹/₈× 9³/₄ in. Ecole Nationale Superieure des Beaux-Arts. Photograph courtesy of the Courtauld Institute of Art, London.

jects. Examining the animated interplay of *all* the forms in this drawing, we can appreciate Kenneth Clark's observation that "here was one of the most sensitive and accurate observers of fact who has ever lived, and one who, as time went on, could immediately find a graphic equivalent for everything he saw."³

Figure 2.47 serves as a useful visual summary of the main points we have been discussing so far in this chapter. Here, we find a resolute constructing by major and secondary planes, the underlying geometric solids these planes suggest, a rich variety of interjoinings, the sense of firm and fluid segments of form, convincing foreshortening, and clues to the figure's forms revealed by the drapery. Rembrandt knows that drapery can reveal as well as hide what it covers. Note the heavy, almost water-soaked character of the drapery. As this drawing so clearly shows, the term

Glancing at the drawings in this book, you notice that most of them depict little, if any, of a subject's immediate surroundings. Sometimes a few lines or tones suffice to suggest some masses and a sense of space. But even in the most abbreviated of statements about a figure's environment, the *quality* of the artist's visual judgments does not waver. Degrees of completion and even of clarity may vary, but concentration and caring may not.

Poussin's *Bacchus and Ariadne* (Fig. 2.48) and Millet's *The Diggers* (Fig. 2.49) illustrate two very different but consistently held attitudes toward structure. Poussin's brief sketch probes the harmonious design possibilities of the subject's major masses. Here,

drapery can be extended to include such diverse items as hats, pillows, book pages, and of course, skin. Rembrandt treats the vestments, tablecloth, chair, and robe with the same kind of inquiry and caring as he does the head and hands. Every form in this work is structurally clear, and all are depicted in a state of lively, complemental interplay. For Rembrandt, structural analysis is indeed a key to graphic invention.

³ Kenneth Clark, *Landscape into Art* (New York: Transatlantic Arts Inc., 1961), pp. 30–31.

the structural factor serves a lyrical visual idea. But for Millet, the weighty substantiality of the draped figures, of their shovels, and of the earth itself is a dominant theme. And the way both artists go about calling out these differing qualities is instructive. In Poussin's drawing, planes and masses are airy, open, and flowing; in Millet's, they are firm, enclosed, and deliberate. Poussin's lines are animated, the tonal changes are gentle and in flux; Millet's lines are short jabs, the tones fixed and boldly contrasting.

Note how differently the artists treat drapery. For Poussin, the flowing drapery serves as a means of connecting groups of figures; its graceful sweeps embrace the entire configuration decoratively. For Millet, the drapery is coarse and volume-revealing; it tells about the forms it covers and of its own density and weight.

Depending on the type of material, the snug or loose fit, and the figure's action, the drapery can be an important expressive tool. In Degas's *Russian Dancer* (Fig. 2.50), the dancer's animated movements are in-

tensified, not obscured, by the drapery's actions as well as by the use of strong color (Plate 5). Degas makes a relative distinction in the weight and texture of the blouse, the heavier skirt, and the leather boots. Observe that hair, as Degas shows, behaves like drapery. Sometimes, as in de Gheyn's *The Bird Catcher* (Fig. 2.51), the drapery carries virtually the entire responsibility for presenting the figure. Although only one arm is bare and the blouse and trousers fit loosely, we sense the body's forms and can tell that the figure is a powerfully built adult male.

Perhaps the most imposing realization about the figure is its vital substantiality—its presence as a living, kindred individual. This appreciation of the figure's spirit and substance has motivated the search for structural as well as emotive clues in representational imagery and has provided an avenue of approach for more subjective graphic inventions, as in the drawings by Léger, Moore, and Neel (Figs. 2.52, 2.53, and 2.54). If extracting the structural and animating essen-

2.49 JEAN-FRANÇOIS MILLET (1814–1875) *The Diggers*

Etching, 9³/s × 13¹/4 in. S.P. Avery Collection. Miriam and Ira D. Wallach Division of Art, Prints and Photographs, The New York Public Library. Astor, Lenox and Tilden Foundations.

2.50 HILAIRE-GERMAIN-EDGAR DEGAS (1834–1917)

Russian Dancer

Pastel over charcoal on tracing paper. H: $24^3/8$, W: 18 in. $(61.9 \times 45.7 \text{ cm.})$

The Metropolitan Museum of Art,

H. O. Havemeyer Collection.

Bequest of Mrs. H. O. Havemeyer, 1929. (29.100.556).

Pen and brown ink on gray paper, $6^{1}/2 \times 5^{1}/8$ in. Museum Boijmans Van Beuningen, Rotterdam.

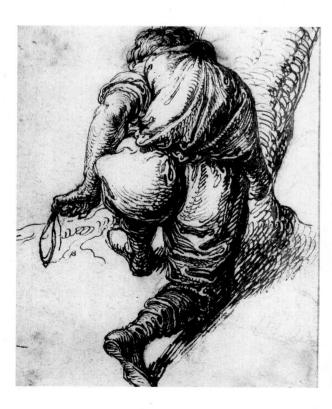

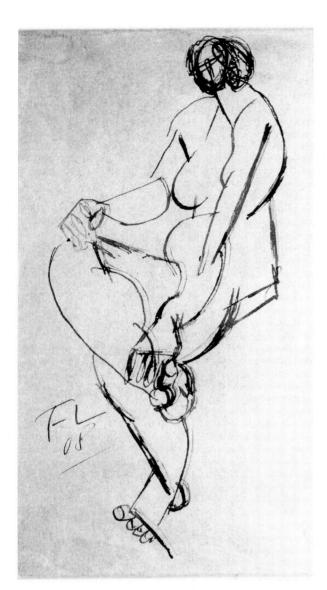

2.52 FERNAND LÉGER (1881–1955)
Study of a Seated Female Nude (1908)
Pen and ink, 9³/4 × 4⁵/8 in.
V & A Picture Library/© 1999 Artists Rights Society (ARS), New York/ADAGP, Paris.

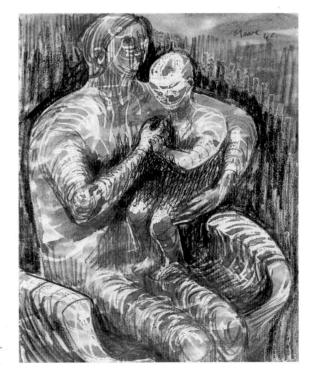

2.53 HENRY MOORE, British (Castleford, W. Yorks, U.K., 1898–1986, Much Hadham, Herts, U.K.) Study for the Northampton Madonna (1943) Crayon, transparent crayon, black ink, gray-black wash, graphite, on laid paper, 22.5 × 17.6 cm. actual.

Courtesy of the Fogg Art Museum, Harvard University Art Museums. Gift of Meta and Paul J. Sachs 1958.24.

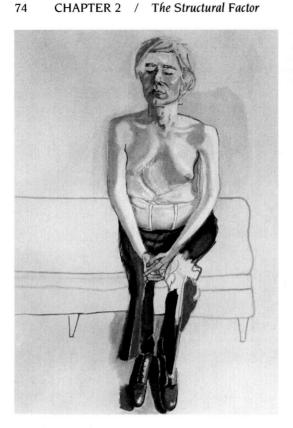

2.54 ALICE NEEL (1900–1984) Andy Warhol (1970) Oil on canvas, 60×40 in. $(152.4 \times 101.6 \text{ cm})$. Collection of Whitney Museum of American Art. Gift of Timothy Collins 80.52. Photograph Copyright © 1998: Whitney Museum of American Art.

2.55 DR. R. E. HERRON Three Back Views of a Seated Female Figure Computer drawing. Courtesy, The Institute for Rehabilitation and Research, The Texas Medical Center, Houston, Texas.

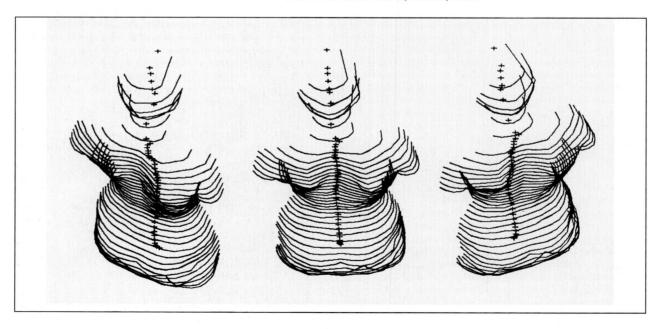

tials from the live or imagined model is a kind of abstracting, so is our transposing of these essentials into lines, tones, and textures on a flat surface. Abstraction, it seems, is at the heart of any work of art. The best exponents of figure drawing are the most adept at recognizing the simultaneity of their marks as referring to both physical facts and to the abstract activities that give human forms a living presence.

In this chapter, we have come by way of the structural factor in figure drawing to one of the most important themes of Chapter 1, namely that the best figure drawings are not *re*-presentations, but *equivalent presentations:* graphic organisms that parallel living ones by coming alive *in their own terms*. An inter-

est in the structural nature of one's subject is the perfect antidote to a fussy concern with surface details and is a visually logical pursuit; we cannot begin to communicate a subject's volumetric state until we understand it. Unless such understanding occurs, superficial details are all one *sees*. But figure drawings that are living graphic organisms emerge from felt perceptions of a subject's structural and dynamic truths, and not from a scrutiny of surfaces. As Henri Matisse put it, "Exactitude is not truth."

SUGGESTED EXERCISES

The following exercises can be done in any order and may be adjusted to suit your own needs and curiosities. When an exercise calls for more than one drawing, try to vary the time you spend on each from a minimum of twenty minutes to a maximum of one hour. Use any medium and suitable surface, but avoid the harder graphite (lead) pencils, which promote timidity and tight handling. As you do these drawings, try several combinations of materials and vary the sizes of your works. However, avoid making very small drawings, which tend toward cautious handling and are usually more difficult to control by virtue of their smallness. A useful range of paper sizes for these drawings is between 10×14 in. and 18×24 in.

- 1. Using as your model one of the photos of the nude in this book, begin a drawing in a free (but lightly drawn) gestural manner and go on to record the shape state of each of the figure's parts using only straight lines. No matter how richly curved an observed edge may be, draw that curve by the several (or many) straight line segments you need to duplicate its configuration (see Fig. 2.41a and b).
- 2. Make three drawings of your hand. In the first, limit the drawing to simple geometric forms such as the block and the cylinder. Show how these forms fit together in a simple manikinlike manner. In the second drawing, analyze the forms of your hand for the major and secondary planes, relying mainly on line and emphasizing straight-line drawing wherever strong curves are found. Where it becomes necessary to use tonalities to clarify various overlappings, use cross-contour or hatched lines that ride on the flat or curved planes in directions that convey the angle—the tilt—of the planes. Emphasize the various interjoinings of forms by trying to see how the form units come together. In the third exercise, draw your gloved (or mittened) hand, stressing the tensions in the fabric produced by

- the hand's position. Emphasize the larger masses and actions of your covered hand. This should be the most fully realized drawing of the three. Imagine that a sculptor will use your third drawing as a guide for a piece of sculpture. Ask yourself whether or not a sculptor could "read" every passage of the terrain in your drawing.
- 3. Rework or redraw several of your figure drawings to show a bold summarizing of planes, forms, and form units. Stress simple form solutions and simple interjoinings in the general manner of Figures 1.41, 2.17, and 2.33. Emphasize flat and curved planes; in drawing the edges, use only straight and simple C-curved lines. This emphasis on straight and C-curved lines promotes decision making based on your analysis of the essential nature of each plane, form, and edge segment. Such drawings are often admirably resolute; they show the strength and authority we associate with affirmative choices—even when they are wrong! Imagine a light source falling on the forms and simplify the drawing's tones to three values: the white of the page, a light gray, and a dark gray, as in Figures 2.15 and 2.37. But use values sparingly, only where you feel they will help clarify volume and space. In doing so, avoid hard, "cutout" shapes of tone. Instead, apply values freely and keep them open-edged, loose.
- 4. Draw several imaginary figures in action in the manikinlike manner of Cambiaso (Figs. 2.1, 2.5, and 2.33). Your drawing should reflect Cambiaso's bold analytic attitude rather than his drawing technique or his particular simplified form solutions. Try to find some form solutions that seem logical to you. Figure 2.27 may provide some ideas for simplifying various parts of the figure.
- Rework or redraw several of your life drawings in the ovoid manner of Tintoretto's drawing (Fig. 2.19).

⁴ From an article by Matisse in the Philadelphia Museum of Art Exhibition Catalogue, 3 April–9 May, 1948, pp. 33–34

- Again, concentrate on the artist's method of analysis, not on his style of drawing. Referring to the anatomical illustrations in Chapters 3 and 4 will help you restate the forms of your drawings in this way.
- 6. Using the drawings of Cambiaso and Figure 2.27 as a guide or point of departure, again devise your own manikinlike system of simple forms and, using some of the photos of the figure in this book, make several drawings using these forms to help clarify the basic geometric nature of the figure's masses. Continue with these drawings, working tonally and developing their manikinlike forms into more human ones. Referring to the anatomical illustrations in Chapters 3 and 4 will help you carry these drawings further.
- 7. Using the manikin system you devised in Exercises 4 and 6, invent several line drawings that show your figures in various severely foreshortened positions. Select one of these views and carry it further, using three values and absorbing the manikin forms into the developing figure forms until they are no longer easily seen.
- 8. Again using the manikin forms developed in the previous exercises, create several line drawings of imagined figures in various standing and seated poses. Use line sparingly and lightly. When these drawings are fairly well established, draw simply draped clothing over them. Assume the drapery to be made of a rather heavy, limp material that will produce large but simple folds. The drapery can be as simple as a heavy towel. You will find that drawing the folds of the drapery will lead you to rely more on values because it is difficult to show the gradual inclination of a curved plane by line alone. Again, select a light source, modeling with three values, but develop these values by hatchings that move on the form rather than by smudges of tone.
- 9. Using the Ingres drawing (Fig. 2.18) as your subject, redraw it three times: first, as if you were positioned high up and saw the figures far below you; second, as if you were lying on the ground *just in front* of the two figures; and third, as if you were standing in a position somewhat to one side of the figure, where one figure slightly overlaps the other. In all three drawings, the forms can be reduced to somewhat more simplified masses.
- 10. Make several line drawings from a live model (or one of the photos in Chapter 8). Begin to draw with a Giacometti-like search for the direction of parts, their shape, and their major planar character (Fig. 1.41), developing each drawing to a point that conveys the figure's general structural character. Avoid using line in a bold, dark manner, as you will work over this stage of the drawing. Proceed by drawing, in fewer, more continuous lines, across the forms with cross-contour lines that move in various directions. For example, cross-contour lines may be drawn downward from the top of the head to the chin, neck, or even down the chest to

- the toes; across the chest; or obliquely on an arm or leg. A computer drawing (Fig. 2.55) shows one method by which you can investigate the changing nature of the subject's surface. Here, the figure's surface structure is revealed by cross-section contours that bisect the figure at fixed intervals. As noted earlier, when such lines are drawn on flat or curved planes turned away from a light source and omitted on planes that face the light, a sense of form and illumination emerges, as in Figures 2.20, 2.23, and 2.24. Imagine the cross-contour lines you draw to be produced by an ink-soaked insect who leaves a trail that discloses the hills and valleys of the figure's changing terrain. Restate the figure's outlines in this more tactile frame of mind. Continue drawing in a manner that regards the Giacometti phase of the work to be a kind of scaffold that is now being draped with the heavier supple forms that characterize a drawing by Rubens (Figs. 1.19, 1.39, and 2.39). Finally, model the forms further by suggesting a light source in the mode described earlier.
- 11. Using Rembrandt's An Actor in His Dressing Room (Fig. 2.47) as a general guide, draw an observed view of a draped figure in an interior. Try to give the sense of firm and fluid masses that show strong rhythmic and tensional behavior. Give the sense of drapery's limp and clinging character to any materials or objects that permit such an interpretation. In so doing, do not lose sight of the need to grasp the essential structural character of all the forms as well as the direction, shape, scale, and location of each.
- 12. Redraw Poussin's *Bacchus and Ariadne* (Fig. 2.48) in the general manner of Millet's *The Diggers* (Fig. 2.49) and redraw the Millet etching in the general manner of the Poussin drawing. You may not be able to decipher all of the planes and forms in the Poussin. Make any changes you wish.
- 13. Draw a life-size self-portrait that emphasizes the planar nature of your facial forms, as in Figure 2.16, but develop the forms by hatchings and cross-contour modeling that run in the direction of each plane's long or short axis, as in Figures 2.4, 2.12, and 2.28.
- 14. Using as your model one of the photos in this book of the nude figure, draw one version of the figure as transforming into stone. Your goal is to show an image that seems roughly hewn of rock. Make whatever moderate changes in the subject's surface forms you feel will emphasize the weight, texture, and overall look of rock. However, do not change the pose or arbitrarily add forms that have nothing to do with the figure. The resulting work may show the subject's forms to have been simplified or elaborated, but the viewer should understand that the drawing represents a figurelike rock formation. Make a second version of the same subject that shows the figure transforming itself into a cloud. Again, make those moderate changes

necessary to convince viewers that they are seeing not a drawing of the figure, but a figurelike cloud formation

15. Working from the live model or one of the photos in this book, make a life-size tonal drawing of a nude or

draped figure. Develop the tones and forms by hatchings and cross-hatchings, referring to any of the drawings in this book that apply, such as Figures 1.21 and 2.15.

3.1 JACOB DE GHEYN II (1565–1629) Allegory of Death
Pen and ink on gray paper, $6^1/4 \times 5^1/8$ in.
Rijksmuseum, Amsterdam.

The Anatomical Factor

Part One: The Skeleton

SOME GENERAL OBSERVATIONS

In the previous chapter, we saw that structural considerations play an important role in drawing the figure well. In this chapter, we will see the part that inner anatomical forms play in alerting us to important surface conditions. To disregard the study of anatomy is to settle for a kind of rote recording of bumps and hollows that neither convinces nor satisfies the discerning viewer. Without basic anatomical information, beginners lack the basis for knowing what to select or change. But once they acquire such information, their drawings begin to show the knowledge and expressive authority that all good figure drawings possess. Just how much structural analysis is sufficient for good figure drawing and how large or small a role anatomy should play, of course, is determined by personal creative interests. But because both of these factors participate in forming images of substance and spirit, the art student must have a knowledge of both.

In this chapter and the next, we will examine those anatomical facts of most importance to the artist. We will do so mainly by visual means. The anatomical illustrations reproduced here will show what the machinery of human anatomy looks like, while photographs and masterworks will show how the figure's anatomy appears in the living state. The

text will point to matters of importance, but it is the visualizations that will inform the visually oriented reader in the most direct and useful way.

The purpose of this and the following chapter, then, is to examine the more important aspects of the figure's skeletal and muscular systems and to consider some ways in which a knowledge of anatomy can benefit our overall understanding of the figure and serve our creative interests.

If the beginner in life drawing regards the skeleton at all, it is probably at those places in the figure where it presses against the surface and strongly affects it. Even then, such passages are only tolerated as complicating, lumpy interruptions of the otherwise smooth-flowing forms. They disconcert the student, who knows they represent parts of masses beneath the skin, but has no way of knowing their form, function, scale, or consequently, their structural or representational importance.

But the seasoned artist welcomes this evidence of the skeleton throughout the figure. He or she realizes its structural importance as both an armature and a protective container for the figure's muscles and organs. Its armaturelike nature aids the artist's understanding of a figure's gestures as well as its propor-

For a listing of anatomy texts, see the Bibliography.

tions; its large containerlike forms help in establishing the major masses of the head and torso (Fig. 3.2). The skeleton's influence on the figure's forms helps the artist understand the pressures, weights, and tensions acting from within on the figure's container of skin, as in Figure 3.3. In some passages, such as the shoulders or hips, the planar character of various bones helps the artist understand the interjoinings of

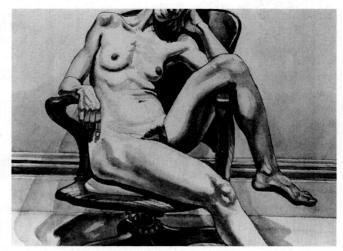

3.3 PHILIP PEARLSTEIN (1924—) Nude Sitting on Chair (1975) Sepia ink on Arches paper, $20^3/8 \times 30^1/4$ in. Courtesy of Jalane and Richard Davidson.

various surface form units. Additionally, the recurring presence of hard skeletal forms at the surface helps explain the skeleton's role as a firm scaffold for the supple drapery of the figure's softer tissues. Such more angular passages serve as visual counterpoints to the figure's more rounded masses, as in Figure 3.4, where we see a pattern of "hard and soft" areas that serves both structural and plastic goals.

Knowing it is the skeleton, more than the muscles, that accounts for a figure's stance and reveals the directions and lengths of its parts in a stick-figure manner is important in analyzing the pose before us or in constructing one from our imagination (Fig. 3.5). And knowing something about the form and purpose of the bony masses beneath the figure's surfaces, particularly in those passages where they are much in evidence, is important in giving our drawings the ring of truth. The skeleton contributes greatly to the figure's unique rhythms, its overall pattern of firm and flowing passages, and its interwoven qualities of power and pliancy.

BONES OF THE SKULL

The skull consists of twenty-two bones, most of them in pairs (Fig. 3.6). All but the jawbone, or *mandible*, are connected to each other by suture (dovetailed) joinings. For the artist, the skull is best regarded as composed of two major masses: the ovoid brain case, or *cranium*, consisting of eight bones, and the blocklike formation constituted by the fourteen facial bones.

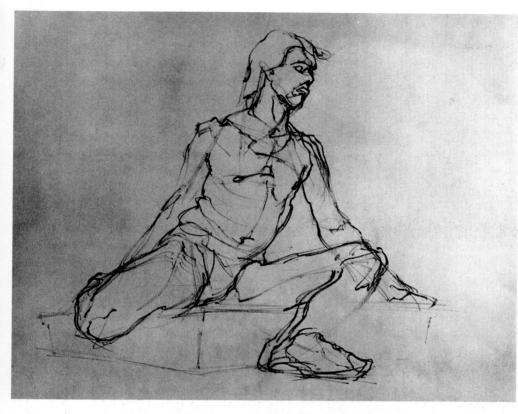

3.4 ALEX MCKIBBEN (1940–)
Male Figure, Seated
Black chalk.
Courtesy of the artist.

3.5 BORGHESE
From Salvage's "Anatomie du Gladiateur
Combattant"
Engraving.
Francis A. Countway Library of Medicine, Boston.

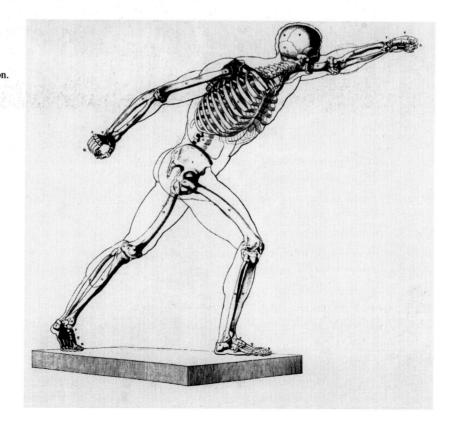

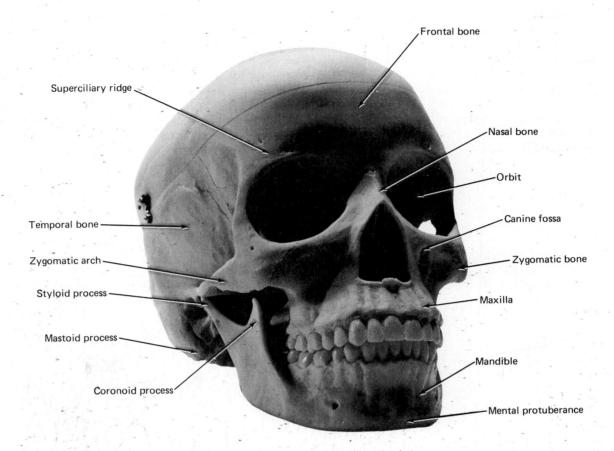

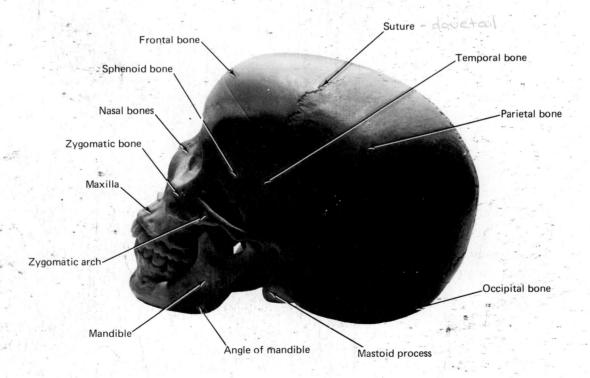

Understanding the skull's basic structure is essential in constructing the head in its various positions (Fig. 3.7). Unlike the limbs or the torso, which are more heavily overlaid by muscular and fatty tissues, the skull, even in heavily fleshed heads, exerts a strong influence on the surface forms (Fig. 3.8). This is particularly true of the cranium's mass, whose egglike form is always evident whether the head is viewed from the front, side, or top. In Lillie's Study of a Woman's Head (Fig. 3.9), the artist's appreciation of

the skull's effect on the living forms is felt in the strong linear rhythms created by lines "chasing" each other along ridges and valleys and in the rugged carving and interjoining of form units. Note the downward tilt of the eye sockets and the underlying presence of the zygomatic, nasal, and maxilla bones. Note, too, the influence of the angular mandible on the drawing of the jaw. Here, the factors of structure and anatomy are energetically interrelated by an animated line quality that suggests a strong and vibrant individual.

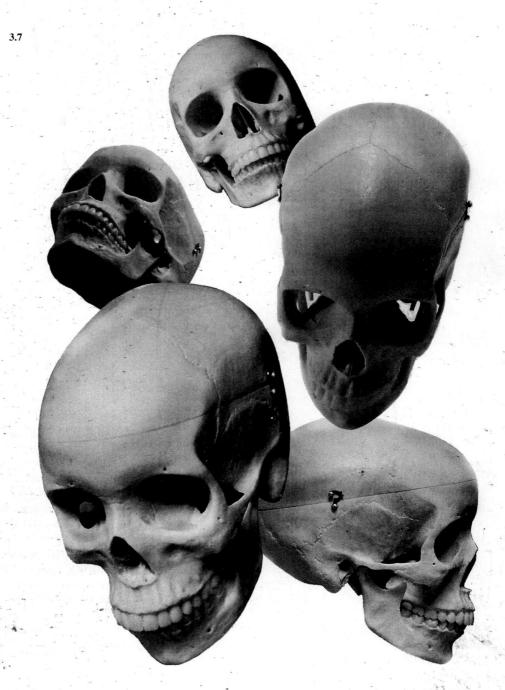

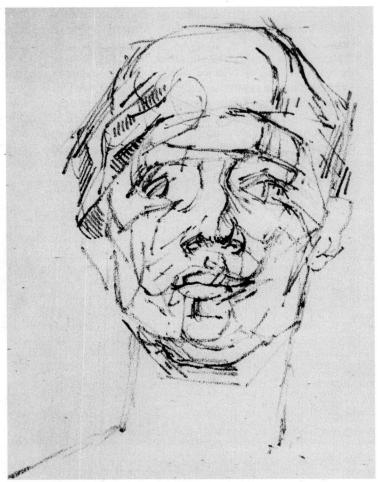

3.9 LLOYD LILLIE (1932–) *Study of a Woman's Head* Pencil, 9 × 12 in. Courtesy of the artist.

In Velázquez's Cardinal Borjia (Fig. 3.10), there is a convincing presence of a skull underlying the surface forms. In this preparatory study (one of only two or three studies known to be by the hand of the great Spanish master), we can easily trace many of the cranial and facial bones. Note how clearly Velázquez defines the zygomatic bone and ridge, the superciliary ridge, and the overhanging ledge of the frontal bone.

BONES OF THE SPINAL COLUMN

The spinal column, comprised of twenty-four movable vertebrae and two immobile segments—the sacrum and coccyx—connects the three large bony

masses of the skeleton: the skull, rib cage, and pelvis. The vertebral column emerges from its base in the pelvis and, tapering as it rises, undergoes four curves along its route to the base of the skull. The four curves, as seen in Figures 3.11, 3.12, and 3.13, are convex in the seven *cervical* vertebrae, concave in the twelve *thoracic* vertebrae, convex in the five *lumbar* vertebrae, and concave in the sacrum and coccyx.

Although the spine represents the central axis of the torso and tall columns of deep muscle flank it on both sides, making a vertical valley all along the back, its presence at the surface is intermittent and not often pronounced.

Because the spinal column connects the skeleton's large masses, major pivotal or bending movements of this moderately flexible chain of vertebrae can occur

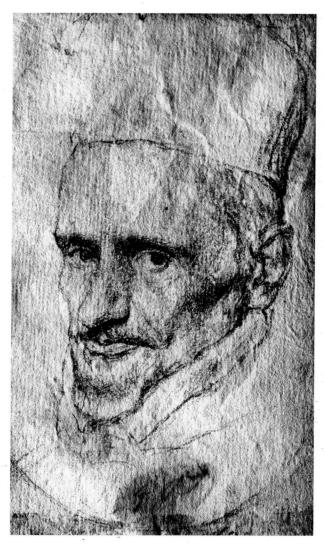

3.10 DIEGO VELÁZQUEZ (1599–1660)Cardinal BorjaChalk.Real Academia de Bellas Artes de San Fernando, Madrid.

only between these masses. Thus, the large bony masses are moved by the movements of the vertebrae between them. Movements of the head are initiated in the cervical vertebrae, and movements of the thorax and pelvis begin with the lumbar vertebrae. The first and second cervical vertebra, the *atlas* and *axis*, respectively, because of their special construction, allow for rotating and pivoting movements of the head (Fig. 3.13). The spine's construction, in addition to its rotating and bending actions between the large masses,

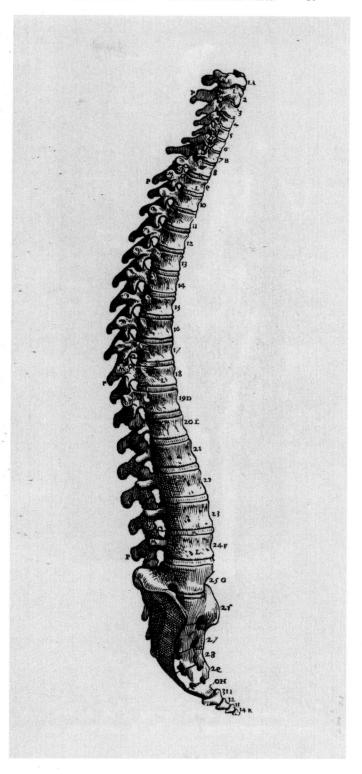

3.11 ANDREAS VESALIUS (1514–1564)

Plate 10 from "De Humani Corporis Fabrica, Book I"

Engraving.

Courtesy of the New York Academy of Medicine Library.

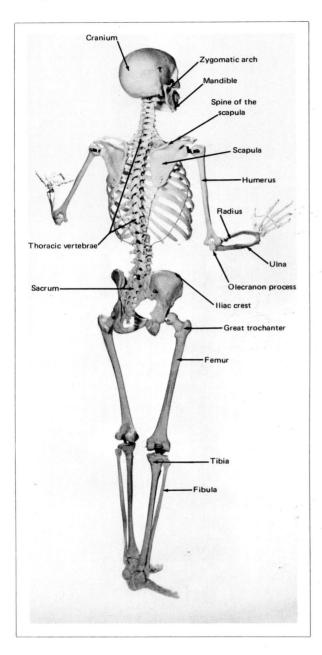

3.12

also allows for a slight curving of the thoracic vertebrae in extreme bending of the rib cage to the side.

BONES OF THE RIB CAGE

Like an egg, small end up and somewhat wider in the front than in the side view, the thoracic cage is com-

posed of twelve pairs of ribs, the twelve thoracic vertebrae with which the ribs articulate (meet with), and the *sternum*, or breast bone (Fig. 3.14). The ribs swing downward and out from either side of the vertebral column for a short distance and then turn sharply to curve toward the front, still turned downward. At no point do the ribs themselves turn upward toward the sternum; their upward "homing in" on the sternum is completed by extensions of cartilage, as shown in Figure 3.14.

Counting downward, the eighth rib marks the widest point of the rib cage from the front view. Because in the back view the sharp forward turn of the ribs occurs at about the same point in each rib, there is a discernible change in the direction of the ribs along a slightly curved vertical line. These lines, marking the abrupt change in the large planes of the back, are called the angles of the ribs. With the arms at rest, the medial (inner) edge of the scapula (shoulder blade) is in rough alignment with this angle (Fig. 3.15). The resulting flattish construction of the back of the rib cage, still evident in the fleshed figure, is unique to humans and accounts for our ability to lie flat on our backs. A large V-shaped opening in the rib cage, its apex at the base of the sternum, is formed by the thick cartilaginous band that "gathers up" the lower five pairs of ribs on its way to the sternum. This V-shaped opening (wider in the male torso) is the thoracic arch, a very pronounced landmark in the fleshed figure (Figs. 3.16 and 3.65).

The dagger-shaped sternum, viewed from the side, tilts obliquely forward and downward from its highest point, at the pit of the throat. It is about seven inches in length and is comprised of three fused segments. Each of the segments is tilted to a slightly different degree, turning more sharply downward in the lower two segments. The sternum is widest in the uppermost segment, the manubrium, notched on either side to receive the clavicles (collar bones) and notched at the top to form the familiar indentation of the pit of the throat (Fig. 3.17). The body, or central segment of the sternum, like the manubrium, is indented along both sides to receive the cartilage extensions of the ribs. The lowest and smallest segment of the sternum, the xiphoid process, is not usually seen in the fleshed figure. Its lower tip marks the top of the thoracic arch (Fig.3.14).

BONES OF THE SHOULDER GIRDLE

From an overhead view, the bones that comprise the shoulder girdle look like a cupid's bow. The bow is formed by the S-shaped *clavicles* in front and the *spines of the scapulas* and *acromion processes* in

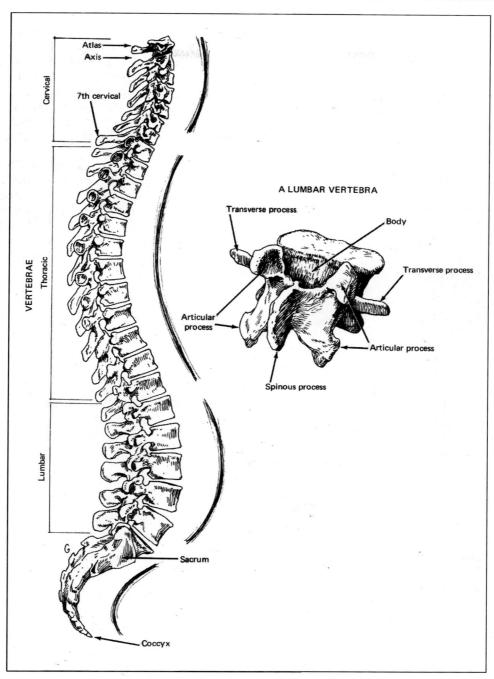

3.14

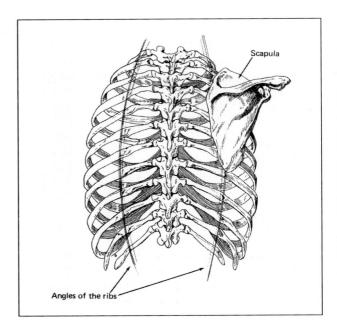

3.15

3.16

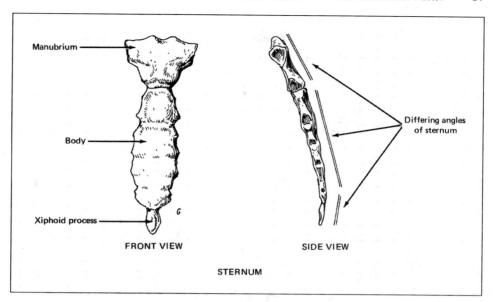

back (Fig. 3.18). The scapula is a trowel-shaped bony plate with a tilted handlelike projection, its spine, near the top. Its medial (nearer to the body's midline) edge is nearly vertical, its lateral (further from the midline) edge is markedly oblique, and its upper edge inclines downward toward the bone of the upper arm. Near the top. its projecting spine, beginning at the medial edge, rises above the slanted upper edge and, at its extremity, turns sharply forward to meet the outer end of the clavicle. This outer end is called the acromion process. In meeting, the acromion process is located just a little beneath the outer tip of the clavicle (Fig. 3.18). With the arms at rest at one's sides, the height of the scapulas (about 61/2 to 7 in.) equals their distance apart at their pointed lower ends. At the lateral upper edge of the scapula, just below its junction with the clavicle, is the glenoid fossa, a rounded socket which receives the head of the humerus, the bone of the upper arm.

Because the scapulas are attached to the skeleton only at their junction with the clavicles, they are free to swing upward, as when we raise our arms above our head, and outward, as when we clasp our hands behind our back. This can be seen in Figure 3.19, where the left scapula, its medial edge and pointed end very evident—pushes outward and the right scapula—less visible because of the muscles that encase it in this position—has moved in an upward arc with its pointed end near to the upper torso's edge. However, when the arm is raised, the scapula remains stationary until the arm approaches a horizontal position. Once the arm is raised above the line of the shoulders, the scapula begins its swing outward to the side of the rib cage.

This outward movement is clearly shown in

Michelangelo's *Studies for "The Libyan Sibyl"* (Fig. 3.20). Note, on the figure's left side, how the spine of the scapula is turned forward to articulate with the clavicle. On the right side, although the arm is raised, its backward movement brings the scapula nearer to the spinal column, causing deep muscles (rhomboids) to bulge into the vertical folds seen on that side.

In this remarkable anatomical study, Michelangelo's knowledge of the interaction of bone and muscle is clearly expressed by his ability to show the volume of specific form units and their interjoinings. Evident here, too, is a sensitive understanding of the design—the harmonies and tensions—of human anatomy. Note the expressive power of these heroic forms: an engaging contrast between the energy suggested in their athletic form and the delicate modeling that caresses them into being. Here again is an example of the four factors brilliantly interacting.

BONES OF THE PELVIS

The pelvis is the single bony mass of the lower trunk. It surfaces in only two places: at the base of the spine (sacral triangle) and at the hips, where the *anterior-superior iliac spines* are visible as bony projections in the front and side views and the *posterior-superior iliac spines* are seen as bony arcs or curved furrows (depending on the lean or muscular state of the figure) in the back view (Figs. 3.21 and 3.22). The anterior-superior iliac spine projections, especially visible in the female figure (Fig. 3.23), are at the leading edge of the *iliac crests*, the thickened rims of the winglike hip bones which, with the sacrum, form the basinlike

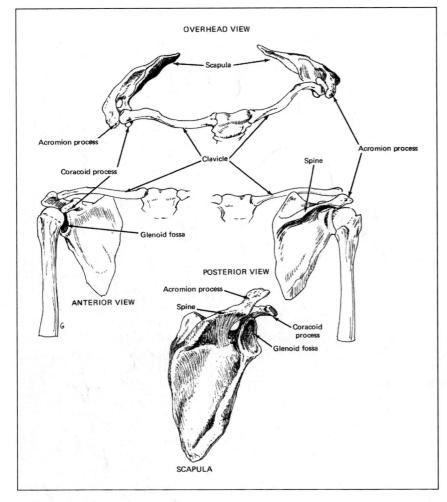

3.18

container for the intestines and reproductive organs. In very lean figures, certain poses reveal most of the iliac crests.

There are some differences of proportion between the male and female pelvis. The female pelvis is wider, shallower, and less massive in bulk. The pubic arch is more rounded and wider. The sacrum, tilting upward a little more than it does in the male pelvis, is shorter and wider, and the pelvic cavity is larger. The male pelvis is thicker and more angular overall (Fig. 3.22). From the side view, the male pelvis appears to tilt forward to a lesser degree than the female pelvis does; note the pronounced backward tilt of the lower trunk in Figure 3.23.

Although deeply embedded in the musculature and fatty tissues of the lower trunk, the pelvis exerts its blocky influence on the living form. In front and back views, the pelvis can tilt markedly to the left or right, always tilting upward on the supporting leg side, as in Kollwitz's *Two Nudes* (Fig. 3.24). Note how the artist makes use of the angular character of the pelvis to shore up her otherwise fluid treatment of the figure's forms and to bolster a design theme of straight and curved lines. Figure 3.25 clearly shows

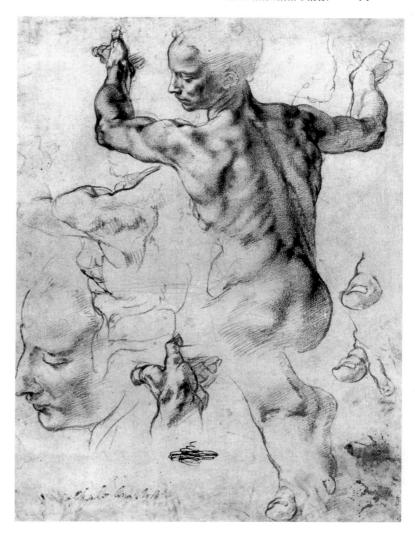

3.20 MICHELANGELO BUONARROTI, Italian (1475–1564)

Studies for "The Libyan Sibyl"
Red chalk on paper, 113/8 × 83/8 in.
The Metropolitan Museum of Art, Purchase 1924, Joseph Pulitzer Bequest. (24.197.2)

the tilting of the pelvis on the supporting leg side and helps us understand the size and shape of the pelvis in the living figure.

Despite the subtle clues in the living form to the mass and position of the pelvis, noting its form and angle is essential to seeing the character of any pose. This is so even in reclining poses. Goodman, in *Model on Draped Table* (Fig. 3.26), clearly depicts the figure's shift from a side view in the upper body to a front view in the lower body by showing the effect on the surface forms of the angle and mass of the pelvis.

BONES OF THE ARM

There are three major long bones in the arm. The longest and thickest is the *humerus*, the bone of the upper arm; in the lower arm, the *radius* and *ulna* are roughly parallel, with the ulna positioned

slightly higher. In the fleshed figure, the *medial* and *lateral epicondyles* of the humerus (protuberances at the bone's lower end) are generally visible, as are the *styloid processes*, the protuberances at the extremities of both the radius and ulna (Fig. 3.27). At the shoulder, the ball-like head of the humerus is often visible, despite the fullness of the deltoid muscle (Fig. 3.31).

A versatile joint at the elbow allows for bending and rotating movements by the lower arm. In bending, the ulna moves around the *trochlea*, a spoollike ending on the humerus. In rotating actions, the rounded end of the radius revolves within the radial notch of the ulna and rotates on the *capitulum* of the humerus in a ball-and-socket manner (Fig. 3.28). When the palm of the hand is turned face up (supine), the radius and ulna are parallel; when the palm is turned face down (prone), the radius crosses over the ulna (3.28).

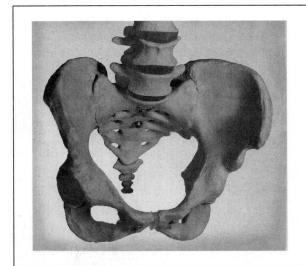

3.22

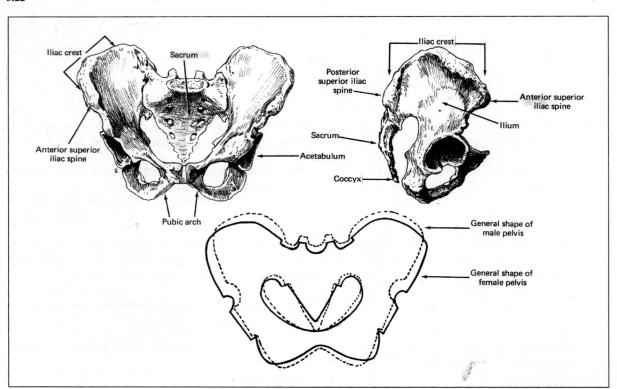

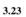

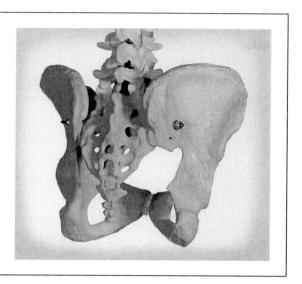

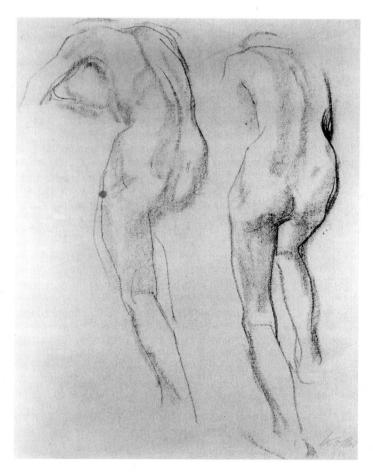

3.24 KATHE KOLLWITZ (1867–1945)
Two Nudes (1904/1906)
Black chalk on laid paper, $.612 \times .480 \ (24^1/_{16} \times 18^7/_8)$.
Rosenwald Collection, Photograph © 1998 Board of Trustees, National Gallery of Art, Washington, D.C.

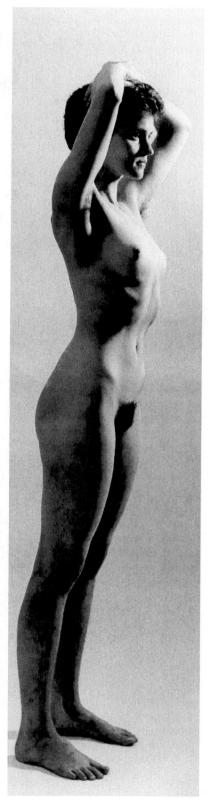

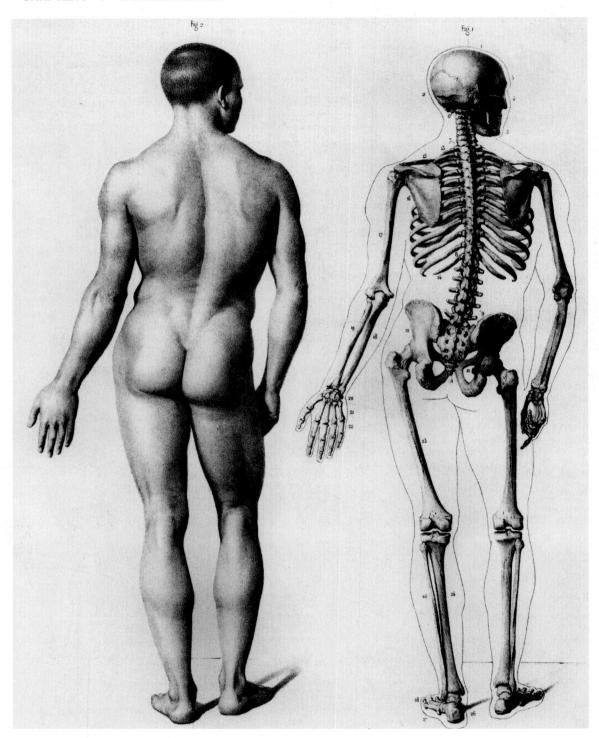

3.25 DR. J. FAU

The Anatomy of the External Forms of Man, Plate 3

Francis A. Countway Library of Medicine, Boston.

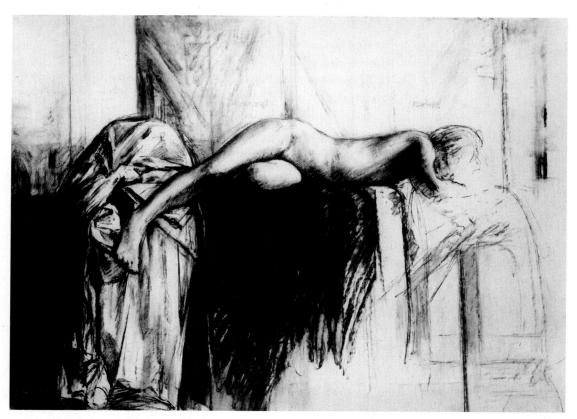

3.26 SIDNEY GOODMAN (1936–)

Model on Draped Table (1977–1978)

Charcoal, 29 × 41 in.

Photo by Eeva-inkeri. Courtesy of Terry Dintenfass, Inc. in association with Salander-O'Reilly Galleries, LCC, New York.

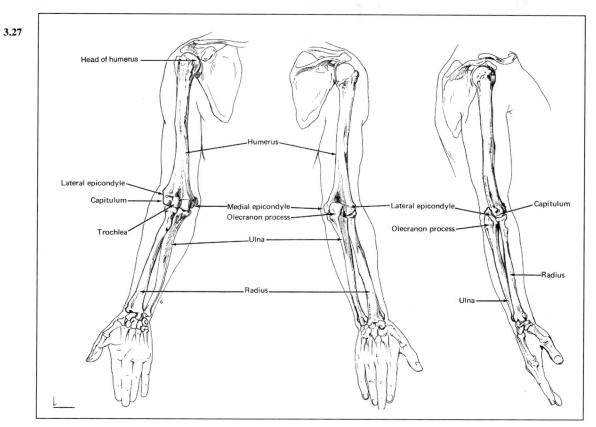

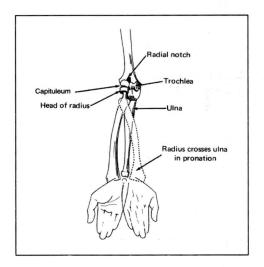

3.28

At the wrist, the rounded head of the ulna (on the little finger side) is visible in the prone position (palm down); when the hand is supinated (palm up), this rounded projection disappears. At the elbow, a posterior view of the extended arm shows the *olecranon process* to be in rough horizontal alignment with the medial and lateral epicondyles of the humerus. When the arm is bent, the three protuberances form a V-like arrangement (Figs. 3.29 and 3.30). Figure 3.31 shows the arrangement of the clavicle, spine of the scapula, and humerus bones at the shoulder, where the head of the humerus is sheltered beneath the junction point of the other two bones.

There are twenty-seven bones in the wrist and hand. In the wrist, eight *carpal* bones form a ball-like mound just below the heads of the ulna and radius. Embedded in the palm are the five *metacarpal* bones. The heads of these slender, curved bones (knuckles) are visible when the hand forms a fist; when the fingers are extended, these protuberances all but disappear. There are fourteen *phalanges* (finger bones). Of the three bones in each finger, those nearest the wrist (proximal phalanges) are longest; those next (medial phalanges) are two thirds the length of the proximal phalanges; and the bones of the fingertips (distal phalanges) are two thirds the length of the medial phalanges (Fig. 3.32). The thumb is composed of only

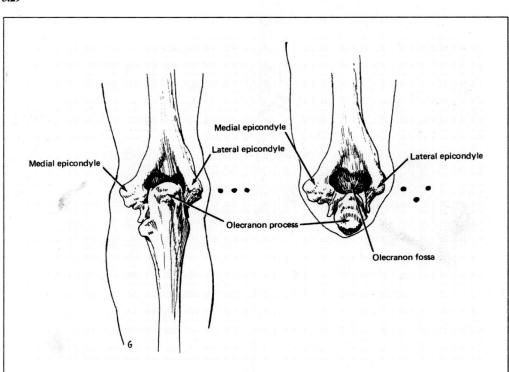

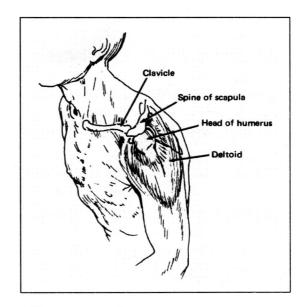

3.30

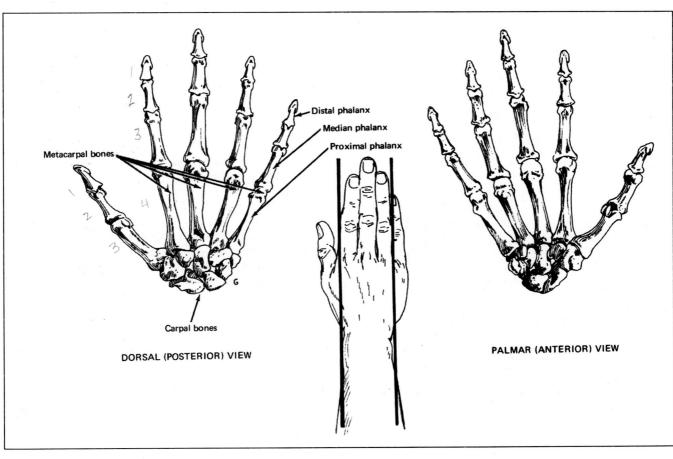

two phalanges, the joint between them falling on a line with the metacarpal heads.

Most beginners draw hands (and feet) too small. Actually, the length of the hand is about four fifths that of the head. Likewise, in width, the hand covers most of the face. When the fingers are extended and held together, the outer edges of the index and ring fingers line up with the edges of the arm at the wrist (Fig. 3.32).

BONES OF THE LEG

There are four bones in the leg and twenty-six in the foot. In the upper leg, the *femur*, which is the longest bone in the body, provides the only bony joining between the torso and the lower limb. At the knee is the *patella* (kneecap), a roughly triangular, shieldlike

3.33 BERNARD ALBINUS (1697–1770)
Skeleton, Front View from "Tabula sceleti et musculorum corporis humani" (1747) (detail)
Engraving.
Francis A. Countway Library of Medicine, Boston.

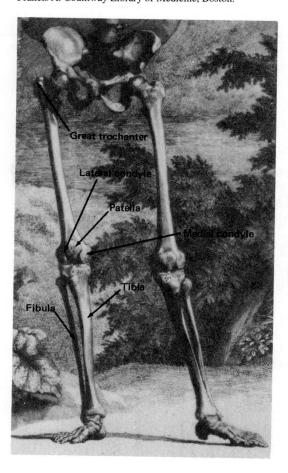

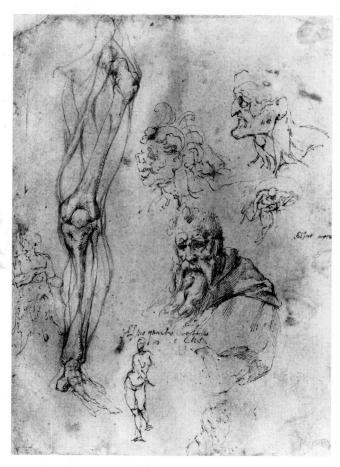

3.34 RAPHAEL DA MONTELUPO Anatomical Studies
Ashmolean Museum, Oxford.

bone. In the lower leg are the *tibia* and *fibula* in a fixed, parallel position (Fig. 3.33).

The lower ends of the tibia and fibula are always visible at the ankle in the living figure, as in Figures 3.34 and 3.38. The femur is sometimes visible in the area of the hip, where the *great trochanter*, a blocky outcrop of bone, shields the femur's slender neck and rounded head. This head is received by the hollowed *acetabulum* of the pelvis in a ball-and-socket joint that permits considerable freedom of movement of the upper leg. The femur is also in evidence at the knee. Here, the medial and lateral *condyles*, the thick rims at the femur's inferior (lower) end, and the raised hills at the center of these bony rims (*epicondyles*) come to the surface in the fleshed figure, as is shown in the "see-through" drawings of the legs in Figures 3.34 and 3.35.

Seen together from the front, the two femurs incline downward to meet at the knees; seen from the

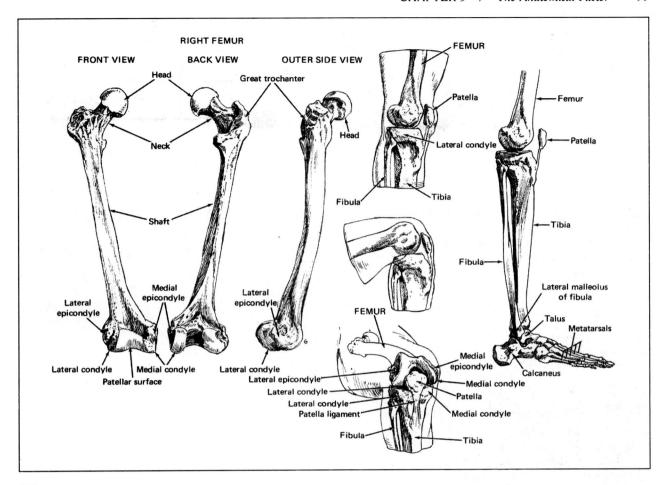

side, the femur describes a subtle curve. Something of these movements can be seen in Figures 3.2, 3.5, and 3.35. At the broad lower base of the femur, the medial and lateral condyles articulate with the tibia. The femur's patellar surface, a smooth depression between the condyles, permits the patella to move in straightening the leg. The patella is always a pronounced landmark in the straightened leg, protruding at the knee even in heavy set individuals, where muscular and fatty tissues encroach on it.

Only the tibia articulates with the lower end of the femur, its broad, flat head meeting with the femur's equally broad base. When the leg is bent, the patella settles in among the protuberances of the femur and tibia, becoming almost lost to view. The tibia's shaft, triangular in cross-section, produces a long vertical plane and ridge at the surface, the familiar shinbone. One of the few places in the figure where the bone lies beneath the skin unprotected by muscular tissue, the shinbone is a prominent land-

mark in the lower leg. The fibula, acting like a flying buttress, supports the broad upper head of the tibia by pushing up against the underside of the tibia's lateral condyle (Figs. 3.33 and 3.35).

Of the seven *tarsal* bones of the ankle, the spool-like *talus* sits astride the *calcaneus*, the blocky, backward-projecting heelbone that provides one end of the arch of the foot. The other end is comprised of the forward ends of the *metatarsals* and *phalanges* (Fig. 3.36). The talus is engaged in the raising and lowering of the foot. The remaining tarsal bones collectively form the upper part of the ankle's inclined ramp connecting the leg and foot. The curved metatarsals correspond to the metacarpals of the hand, but their more evident curve more emphatically influences the fleshed forms of the foot. As any footprint shows, the points of contact with the ground are greater on the outer side of the foot (Fig. 3.36).

The arch of the foot is more visible on the medial side view, with the form of the foot rising almost ver-

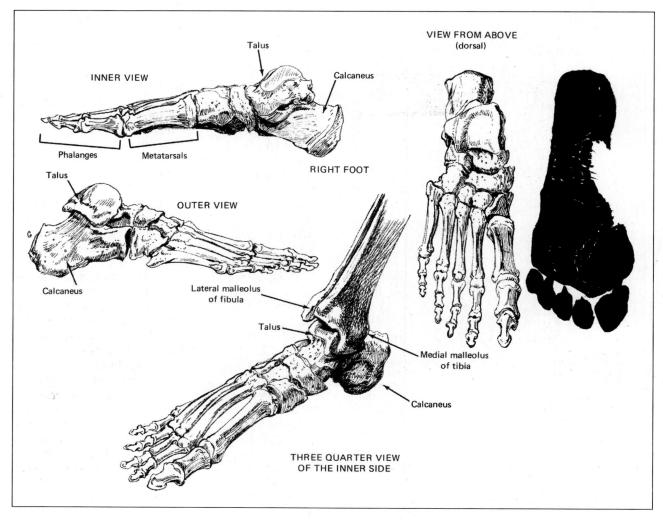

3.36

tically on that side and its base lifted from the ground between the metatarsals and the calcaneus. A sizable protuberance produced by the medial malleolus of the lower tibia marks the juncture of the tibia and the talus. On the lateral side, the foot is flat on the ground all along its base, its form rising at a marked angle. In the front view, the protuberance of the lateral malleolus of the fibula can be seen to be lower than its counterpart on the inner side of the ankle. The foot is narrower and higher at the heel, wider and lower at the toes, its essential mass being wedgelike (Fig. 3.37). The blocky nature of the four small toes, the result of each turning downward at its ending, and the upward turning of the large toe can be seen in Figure 3.38, which also shows the foot's wedgelike character, the backward-projecting calcaneus, and in the lower foot, the lateral malleolus.

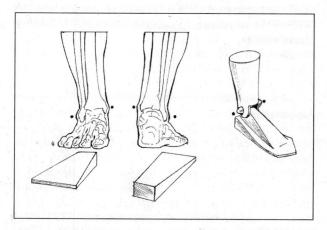

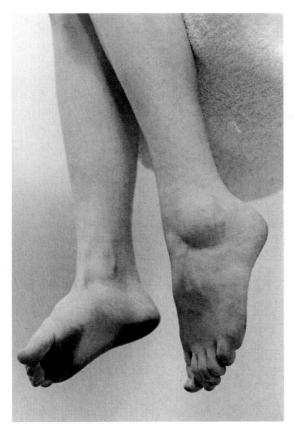

3.38

SKELETAL PROPORTIONS

No system of measurements can replace sensitive perceptual inquiry. Any system of skeletal proportions is of limited value since it refers to varying lengths of parts seen in the same plane, as when the figure is standing at attention. Knowing that the femur is twice the length of the skull may puzzle some beginners when the upper leg is seen in severe foreshortening; and the fact that the humerus is half again the length of the radius and ulna may also confuse beginners who observe the reverse to be the case, as in Figure 3.39. However, knowing certain relationships of scale and location *can* be useful in clarifying what is observed and especially in guiding what is invented. A prior knowledge of the skeleton's proportions can assist perception but should never dictate to it.

The measurements that follow should be regarded as general, not precise. Several different canons of proportion have been devised in the past. Some, like the heroic proportions of Michelangelo's Adam (Fig. 1.14) or those used by the Mannerists to elongate the figure (Fig. 3.40), were designed to endow the figure with certain expressive qualities. Other canons, resulting in the more plebeian proportions of the figures by Goya (Fig. 1.24) or Rembrandt (Fig. 1.21), were necessary for their more earthly expressive interests. The proportions offered here represent average calculations. We should bear in mind that human adults may vary from less than 5 ft. to about 7 ft. in height; they may be big-boned or frail; and they may be powerfully or subtly muscled. More important, we should recognize that the artist, unlike the anthropologist,

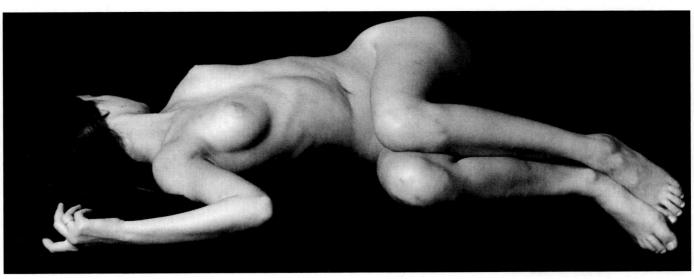

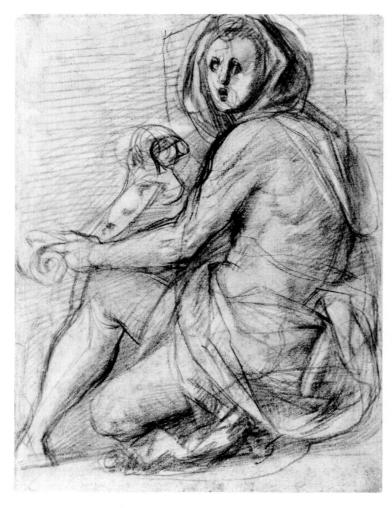

3.40 Italian, Tuscan Florentine, Drawing, 16th Century. ?Pontormo (Jacopo Carrucci da Ponterme, called II Pontormo) (1494–1556) Sibyl

Red chalk with erased highlights on buff antique laid paper, 28.5×20.7 cm. actual..

Courtesy of the Fogg Art Museum, Harvard University Art Museums. Bequest of Charles A. Loeser. 1932.143.

does better to support perception with intuition than with calipers.

The traditional unit of measure in the skeleton is the skull. Although, as noted earlier, different systems of proportion have been developed, such as the one devised by the nineteenth-century anatomist Salvage, who based a system of measurement on the division of the figure into eight units (Fig. 3.41), the average figure universally is about seven and one-half skull lengths. In both the male and female (Fig. 3.41), measuring one skull length down from the skull strikes a point at the tip of the xyphoid process in front and just above the lower end of the scapula in back. Measuring one more skull length down strikes a point just below the highest point of the iliac crest in the male skeleton; in the female skeleton, it is just at the highest point of the iliac crest. Another skull length down strikes a point about 2 in. below the great trochanter in both the male and female skeletons and just at the carpal bones when the arm is held alongside the body.

As Figure 3.41 shows, each of the remaining three and one-half skull lengths falls between, rather than on, useful landmarks. However, this changes if we now begin to measure skull lengths from the base of the foot upward (Fig. 3.42). The first length brings us to a point halfway to the knee; a second measure strikes the patella; a third evenly divides the femur; and a fourth skull length strikes the top of the great trochanter.

It is useful to know which bones are roughly the same in length. As Figure 3.43 illustrates, the sternum, scapula, clavicle, pelvis, ulna, radius, and skeleton of the foot all measure just over or under one skull length. The bones of the wrist and hand are about three fourths of a skull length, as are the sacrum and coccyx together. The rib cage, humerus, tibia, and fibula are likewise similar in length, about one and one-half skull lengths.

Some additional proportions worth noting are shown in Figure 3.44. It is one skull length from the seventh cervical vertebra to the lower tip of the

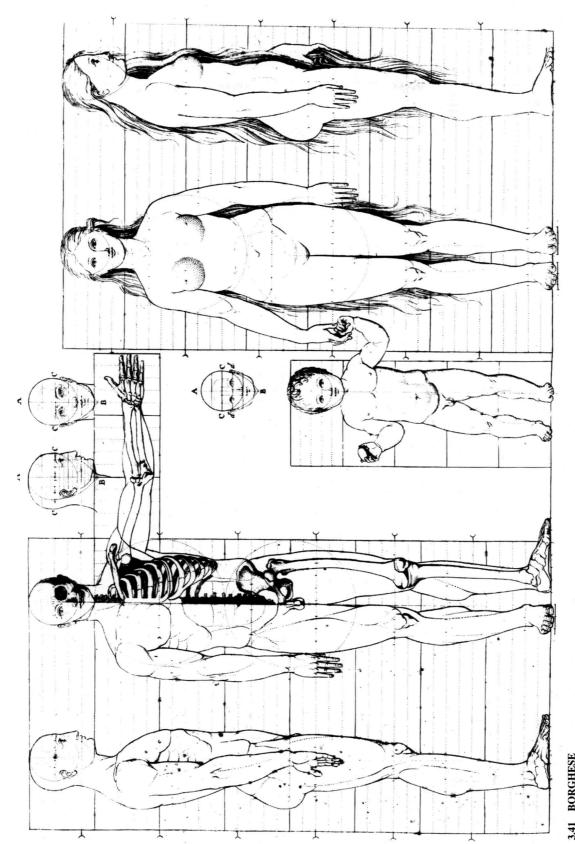

3.41 BORGHESE
From Savage's "Anatomie du Gladiateur Combattant," Plate 19
Francis A. Countway Library of Medicine, Boston.

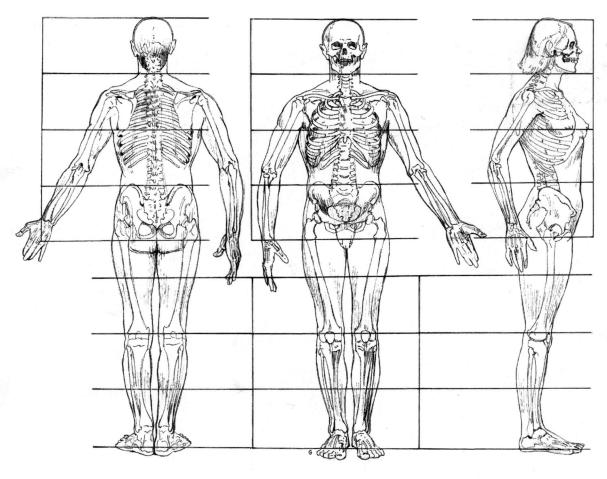

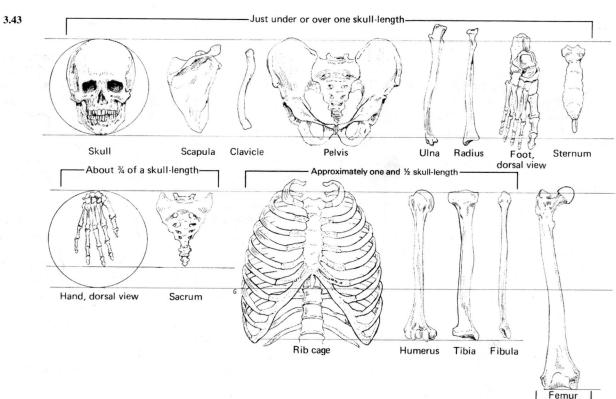

Two skull-lengths

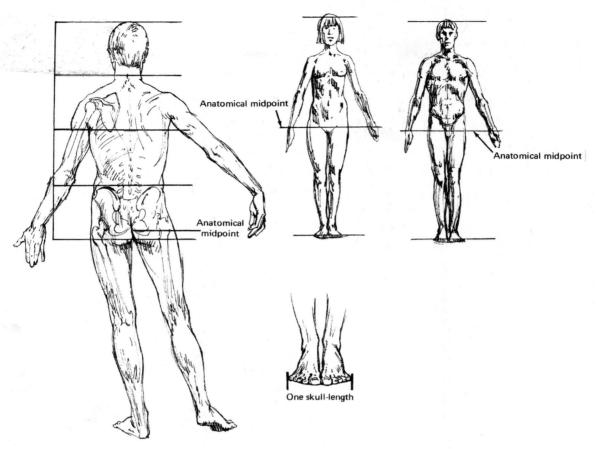

scapula and one skull length from that point to the iliac crest. Another skull length down strikes a point just below the great trochanter. The midpoint in the male skeleton is just at the pubic bone; in the female, it is slightly above the pubic bone. Hence (fashion illustrations notwithstanding), the female's legs are slightly shorter relative to the height of the figure than is the case in the male figure. Both feet, when placed together at the heels but pointed outward, measure about one skull length in the front view.

The three anatomical plates by the famous Renaissance anatomist Albinus (Figs. 3.45, 3.46, and 3.47) show in accurate detail the skeletal forms, proportions, and locations discussed in this chapter and serve as a visual reference and summary.

THE SKELETON IN FIGURE DRAWING

A knowledge of the skeleton stimulates and guides good figure drawing. In Ingres's *Three Studies of a Male Nude* (Fig. 3.48), the elegant flow of the forms

is enhanced by the artist's response to the skeleton's influence on the living forms. The bony "eruptions" serve to keep the forms from becoming too fluid and soft. Ingres uses bony landmarks like commas to provide visual pauses that establish a measured pace and to clarify the figure's construction. Note the skull's influence on the forms of the head, the knowledgeable drawing of the bones at the elbows, wrists, knees, and ankles, the clearly visible mass of the rib cage, and at the hips, the tilt of the pelvis and the influence of the great trochanter.

It is important to recognize the skeleton's potential for contributing to a figure drawing's structural, dynamic, and emotive conditions. Indeed, in some poses, the skeletal frame is a very imposing aspect of what we see (Figs. 3.49 and 3.50). As Figure 3.50 shows, the skeleton's presence is not necessarily more evident in the male figure. Recognizing the general masses of the rib cage and pelvis in Figure 3.50 is fundamental to understanding this pose. In the poses of Figures 3.49 and 3.50, the skeleton's role in forming planes and form units produces strong energies—

3.45. BERNARD ALBINUS (1697–1770)
Skeleton, Front View from "Tabula sceleti et musculorum corporis humani" (1747)
Engraving.
Francis A. Countway Library of Medicine, Boston.

3.46 BERNARD ALBINUS (1697–1770)

Skeleton, Side View from "Tabula sceleti et musculorum corporis humani" (1747)

Engraving.
Francis A. Countway Library of Medicine, Boston.

3.47 BERNARD ALBINUS (1697–1770)
Skeleton, Back View from "Tabula sceleti et musculorum corporis humani" (1747)
Engraving.
Francis A. Countway Library of Medicine, Boston.

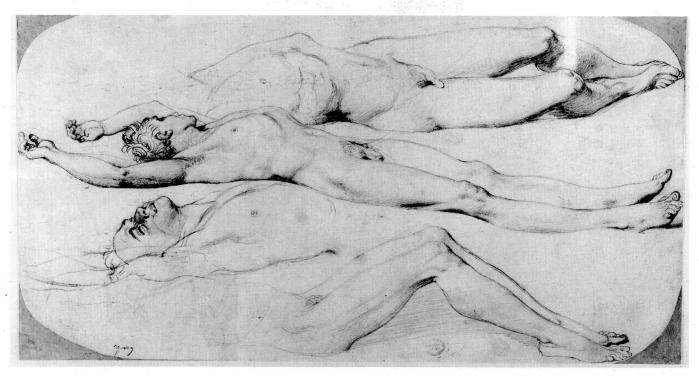

33.48 JEAN AUGUSTE DOMINIQUE INGRES, French (1780–1867) *Three Studies of a Male Nude* Lead pencil on paper, H: 7³/₄ in., W: 14³/₈ in. The Metropolitan Museum of Art, Rogers Fund, 1919. (19.125.2)

3.51 HYMAN BLOOM (1913–) Seated Figure (1976) Gouache, 18³/₄ × 16¹/₈ in. Courtesy of Terry Dintenfass, Inc. in association with Salander-O'Reilly Galleries, LLC, New York.

rhythms and tensions—that can enliven a drawing. Then, too, we should take into account the expressive power—the physiological drama—of the skeleton pressing and pulling on its encasing muscles, fat, and skin. That this anatomical tug of war can stimulate strong expressive meanings is especially evident in the drawings of Michelangelo (see Figs. 1.14, 2.36, and 3.20). A contemporary response to the skeleton's role in shaping surface form and expressive power is Bloom's *Seated Figure* (Fig. 3.51). Indeed, here the skeleton, whether sensed or seen, is one of the drawing's major themes.

Nadelman's structurally insistent *Head and Neck* (Fig. 3.52) is based on a sound knowledge of the forms of the skull. Hardly an accurate visual account of the skull's influence on the fleshed forms, the drawing does convey a strong architectural idea stimulated by the skull's structural character. But the same skeletal forms can suggest entirely different interpretations.

Although structurally powerful, the main thrust of Rothbein's woodcut *Angel of Death* (Fig. 3.53) is to-

ward an enigmatic but moving expression. The artist's knowledge of the skull's forms enables her to alter and order them in a way that creates a provocative image—one that is both skeletal and fleshed, tangible and ethereal, foreboding and compassionate.

Even in drawings where the anatomical factor plays a minor visual role, the knowledgeable artist is able to integrate skeletal facts with creative needs. In Golub's *Standing Figure*, *Back View* (Fig. 3.54), the drawing of the spinal column and sacral triangle not only helps explain the form of the figure's back but also intensifies the curved forward "rush" of the torso and contributes to the pattern and density of the drawing's linear design. And in Falk's quick sketch, *Reclining Figure* (Fig. 3.55), a knowledge of the skeleton helps this well-known actor and artist establish a complex arrangement of foreshortened forms *and* a system of bold diagonal thrusts.

Although in most drawings the skeleton is suggested but not shown as such, Lebrun's *Three-Penny Novel*, *Beggars into Dogs* (Fig. 3.56) makes the

3.52 ELIE NADELMAN (1882–1947) *Head and Neck* (ca. 1905–07)
Pen, black and brown inks on beige paper, H: 11¹/₈ in., W: 7¹/₂ in.
The Metropolitan Museum of Art, Gift of Lincoln Kirstein, 1965. (65.12.9).

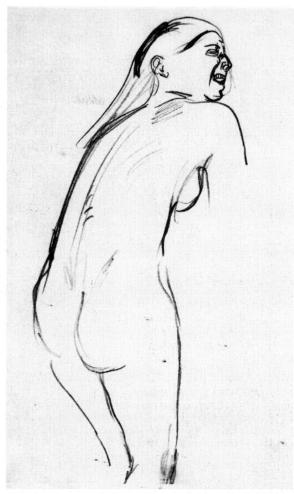

3.54 LEON GOLUB (1922–) Standing Figure, Back View
Pencil, 5³/4 × 9 3/8 in.
Courtesy of the artist.

3.55 PETER FALK (1927-) Reclining Figure
Black chalk, 18 × 24 in.
Courtesy of the artist.

3.56 RICO LEBRUN (1900–1964)

Three-Penny Novel, Beggars into Dogs (1961)

Black ink applied with pen on off-white illustration board. 37¹/4 × 29²/8 in.

Worcester Art Museum, Worcester, Massachusetts. Gift of Daniel Catton Rich in memory of Bertha James Rich. 1969.121.

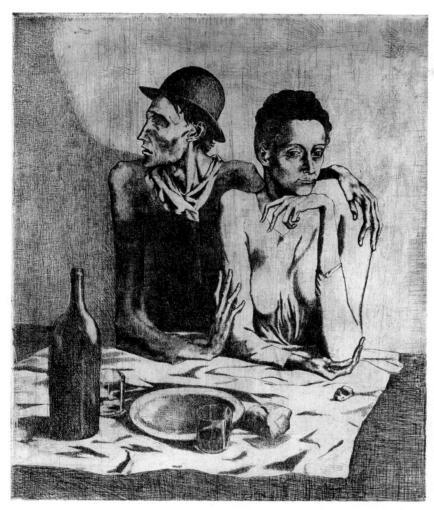

3.57 PABLO PICASSO (1881–1973)

The Frugal Repast (Le repas frugal) (1904)

Etching (zinc) plate, .463 × .377 (18¹/₄ × 14¹³/₁₆ in.).

Gift of Mr. and Mrs. Burton Tremaine, Photograph © 1998 Board of Trustees, National Gallery of Art, Washington, D.C. 1971.87.13/
© 1999 Estate of Pablo Picasso/Artists Rights Society (ARS), New York.

skeleton itself a part of the subject, as do the works by de Gheyn and Bloom (Figs. 3.1 and 3.51). Here, drawn in swift, delicate lines, femurs, tibias, scapulas, and other indefinable bones add to the drawing's quiet terror.

In Picasso's etching *The Frugal Repast* (Fig. 3.57), the skeleton's presence is felt throughout the drawing of both figures and sometimes appears in surprising clarity, as at the shoulders, arms, and hands. Note the shallow depression of the temporal bones in both heads, the lateral end of the clavicle in the man's right shoulder, and the lateral epicondyle at the elbow. Note, too, the bones of the wrists and hands of both figures. But Picasso's interest in the skeleton is not clinical, and these anatomical niceties are not in-

cluded merely for accuracy. Picasso's emphasis on the skeleton serves the interests of design and expression. As an agent of design, it enriches edges and forms with engaging linear and planar activities and, through the subtle distortions of skeletal facts, helps emphasize the squares and L-shapes formed by the torsos and arms. As an expressive agent, the skeletal presence, by stressing the figures' lean but strong and graceful bodies, seems to evoke the durability of humans in the face of mortality.

It is fitting to end this brief review of some ways that the skeleton may bolster and amplify the structure and meaning of figure drawing, or can serve as the subject itself, with Bageris's *Seated Skeleton I* (Fig. 3.58). In this engaging interpretation

3.58 JOHN BAGERIS (1924–) Seated Skeleton I Sepia and black ink, some gouache, 10×13 in. Collection of Mrs. Lucy Stone, Cambridge, MA. Courtesy of the artist.

of the skeleton, Bageris extracts powerful structural and dynamic meanings which, in drawings of the living forms, operate more subtly under the figure's fleshy cloak. But as this drawing demonstrates, a knowledge of the skeleton's masses can provide a rich source of intense dynamic energies. Although this drawing represents one artist's version of the skeleton's limitless potential for both suggesting and participating in structural and dynamic meanings, we can benefit from the artist's x-ray glimpse of forces at

work within the figure's bony armature. In drawing the figure, we need to penetrate the surfaces to experience the masses and movements that shape them from within. We may come away with a very different set of responses than the explosive ones in Bageris's drawing, but a sensitive awareness of the forms and forces below the surface—and the anatomical knowledge that enables us to make such a penetration—is necessary if we are to avoid the trite and the commonplace.

SUGGESTED EXERCISES

Clearly, the more we know about the skeleton, the more convincingly we can establish the figure's masses in space, utilize (as we saw in Chapter 2) the skeleton's role as an armature and influencer of surface forms, and benefit from its structural, relational, and expressive potential. To do this, we should make a serious study of the skeleton. Examining and making studies of illustrations and photographs of the skeleton, as in Figure 3.59, are extremely important. And because no single anatomy text can fully communicate the form and location of every bone (or muscle), the student

should own at least two good anatomy books and study others. But even the best anatomical illustrations cannot compare with the understanding provided by examining and drawing from the skeleton itself.

When the school or class cannot provide a skeleton for study, drawings can be made from specimens in museums of natural history or in local medical schools. Best of all, the student can purchase all or part of a skeleton from a medical supply house. This is not as difficult or expensive as it may seem. When necessary, several students can purchase a skeleton on a cooperative basis. In addition to authentic skeletons, today there are available very accurately detailed, life-size plastic skeletons or parts of skeletons. These, too, can be purchased from medical supply manufacturers or suppliers. All the photographs of the skeleton shown in this chapter were made from one of these replicas, in this case, a product of Medical Plastics Laboratory (see the Bibliography).

Almost as useful (and far less expensive) are small plastic skeletons. Generally about 18 in. high, the best of these allow for considerable mobility and are quite accurately scaled.

Because most anatomical illustrations of the skeleton are of the traditional standing front, back, and side view, one of the immediate advantages of drawing from the skeleton itself is the freedom to pose it in ways that enable you to study various foreshortened views of the bones, as in Figure 3.60. Equally important, the structural character of the bones and how they fit and relate to each other are more fully experienced than when they are studied in illustrations and photographs. Huntington's Skeleton Study (Fig. 3.61) is an example of the richness of form available in drawing directly from the skeleton. This drawing also suggests the degree of accuracy and development of masses you should aim for in your more extended anatomical studies. Although the wired skeleton is limited in its movements, and some bones in certain poses will not occupy their correct position, the importance of familiarizing yourself with the way the bones look from various angles more than compensates for these minor restrictions and inaccuracies.

Finally, the inexpensive plastic skulls available at some science museums, hobby shops, and art stores, despite their inferiority to those available from medical suppliers, are useful in studying the skull from various angles and as an armature for muscle studies made by applying "muscles" made of Plasticine®.

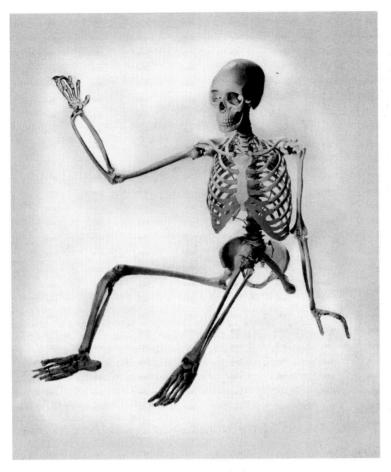

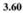

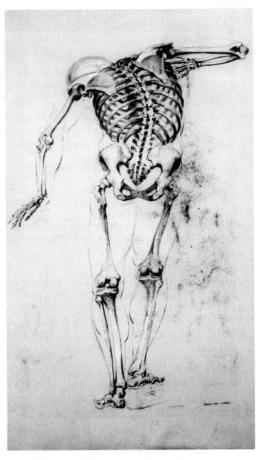

3.61 DANIEL HUNTINGTON (1816–1906) Skeleton Study (ca. 1848) Charcoal, crayon, and white chalk, $15^{1/8} \times 9^{3/4}$ in. Brooklyn Museum of Art. Gift of the Roebling Society. 68.167.3.

The following exercises suggest some ways of studying the skeleton. When necessary, they may be simplified to suit your drawing skills. Some of these exercises may suggest other ways of learning to understand the skeleton's forms and proportions and stimulate your interest in its creative possibilities. Do not hesitate to explore any approach to familiarizing yourself with the skeleton. The only wrong way to regard the skeleton is with a casual eye, born of the misconception that what is not actually visible on the figure's surface is less important than what can be seen by the naked eye.

In doing these exercises, use any erasable medium and any compatible drawing surface. Unless otherwise indicated, avoid making your drawing smaller than 10×14 in. or larger than 18×24 in. Very small drawings do not permit a comfortable handling of details in extended studies, and very large ones are more difficult to keep in proportion. And in most of these exercises, objective accuracy is an important consideration. Although none of these exercises is restricted by time, none can be usefully experienced in fewer than 45 min.; some may take you considerably

longer. Because your aim is to familiarize yourself with skeletal facts, you may wish to develop these exercises in several drafts on tracing paper. By placing a first draft under a fresh sheet of tracing paper, you can quickly redraw it, making corrections more easily than by extensive erasures on the same sheet. Furthermore, reversing the tracing paper to examine the drawing helps you quickly see errors in scale, shape, structure, and location.

- 1. Referring to a skeleton, to anatomy texts, or to the illustrations in this chapter, draw a 12-in. high detailed study of the skeleton as it would appear from the pose shown in Figure 3.62. Note the skeletal clues in the figure. Your drawing should approach the degree of precision in Figures 3.61 and 3.63.
- 2. Using a manikinlike system of simple forms such as those you devised for Exercise 6 in Chapter 2, lightly sketch one front and one back view of the side view pose shown in Figure 3.62. These drawings should be at least 12 in. high. If necessary, make a simple stick-figure model out of wire or pipe cleaners to help you es-

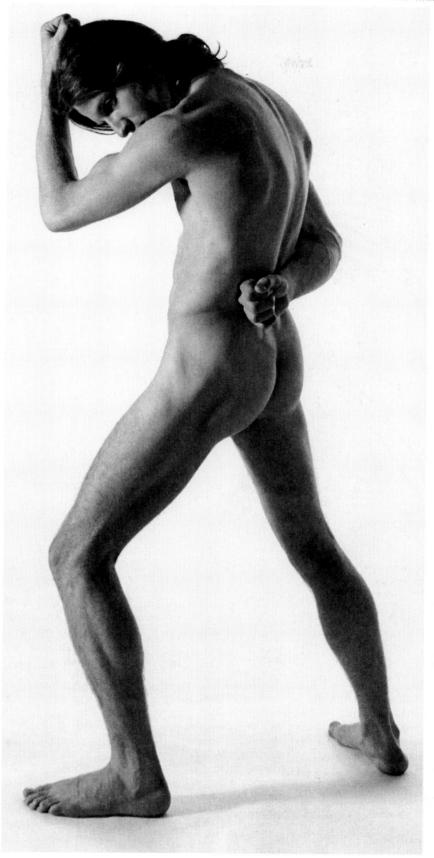

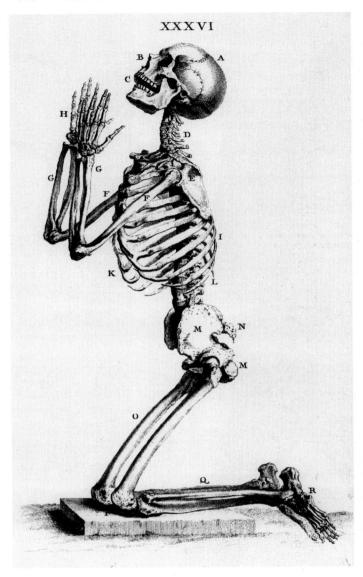

3,63 PLATE XXXVI from Cheselden's "Osteographia" or "The Anatomy of the Bones"
Francis A. Countway Library of Medicine, Boston.

tablish the two views. Or if working in a studio classroom, have the model take the pose in Figure 3.62 long
enough to allow you to rough in the essentials of the required two views. Next (working on a tracing paper
overlay would be useful here), draw the skeleton as it
would appear in the two views, allowing your schematic
underdrawing to guide you in establishing the foreshortening of various bones, their scale, and their placement.
Make these drawings rather generalized and simplified.
For example, the rib cage need not be drawn rib by rib,
but it should suggest its egglike mass and perhaps something of the straplike nature of some of the ribs.

3. Rework or redraw several of your figure drawings (or draw any of the photos of the figure in Chapter 8), thinning down the forms to exaggerate the skeleton's influence on the surface forms. The results should suggest emaciated figures.

- **4.** Using the skeleton or any other visual reference material to assist you, draw either a three-quarter view, an overhead view, or a worm's eye view of any of the Albinus skeletons (Figs. 3.45, 3.46, and 3.47).
- 5. Working from the skeleton itself or any of its representations in this chapter, draw any standing view of the skeleton as it would appear if wrapped in a thin, semitransparent, "togalike" material that clings to the forms. Show the material stretched taut in some places and loosely draped in others. The entire skeleton need not be covered, and the material may wrap around some forms several times, thickening them.
- **6.** Working from the skeleton itself, make the following series of carefully observed drawings:
 - a. Several studies of different views of the skull.
 - b. Several studies of different views of the shoulder

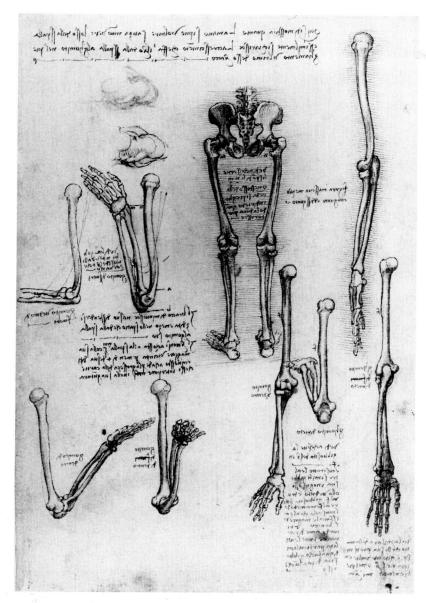

3.64 LEONARDO DA VINCI (1452–1519) *The Extremities*

Pen and ink, $11^{3}/8 \times 7^{3}/4$ in.

The Royal Collection © Her Majesty Queen Elizabeth II.

girdle. Be sure to include a view that looks down on the shoulder girdle. In the study of the back view, include the entire scapula.

- **c.** Several studies of the bones of the torso, including at least one foreshortened view.
- **d.** Several studies of the bones of the arm and hand. In at least one of these drawings, the lower arm and hand should be pronated (Fig. 3.64).
- e. Several studies of the bones of the leg and foot, showing the pelvis in at least one of these (Fig.
- 3.64). One of the studies should show the leg bent at the knee.
- 7. Using Figures 3.65 and 3.66 as models and any water-based medium in combination with your pencil or chalk, make a drawing of each pose in which you extract strong structural and dynamic ideas and energies, as Bloom and Bageris have done in Figures 3.51 and 3.58 (see also Bageris's Seated Skeleton II, Fig. 7.12). Do not hesitate to alter, omit, or add anything that will

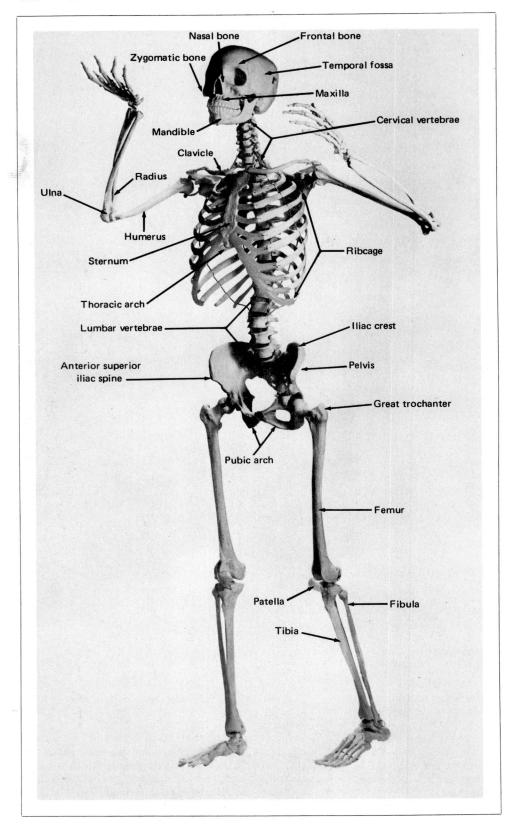

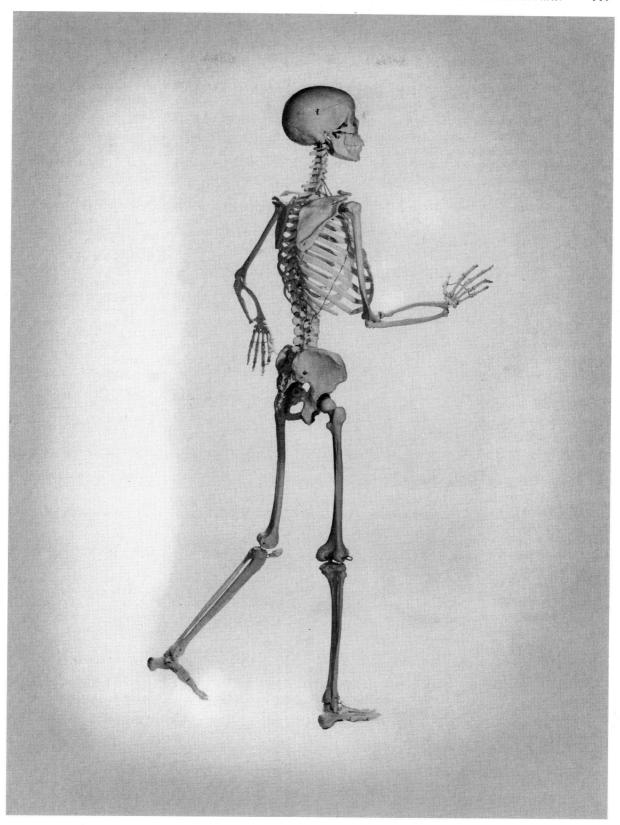

- help make your drawings intensely personal responses to the subjects. Because these drawings should mirror *your* reactions to the two poses, the Bloom and Bageris drawings should be regarded more as examples of the creative freedom possible than as goals to emulate.
- 8. Make a line drawing in a broad and free manner of four or five skeletons dancing, leaping, or floating around the page. Simplify the forms as much as you wish. The point is to experience the gesture and design possibilities of the skeletal forms. Allow skeletons to overlap or interpenetrate, as if they were transparent. Contours may be simplified into straight and curved segments or can exaggerate the ins and outs of a form's edge. Try to create interesting rhythms and shapes. Do so not by arbitrarily distorting the bones but by permitting gesture responses to influence your general handling and style of drawing. These drawings may be more two- than three-dimensional in conception, or they may allude to solid masses by modeling the forms with hatched lines.
- 9. Invent a skeleton that is related to our human one but differs from it in proportion and, to some slight extent, in design. You can think of your drawing as a representation of the skeleton of a prehuman "missing link" or as some humanlike skeletal system of an inhabitant of another planet. Insist on making each bone so structurally clear that a sculptor could construct this skeleton using your drawing as a guide.

- 10. Using a skeleton you invented in the previous exercise as a model, redraw it in an action pose that produces some markedly foreshortened forms. Suggest what the figure might look like in the life state by giving it a lean cover of skin. Without the musculature and fat to help support and shape this skin, it will, of course, behave much as tight-fitting clothing would if draped on a human skeleton. Again, insist on volumetric clarity, modeling the forms in any manner that will make them convincingly three-dimensional.
- 11. Working from the live model or from any of the photographs of the figure in this book, make a line drawing as accurately as you can. Next, draw the skeleton as it would appear from the view of the figure you have drawn. The skeleton can be drawn directly on your line drawing of the figure or on a tracing paper overlay. This drawing of the skeleton can be generally stated.
- 12. Draw a skeletonlike figure intended as an illustration for a magazine article on famine. Anatomical accuracy may be subordinated to an imaginative image that expresses the article's dire theme. Forms may be unfocused, fragmented, or distorted to the point of abstraction.
- 13. Using as your model any of the photographs of the entire skeleton that appear in this chapter, make a drawing that shows another view of the pose selected. For example, Figure 3.65 can be drawn as you would imagine it to look from a front or a side view.

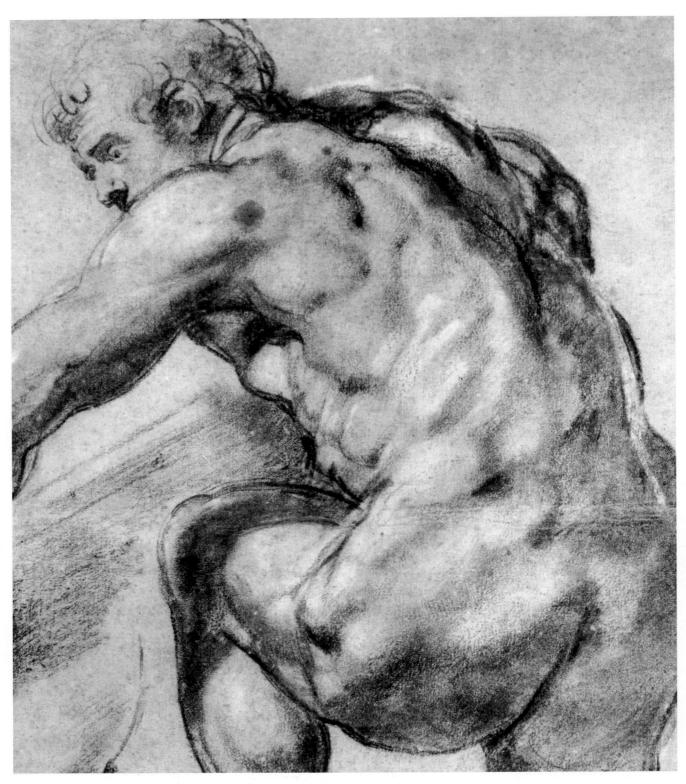

4.1 PETER PAUL RUBENS (1577–1640)

A Nude Man Kneeling (detail)
Black and white chalk, 20¹/4 × 15¹/2 in.

Museum Boijmans Van Beuningen, Rotterdam. Photo by A. Frequin.

The Anatomical Factor

Part Two: The Muscles

SOME GENERAL OBSERVATIONS

In this chapter, we will examine those muscles most influential in shaping the figure's living forms and consider their morphological role—how the muscles affect the body's surfaces. We will also explore how the muscles may serve as agents that stimulate visual inventions concerning structure, design, and expression.

In this anatomical survey, visualizations carry the main burden of communication. Although important features concerning attachments and surface effects are described, the overall arrangement and character of the muscles are best studied through the anatomy illustrations and the reproduced drawings, photographs, and sculptures.

One of the more distressing errors in the drawings of some beginners shows the head, neck, and limbs as only tenuously attached to the trunk. Similarly, the upper and lower parts of a limb are drawn as if each part ended before the next began. This tendency toward what may be called the "sausage-link syndrome" probably stems from the assumption that because the figure's forms are thinnest at the joints and appear most swelled between them, and as the segments must be free to bend, each segment must therefore be self-contained, its muscles terminating short of the joint. But if this were true, the body

would be immobilized. It is only by muscles crossing over joints to attach to bones on the other side that mobility is possible. Muscles attach to bone or other tissues by *tendons*—tough, nonelastic tissues located at the ends of the long muscles and at the edges of broad ones. Muscles function as levers in moving bones by acting across the joints, which in turn act as points of support (Fig. 4.2).

Although the figure's fleshy forms do taper at the joints, it is not the result of a bundle of muscles ending where another one begins, but of muscles thinning down to cords and sheets of tendon that often interlace with other muscles as they move across joints in both directions. Instead of sausage-link attachments, the head, neck, and limbs are deeply embedded in the torso by muscles and tendons woven far beyond the apparent end of any single part. Thus, throughout the body, most of the muscles appear braided in various ways. Something of the interlaced nature of the figure's muscles and the deep embedding of the limbs can be seen in Figure 4.1.

Muscles work by contracting their fleshy fibers, or *bodies*. In contraction, the muscle body is drawn together, growing shorter and thicker. To do this, one attachment of the ends of a muscle must be fixed; the other must be movable. A muscle's *origin* is the point of fixed attachment; its *insertion* is the movable point of attachment. In Figure 4.2, the muscle's upper at-

tachment is the origin because it pulls the lower form toward the upper one. Figure 4.2 shows another important feature of muscle movements. No muscle acts alone. Whenever a muscle or group of muscles contracts, other *opposing* muscles are activated to modify or regulate the action of the contracting ones.

This arrangement of muscles in opposition to each other is a necessary anatomical condition, allowing not only for fine-tuned regulation of actions but also for the controlled return of parts after their movement. For example, in the lower arm, the *flexor* muscles bring the fingers together in a fist, the *extensor* muscles extend the fingers, and the *supinator* muscles enable the lower arm and hand to rotate. But all these muscles are engaged in each of these actions, either in contracting or relaxing functions. Additionally, these three muscle groups, working in complicated harmony, permit the many other combinations of movements of the lower arm and hand.

In general, then, for any bodily movement to occur, some muscles must work by contraction while other muscles, related to the function of the moving part, are to some degree relaxed. This is the case whether it is the bending of a finger or of the torso. Knowing which muscles are at work in a pose and which are relaxed can help us decide which surface forms to emphasize. Normally, artists more strongly indicate (and even exaggerate) those muscles actively engaged in producing an action and modify muscles that are relaxed. To give equal attention to every muscle (unless for purposes of study) can actually reduce the viewer's understanding of the gestural nature of a pose and can result in a drawing that, in Leonardo da

Vinci's words, will look "more like a bag of nuts than a human figure." ¹

We can better understand the behavior and form of many of the figure's muscles (and bones) by testing their function in our own bodies. Where feasible, try to isolate and operate the muscles discussed in the following sections. The advantages, for study, of a little privacy and a full-length mirror are obvious.

MUSCLES OF THE HEAD

While the skull, as we saw in Chapter 3, is an everpresent influence on the surface forms of the head, the muscles of the head play a less important role. Most of the facial muscles are small, thin, or deeply embedded in fatty tissue; likewise, the thin muscles of the cranium have little effect on the fleshed forms. But some of the muscles shown in Figures 4.3 and 4.4 do affect contours or surface conditions and warrant special attention.

The *masseter*, from its origin at the underside of the zygomatic arch to its insertion at the angle of the mandible, is one of the most visible muscles of the head, accounting for the obliquely turned bulge running from the corner of the jaw to the cheekbone in the front view.

The fan-shaped temporalis, along with the masseter, operates the closing and biting movements of

¹ Leonardo da Vinci, *The Treatise on Painting*, trans. A. Philip McMahon (Princeton, N.J.: Princeton University Press, 1956), vol. 1, p. 125.

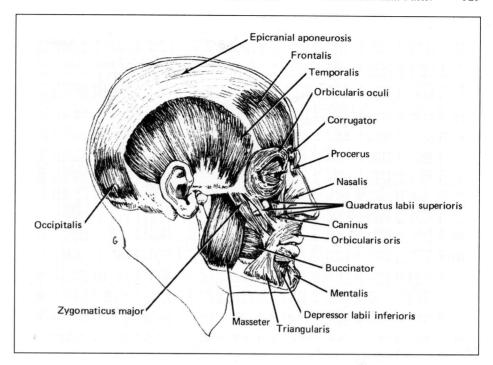

the mandible. The temporalis originates and largely fills the recessed plateau of the temporal fossa, passing under the zygomatic arch to insert into the coronoid process, the forward prong of the mandible (see Fig. 3.6). Less visible than the masseter, the temporalis nevertheless influences the surface form of the temple as Figure 4.4 shows.

The *frontalis*, a flat, broad muscle divided vertically, is of interest because it wrinkles the brow horizontally and lifts the eyebrows. Although its form contributes little to the contour of the forehead, its upper, curved origin, high on the frontal zone, often shows if the hairline is high enough. The frontalis inserts into the skin of the brow and nose (Fig. 4.4).

The *corrugator*, originating at the medial end of the superciliary arch and inserting into the skin at the eyebrows, is a small muscle that strongly affects the surface of the forehead in frowning expressions. It forces the vertical wrinkles of the brow and causes the eyebrows to bunch up near the nose (Figs. 4.4 and 4.5).

Encircling the mouth is an elliptical muscle, the *orbicularis oris*, which has the unique distinction of having no bony points of attachment. Instead, it originates among some nine small muscles around the mouth, most of which are aimed at the mouth, and inserts into the skin surrounding the lips. Contractions of this muscle produce all the closing, pursing actions of the mouth (Fig. 4.5). Repeated contractions account for the permanent radiating creases often seen

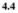

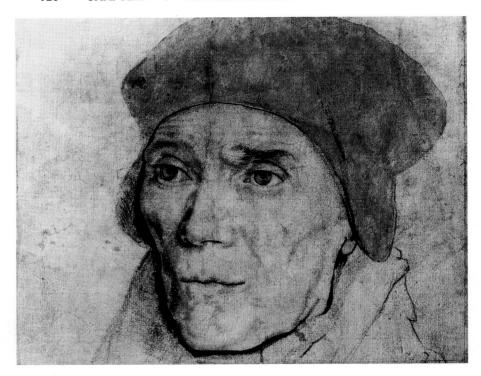

4.5 HANS HOLBEIN the Younger (1497–1543)
Cardinal John Fisher
Red and black chalk, brown ink, washes, pen and India ink on primed paper.
The Royal Collection
© Her Majesty Queen Elizabeth II.

in the elderly. The *orbicularis oculi* is also a circular muscle that encompasses the eye and operates the opening and closing of the eyelids. Here again, radiating creases, the familiar crow's feet, testify to its encircling contractions (Fig. 4.5).

Originating from the zygomatic arch and inserting into the corner of the mouth, the zygomaticus major provides an important oblique line of abutment between the planes of the side and front of the face, as can be seen in Figures 3.10 and 4.5. Note in the latter the effects of the frontalis and corrugator muscles and Holbein's allusions to bone and muscle throughout the head.

SURFACE FORMS OF THE HEAD

The forehead consists of the area represented by the frontal bone and closely corresponds to its form. In planar terms, the forehead can be divided into a broad, bulging center plane, often sloping somewhat backward, and a smaller plane near each temple which abuts the center plane at a point about one third in from the outer edge of the eyebrows. The eyeball is deeply set into the orbital cavity, the eyelids acting as upper and lower "awnings." Because most light sources are located above us, the upper eyelid usually casts a shadow on the upper part of the eyeball. The upper lid, the larger and more clearly defined of the

two, is the more mobile. When the eyes are shut, the upper lid covers most of the visible eyeball. The eyelids closely follow the curve of the eyeball, the upper lid appearing to overlap the lower one at the outer corner of the eye. In the front view, the crest of the curved lower margin of the upper lid is close to the nose; in the lower lid, the crest of the curve is away from the nose (Fig. 4.6a). In the side view, the eyelids align on an angle dropping backward (b). Like the forehead, the eyelids can be reduced to three planes each (c). In the front view, the eyes are located almost one eye length apart (d). A line drawn downward from the inner corner of the eye will strike the outer edge or outer portion of the nostril (d).

The nose, wedgelike and projecting at an inclined angle from the general plane of the face, can be reduced to four major planes. The central plane (bridge of the nose) often widens at the junction of the nasal bone and the *lateral cartilage* and again at the bulb of the nose. Two side planes are inclined obliquely downward from the left and right edges of the central plane. The plane of the base of the nose, free of the plane of the face, may be horizontal or show a slight upward or downward tilt and is roughly triangular in shape. The nostrils are located nearer to the edges of the triangle than to its midline (Fig. 4.7a).

The medial partition separating the nostrils, the *septum*, represents the lowest point of the nose in both the front and side views. The nostrils curve upward

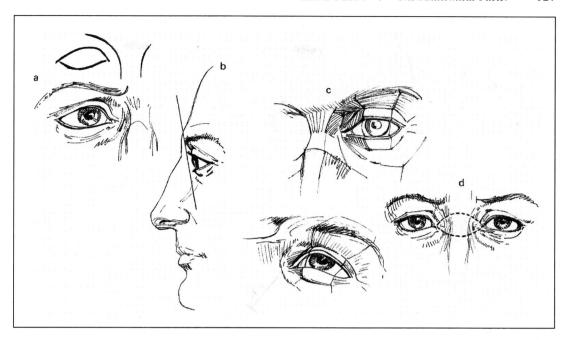

at an angle, in providing the smaller, beveled planes of the end of the nose, and modify the general plane of the base (Fig. 4.7b). Both the bulb of the nose and the nostrils may be either rounded or angular, reflecting the character of the cartilage underlying these forms. Sometimes a central groove is visible at the tip of the nose, marking the junction of the two *alar cartilages* which shape the end of the nose and part of the nostril openings. In the side view, a change in profile is most likely at the junction of the nasal bone and lateral cartilage and again at the bulb of the nose (Fig. 4.7c).

The ear (Fig. 4.8) is located behind the upper angle of the mandible and is vertically centered on the zygomatic arch. In a side view of the head, the ear is roughly aligned between the eyebrow and the base of the nose. Ovoid in shape, its major features are the concha, the hollow in the lower half of the ear; the helix, the rolled outer edge of the ear; the antihelix, the Y-shaped inner curved form that is parallel with the helix near the bottom of the ear but turns away from it as the two forms rise; the tragus and antitragus, the two facing "bumps" near the bottom of the concha; and the lobe, which may vary from a barely rounded form to a pronounced pendant. The shape of the ear varies greatly, but generally the helix emerges near the antitragus and above the earlobe. The helix describes a simple C-curve and turns sharply inward to the upper end of the concha, about halfway down the ear. Seen from the front, the upper half of the ear is turned slightly downward toward the concha, the lower half is turned upward, and the antihelix obscures part of the helix.

The lips (Fig. 4.9), centered horizontally on the midline of the head, occupy a position a little nearer to the nose than to the chin. Usually, the upper lip is slightly more forward than the lower and is characterized by the *tubercle*, the swelled central portion, and the two slightly curled wings. Together, these three segments often form a widely spread M-shaped form. When closed, the lips are in contact at every point, making one lip appear thin where the other is thick. The lower lip often forms a widely spread W-shaped line where it meets the upper lip but may also appear as a simple curved form. When viewed from above, the overall curve of the lips on the curved surface of the face becomes apparent.

There are three areas that are not actually part of the lips but are important considerations in modeling them: the small fleshy mounds near the corners of the mouth; the *philtrum*, or groove below the nose, whose oblique margins strike the two peaks of the upper lip; and the furrow under the lower lip, which in some individuals may be a pronounced oblique plane that softens as it broadens to either side of the mouth, enveloping a large part of the lower portion of the face. This can be seen in Abeles's *After Her Eye Operation* (Fig. 4.10), where only the lower end of the mandible protrudes through the otherwise darkened curving plane beneath and to either side of the mouth. Abeles's knowledgeable drawing of the head also illustrates another useful relationship: In almost every

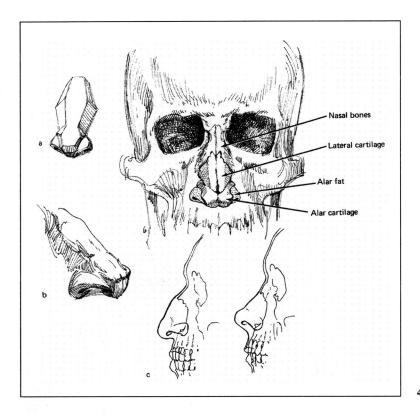

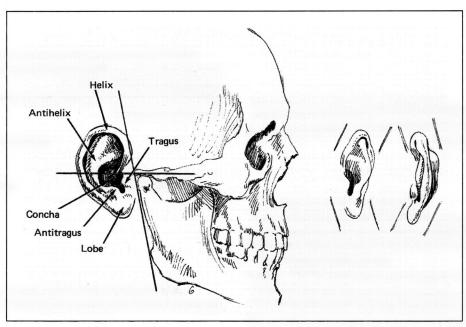

4.8

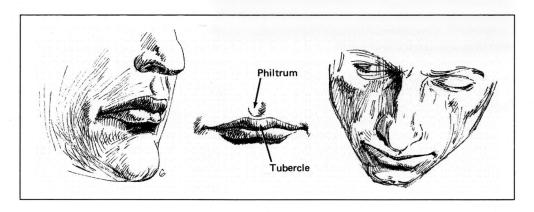

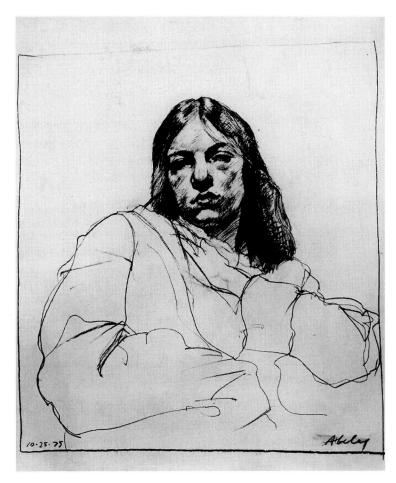

4.10 SIGMUND ABELES (1934—) *After Her Eye Operation*Charcoal and pencil, 22 × 30 in.
Collection of Paul M. Maguire, Portland, Oregon.

individual, the corners of the mouth are located where a line drawn upward toward the eyes would strike their centers.

A careful study of the Abeles drawing shows that the artist is well aware of the surface anatomy of the features just discussed *and of the areas separating them.* Notice, for example, how convincingly he defines the foreshortened plane of the underside of the chin and how deftly he establishes he abutment of the central plane of the nose with the curved plane of the forehead.

Watteau, in his Two Studies of the Head of a Young Woman (Fig. 4.11), demonstrates a masterful grasp of the forms of the head, here expressed with an impressive economy and grace. Note how the skull's presence is delicately suggested, how simply the lips and ears are stated, and how clearly, in the head on the right, the side planes of the nose are drawn. And as in Figure 4.10, we know a great deal about the form of those passages that separate the eyes, ears, nose, and mouth.

When drawing the head, the beginner too often concentrates almost exclusively on the features just described, leaving the terrain between them largely unregarded. The results often show modeled features floating on a flat enclosure representing the shape, but not the structural nature, of the head. A far better attitude toward the forms of the head is to recognize that every part is an important feature, a unit of form that interjoins others, usually in a quite harmonious way. In most faces, as you can readily observe, the creases in the forehead "imitate" the eyebrows, the curved eyebrows "anticipate" the nose, the folds in the skin near the nostrils spread out to "measure" the mouth, the fleshy mounds at the corners of the mouth "parenthesize" it. This rhythmic play, so pronounced between the form units of the head, is found to varying degrees throughout the figure.

Although the areas of the cheek, temple, chin, and forehead do not offer boundaries and masses as clearly defined as, say, those of the nose or mouth, it is important to appreciate the skull's influence in these large areas and to regard them with the same attention we give to the smaller features. Because fatty deposits, sometimes considerable, are often the dominant factor in forming the terrain of the cheek and chin, the surface terrain in these areas may vary

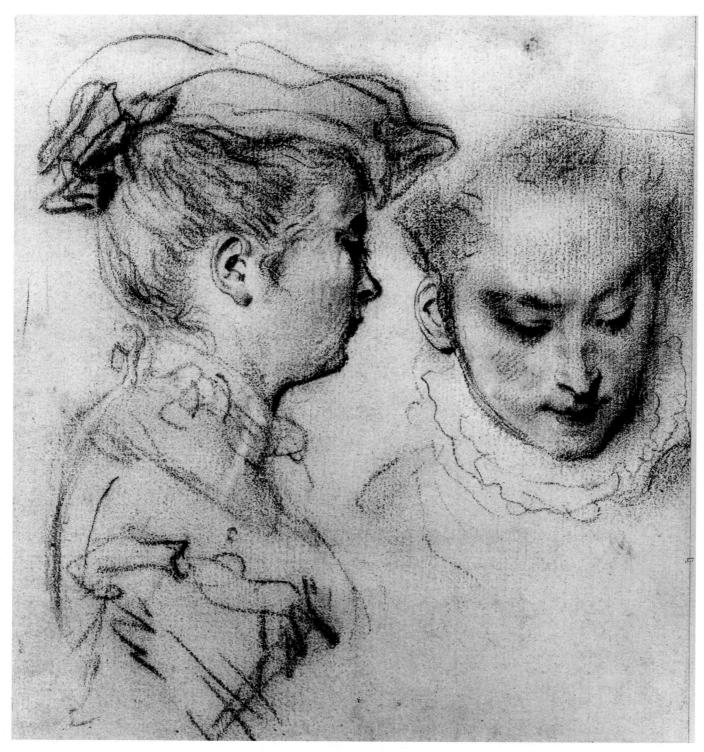

4.11 ANTOINE WATTEAU (1684–1721) *Two Studies of the Head of a Young Woman* Red and black chalk, $6^3/4 \times 6^1/8$ in. © The British Museum.

4.12 JOHN SINGLETON COPLEY (1738–1815)
Henry Earl of Bathurst (Study for "The Death of the Earl of Chatham") (1779–1781)
Black and white chalk on blue paper, 26 × 19¹/2 in.
M. and M. Karolik Collection. Courtesy, Museum of Fine Arts, Boston. 41.683.

widely. Nevertheless, in the cheek, the zygomatic bone and arch and even the canine fossa are often visible, even in heavily padded faces. And despite the familiar double chin and jowls in some corpulent figures, traces of the mandible's angularities are never altogether obscured (Fig. 4.12).

MUSCLES OF THE NECK

In the anterior (front) view (Figs. 4.13 and 4.14), the contours of the neck are formed by the *sternomastoids*. They originate at the sternum and inner end of the clavicle, sweeping gracefully upward to insert into the mastoid process of the temporal bone. The fullness of the longer *sternal* body contrasts with the straplike *clavicular* branch. The sternomastoids oppose each other in turning the head left or right, but they act in unison to raise and lower the head. Their tendonous attachments at the pit of the throat are always visible, even in necks otherwise devoid of mus-

cular detail. The entire muscle becomes boldly evident when the head is turned far to one side, as in Figure 4.15.

In the front view, the *trapezius*, a muscle of the back, provides the triangular wedge that fills in the area between the contour of the neck and the clavicles, into which it makes one of its several insertions (Figs. 4.13, 4.14, and 4.15).

Between the sternomastoids is an inverted triangular area, its apex at the pit of the throat and its base abutting the base of the plane of the underside of the chin (Figs. 4.16 and 4.17). Most of the space between the sternomastoids is filled by the swallowing apparatus and by the larynx, whose lower part is formed by the ring-shaped *cricoid cartilage* (Fig. 4.17). The U-shaped *hyoid bone* is located at the common baseline between the aforementioned triangular area and the plane of the underside of the chin. Directly below the hyoid bone is the *thyroid cartilage*, its protrusion forming the familiar Adam's apple (Figs. 4.17 and 4.18).

4.13

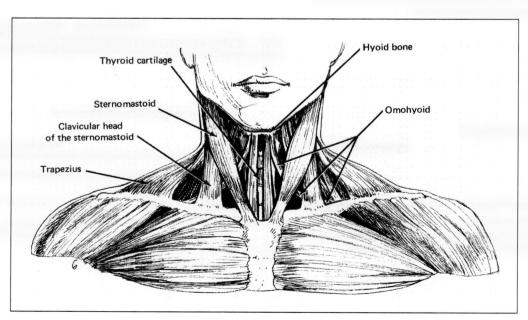

In the side view (Figs. 4.16 and 4.18), the contours of the neck are formed by the trapezius on the posterior side and, in the anterior view, by the larynx, the sternomastoid, and the *sternohyoid*, a muscle that depresses and hyoid and larynx. The space between the trapezius and sternomastoid is filled by three muscles, somewhat recessed and thus not often visible. They are the *scalenus*, the *splenius*, and the *levator scapulae* (Fig. 4.18). The scalenus and splenius act in movements of the head; the levator scapulae raise the scapula. Note that the scalenus is rather vertically placed, but the other two muscles are decidedly oblique. Emerging from under the forward edge of the

sternomastoid are several muscles of only passing interest to the artist. The *omohyoid* is of importance as the only muscle to intrude on the triangular hollow between the trapezius and sternomastoid (Figs. 4.13 and 4.14) and for its occasional appearance behind the sternohyoid. This muscle is itself visible when the chin is thrust forward and, usually in the elderly, where the sternohyoids appear as curved cords that run from the underside of the chin toward the pit of the throat, as in Figure 5.19.

Viewed from the back, the contours of the neck are again formed by the sternomastoids, the lines of the trapezius cutting diagonally across them, making

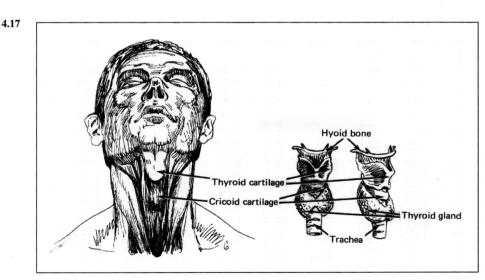

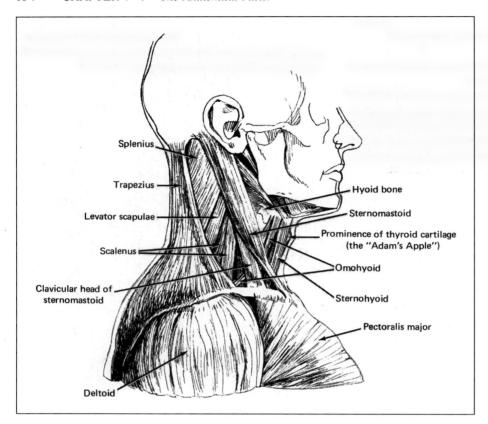

the neck appear shorter. In contrast to the pronounced surface activity often found in front and side views of the neck, the back view tends to be simpler, the neck's cylindrical form more evident.

It is important to remind ourselves that our examination of specific anatomical facts should mainly serve to broaden creative freedom, not restrict it. At first glance, Michelangelo's drawing in the detail from *Studies for the Crucified Haman* (Fig. 4.19) appears flawlessly accurate, but a closer inspection shows that the artist has somewhat changed the scale and position of muscles in the neck and chest. Indeed, the muscular definition throughout this figure and in all of Michelangelo's figure drawings, more typical of the leaner, *ectomorphic* type, is unlikely in the massively proportioned figures favored by the artist. Michelangelo seems always to give his figures the anatomical definition of lean, muscular types and the proportional heft of the athletic, *mesomorphic* types.

MUSCLES OF THE TORSO

In the front view (Figs. 4.20, 4.21, and 4.22), the clavicles can be seen as firm bars of attachment for the muscles of the neck, shoulder, and chest, gracefully

springing from them in all directions. The clavicle's superior (upper) surface receives the trapezius and sternomastoid muscles; its outer (lateral) inferior (lower) surface holds the deltoid, the powerful encasing muscle of the shoulder; and on the medial underside of the clavicle, the pectoralis major, the great muscle of the breast, completes the clavicle's muscular encirclement. The pectoralis major, in addition to its origin on the inferior surface of the clavicle, also emerges from the anterior of the sternum and from the costal cartilage below it. Thus, its origins roughly describe three sides of a square. Its insertion into the upper part of the humerus, instead of providing the fourth side of the square, draws the upper and lower boundaries of the muscle together to a point at the armpit, creating the impression of a triangle (Fig. 4.21). The muscle twists at its narrowest point, just before inserting into the anterior surface of the humerus. As a result, its lower fibers attach at a higher point on the humerus than do the higher fibers, giving the muscle bundles of the pectoralis major a fanlike radiating pattern.

These bundles of muscle fiber, also characteristic of the deltoid, give both of these prominent muscles a rich surface character (Figs. 4.13 and 4.16). Like the pectoralis muscle, the deltoid, from its origin at

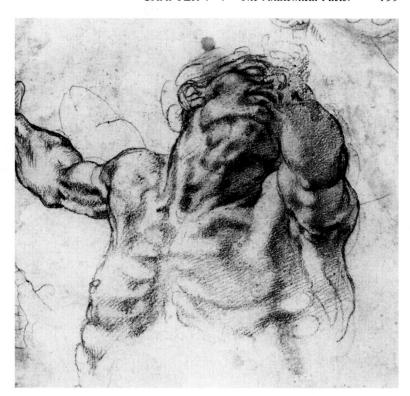

4.19 MICHELANGELO BUONARROTI (1475–1564)

Studies for the Crucified Haman

Black chalk, 13 × 8⁷/8 in.

Teylers Museum, Haarlem.

the clavicle to its insertion almost halfway down the humerus, is somewhat fanlike in character.

The mammary gland occupies the lower, outer corner of the pectoralis major in both the male and female figure. In the male, there is a general angularity to the entire muscle, the glandular and fatty tissues of the mammary gland only subtly softening the area of the breast (Figs. 4.19 and 4.22).

In the female, the fuller breasts descend below the bottom margin of the pectoralis major. The form of the breast begins at the xiphoid process, but its influence can be seen as far up as the base of the manubrium. The breast is fullest at the lower, outer side (Fig. 4.23). In the front view, the nipples are decidedly to the outside of center. Only when one breast is in profile will the nipple on the opposite breast appear centrally positioned (Fig. 4.56).

Below the pectoral muscle, the torso's front view contour is taken up by the *latissimus dorsi*. Actually a large muscle enveloping the back, its thickened forward edge is visible in the front view only. This muscle contributes to the V-shape of well-developed torsos, especially when the arms are raised (Figs. 4.24 and 4.25).

Slipping out from under the latissimus dorsi are four or five small fleshy pads, or *digitations*, of the *serratus magnus*. These fleshy pads are interlaced by

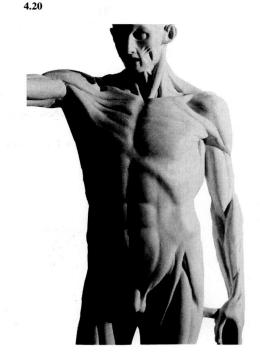

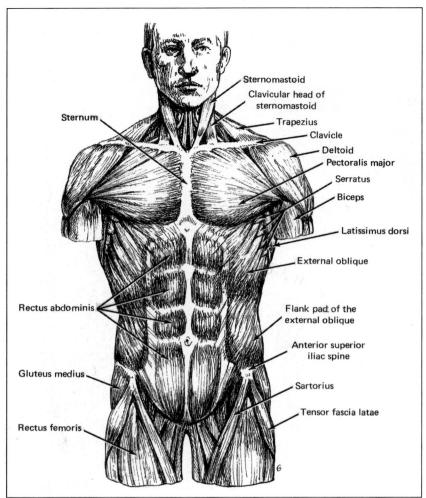

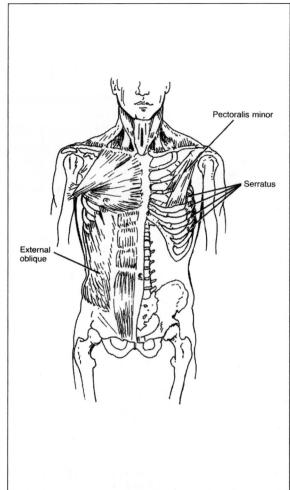

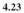

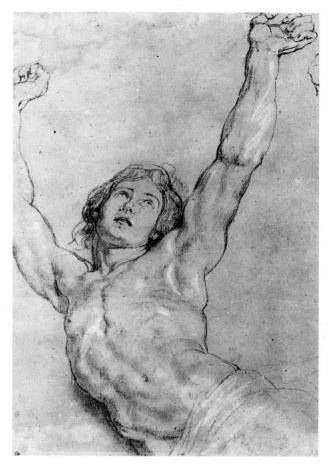

4.24 PETER PAUL RUBENS, Flemish (1577–1640) *A Study for the Figure of Christ* (ca. 1609–10) Black chalk and charcoal, white chalk, on buff antique laid paper, 40×29.8 cm. actual. Courtesy of the Fogg Art Museum, Harvard University Art Museums. Gift of Meta and Paul J. Sachs 1949.3.

thin digitations of the *external oblique*, a muscle that fills much of the area between the abdominal cavity and the latissimus dorsi. The external oblique continues the front-view contour of the torso, dropping backward from its high point near the thoracic arch until it reaches the waist. It then turns somewhat outward below the waist. A thin muscle, the external oblique thickens markedly near its termination at the iliac crest. This thickened, fleshy mound at the root of the thigh, much favored by Greek and Roman sculptors, is called the *flank pad* of the external oblique (Figs. 4.21, 4.25, 4.26, 4.27, and 4.28).

The *rectus abdominus* muscle fills the surface area of the abdominal cavity (Figs. 4.21 and 4.27). It is divided vertically by tendons into two rows of four fleshy pads, themselves separated horizontally by ten-

dons. These tendonous borders separating each horizontal pair of muscle pads appear more like chevrons as they ascend. Note that the lowest group is twice the length of any of the rest. The abdominal group originates at the crest of the pubic bone and inserts into the cartilage straps of the fifth, sixth, and seventh ribs. This group of muscles bends the spine forward, constricts the abdomen, and elevates the pelvis.

In Figure 4.28, three scapular muscles come into view: the *infraspinatus*, in a line with the top of the deltoid; the *teres minor*, in the center; and the *teres major*, at the bottom of the group. All three muscles originate on the scapula and insert into the greater tuberosity of the humerus or high on its shaft. These muscles lengthen considerably when the arm is extended forward or raised high, even appearing in the

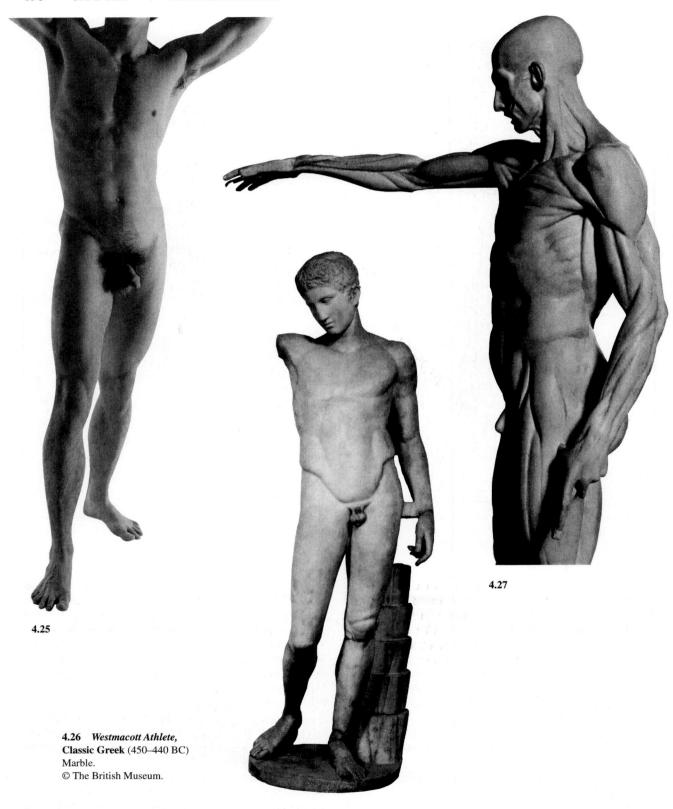

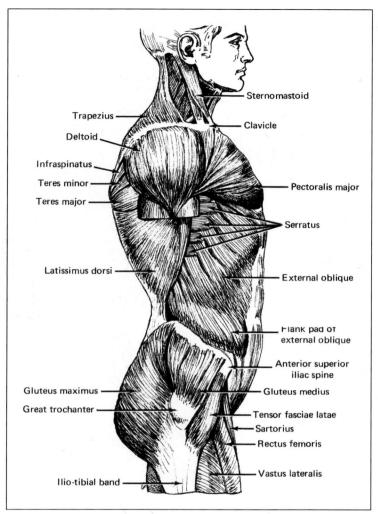

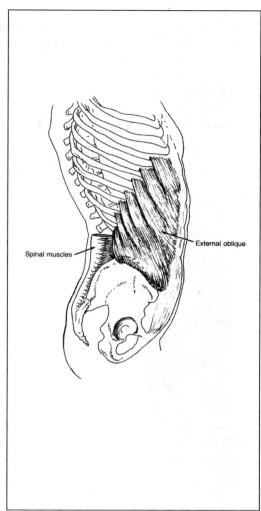

4.28

front view (Fig. 4.25). In Michelangelo's *Study for a Christ on the Cross* (Fig. 4.29), the teres major is visible on the central figure's left side as a pronounced swelling behind the armpit. In this informing study, notice the flank pads and the sternal attachments of the pectoral muscle on the central figure and the latissimus dorsi and digitations on the serratus magnus and external oblique in the side view. As this drawing demonstrates, when the arms are raised, the clavicles are almost entirely hidden. This can also be seen in Figure 4.25.

The three-quarter view of the torso in Figure 4.30 gives us a better visual idea of the front and side views discussed so far. Notice that the ribs and costal cartilage that form the thoracic arch are still much in evidence, even in a well-muscled figure. These bony landmarks are also in evidence in Figure 4.24.

In the posterior view of the torso (Figs. 4.31 and 4.32), the trapezius appears as a four-pointed geometric shape. The long lower segment aims downward where it terminates at the last three thoracic vertebrae; the topmost segment appears driven into the occipital bone; and the two side segments reach to the acromion processes of the scapulas. These scapular attachments and the clavicular attachments seen in the front view are the places of insertion of this large muscle. The trapezius, involved in movements of the scapulas and the head, originates at the occipital bone and among all the spinous processes up to the last thoracic vertebra.

An important characteristic of the trapezius affecting the figure's surface form is its several tendonous areas. The largest is a spearhead-shaped tendonous plateau that reaches to the occipital bone above and

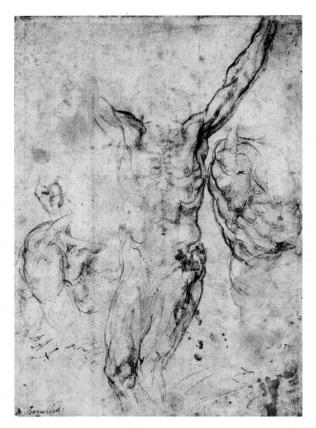

4.29 MICHELANGELO BUONARROTI (1475–1564) Study for a Christ on the Cross Black chalk, $12^{1/2} \times 8^{3/4}$ in. Teylers Museum, Haarlem.

ends at the second or third thoracic vertebra. The seventh cervical vertebra, the last outpost of the skeleton of the neck, is located at the center of this plateau. Two smaller but important tendonous areas related to the trapezius separate this muscle from the deltoids and cover the scapulas' spines. In poses where the arms are placed behind the torso, as in Figure 4.33, the hills of muscle can be seen descending to the vallevs of tendon, even though the tendon in these areas covers the protruding spines of the scapulas. When the arms are placed in front of the torso, the general mass of the scapula asserts itself, as we see in the right arm in Figure 4.34. When, as in these two examples, the arm is raised high, the scapula's movement toward the figure's side tends to obscure the scapula somewhat, whether the arm is before or behind the

figure. But when the arm is held low, the scapula's form becomes easier to see. Note that a pronounced backward positioning of the arm, such as that of the left arm in Figure 4.33, causes the pointed base of the scapula to protrude.

Abutting the trapezius at the scapular spine, the deltoid's lower margin cuts across the three scapular muscles as it leaves the torso to insert into the humerus. Note the enveloping nature of the latissimus dorsi, its upper edges curving upward as it, too, goes to its insertion in the humerus (Fig. 4.32). Below, the latissimus dorsi originates among thoracic and lumbar spinal processes and from the iliac crest. Here, too, a large diamond-shaped tendon is bounded by the oblique fleshy ends of the latissimus dorsi and by the gluteal muscles, whose curved tendonous attachments

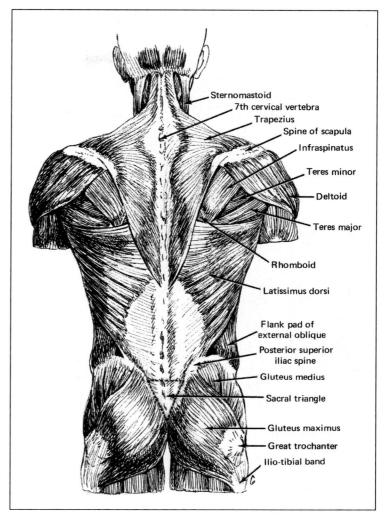

4.32

to the iliac crests emphasize the presence of these bony masses. A little of the flank pad of the external oblique is often visible in the back view.

Two areas in the back are affected by layers of deep muscle. The *rhomboid*, almost entirely hidden by the trapezius, extends from its origin on the spinal column—from the seventh cervical to the fifth thoracic vertebra—to its insertion into the inner border of the scapula (Fig. 4.35). It operates the scapula's upward and backward movements. When contracted in pulling the scapula up or toward the spinal column, it forms quite pronounced vertical bulges that greatly affect the torso's posterior surface. In well-muscled figures, the influence of the rhomboid overtakes that of the trapezius even when such backward movements of the scapula are only slight. Note the vertical bulges on the left side of the figure's back in Rubens's

A Nude Man Kneeling (Figs. 4.1 and 4.36). In Figure 4.33, the small "dot" alongside the vertical bulges caused by the contracting rhomboid marks the superior medial corner of the scapula.

The *erector spinae*, a group of muscles running on either side along the length of the spinal column, are also deep muscles that affect surface form. In the fleshed figure, especially in the lower back, they suggest vertical columns flanking the long spinal valley of the back (Figs. 4.31, 4.34, and 4.35).

As we can see, the surface forms of the torso are especially bold and flowing. Interweavings, eruptions, and abutments of masses play all around the torso, producing forms whose design suggests continuity from part to part. In Pontormo's *Studies for the Pietà* (Fig. 4.37), anatomical facts help explain the character of this torso's massive and rugged structure. In

4.33

Chapter 5, we will explore some ways in which anatomical formations stimulate dynamic activities such as these. But here we should note that it is the artist's appreciation of the tensions and energies alive in the torso, as well as its precise anatomical nature, that guides his or her choices of what to stress and what to subdue.

When objective anatomical study is not the artist's major purpose, such knowledge can still add to the visual options available, no matter what the theme of the figure drawing may be. In Boccioni's *Muscular Dynamism* (Fig. 4.38), the artist evokes the muscles' potential for exertion and action. Note the great amount of anatomical detail still discernible in this extraction of the figure's power and movement: Deltoids, scapula, spinal valley, even a suggestion of the deep erector spinae tell us of the artist's understanding of anatomy, despite the drawing's rather abstract manner.

Often, much of the torso's anatomy (as well as the rest of the figure) is obscured by considerable amounts of fatty tissue, a consideration to be discussed later in this chapter. But even when this is the case, artists with a sound knowledge of anatomy are able to draw figures whose underlying bone and muscle we believe in—works that are convincingly alive

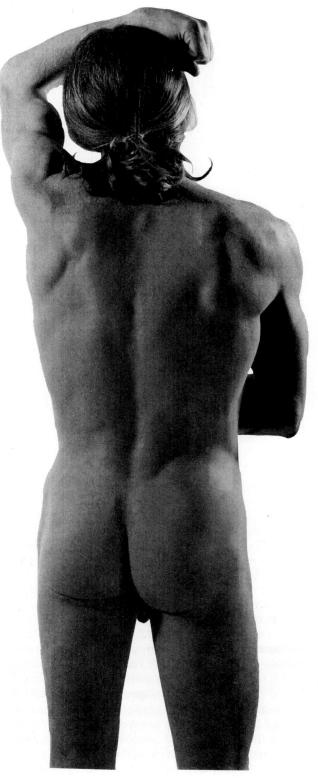

4.34

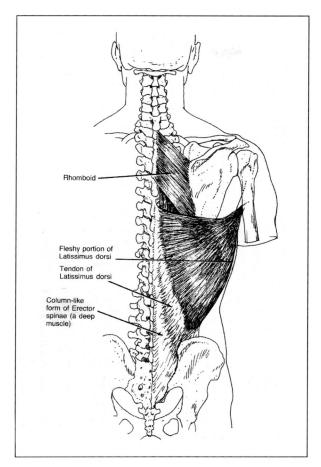

as figurative presentations and as expressive graphic inventions. In Degas's *Standing Nude Woman, Back View* (Fig. 4.39), there is no doubt about the figure's skeletal and muscular properties, although Degas is sparing in his use of anatomical detail.

MUSCLES OF THE ARM

We have seen that the bones of the lower arm rotate to permit the hand to face up (supinate) or down (pronate). This freedom to rotate creates a great number of possible contours of the arm. When the hand is fully rotated, the thumb describes almost a full circle. Comparable changes in the form and contours produced by various stages of rotation require a careful study of the arm. De Gheyn, in his *Study of Arms* (Fig. 4.40), examines just such changes. Although the changes resulting from the arm's mobility may seem to make its anatomy difficult to study, its muscle system is no more of a challenge than that of the torso.

The upper arm is composed of only a few muscles, and the lower arm's many muscles conveniently separate into three visual and functional groups, making it far easier to understand the form and mechanics of the lower arm. In the hand, as in the head, only a few muscles are of practical interest to the artist.

As you can see in Figure 4.41 (and in all the illustrations of the supinated arm), when the arm is held with the palm facing up, the short axes of the basic masses of the upper and lower arm are in opposition. In this position, the upper arm is seen to be narrow and the lower arm appears wide. When the palm is turned down (b), the upper arm is wide and the lower arm is narrow. In the supine position, the upper arm, especially in well-developed figures, tends to be flatter on the sides than on the top and bottom. The lower arm is somewhat more rounded in its upper portion, but toward the wrist, it develops a blocky character:

4.36 PETER PAUL RUBENS (1577–1640) *A Nude Man Kneeling*Black and white chalk, 20¹/4 × 15¹/2 in.
Museum Boijmans Van Beuningen, Rotterdam. Photograph by A. Frequin.

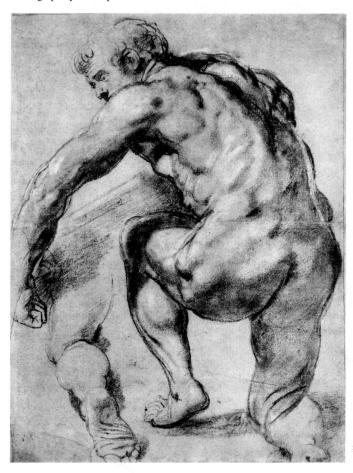

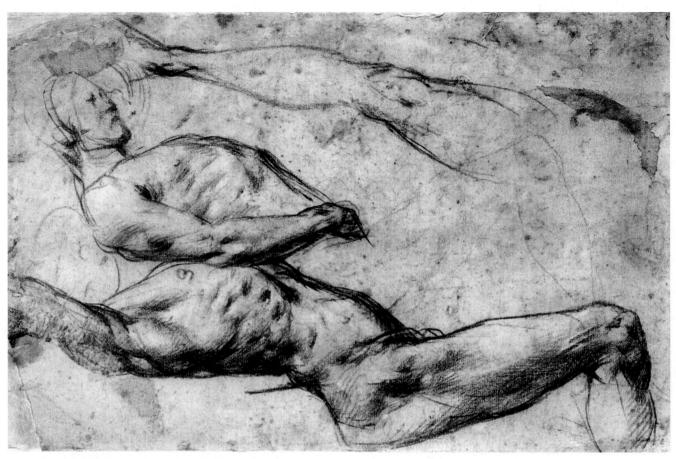

4.37 JACOPO DA PONTORMO (1494–1556) *Studies for the Pieta* Chalk, $7 \times 9^{3/8}$ in. Museum Boijmans Van Beuningen, Rotterdam. Photograph by A. Frequin.

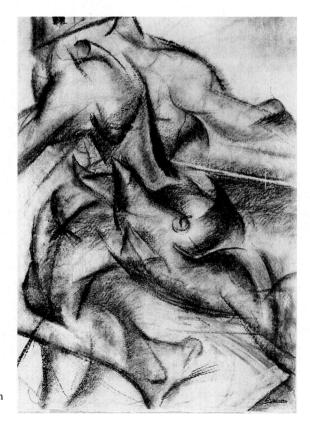

4.38 UMBERTO BOCCIONI (1882–1916) *Muscular Dynamism* (1913) Pastel and charcoal on paper, $34 \times 23^{1}/4$ in. (86.3 × 59 cm). The Museum of Modern Art, New York. Purchase. Photograph © 1999 The Museum of Modern Art, New York.

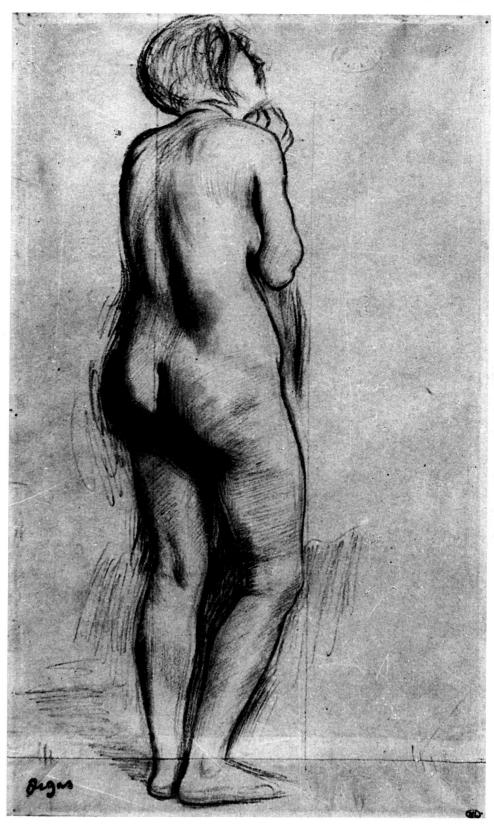

4.39 EDGAR DEGAS (1834–1917) Standing Nude Woman, Back View Black chalk on tan paper, $16^{1}/2 \times 10^{3}/4$ in. Photo R.M.N./Musee du Louvre, Paris.

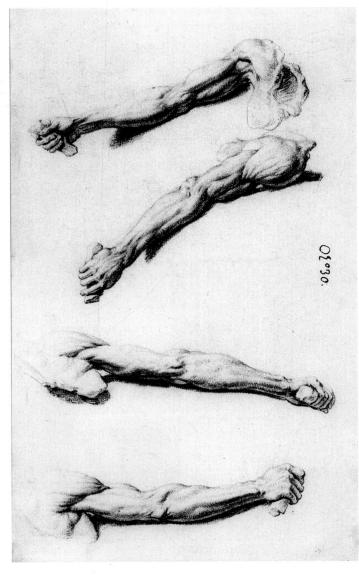

4.40 JACOB DE GHEYN 11 (1565–1629) Study of Arms
Black chalk, 14 × 9 in.
Rijksmuseum, Amsterdam.

broad, flat planes on top and bottom and narrow, flat planes on the sides. Although the hand can be aligned with the lower arm, when relaxed, it turns naturally inward, toward the body.

Mechanically, the scapula, the scapular muscles, and the pectoralis major participate in some operations of the arm and are part of it, but visually the arm, at least in the anterior view, begins with the deltoid. Notice in Figures 4.40 and 4.41 that the contour of the deltoid does not curve out furthest at the top; it does so lower down, nearer to its insertion point a lit-

tle above the origin of the *brachialis*, a muscle that flexes the arm. The brachialis is overtaken in mass by the *biceps* and *triceps* to such a degree that, in the supine anterior view, the lateral contour of the arm passes directly from the deltoid to the triceps, the single muscle of the back of the upper arm. But note that a small portion of the brachialis reappears at the medial lower portion of the biceps. In the medial side view, this small segment of the brachialis is of some importance, but in the anterior view, the brachialis has scant influence on the arm's surface form.

In the supine anterior view, the biceps is centrally located on the upper arm, flanked on either side by the triceps. The biceps, as the term suggests, has two heads, originating at two places on the scapula: the short head (on the medial side) from the coracoid process; the long head (on the lateral side) from the edge of the glenoid cavity. These heads unite under the deltoid and emerge in the familiar long and rather squarish muscle, which in contraction becomes more or less ovoid. The biceps inserts into the radius by a tendonous cord sometimes visible just above the bend of the arm and by a thin tendonous sheath, or fascia, along the upper medial surface of the lower arm. The biceps participates in supination; when we bend our arm and rotate our hand, the biceps contract when the hand is supine and relax when it is prone.

Figures 4.42 and 4.43 show some of the muscles already discussed and others to be discussed. They are illustrated separately to show their origin and insertion points as well as the form of some from various views. You will find it useful to refer to these two illustrations as we continue to examine the arm's musculature.

The superficial muscles of the lower arm are basically either flexors, muscles that draw the fingers together in a fist, or extensors, muscles that extend the fingers. Additionally, some of these muscles work to supinate or pronate the lower arm and hand. There are two large muscles, one a flexor and one an extensor, that are engaged in rotation. The supinator longus and the extensor carpi radialis longus together form a discernible mass that helps us think of the lower arm as composed of three muscle groups. When the arm is supinated, the former continues the contour above the elbow; the latter below it. When pronation occurs, these muscles unite to form a graceful spiral that begins with their emergence from the humerus, the fleshy bodies seeming to push the triceps and brachialis aside. The supinator longus attaches to the end of the radius; the extensor carpi radialis longus attaches to a metacarpal bone. Note that in the supinated anterior view, the biceps' fascia and the pronator teres form a distinct X just below the elbow toward the inside edge of the lower arm. The pronator

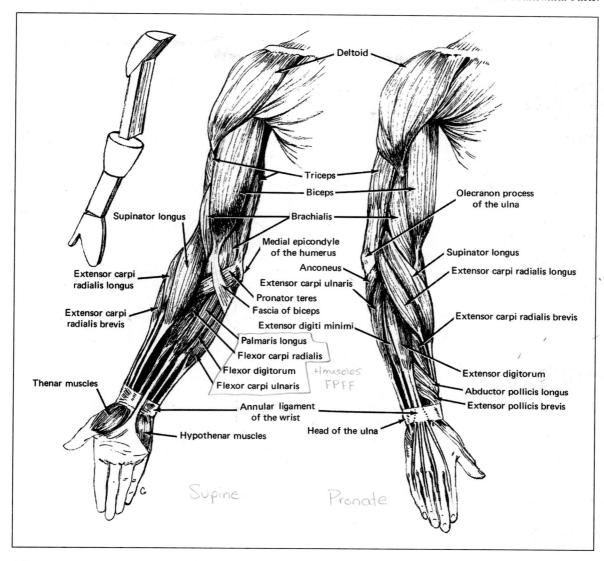

teres originates on the medial epicondyle of the humerus, inserting into the radius, which it pronates.

The medial epicondyle is a common point of origin for four more muscles, all flexors: the flexor carpi radialis, palmaris longus, flexor digitorum, of these four muscles, and the flexor carpi ulnaris. The fleshy body of each of these four muscles tapers to a tendon at about the same point, approximately halfway down the forearm. In the living model, these bodies are not seen separately but as a united form. In the supine position of the hand, only two groups of muscles are of importance in substantially affecting surface form: the thenar muscles of the thumb and the hypothenar muscles at the little finger side.

In the pronated anterior view, the triceps and the

olecranon process of the ulna are prominent. Three small extensor muscles located in the lower part of the forearm share the diagonal orientation of the two large supinators. They are the extensor carpi radialis brevis, the abductor pollicus longus, and the extensor pollicus brevis. The first of these extends the fingers of the hand; the latter two operate the thumb. The abductor pollicus longus is the most visible of the three.

The extensor digitorum, originating on the lateral epicondyle of the humerus, emerges from under the extensor carpi radialis longus and runs vertically alongside the three smaller extensor muscles just described, sending one tendon to each of the four fingers. These are the familiar radiating cords on the back of the hand. Running between the extensor carpi

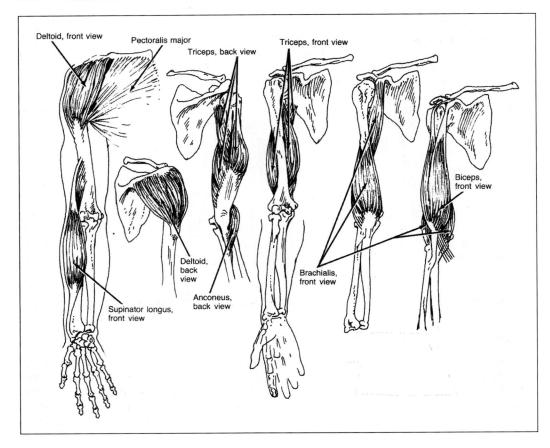

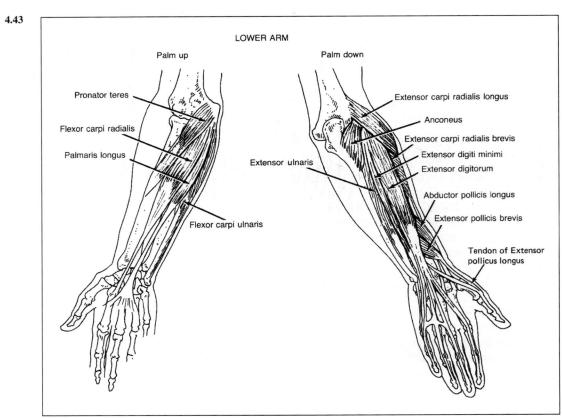

ulnaris, which bends the hand to the ulna side and extends the wrist, and the extensor digitorum, with which it shares its tendon, is the slender extensor digiti minimi, seldom seen on the surface. Beyond the extensor carpi ulnaris, near the elbow, the anconeus, which also originates on the lateral epicondyle, inserts nearby into the olecranon process and to the posterior end of the ulna. Despite its short turn, the anconeus creates a marked triangular plane on the surface. In the pronated arm, it appears as a focal point for the longer extensors (Fig. 4.44).

Returning to the supine view in Figure 4.41, note that a subtle furrow extends from the bend in the arm to the thumb, separating the extensors from the flexors. An exception in the extensor group is the supinator longus, which is a flexor muscle and originates higher on the humerus. The extensor group appears higher on the forearm and more ruggedly shaped than the mass of the flexors opposite it. Between the two groups, just above the wrist, are two recessed flexors with little effect on surface form, except for the tendon of the extensor pollicus longus, which runs the length of the back of the thumb (see the prone view in Fig. 4.41). Note that the lateral contour of the supinated front view of the arm is rich in its changes of direction, while the medial contour is relatively subdued in changes, making it reducible to a simple curve.

As Figures 4.45 and 4.46 illustrate, the supinator group, gracefully bridging the upper and lower arm, is more in evidence in the outer side view. Note that this view of the supinated arm shows a reversal of the basic masses of the arm shown in Figure 4.41. Now the upper arm is wider than the lower. With the hand pronated 180 degrees, the forearm undergoes a twist, changing direction more in its lower than upper half. The upper arm turns even less, about 90 degrees, and the deltoid turns least, about 40 degrees.

As Figure 4.46b shows, between the extensor carpi ulnaris and the flexor carpi ulnaris is a pronounced furrow called the *ulnar crest*. This long depression is easily seen in the fleshed figure and marks the boundary separating the two opposing muscle groups. This corresponds to the furrow seen in the anterior view. The anconeus slips into this hollow to insert into the ulna.

From an outer side view, the triceps, with its characteristic high fleshy mound and low tendonous plateau, becomes an important influence on the surface forms, especially in pronation. As the term indicates, the triceps is composed of three heads. The medial head originates on the posterior and medial portion of the humerus; the middle, or long, head below the glenoid cavity; and the lateral head below the tuberosity of the humerus. All three share a broad, tendonous sheath that inserts on the olecranon. In a

4.44 UMBERTO BOCCIONI (1882–1916) **Study of Man's Forearm** (ca. 1907) Pencil on buff paper, 8¹/₄ × 11⁵/₈ in. The Lydia and Harry Lewis Winston Collection. Courtesy of Mrs. Barnett Malbin.

4.45 JACOB DE GHEYN II (1565–1629) *Study of Arms* (detail) Black chalk, 14 × 9 in. Rijksmuseum, Amsterdam.

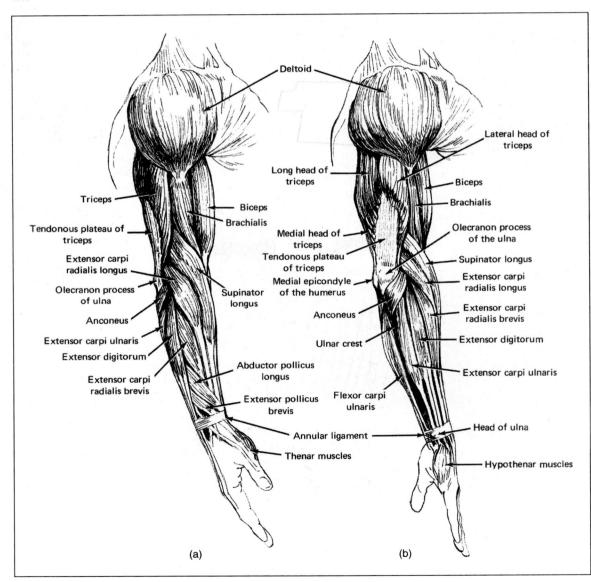

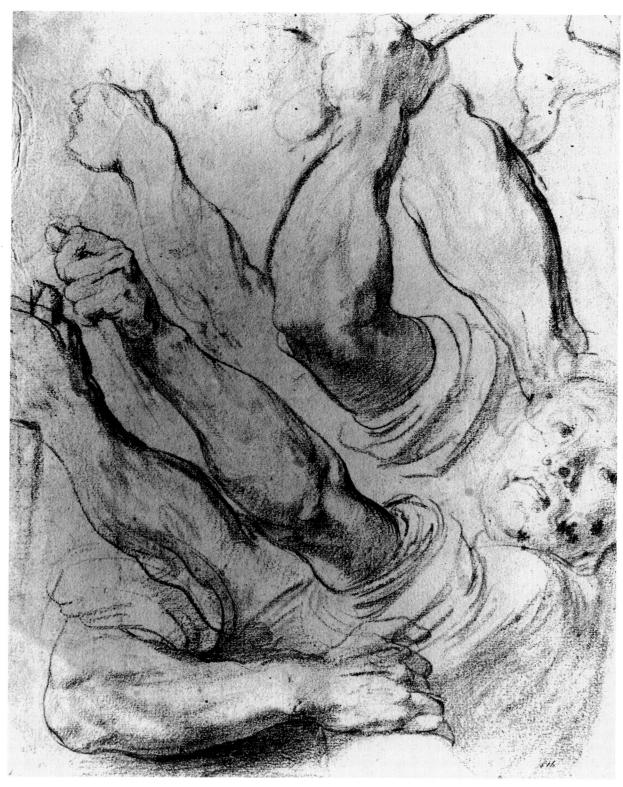

4.47 PETER PAUL RUBENS (1577–1640) **Studies of Arms and a Man's Face** Black chalk, $15^3/4 \times 12^1/8$ in. V & A Picture Library.

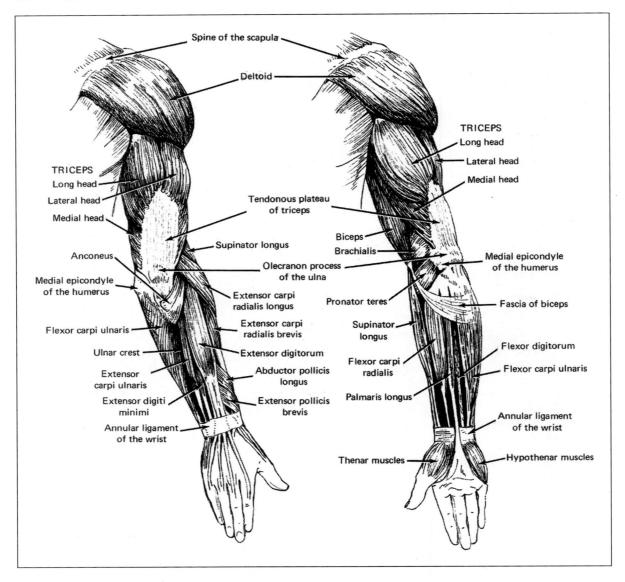

4.48

well-developed arm, it is easy to discern the inverted V-shaped mound of the triceps muscle and the flat plane below it. The triceps extends the arm and is the antagonist to the biceps. Note that the pronated view (Fig. 4.46b) turns the upper arm to reveal more of the triceps.

From behind (Figs. 4.47 and 4.48), the deltoid cuts across the triceps, turning out of sight before its insertion. The teres major and latissimus dorsi aim for the armpit, meeting the inner contour of the upper arm provided by the medial head of the triceps.

In the supine view, the upper ends of the anconeus and the extensors carpi ulnaris, digitorum, and carpi radialis brevis all come together and sink beneath the extensor carpi radialis longus. In the pronated posterior view, the biceps and its fascia attachments come into view. Note the arm's greater degree of rotation below than above.

From the medial side view (Fig. 4.49), the *coracobrachialis* can be seen between the biceps and triceps. Originating on the coracoid process of the scapula and inserting at about the middle of the shaft of the humerus, it becomes visible when the arm is extended or raised. When the arm is bent (Fig. 4.50), the coracobrachialis and the brachialis, appearing below the biceps, form a curve that appears before and after the swelled center of the biceps.

The arrangement of the muscles in Figure 4.50

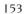

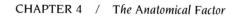

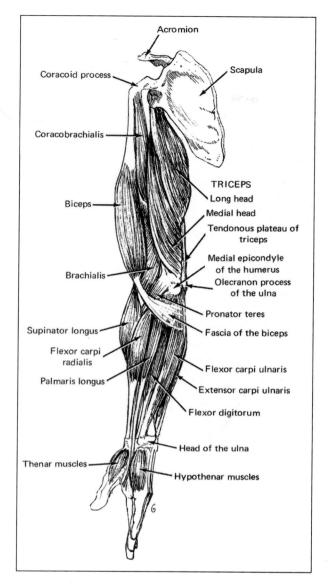

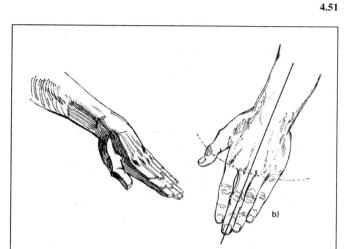

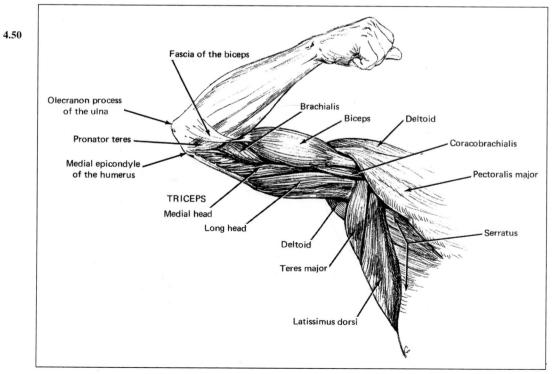

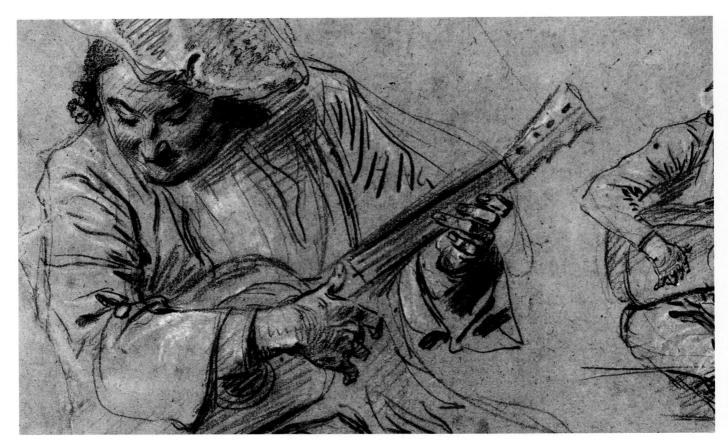

4.52 ANTOINE WATTEAU (1684–1721) *Two Studies of a Man Playing a Guitar* Red, white, and black chalk on tan paper. © The British Museum.

shows the long and medial heads of the triceps, the teres major, the biceps, the coracobrachialis, and the latissimus dorsi all interlaced at their entry into the armpit. The brachialis, aimed in the same direction, dies out before reaching the armpit.

In considering the structure of the hand, we should take into account the bones of the wrist. Following the blocklike character of the lower arm, the "ball" of the bones of the wrist gives way to the corrugated plane of tendons on the back of the hand. This plane becomes an evident ramp when the hand is lower than the wrist, especially if the fingers are turned up (Figs. 4.51a, 4.52, 4.53, and 4.54). An overhead view of the hand (Fig. 4.51b) shows the middle finger to be straightest, the others turning toward it. Note that the knuckles (heads of the metacarpal bones) line up with the last joint on the thumb. The fingers tend toward rhythmic arrangements, whether at rest or in action (Figs. 1.5, 4.53, and 4.54). The top

and side planes of the fingers are rather flat, giving the fingers a more angular and stepped appearance above and, because of the fatty pads beneath the phalanges, a softer character below (Fig. 4.55).

The arms in Pascin's *Reclining Nude* (Fig. 4.56) are knowingly expressed. The bulging on the figure's right arm of the supinator and extensor muscles, the strong protrusion of the olecranon, and the interplay of muscles on the inner upper arm are the results not only of observation but of sound anatomical understanding. Indeed, the slow, caressing line, emphasizing and simplifying as it moves, reveals the artist's anatomical knowledge throughout the drawing.

MUSCLES OF THE LEG

Figures 4.57 and 4.58 illustrate some of the muscles to be discussed, drawn in an isolated way to better

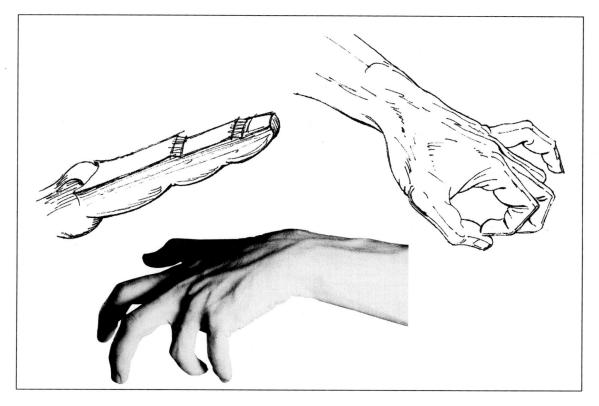

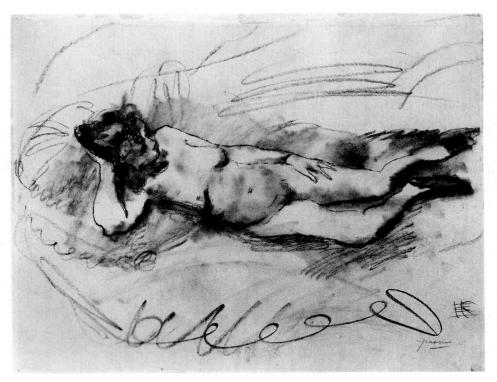

4.56 JULES PASCIN (1885–1930)
Reclining Nude (1928)
Charcoal and pencil on paper, 19⁷/₈ × 25¹/₂ in. (50.4 × 64.6 cm).
The Museum of Modern Art, New York.
Gift of Mr. and Mrs. Peter A. Rubel.
Photograph © 1999
The Museum of Modern Art, New York/© 1999 Artists Rights Society (ARS),
New York/ADAGP, Paris.

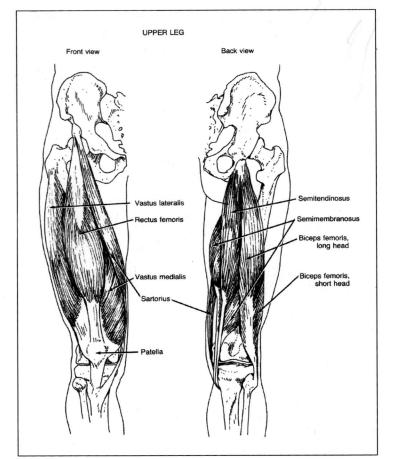

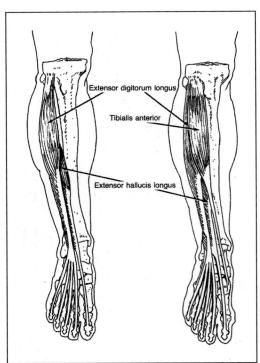

4.59 AUGUSTE RODIN, French (Paris, France 1840–1917, Meudon, France) **St. John the Baptist** (1878–1881)

Metal, 80.01 × 54.61 cm. actual (Front view).

Courtesy of the Fogg Art Museum,

Harvard University Art Museums.

Bequest of Grenville L. Winthrop 1943.1147.

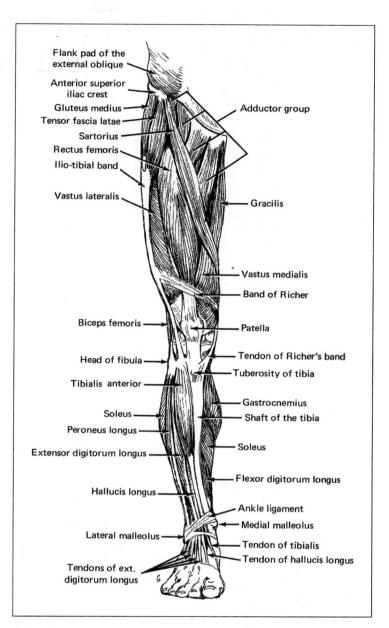

4.60

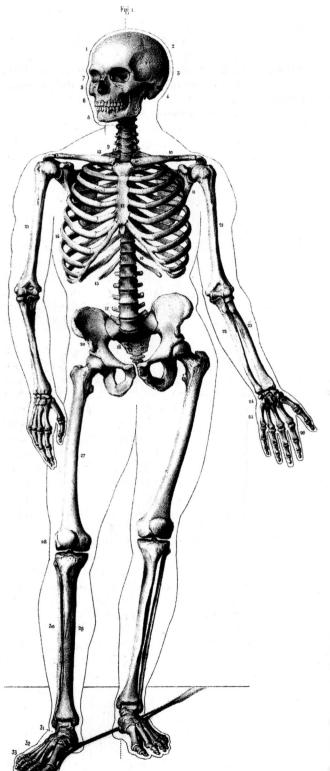

4.61 DR. J. FAUThe Anatomy of the External Forms of Man, Plate 2

Francis A. Countway Library of Medicine, Boston.

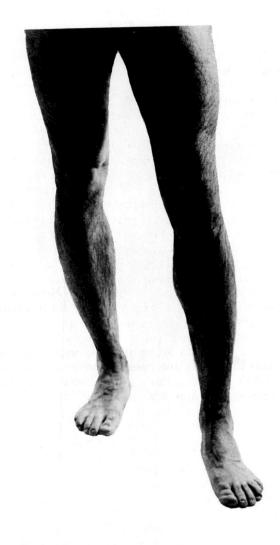

show their origins, insertions, and form. As we have seen, the pelvis provides the strong bony base that supports and permits movements of the upper body. Similarly, the lower extremities require the pelvis as a fixed base for attachments to enable the legs to move.

In the anterior view (Figs. 4.59 and 4.60), the *gluteus medius*, originating on the lateral surfaces of the ilium and the iliac crest, begins the contour of the leg. The gluteus medius inserts on the great trochanter of the femur, which, because of the bulk of the surrounding muscles, often appears as a low point in the fleshed form of the leg rather than as a rise. An exception occurs in the leg bearing the figure's weight in a standing pose, where the mass of the great trochanter

does influence the surface form (Fig. 4.61). This is an example of an occasional occurrence in the figure: Prominent outcroppings of bone in the skeleton become sites of depressions in the living model (as we saw in our examination of the scapula).

The oblique direction of the gluteus medius is duplicated by the *tensor fasciae latae*, arising from the anterior tip of the iliac crest and inserting into the *iliotibial band* at a point just below the great trochanter. The tensor fasciae latae is a small but substantial muscle often affecting the surface terrain. It forms, with the *sartorius*, an inverted V-shape. The sartorius likewise originates at the upper tip (or spine) of the iliac crest. It spirals downward gracefully to its insertion at the upper medial surface of the tibia. In doing so, it divides the centrally located extensor muscles from the *adductor* group on the medial side (those muscles which rotate the leg inward). The sartorius, then, is an important muscular landmark, most easily seen when the leg and foot are turned slightly inward (Fig. 4.59).

Occupying the entire anterior surface of the upper leg, and thus providing its contour, is the quadriceps femoris, a muscle system important for its effect on the surface form. Actually, we see only three of the four muscles of this group, one being deeply embedded. They are the rectus femoris, originating on the lower iliac spine; the vastus lateralis; and the vastus medialis. Both vastus muscles arise from nearby points near the top of the femur. All three muscles are extensors and share a common tendon that fits over the patella. Their individual masses are substantial and generally visible to some extent, especially when the leg bears the weight of the figure. The fleshy portion of the vastus lateralis ends well above the knee. The vastus medialis, however, swelling out and obscuring the lower part of the sartorius, "crowds" the knee to insert low on the side of the common tendon. Note the band of Richer, a tendonous sheath obliquely stretching across this muscle group. Not visible itself, the restricting tendon causes these muscles to bulge out above it when they are relaxed, as in the left leg in Figure 4.62.

On the medial surface of the upper leg, isolated by the sartorius, are the adductor muscles. Rarely seen individually in living forms because of fatty deposits in this region, the adductors influence the surface as a group, providing the armature for the rounded bulge high on the inner thigh (Fig. 4.63).

In the lower leg, the muscles suggest two masses: those grouped from the anterior edge to the tibia and those of the calf. In front, the *tibialis anterior*, in its curving tilt, echoes the spiral of the sartorius. Positioned on the lateral side of the tibia, it is one of the more visible muscles of the lower leg, its long tendon inserting into the big toe, its fleshy upper half

swelling when the foot is flexed (moved upward). Between the tibialis anterior and the lateral contour, provided by the *soleus*, a calf muscle, are the other three muscles of the anterior group. Often visible in various turning, extending, and flexing actions of the foot, they are the *extensor digitorum longus*, the *peroneus longus*, and emerging between the lower portions of these muscles, the *peroneus brevis*. The extensor digitorum longus originates high on the tibia and fibula; the other two on the fibula only. All three muscles insert into the foot, the extensor digitorum longus sending tendons to all but the big toe.

On the medial side of the tibia, the medial head of the *gastrocnemius*, the large muscle of the calf, provides the highest segment of the contour of the inner lower leg. The soleus, appearing again on the medial side, continues the contour, and the *flexor digitorum longus* completes it. Note that the fleshy portions of the muscles of the lower leg, like those of the lower arm, taper as they descend, their tendons running down together until they radiate in the extremity. Note also that the medial malleolus is higher than the lateral malleolus.

The leg's deep "roots" become apparent in the back view, embedded not much below the waist (Figs. 4.64 and 4.65). The attachment of the gluteus medius on the iliac crest marks the highest point of the leg's penetration into the trunk, The gluteus maximus reaches almost as high, emerging from the posterior surface of the ilium and from the sacrum and coccyx. It inserts just below the great trochanter and into the ilio-tibial band. Note the oblique angle of the top, bottom, and medial margins of the buttock muscle and its vertical lateral margin. Note also the lazy S-shaped depression along the outer edge of the gluteal muscles, the great trochanter marking the center of the indented area. This subtle hollow is often seen in the fleshed figure.

The straight descent of the *gracilis* contrasts with the rich curve of the vastus lateralis overlaid by the ilio-tibial band on the lateral side of the leg. The three hamstring muscles, all originating on the lower pelvis, function in pulling back or bending the leg. The gluteus maximus overlaps their common point of origin. Both the *semimembranosus* and *semitendinosus* insert into the medial surface of the tibia, but the *biceps femoris* inserts into the fibula. In thus parting from their parallel descent to insert into opposite sides of the lower leg, they produce a pincerlike effect on it. Note that the semimembranosus appears again just above the back of the knee, and the *adductor magnus* fills the space alongside the gracilis, below the buttock.

In the back view of the lower leg, the gastrocnemius, originating at the medial and lateral condyles of

4.63 FEDERICO BAROCCI, Italian (1526–1612)
Studies of Legs and a Foot for St. Sebastian in the Genoa Crucifiction
Black, white and red chalk on brown prepared paper, 41.8 × 2.73 cm.
The Art Museum, Princeton University. Bequest of Dan Fellows Platt, Class of 1895. 1948-599.

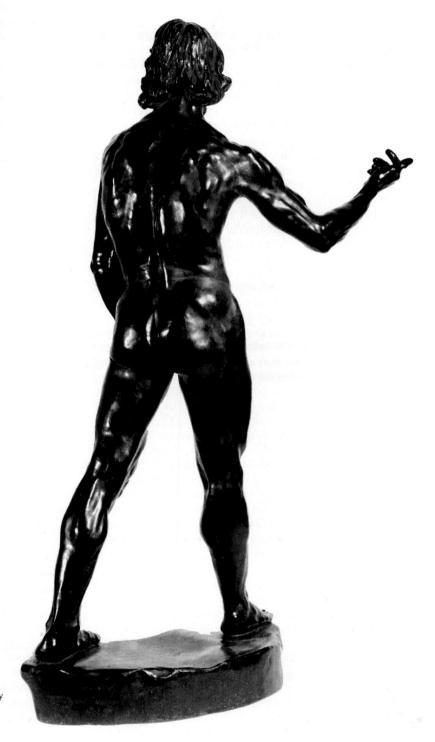

4.64 AUGUSTE RODIN, French (Paris, France 1840–1917, Meudon, France)

St. John the Baptist (1878–1881)

Metal, 80.01 × 54.61 cm. actual (Front view).

Courtesy of the Fogg Art Museum, Harvard University Art Museums. Bequest of Grenville L. Winthrop 1943.1147.

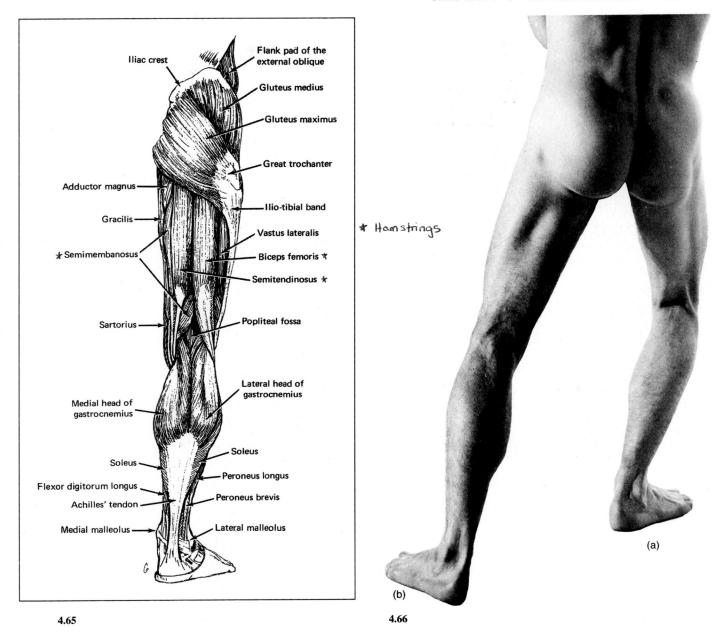

the femur, also parts at the back of the knee, resulting in a hollowed area, the *popliteal fossa*. This hollow shows only when the leg is bent, as in Figure 4.66a; when the leg is straight, the area appears somewhat convex, the result of fatty tissue in this location (Fig. 4.66b).

As in Figure 4.66, the hamstring muscles are almost never seen individually but appear in the fleshed figure as a rounded mass. The two heads of the gastrocnemius constitute the major fleshy form of the back of the lower leg. The soleus, originating on both

the tibia and fibula, runs down from under the bottom of the medial bulge of the gastrocnemius and along the outer edge of its lateral bulge. As in the leg's front view, the flexor digitorum longus emerges from under the soleus, continuing below the ankle where it turns forward and out of view. The gastrocnemius and soleus join to the broad but tapering *Achilles tendon*, which inserts into the calcaneus, the heel bone.

From the lateral side view (Figs. 4.67 and 4.68), the gluteal muscles converge on the great trochanter. The ilio-tibial band, a long and tapering sheath of ten-

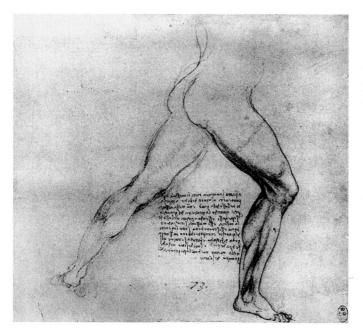

4.67 LEONARDO DA VINCI (1452–1519) *Myology of the Lower Extremity* Black chalk, some pen and ink, $11^3/8 \times 7^3/4$ in. The Royal Collection © Her Majesty Queen Elizabeth II.

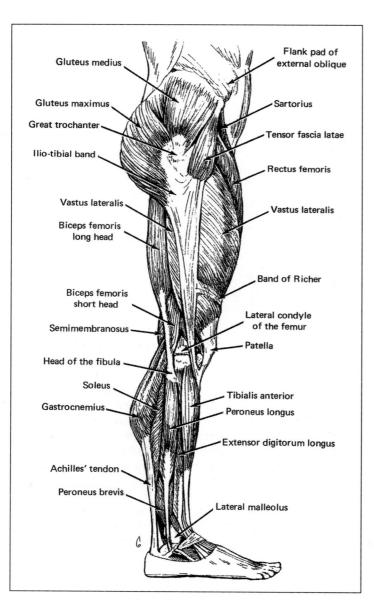

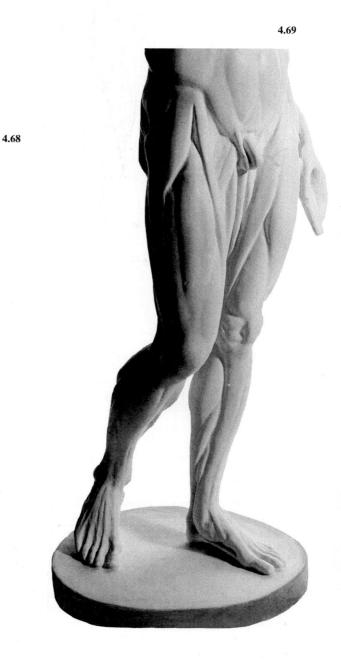

162

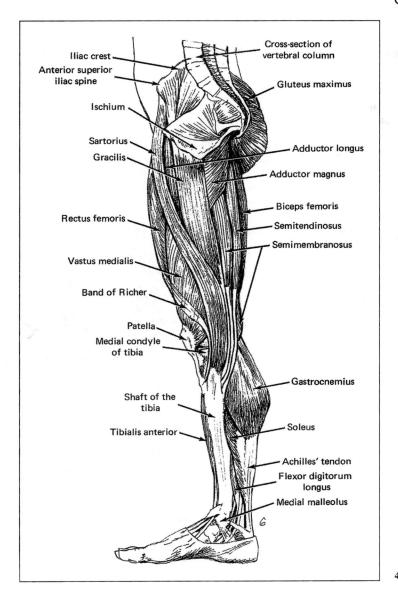

don attached to the lateral condyle of the tibia, forks at the top to receive the fleshy fibers of the gluteus maximus and the tensor fasciae latae. From this view, the contour of the posterior of the upper leg begins with the gluteus maximus, continues with the long, simple curve of the biceps femoris, and is completed by the semimembranosus. In the lower leg, the gastrocnemius and the Achilles tendon provide the posterior contour.

In the lateral side view, the rectus femoris above and the vastus lateralis near the knee account for the upper leg's anterior contour. In the lower leg, the tibialis anterior alone carries the anterior contour to the ankle. At the knee, the forms of the patella and the head of the tibia influence the contour. In this view, note that the sweeping curve of the front of the upper leg appears to continue through the gastrocnemius, creating a large, reversed lazy S-curved movement.

In this (as in any other) view of the leg, the muscles of the lower leg are more in evidence than those of the upper leg. The soleus is often discernible as separate from the gastrocnemius, and the two peroneal muscles are also sometimes visible (Fig. 4.67).

From the medial side view (Figs. 4.69 and 4.70), the sartorius, gracilis, semitendinosus, and semimembranosus all converge on the tuberosity of the tibia.

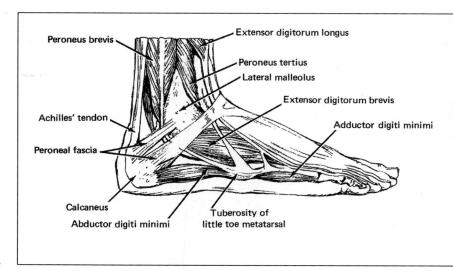

4.72 JOSE CLEMENTE OROZCO (1883–1949) *Legs* (1938)

Charcoal on light gray paper, $25^7/8 \times 19^5/8$ in. $(65.7 \times 49.8 \text{ cm})$. The Museum of Modern Art, New York, Inter-American Fund. Photograph © The Museum of Modern Art, New York/© Estate of Jose Clemente Orozco/Licensed by VAGA, New York, N.Y. Reproduccion authorizada por fi Instituto Nacional de Bellas Artes y Literatura.

Note the broad expanse of the tibia visible in the lower leg. The fatty pad beneath the patella affects the surface form of the knee in this view. The calcaneus, thrusting backward, affects the contour of the foot.

In the foot, as in the hand, muscles play a minor role. Here, the important surface characteristics are the result of bone, tendon, and fat. On the lateral (little toe) side, the lateral malleolus of the fibula is a prominent landmark, the tendons of the peroneal muscles turning around from behind (Fig. 4.71). Less evident, the small bump about midway between the heel and the little toe represents the tuberosity of the fifth metatarsal; it also marks the insertion of the tendon of the peronus brevis. The *extensor digitorum brevis*, positioned parallel with the long axis of the foot, appears as a subtle mound in front of the lateral malleolus.

On the medial side of the lower leg, the medial malleolus, the tendons curving around it, the tendon of the tibialis anterior, and the pronounced masses of the heel and ball of the foot are characteristic features. From either side view, the arched curve of the bones of the foot is an important trait. From below, the considerable mass of the fatty pads behind the toes and at the heel are evident (Fig. 4.72). Note also the tendency of the toes to "aim" for the second toe, which is the straightest (Figs. 4.69 and 4.73).

Reduced to simple geometric masses (Fig. 4.73), the arch bears a resemblance to the ramp of the hand. Note the "walkway" on the outside and also the straight drop on the inside of the foot.

The accompanying plates by the Renaissance anatomist Albinus (Figs. 4.74, 4.75, and 4.76), the full anatomical figure after the original by Houdon (Fig. 4.77), and the plates *from Salvage's Anatomie du Gladiateur Combattant* by Borghese (Figs. 3.5, 4.78,

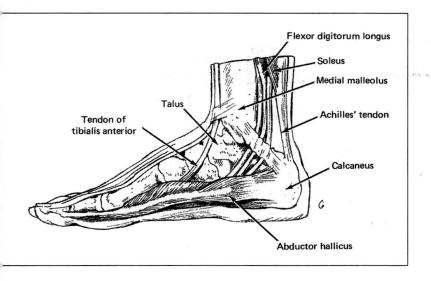

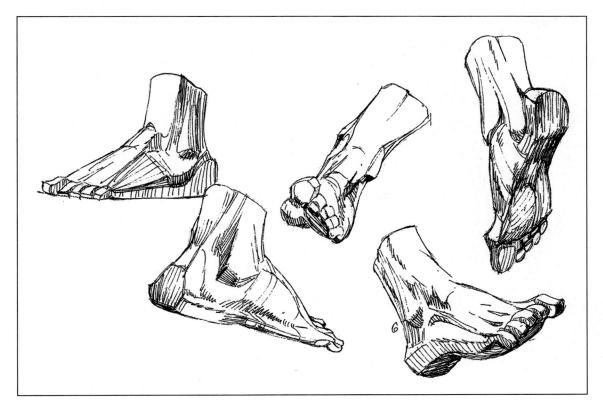

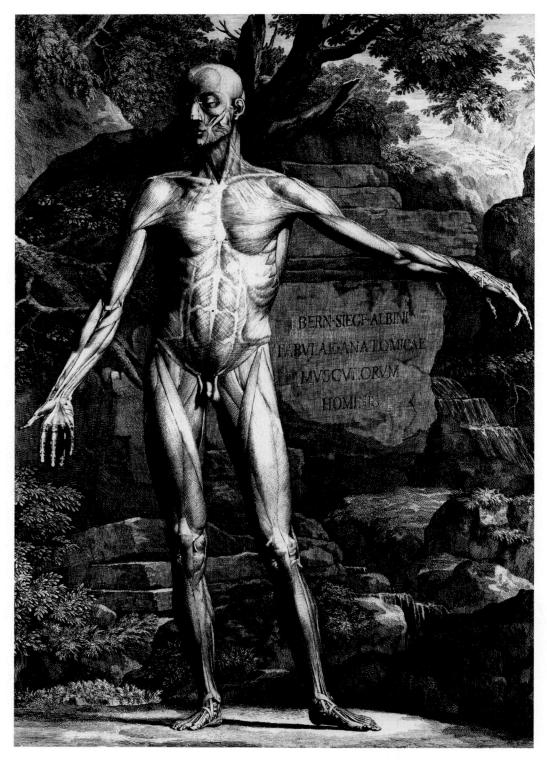

4.74 BERNARD ALBINUS (1697–1770)

Muscles, Front View from "Tabula sceleti
et musculorum corpus humani"

Francis A. Countway Library of Medicine, Boston.

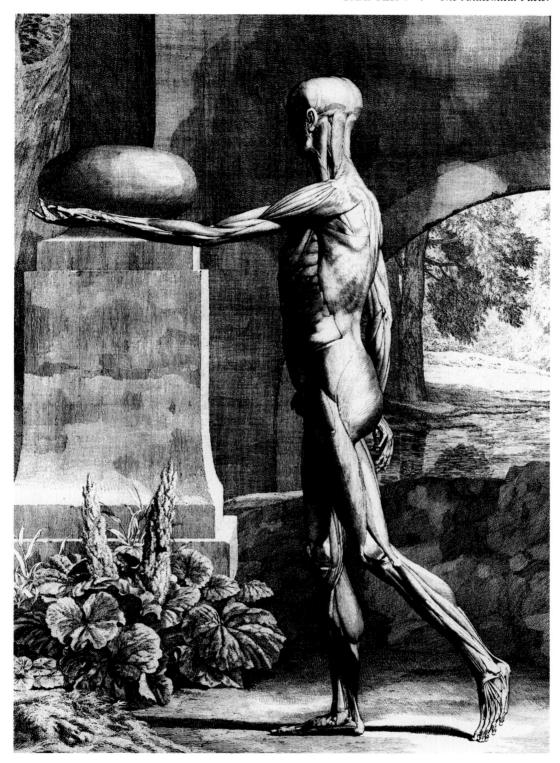

4. 75 BERNARD ALBINUS (1697–1770)

Muscles, Side View from "Tabula sceleti et musculorum corpus humani"

Francis A. Countway Library of Medicine, Boston.

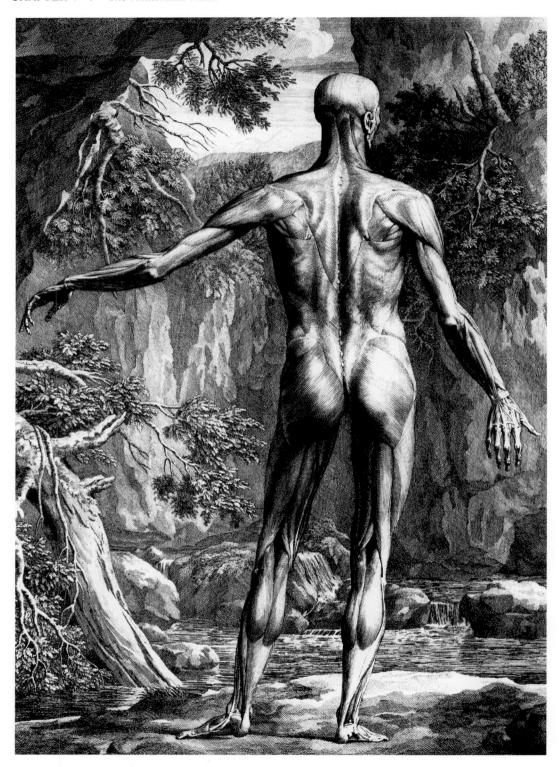

4.76 BERNARD ALBINUS (1697–1770)

Muscles, Back View from "Tabula sceleti
et musculorum corpus humani"

Francis A. Countway Library of Medicine, Boston.

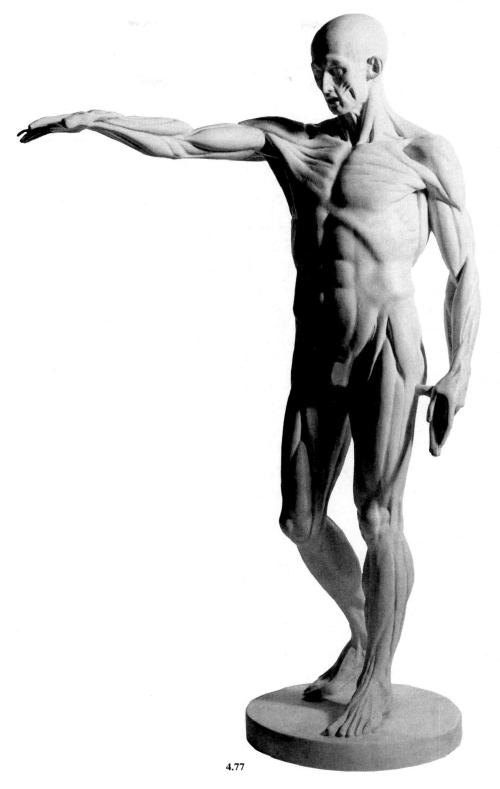

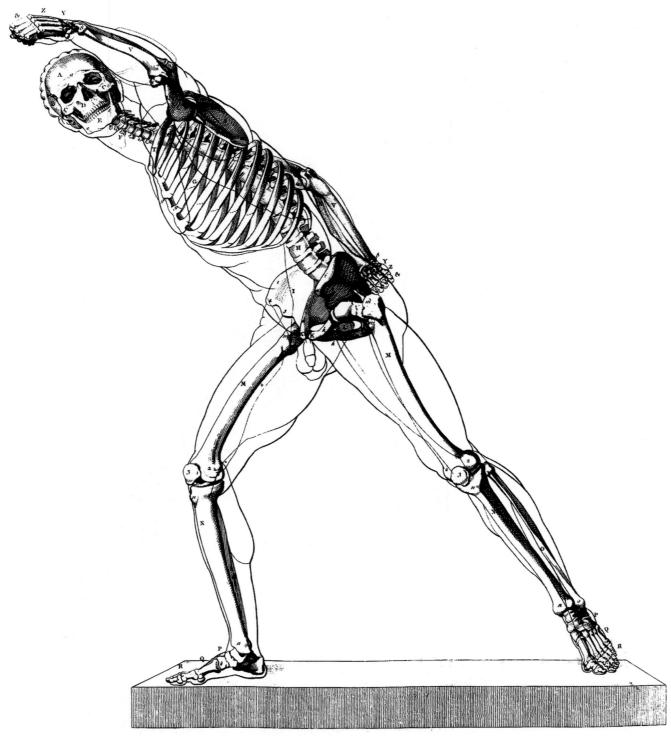

4.78 BORGHESE *From Salvage's "Anatomie du Gladiateur Combattant"* Francis A. Countway Library of Medicine, Boston.

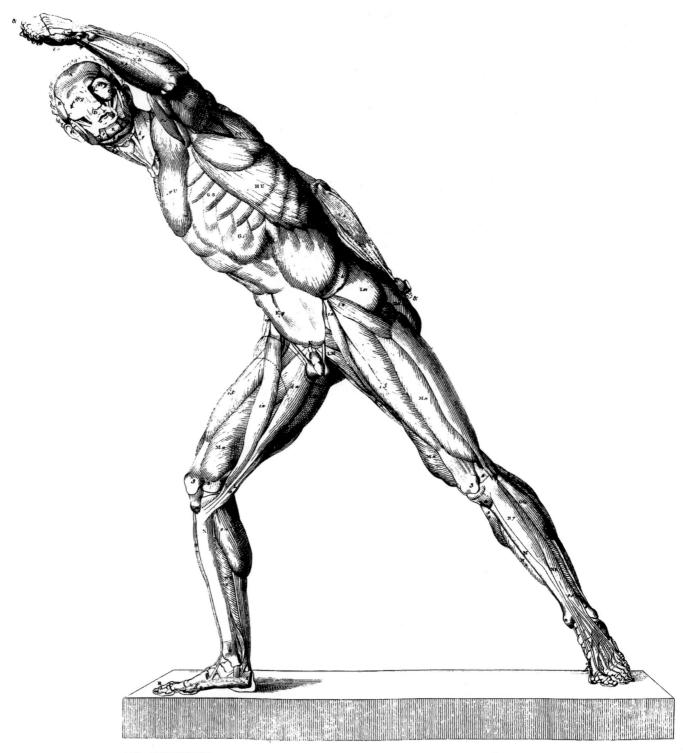

4.79 BORGHESEFrom Salvage's "Anatomie du Gladiateur Combattant"
Francis A. Countway Library of Medicine, Boston.

and 4.79) serve as a visual summary of the material covered thus far. They provide the relationships of scale, location, and rhythm among parts of the figure that have been missing from previous illustrations of those parts. Additionally, they demonstrate that even an objective study of anatomical fact can have aesthetic worth.

SKIN AND FAT

In the living figure, the skin and fatty tissue modify the musculature of even the thinnest person.² Although the skin represents a fairly even covering, it is slightly thicker in some locations, such as the palm of the hand, the sole of the foot, and the upper part of the back. Additionally, its limited freedom of movement, the result of a loose attachment to the tissues beneath it, also varies somewhat. For example, the skin covering the top of the head, along the anterior and posterior median lines of the torso, on the palms of the hands, on the feet, and even on the inner side of the lower parts of the extremities is less mobile than the skin on the face, around the waist, and at the joints.

Superficial body fat is also unevenly distributed, and to a far greater extent than the skin thicknesses. These differences in the distribution of fatty deposits, sometimes so pronounced as to create surface forms that are independent of the anatomical forms below, should alert us to the error of regarding skin and fat as uniformly softening the terrain of bones and muscles.

Generally, fatty deposits are heavier on the torso than on the limbs and heavier on the upper than the lower parts of the limbs. Something of these characteristics can be seen in Figure 4.80. Often, more abundant amounts of fat are present in the female figure, softening or leveling the valleys, padding or grading the hills, and providing the graceful surface undulations characteristic of that sex. In most infants and in the excessively overweight, fatty tissue not only effaces the forms below but also creates substantial forms of its own. These rolls of fat usually appear to encircle the forms they are on, as may be seen in the legs of the seated child in Boucher's *Nude Children* (Fig. 4.81) and in the obese figures in Rubens's *Fall of the Damned* (Fig. 4.82).

In areas such as the ears, the eyelids, and the bridge of the nose, there is no subcutaneous fat. Minimal amounts are present on the back of the hand, the foot, the sternum and clavicle area, and at the wrists and ankles. Ample deposits are found on the lower part of the face; the torso, especially at the breasts,

abdomen, and buttocks; and on the upper parts of the limbs. Although fatty deposits are greater in the female breast, fat is present in the male breast also.

In the typical female figure, fat liberally invests the upper posterior part of the thighs and the buttocks. Above and behind the wings of the pelvis, it fills in the depressions in the muscular terrain, accounting for the large inclined plane that begins at the buttocks and extends almost to the waist (Fig. 4.83). In so doing, the fat obscures the hollow surrounding the great trochanter and the upper margins of the pelvis. No such long plane exists in the average male figure. Compare the squarish buttocks, the hollow at the site of the great trochanter, the curving margins of the pelvis, and the columns of deep spinal muscles that give this region a far different character in the male (see Fig. 4.66).

Another drawing by Boucher, *Reclining Nude* (Fig. 4.84), provides a good example of the modifying effects of fat. Here, despite the obscuring of the musculature, the stronger forms beneath still have an effect, however muffled, on the surface terrain. The figure's heavy forms are not arbitrarily cylindrical or without clues to the anatomical forms below the surface. They subtly suggest the vastus muscles, the trapezius, the extensors and flexors of the arm, the tibia, the manubrium, and so on. A sound knowledge of anatomy enables an artist to know which bones and muscles will continue, though muted, to influence surface structure and which will be effaced by fat.

Gravity, too, plays a role in altering the position and shape of the figure's forms. In Boucher's drawing, the weight of the abdomen causes it to overlay the upper leg. In Figure 4.82, gravity's effect on breasts, torsos, arms, and legs is convincingly shown.

FURTHER OBSERVATIONS ON SURFACE FORMS

Let us now examine more specifically how bones and muscles influence the padded surfaces of the figure and then go on to see how anatomical fact enhances expression.

In Figure 4.85, the vertical furrows in the brow reveal a contraction of the corrugators. Light and dark planes encircling the eyes suggest the eye sockets. Above, the ledge of the brow protectively overhangs the eyes. A highlight running from the corner of the figure's right eye to the corner of the mouth divides the front and side planes of the head. At the right shoulder, the head of the humerus is forced to the surface by the pressure on the arm supporting the torso. Above this protuberance, the spine of the scapula and the lateral end of the clavicle join to form the rugged surface at the top of the shoulder. Compare the mass and form of the working deltoid with the relaxed del-

² Paul Richer, *Artistic Anatomy*, trans. R. B. Hale (New York: Watson-Guptill Publications, 1971), pp. 78–81.

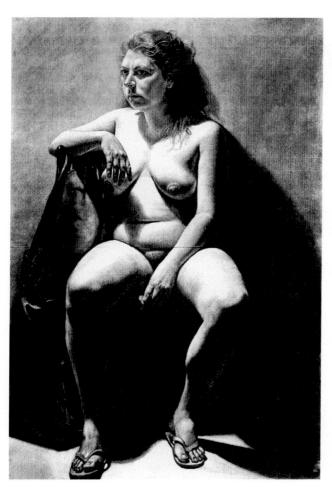

4.80 JAMES VALERIO (1938–) **Seated Model** (1983) Charcoal on paper, 39¹/₈ × 25¹/₄ in. The Arkansas Arts Center Foundation Collection 1985. #85.2.3.

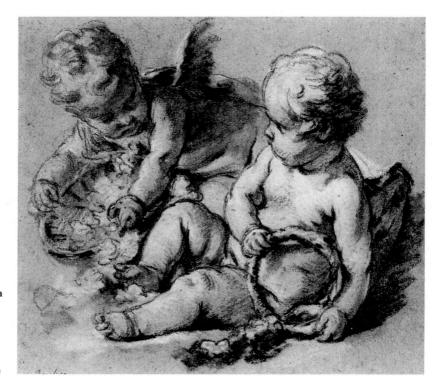

4.81 FRANÇOIS BOUCHER, French (1703–1770) *Nude Children (Amorini)*Black chalk heightened with white on light brown paper, H 8⁵/₁₆, W 9¹/₄ in. The Metropolitan Museum of Art. Gift of Charles K. Lock, 1960. (60.175.1)

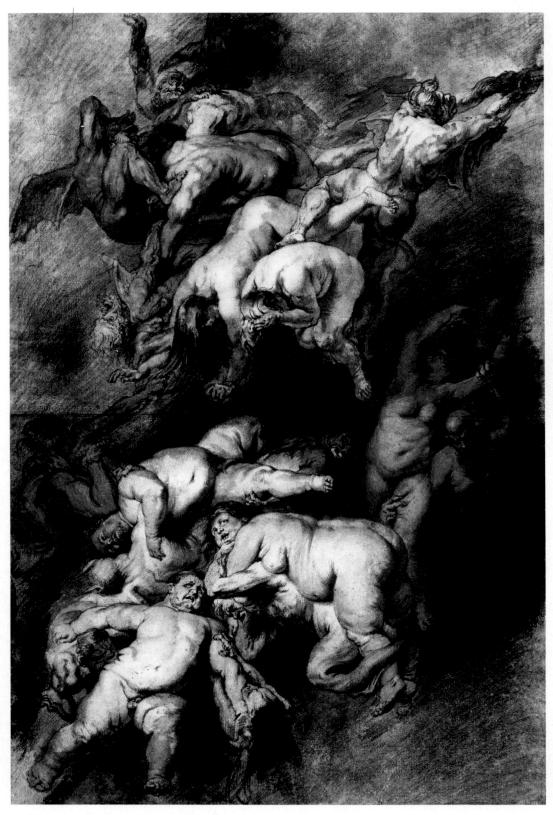

4.82 PETER PAUL RUBENS (1577–1640) *Fall of the Damned* Chalk, $29^{1/2} \times 20$ in. © The British Museum.

4.84 FRANÇOIS BOUCHER, French (1703–1770, Paris)
Reclining Nude
Red and white chalk on tan antique laid paper,
31.5 × 41.5 cm.
Courtesy of the Fogg Art Museum, Harvard University Art Museums. Bequest of Meta and Paul J. Sachs. 1965.235.

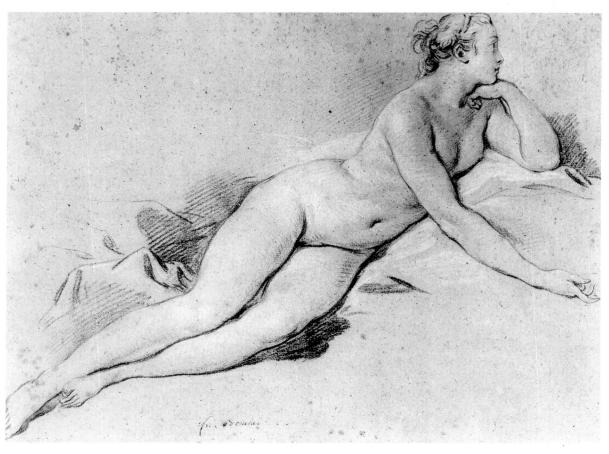

toid of the left arm. Here, the abdominal muscles are clearly seen and together form a kind of block, sitting slightly ahead of the planes to either side of it. Just above the left knee, a highlight indicates the medial condyle of the femur. In the lower left leg, the gastrocnemius and the tibialis account for the back and front contours, respectively, but note that the same muscles provide the contours in the foreshortened right leg. At the hips, the buttock muscles form a segment separate from the mass of the leg, the result of the tensor fascia latae's insertion into the ilio-tibial band.

Kokoschka, relying more on linear than tonal divisions between planes in his Portrait of Joseph Hauer (Fig. 4.86), indicates the aforementioned construction of the eye and socket, the overhanging brow, and the division between the front and side planes of the face. For Kokoschka, these anatomical facts and those of the flattened plane at the temple, the wrinkles caused by the corrugator and frontalis muscles, the knowledgeable configurations of the ear and nose, the bony ridges above and blow the eyes, and so on do not represent obligations to objectivity but opportunities for expression. In sensing the drawing's energy and strength, we sense these qualities in the sitter. Note that the artist utilizes the design possibilities of the hair on the head and face to intensify the urgency of the rhythms that animate the portrait.

On the torso, the clavicles, sternum, and rib cage

(especially the thoracic arch) are frequently visible even in simple standing poses, as Figure 4.87 demonstrates. Often, as here, the hollows at the pit of the throat and at the xiphoid process (a, b) are deeply carved. In this view of the upraised arm, the biceps and triceps seem to emerge from under the "cap" formed by the pectoralis major and the deltoid. Note the similarity between the angles of the thoracic arch (c) and the serratus muscles (d) and that both epicondyles of the humerus are visible (e).

4.85

In a well-developed male (Figs. 4.85, 4.87, and 4.88), the pectoral muscles form a graceful, fleshy mantle over the rib cage, ending in a "cupid's bow" (Fig. 4.88a) similar to the one formed by the clavicles (b). A third cupid's bow occurs at the torso's lower boundaries, formed by the flank pads of the external oblique and the abdominal muscles (c). Some additional observations worth noting are the torso's median furrow ending at the navel; the hollow marking the emergence of the sartorius and tensor fascia latae muscles (d); the diamond shape formed by the clavicles and the sloping lines of the trapezius muscles (e); the hollows separating the deltoids from the pectoral muscles (f); the muscle pads of the abdominal muscles (g); the constricting of the leg muscles by the band of Richer (h); the gastrocnemius muscle visible on both sides of the lower left leg (i); and the wedgelike character of the feet.

4.86 OSKAR KOKOSCHKA (1886–1980)

Portrait of Joseph Hauer (1914)

Black chalk, 16 × 12 in.

Die Bayerische Staatsgemaldesammlungen, Munich.

Gift of Sofie and Emanuel Fohn/© 1999

Artists Rights Society (ARS), New York/

Pro Litterio, Zurich.

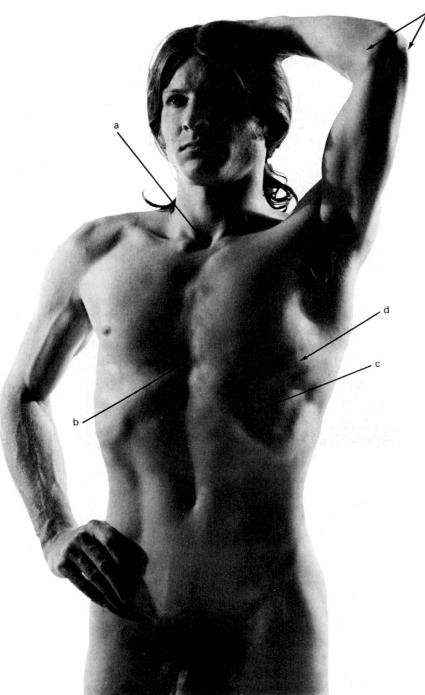

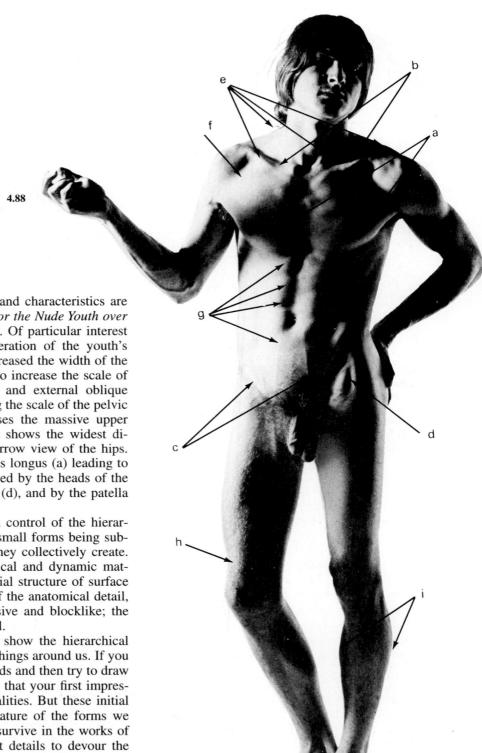

Some of these landmarks and characteristics are seen in Michelangelo's *Study for the Nude Youth over the Prophet Daniel* (Fig. 4.89). Of particular interest here is Michelangelo's exaggeration of the youth's chest. To do this, he subtly increased the width of the rib cage, making it necessary to increase the scale of the serratus, latissimus dorsi, and external oblique muscles while slightly reducing the scale of the pelvic area. Michelangelo also stresses the massive upper body by selecting a pose that shows the widest dimension of the chest and a narrow view of the hips. Note the clarity of the peroneus longus (a) leading to the knee, itself so well explained by the heads of the fibula (b), tibia (c), and femur (d), and by the patella (e) and the patella ligament (f).

Michelangelo is always in control of the hierarchy of the figure's forms—of small forms being subordinate to the bigger forms they collectively create. His involvement with anatomical and dynamic matters never overtakes the essential structure of surface forms. The chest, despite all of the anatomical detail, is still seen primarily as massive and blocklike; the limbs are essentially cylindrical.

All good figure drawings show the hierarchical order by which we all see the things around us. If you glance up for one or two seconds and then try to draw what you saw, you will realize that your first impressions dealt mainly with generalities. But these initial impressions of the essential nature of the forms we see are important and always survive in the works of the masters, who never permit details to devour the forms of which they are a part.

In Chapter 2, we saw that small form units can be seen as either emerging from simple larger masses or as being reduced to such simple masses. But in either case, the large masses should prevail. Here, we should

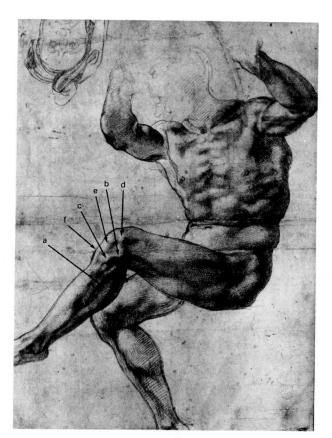

4.89 MICHELANGELO BUONARROTI, Italian (1474–1564) Study for the Sistime Chapel Ceiling: The Nude Figure next to the Prophet Daniel (c. 1511)
Red chalk over black chalk, 34.3 × 24.3 cm.
Copyright © The Cleveland Museum of Art, 1998,
Gift in memory of Henry G. Dalton by his nephews
George S. Kendrick and Harry D. Kendrick, 1940.465.

understand that these small form units are shaped by bone, muscle, and fat. Cambiaso poises his drawing *Hercules* (Fig. 4.90) just at that intriguing point where we wonder if specific surface forms are being absorbed by larger geometric ones or are emerging from them. Cambiaso's drawing provides an excellent example of the interaction of the structural and anatomical factors.

As we examine Figure 4.90, it is instructive to see which anatomical landmarks and forms the artist selects as modifiers of the drawing's simpler masses. In the head, the curved frontal bone and the zygomatic bone and arch are clearly indicated; in the neck, the sternomastoids, the pit of the throat, the larynx, and the flow of the trapezius to the deltoid are suggested by a few select shorthand marks that denote both the edges and structure of these forms. In the torso, complex muscles such as the external oblique and pec-

toralis major are reduced to the most general shape and form clues. Yet these shorthand lines are rich in detail. The hollow near the deltoid, the lumpy surface effects of the sternum and the thoracic arch, the nipples, the midline ending at the navel, and at least a hint of the interaction of the muscles at the side of the torso are all shown. In the limbs, although Cambiaso

4.90 LUCA CAMBIASO (1527–1585)

Hercules

Brown ink on cream antique laid paper darkened to brown, 27.5×15.1 cm. actual $(10^3/4 \times 5^5/16$ in.).

Courtesy of the Fogg Art Museum, Harvard University Art Museums. Gift of Mrs. Herbert Strauss 1938.56.

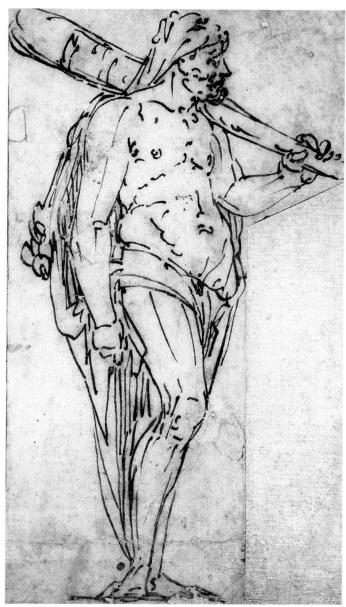

conceives them as essentially tapered blocks, again each modifying mark *tells*. In the figure's right arm, he suggests the swell of the deltoid and supinators, the bones of the lower arm at the wrist, and (in the figure's left arm) the biceps, the tendons of the lower arm, and the muscles at the base of the palm. In the leg, he sorts out the tendon, muscle, and bone that construct the knee; he shows the gastrocnemius, soleus, tibia, and peroneus longus and hints at other muscles on the lateral side of the lower leg. The con-

struction of the feet indicates the bones of the ankle and the downward arc of the tendons to the toes. A careful study of this drawing reveals even more anatomical details than those just mentioned. Cambiaso's *Hercules* is an impressive feat of economy based on a sound grasp of the human figure's general structure and the specific anatomical reasons for it.

The scapula provides one of the most pronounced landmarks of the back. As Figure 4.91 shows, the scapula's mechanical function as part of the arm

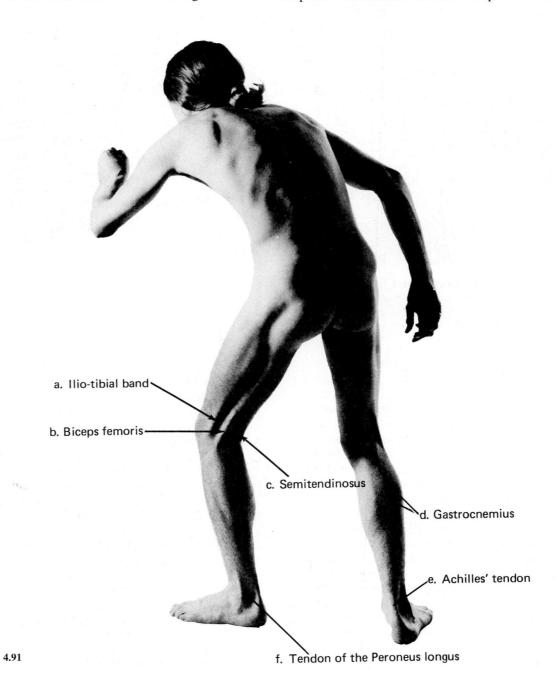

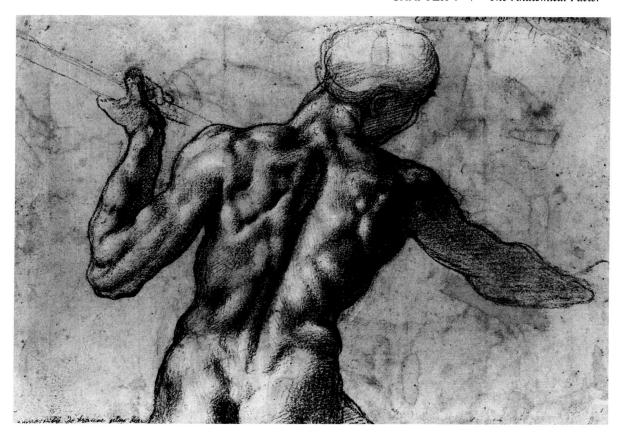

4.92 MICHELANGELO BUONARROTI (1475–1564) *Male Torso, Seen from the Back* Charcoal and lead white, $10^5/8 \times 7^3/4$ in. Graphische Sammlung Albertina, Vienna, Austria.

brings it gliding over the ribs toward the side when the arm moves up and forward. Here, because of the thick masses of the gluteal and flank pad muscles attaching to them, the location of the iliac crests is marked by curved valleys, not hills. With the rib cage bending forward, several ribs come to the surface, their downward curve pronounced. The teres major and latissimus dorsi form a sweeping curve along the torso, and at the hips, the gluteus medius muscles overhang those of the buttocks.

In the legs, the muscles of the posterior upper leg form a single muscular mass. On the outer side, the form of the vastus lateralis is visible, strapped down by the ilio-tibial band. At the knee, the tendonous cords of the ilio-tibial band and the biceps femoris are in sharp relief (a, b). On the inner side of the knee, the tendon of the semitendinosus is visible (c). Note that in the lower legs the curve of the lateral contour occurs higher than the curve of the medial one. In this pose, the two heads of the gastrocnemius (d), the Achilles tendon (e), and on the left foot, the tendon of

the peroneus longus (f) are all noteworthy surface characteristics. The position of the right foot allows us to see that it is decidedly more narrow at the heel than at the toes. Notice that the shadow on the back stops just at the angle of the ribs, where they turn more sharply to the front.

Michelangelo's brilliant study of the back (Fig. 4.92) is a rugged landscape of muscle. But despite the gnarled terrain, the forms never lose continuity, the harmonious flow that human forms always possess. For example, the deep rhomboids overtaking the form of the trapezius, because of the left arm's position, create bulges that are in rhythmic accord with the surrounding hills and valley. Note the clarity of the seventh cervical vertebra, the scapulas, the lower margin of the trapezius (not often seen), and the lower diamond-shaped tendonous plateau.

In this drawing, accuracy sometimes gives way to creative intent and instinct. Perhaps it is Michelangelo's interest in the dramatic "landscape" of the back that accounts for the exaggerations and changes in the

muscles of the lower back and for every muscle appearing to be in contraction. After all, the freedom to interpret forms in any way that is visually logical and expressively accurate is a basic creative necessity. Da Vinci, who was fascinated by the study of anatomy, recognized this necessity when he advised, "He who finds it too much, let him shorten it; he who finds it too little, add to it; he for whom it suffices, let him praise the first builder of such a machine." But even if anatomical considerations are to play a minor role in your drawings, you must have a working knowledge of anatomy if the results are to ring true.

When the female torsos of Figures 4.23 and 4.93 are compared with the male torso of Figure 4.87, obvious and subtle differences are seen, such as the greater scale and heft of the rib cage and the wider opening in the thoracic arch in the male in contrast to the greater investment of fatty tissue in the breasts, the longer waist, and the wider pelvic area in the female. There are subtler differences in proportion, too. In the female, the neck appears longer, the muscles throughout the figure are often less evident, and the

bones are more delicately fashioned, showing fewer abrupt eruptions at the surface. But these smoother, more rhythmic lines are due in great part to the leveling and grading effects of the female's slightly greater endowment of fatty tissue. Even so, the female figure discloses much of its bony and muscular systems, and these are, of course, substantially the same in both sexes.

In Figure 4.93, the points of emergence and insertion of the sternomastoid, as well as its form, are very clear. With the arms upraised, the sternal attachments of the pectoral muscles become visible. In this position, the clavicles rise sharply and become somewhat obscured by the overlapping deltoids and pectorals, and the latissimus dorsi (a) and teres major (b) come into view. The breasts, despite the uplifted arms, remain low on the chest. Note how the flank pad and the gluteus medius muscles provide the widening contours running from the waist over the iliac crests to the legs and how the anterior iliac spines (c, d) project at points which, with the nipples, form the four points of an imaginary rectangle. The subtle mound below the navel is a characteristic

of the abdomen in even the most slender female figure.

In Figure 4.94, the continuity of the scapular area with the arm is clear, as is the scale and fullness of the deltoid and the triangular arrangement of the bony projections at the elbow. The graceful curve of the torso, continued by the backward tilt of the pelvis, is

typical of the side view of the female figure. A similar but more open curve characterizes the upper leg, its front contour turning sharply inward on approaching the knee to overhang the straighter lower leg, which set a bit behind the upper leg.

Matisse, in *Two Sketches of a Nude Girl Playing a Flute* (Fig. 4.95), evokes those characteristics just

4.95 HENRI MATISSE (Cateau-Cambresis, France, 1869–1954, Nice, France)
Two Sketches of a Nude Girl Playing a Flute (ca. 1905–1906).
Graphite on off-white laid paper, 34.4 × 21 cm. sight.
Courtesy of the Fogg Art Museum, Harvard University Art Museums. Gift of Mr. and Mrs. Joseph Kerrigan 1928.71/© 1999 Succession H. Matisse, Paris/ Artists Rights Society (ARS), New York.

described. The artist emphasizes the graceful arc of the torso, treats the legs as tapering cylinders (whose contours reveal Matisse's sure knowledge of anatomy), draws the right upper leg as overhanging the lower, and suggests the more angular nature of the elbows. In the figure on the right, Matisse notes the gluteus medius and external oblique and suggests the collective form of the muscles on the upper part of the uplifted leg as well as the long inclined contour running from the buttocks to the waist, a characteristic feature of the female's lower torso.

In the figure on the left, Matisse extracts and intensifies these particular traits to support the drawing's theme of the female figure's potential for powerful visual rhythms. In the torso on the right, Matisse slows down—both the speed of the movements *and* of the lines—forsaking some of the figure's serpentine qualities in favor of its sculptural ones. Thus, the same artist, on the same page, adjusts anatomy's role to serve different intentions.

In the torso sketch, Matisse employs an evenhanded treatment of the figure's structure and rhythmic energy, while in the full-figure sketch, he emphasizes movement rather than mass. This difference in stress points to the heart of the serious artist's constant concern to invent a personal "recipe" of response from these two basic ingredients of perception.

Every view of the figure offers graphic ideas rich in both design and structure. In Figure 4.96, the bony armature persists through the layers of muscle and fat, affecting the surface form, while these layers produce surface forms of their own. At the same time, supple undulations, shapes, and values set off strong patterns of harmonies and contrasts. These impressions of structure and design are continually interacting. For

example, the median furrow, reinforced by the cartilage of the thoracic arch, is a structural fact; its visual alignment with the tendon of the left sternomastoid is a dynamic fact. Similarly, the left upper arm and left upper leg are simultaneously understood as cylindrical volumes and as forms that move obliquely forward, canceling out each other's direction. They create an hourglass spatial cavity that echoes the hourglass shape of the figure's torso.

Direction—the straight or curved course of an edge or an axis—is one of the strongest visual forces that animate an image. For example, in Figure 4.97, note the similarity between the horizontally oriented arcs of the left upper leg, the left forearm, and the left clavicle. Note, too, that the left thigh's arc continues to sweep upward to the neck, generating a strong action that is countered by the downward thrust of the right thigh, right lower arm, and left upper arm. Such moving rhythms, when noted at the outset of a drawing, help us understand both the design and the orientation of the masses of the subject before us.

Negative shapes also play a part in organizing our images. In the back view shown in Figure 4.98, the long, pointed negative shape between the left arm and the torso is related to the downward-pointing shard of light on the left scapula. It finds its opposite in the dark and downward-pointing left arm. Note that the shape of the foreshortened right upper arm is nearly the twin of the negative shape alongside it. Directionally, the right thigh, the contour of the waist on the right side, the spinal furrow, and the left upper arm all lean somewhat toward the right, countered by the turn of the head, the left-leaning scapulas, and the similar direction of the light-toned area of the sacrum and right buttock.

Here, the large plane of the female's lower torso is clearly evident. Note the gentle mound of the sacral triangle, the disappearance of the iliac crests beneath the fatty tissue at the hips, and the gluteus medius extending farther out at the side than the gluteus maximus. In the extended arm, the hollow on the outer side of the elbow is formed by the supinators' taking a different course from that of the extensors. The relaxed hand is aligned with the long axis of the lower arm, and the differing positions of the arms show the range of the scapulas' movements on the back.

Lillie's interpretation of a similar back-view pose (Fig. 4.99) shows the surface anatomy discussed in Figure 4.98 transformed into engaging graphic ideas. Lillie, especially sensitive to the design possibilities of anatomy, exaggerates some forms and seems to call to the surface others that were probably only weakly discernible in the model. Here structural and dynamic discoveries fuse, amplified by the artist's knowledge of anatomy and his instinct for dynamic order—an expression of certain truths about the nature of human form *and* spirit. Note how the negative shape that separates the legs bears a striking resemblance to the several light and dark shapes that construct the figure's back.

In the female, the greater distance between the rib cage and the pelvis accounts for the longer, more flexible waist area that keeps the upper torso from being pressed against the lower torso in a seated pose, such as shown in Figure 4.100. The rib cage and pelvis approach a right-angle arrangement, yet the upper torso appears free of pressing against the forms below it. In the male, the larger rib cage and the taller pelvis bring these bony masses almost together, re-

4.99 LLOYD LILLIE (1932–) *Standing Figure, Back View* Black chalk, 12 × 17¹/₂ in. Courtesy of the artist.

sulting in a more compressed arrangement of forms (Fig. 4.101). Note, in Figure 4.100, that there are two folds in the torso: The upper one represents the lower boundary of the rib cage; the lower fold represents the upper boundary of the pelvis. Note also that in this pose more of the abdomen is visible than in the male figure, while in the male the rectus abdominal muscles and the latissimus dorsi are far more prominent.

In a standing pose, the patella is quite visible (Fig. 4.94). When the legs are bent to the extreme degree shown in Figure 4.100, however, the patella all but disappears between the broad protuberances of the femur and tibia. In this view of the upper leg, the subtle curve of the femur is reflected in the curve of the fleshed form. The foreshortened view of the left upper arm clearly shows the rounded form of the up-

per part and the squarish form of the lower part. Notice the ball-like mass of the bones of the wrist and the graceful rhythm of the hand.

Comparing Rembrandt's drawing of a heavy-set woman (Fig. 4.102) with the woman in Figure 4.100, we notice the effects of substantial deposits of fat on surface forms. But because fat is stored mainly on the lower torso and upper parts of the limbs, the skeleton and muscles still play an important role in shaping the surfaces of even obese figures, if only in the lower parts of the limbs and at the joints (Fig. 4.82). Moreover, bone and muscle continue to influence, if only weakly, the *general* structural character of the rest of the body, however much overlaid by fat.

In Rembrandt's drawing, the shape of the cranium, the angularity of the jaw, and the bony passages

4.101

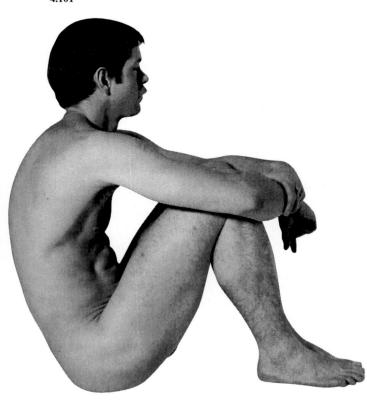

and projections at the joints all show the skeleton at the surface. And except for the abdomen, firm inner masses and shafts of support are sensed throughout the figure. Rembrandt subtly suggests the rib cage, the scapular muscles, the latissimus dorsi, and on the figure's left hip, the heavily overlaid wing of the pelvis.

A major theme in this drawing appears to be the figure's weighty substantiality. To convey this, Rembrandt simplifies the forms by emphasizing the major and secondary planes. For example, he interprets the legs as blocklike and even treats the knees as squared off. Likewise, the lower torso hints at its spherical basis, the head and upper torso suggest ovoids, and the neck and upper limbs suggest cylinders. In discreetly hinting at the geometric essence of the forms, Rembrandt achieves a strong sense of solidity.

But nowhere does he allow simplifications to override important characteristics of surface anatomy that help heighten the drawing's humanistic theme: a woman relaxed, lost in some amusing reverie. Here, structural and anatomical factors interact in a way that enables each to contribute to the sense of weighty human form. Rembrandt's grasp of any form's essential structure helps him convincingly and economically convey anatomical observations such as the complex structure of the knee or the arrangement of the flexors and extensors of the arms. Conversely, his knowledge of anatomy assists his structural theme of summarizing the figure's forms. For example, the blocky plane in the left upper leg is only a modest exaggeration of the flattening effect of the ilio-tibial band. And in the lower leg, where many artists might use the pronounced line of the tibia's sharp edge to explain a change in planes, Rembrandt uses the tibialis muscle as the dividing line between the front and side planes to continue the blocky L-shape of the entire leg.

Here, as in most of Rembrandt's drawings (and paintings), the formula is to resist simplifying structure when it would intrude on the humanistic aspects of his image and to omit surface niceties when they would diminish its structural and dynamic strength. Further, he knows that the figure's structure and anatomy must interplay with its design and expression, too, and that the subject's substantiality of form and significance of spirit must be felt as well as seen.

A sound understanding of structure and anatomy is evident in master drawings, even when the subject is the draped figure. In Piranesi's studies of an action pose (Fig. 4.103), the underdrawing of the nude figure helps him establish the gesture and basic masses of the forms to be draped and to drape them more convincingly. In the figure on the left, the clothing,

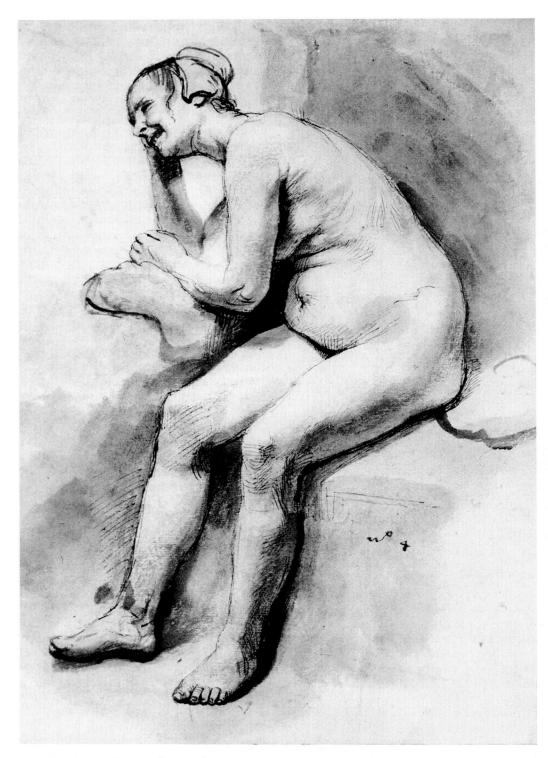

4.102 REMBRANDT VAN RIJN (1606–1669) *Seated Nude Woman*Pen and ink, some washes, $10^1/4 \times 7^1/4$ in. Photo R.M.N./Musee du Louvre, Paris.

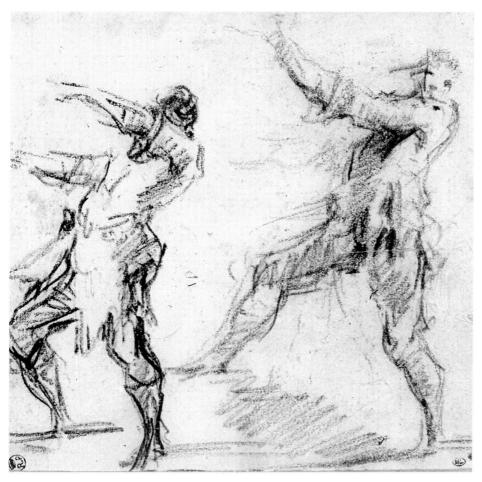

4.103 GIOVANNI BATTISTA PIRANESI (1720–1778) *Two Studies of a Man Standing, His Arms Outstretched to the Left* Black and red chalk, $7^3/4 \times 7^5/8$ in. Photo R.M.N./Musee du Louvre, Paris.

stretched taut on the upper right leg, forms sharp folds that turn and radiate in a way that describes the form and action of the leg and suggests that further raising of the leg must meet even more resistance from the restraining pant leg. Despite the drapery, we know the tilt and mass of the upper torso and the differing direction and mass of the hips. The arms and legs are still more fully revealed. Piranesi even suggests the upper leg's overlapping of the lower one at the knee and the contours of the tibialis and gastrocnemius muscles.

While the skeleton and muscles may be thought of as the substances that shape the figure's structure, anatomy need not always be wedded to the realization of volumes in space. In Lebrun's *Running Figure*

(Fig. 4.104), the artist is more concerned with the shapes than with surface terrain. By exaggerating the ins and outs of the figure's contours and emphasizing enclosed linear units, Lebrun creates violent clashes of strong shapes that add to the drawing's forceful expression of terror. Lebrun's mastery of anatomy enables him to create powerful interpretations of human forms, whatever their positions, as the inventive drawing of each of the arms and legs demonstrates.

While Lebrun distorts the figure's forms, he never ignores or violates fundamental anatomical facts. These distortions are not arbitrary. On the contrary, they are intensifications of the way bone and muscle really do shape human surfaces. Even the strained-

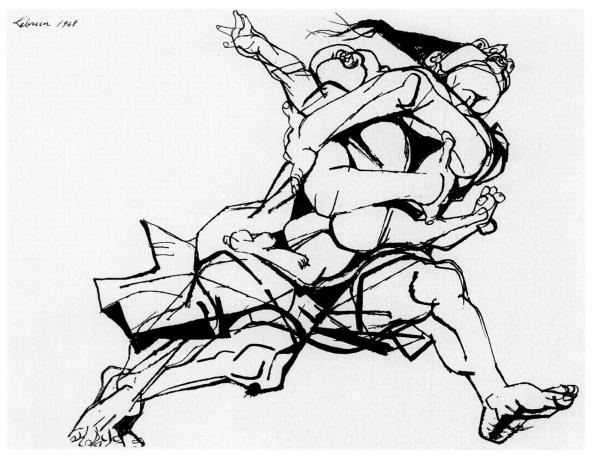

4.104 RICO LEBRUN (1900–1964) Running Figure (1948) Ink on paper, $18^3/4 \times 24^3/8$ in. (47.6 × 61.9 cm.). Collection of Whitney Museum of American Art, New York. Purchase 48.12. Photograph Copyright © 1998: Whitney Museum of American Art.

looking placement of the child's legs is only a slight exaggeration of an anatomically possible situation. It is useful to hold in mind drawings such as these and to realize how important a knowledge of the figure's substructure is to the expansion of our response options.

An example of just how far such knowledge may carry us into the realm of abstract drawing solutions to the figure's limitless challenges is Boccioni's *Male Figure in Motion* (towards the Left) (Fig. 4.105). Here, despite the strong insistence on the two-dimensional activity of line, value, texture, and openended shapes, bone and muscle still stimulate dy-

namic activities, still help express human forms and movements.

In this chapter, we have seen that the purpose of a knowledge of anatomy, whether we simplify, embellish, or objectively record the figure's forms, is to increase the structural, dynamic, and emotive quality of our figure drawings and thus to expand, and not restrict, our creative options. Anatomy's contributions to the factors of structure, design, and expression are many, then, but among the most important is its imparting to our drawings the ring of truth, without which figure drawings cannot come alive.

44.105 UMBERTO BOCCIONI (1882–1916) *Male Figuer in Motion (towards the Left)* (1913) Pencil, $6 \times 4^{1/8}$ in.

The Lydia and Harry Lewis Winston Collection. Courtesy of Mrs. Bernard Malbin.

SUGGESTED EXERCISES

These exercises concern the study of anatomy, taking into account its role in creative figure drawing. You may change them in any way more suited to your approach to drawing, for any examination of anatomical facts will stimulate more inventive responses. Although the anatomical illustrations in this chapter should suffice, these exercises may be done with the help of other anatomical texts (see the Bibliography). As in the previous chapters, vary the size and media of these drawings, but favor large rather than small drawings and use erasable rather than permanent media. Unless otherwise indicated, work from the model. If none is available, work from the photographs provided in this book or others. Unless otherwise noted, there are no time limits on any of these drawings.

 Draw two more or less simplified skulls: one front, one side view. Then, place a sheet of tracing paper over these and draw the muscles of the head as they would appear in each view. Next, place a sheet of tracing paper over the muscle drawing and draw schematic planar versions of the two heads. Try to reduce the planes of the head to the fewest necessary to convey the essential form character of every segment of the heads, taking into account the forms of the muscles and the bones already drawn. These schematic heads should look somewhat like unfinished marble sculptures strong planar judgments but no fussy modeling. Finally, reverse the planar drawing and, by vigorously rubbing with a spoon or any broad instrument, transfer the pencil or chalk drawing to an illustration board or sheet of bristol or vellum paper and check for errors in proportion, location, and so forth. Using this transferred drawing as a guide, draw the surface forms of the two heads, making one female and the other male.

These heads should be developed tonally, the idea being to draw convincing, volume-informing representations of two heads. Of course, this process of developing a part of the figure from the bones up to the surface is an excellent way of studying *every* part of the figure and is suggested for segments that you find especially difficult to understand.

- 2. Draw a three-quarter front view and a three-quarter back view of the flayed torso. Refer to the Houdon flayed figure reproduced in this chapter (Fig. 4.77), but avoid choosing views that closely match these illustrations. Instead, select a view and pose that involve some small bend or twist in the torso. If your first attempt becomes overworked and confused, make a second draft on a sheet of tracing paper overlaid on the first. In this way, you can salvage those areas that are successful. If you wish, you may begin these two views by working from the model. Once the pose has been established, develop the muscular forms on the same sheet or on a tracing paper overlay.
- 3. Using the flayed torso drawings of the previous exercise, place tracing paper over them and freely follow the undulating pathways of the contours and edges of muscles. Allow your lines to move along the rhythmic routes. Start by following the strongest movements and, later in the drawing, shift to less evident or smaller curves and rhythms. Try not to lift your pencil or chalk at all. Instead, travel over earlier drawn lines to reach other areas to strengthen the rhythmic energy of an area. Or leave off following edges to draw the muscle bundles of a part or to describe the straight, curved, or radiating flow of muscle fibers. Keep the line moving; but should you stop, simply refrain from lifting your pencil and begin again. This exercise is intended to familiarize you with the graceful movements that course through the torso's musculature. There is no need to be concerned with structure or even accuracy. The more scribbled and busy these drawings are, the more rhythmic harmonies you have probably uncovered.
- 4. From any standing pose of the male figure, reduce the surface forms to simple planar masses that do not ignore or distort major anatomical facts. Next, from the same or a similar pose of the female figure, make another drawing in the same manner. The results should show rather broadly carved figures, somewhat similar to Giacometti's or Cambiaso's drawings (Figs. 1.41 and 4.90). When you have completed both drawings, try to superimpose on them (or draw on a tracing paper overlay) the position of the bones of the skeleton, as in Figures 3.5, 3.41, and 4.78.
- **5.** Working either from the model or by using a mirror and your own free arm, drawing the following:
 - a. Any supinated view of the extended arm.
 - **b.** Any pronated view of the extended arm.
 - c. Any view of the arm in a bent position, with the hand either prone or supine. This drawing may show a foreshortened view.

Next, on a tracing paper overlay, draw the muscles as they would appear in these differing views. On another sheet of tracing paper, make a study of the rhythms of the arm muscles in the manner described in Exercise 3. Finally, returning to your original three views of the arm, rework or even redraw them, suggesting lean, muscular arms that strongly suggest the bones at those places where they come to the surface. Stress the clarity of the muscles as they might appear if the skin were translucent.

- 6. In the same manner described in the previous exercise, draw the following:
 - a. A front view of the legs, the weight on one leg, the other relaxed but straight.
 - **b.** A side view of the legs, the weight on one leg, the other relaxed but slightly bent.
 - c. A three-quarter back view of the legs, the weight on one leg, the other slightly raised by being placed on a small block or stool.
 - d. A front view of the legs as they would appear in a seated pose with the legs crossed at the knees.
- 7. Using your own hands and feet as models, draw as many life-size views of them as you can conveniently fit onto a sheet of paper about 20 × 30 in. Some of these drawings may go off the page; some may be partially hidden behind others. Use a mirror to increase the variety of poses and views. Begin each drawing with a light gray chalk or any comparably light-toned chalk, using it to establish the general masses and proportions. Next, using a slightly darker tone of chalk, draw in a sparing and simplified way the general masses of the bones and major muscles and tendons of the hands and feet. Finally, using black chalk and allowing some erasures of the underdrawing wherever you wish to simplify or lighten it, draw the surface forms as convincingly as you can, concentrating on the impression of solid, weighty volumes.
- 8. Using a light gray or comparably light-toned chalk, draw one male and one female figure in action poses. Make each figure about 30 in. tall and suggest their muscles as strongly as might be the case if their skin were translucent. That is, draw these figures in a way that suggests the muscles and tendons below, but in a generalized, suggestive manner. You may want to generalize some of the smaller muscles, establishing their collective mass instead. Emphasize the rhythms and flow of the muscles. Suggest bony passages where they come to the surface. Next, lightly rub the drawings to further generalize and soften them and continue the drawing with black chalk, establishing the surface forms but allowing the underdrawing to influence the amount of muscular detail to be shown. The completed drawing should be of rather lean but muscular figures, their skin still "thin" enough to permit us to see many of the forms and harmonies of the anatomy below the surface, as is often the case in Michelangelo's drawings (Figs. 3.20, 4.89, and 4.92).

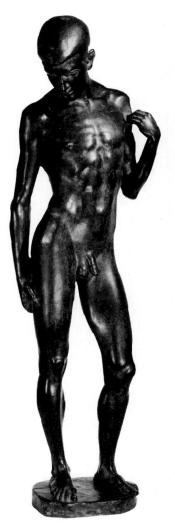

4.106 ARISTIDE MAILLOL, French (1861–1944) Young Cyclist (ca. 1907–1908). Bronze (1925 cast), 96.52 cm. actual. (H: 38 in.). Courtesy of the Fogg Art Museum, Harvard University Art Museums. Friends of the Fogg Art Museum and Alpheus Hyatt Funds 1962.199/ © 1999 Artists Rights Soeiety (ARS), New York/ADAGP, Paris.

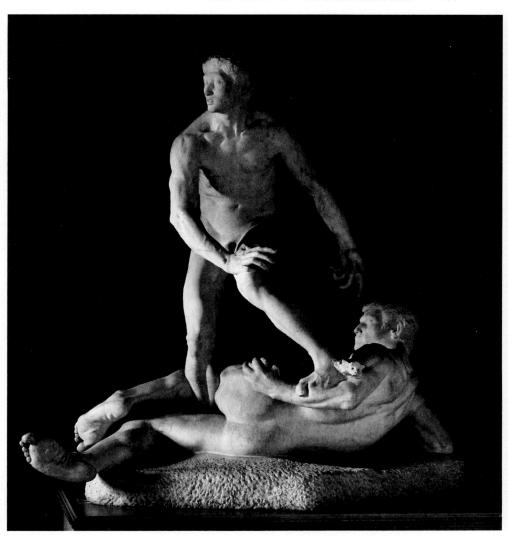

4.107 GEORGE GREY BARNARD (1863–1938) *The Struggle of the Two Natures in Man* (1894) Marble, H: 101¹/₂ in., W: 102 in., D: 48 in. The Metropolitan Museum of Art, New York. Gift of Alfred Corning Clark, 1896. (96.11)

- 9. Using Figure 4.106 as your subject, draw the figure from any other view. Imagine being able to step around to his left or right side. What would the forms look like from these views? It is best to develop these invented views by stages, working first with structural summaries on tracing paper, until you work out the arrangement of the basic forms of these imagined views.
- 10. Using Figure 4.107 as your subject, make a free interpretation of these figures, allowing some modest exaggerations and distortions to express your impression of these two struggling figures. You can stress or subordinate volume; you can, within reasonable limits, relocate parts of these figures and even make anatomical matters play a minor role.

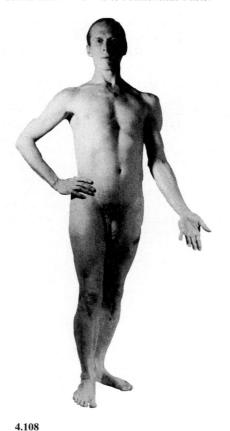

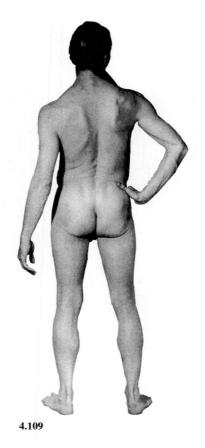

- 4.100
- 11. Working from your imagination, fill a page with small action poses that show the interactions of structure, anatomy, and your feelings and ideas about the mood and energies of each pose. Although we have not yet discussed the factors of design and expression in depth, every pose suggests some expressive action; all possess harmonies and contrasts of direction, shape, value, and mass. Try to convey something about these visual and expressive states in each pose. Each of these small figures should be drawn in less than 7 or 8 min.; even 5 min. allow for some comment on each of the four factors. These poses may be of both male and female figures or may show consecutive stages of a particular action. For example, you can show the various stages of a dancer completing a leap or spin, a boxer falling down, an acrobat performing a stunt, and so on.
- 12. Draw two or three faithful copies of drawings by artists whose approach to figure drawing strongly attracts your interest. Next, try to draw several figures (from the model) in the manner of these artists. Study and copy their drawings to sense the artists' intentions and interests but not to adopt their "handwriting." Select artists who draw very differently from each other. For example, Michelangelo, Degas, and Pascin provide an informative collection of themes, attitudes, and approaches to the figure's anatomy.

- 13. Cover a small sculpture armature, manikin, plastic skeleton, or plastic skull with muscles you have shaped out of Plasticine® clay. If such supports are not available, make an armature out of simple wooden, metal, or even cardboard forms, wrapping thin-gauge wire around them to hold the clay better. If you make this a reclining figure, you may omit the armature.
- 14. Make a drawing of the model (or figure in a photograph) as he or she would look after gaining fifty pounds. Remember that fatty deposits vary throughout the figure.
- 15. Draw a flayed figure that represents your guess as to what the "missing link" in human evolution looked like. Start by drawing a generalized skeleton that shows some differences in proportion. Then, develop the forms as described in Exercise 8, taking into account your ideas about the differences in musculature that this skeleton may require.
- 16. Draw a draped male figure. Suggest as much as you can about the surface forms below. Make a similar drawing of a female figure. Think of the drapery as wet, clinging to the forms in some places, its folds explaining the general masses in other places.
- 17. Rework or redraw some of your earlier life drawings, indicating important bony and muscular landmarks. In

- some of these drawings, try to show the figures as emaciated, their bones and muscles strongly evident.
- 18. Place a sheet of tracing paper over each of the Albinus drawings (Figs. 4.74, 4.75, and 4.76) and draw the figures as they would look in the living state. Working tonally, allow some of the important anatomical landmarks to be evident in the completed drawings.
- 19. Examine Figures 4.38 and 4.105 by Boccioni. Working from the model, aim in several drawings for a similar, somewhat cubist image that strongly suggests energy and action. In doing so, emphasize anatomical features.
- **20.** Using Figures 4.38 and 4.105 as "models," draw what you believe the model posing for Boccioni looked like in each of these two poses. Draw these poses in a more

- objective mode, but try to suggest the muscular energy that these drawings convey. To help you do this, look at another, more realistic drawing by Boccioni (Fig. 4.44).
- 21. Tape tracing paper over Figures 4.108 and 4.109 and carefully draw each figure's outline. Remove the tracing paper and continue by drawing the skeletons on it, as each would appear in each pose. Next, place another sheet of tracing paper over the first sheet, redraw each figure's outline, and continue by drawing the muscles as they would appear in each pose. In addition to the muscle illustrations in this chapter, Figures 4.108 and 4.109 provide useful information for this stage of the exercise. Concentrate on the larger muscles, leaving smaller ones (such as the muscles of the lower arm or leg) as more generalized masses.

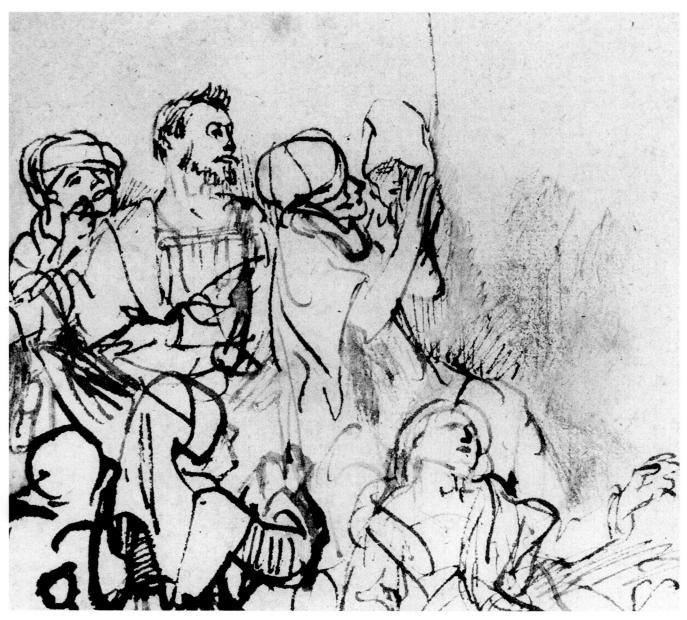

5.1 REMBRANDT VAN RIJN (1606–1669)
Study for the Group of the Sick
in "The Hundred Guilder Print" (detail)
Reed and quill pen, wash, 45/8 × 43/8 in.
Photograph by Walter Steinkopf. Staatliche Museen
Preussischer Kulturbesitz, Kupferstichkabinett, Berlin.

5

The Design Factor

The Relational Content of Figure Drawing

SOME GENERAL OBSERVATIONS

In the three preceding chapters, we concentrated on what can be thought of as the "semantics" of figure drawing—the structural and functional aspects of the figure's forms. In this and the following chapter, we will examine the "syntax" of figure drawing-the ordering of the relational and emotive meanings of the figure's forms. Throughout our exploration, we should bear in mind that separating design considerations from those of expression, if it can be done at all, unnaturally divides interacting aspects of what we perceive as one phenomenon in a drawing. For example, the design strategy of Lillie's Running Figure (Fig. 5.2) is based on the rhythmic harmonies of an airy web of thick-thin and light-dark curvilinear lines. But the urgent speed of these lines, their furious calligraphy, and their allusions to supple, straining human forms are powerfully expressive messages. All these lines are engaged in both syntactic functions simultaneously.

Nevertheless, separating these two dynamic factors for the time being will help us explore more fully the essential nature of each. For while always deeply interlaced, each factor has its own discernible effects. A drawing's design is the state of its abstract life and order—its relational, or *formal*, condition; a drawing's expression is its emotional content and consists

of two kinds of emotive material. First, there is the drawing's psychological mood or tone, which is the vigorous, reflective, melancholy, joyous, or other mood carried by the overall state of the design and, second, by the various interactions, tensions, and movements among the parts of a drawing. The drawing style itself may show an urgent, deliberate, sensual, or other kind of calligraphy and handling. Additionally, in figure drawing, expression is, also present in its human theme. A drawing's design, then, is the organizational consequence of its abstract and representational occurrences and includes the relationships of value, scale, direction, and the like that exist among the things and situations represented in the drawing and among the drawing's marks. A drawing's expression is the felt effects of these occurrences on the viewer. In this chapter, we will concentrate on the visual relationships at work in well-designed drawings.

Simply stated, a good design is one in which all the seemingly different parts relate visually to form balance and unity. But don't we naturally associate the objects we see? After all, isn't it almost impossible to keep from seeing that a finger belongs to the greater unit of the hand, that a small fold in the brow is similar in shape to one in the cheek, and that arms are shorter than legs? Of course, we see these and countless other relationships. But where we often falter is in showing these relationships only within a

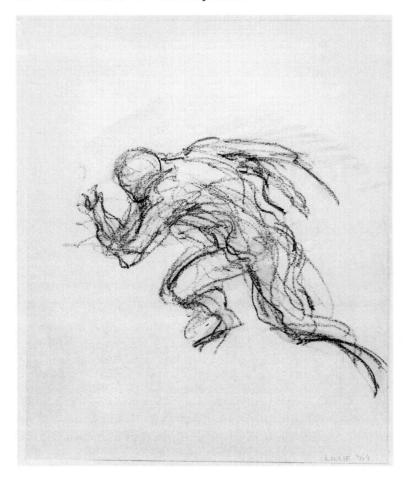

5.2 LLOYD LILLIE (1932–) *Running Figure* Pencil, 15 × 18 in. Courtesy of the artist.

part; that is, only in small sections of the drawing that do not relate to each other. Thus, the finger is seen as part of the hand, but the hand may not be seen in relation to the other hand or to a nearby fold or object. The arms and legs are drawn in proportion, but their various shapes, directions, and tones might not be related to other shapes, directions, and tones elsewhere in the drawing.

In the best drawings, however, every line and value, every shape and texture, every inference of movement is interrelated with others in some kind of visual network that creates a particular scheme of order throughout the drawing. A single drawing generally shows several of these schemes, or *visual themes*. Visual themes are often partly intended and partly intuitive.

A visual theme can be any sequence or configuration among the visual elements that reappears in a drawing, always in variations on itself. Variations may include an inversion of order: The symmetrical composition, for example, is based on a reversal of material along a vertical midline. Or a visual theme that repeatedly appears among the shapes and forms in a drawing may be developed into a larger compositional theme. For example, notice all the L-shaped configurations in Barnet's *Figure and Cat, Study for Dusk* (Fig. 5.3). There is one formed by the cat's head representing the vertical stem of an L-shape, with its body forming the horizontal stem. The pillow on which the woman's (L-shaped) arm rests is also L-shaped, as is the woman herself. Barnet then uses this motif as the drawing's overall compositional theme by having the woman's vertically oriented upper body "turn the corner" of the drawing's otherwise horizontal alignment of parts.¹

A visual theme may be gradually transformed into or fused with another theme. Rembrandt's *Study for the Group of the Sick in "The Hundred Guilder Print"* (Figs. 5.1 and 5.4) provides an excellent example of the interrelation of the elements and of several

¹ For a comprehensive discussion of visual themes and compositional structures, see Nathan Goldstein, *Design and Composition* (Upper Saddle River, N.J.: Prentice Hall, 1989).

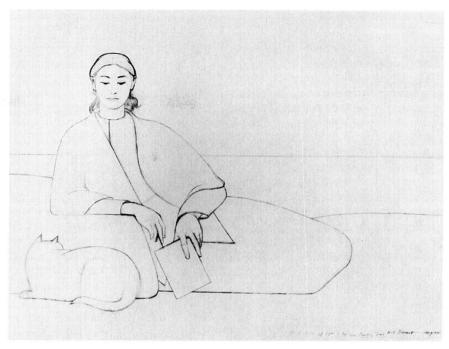

5.3 WILL BARNET (1911–) *Figure and Cat, Study for Dusk* (1975) Pencil on paper, 35³/₄ × 43 in.

The Arkansas Arts Center Foundation Collection: The Museum Purchase Plan of the NEA and the Tabriz Fund, 1976. #76.10.f/© Will Barnet/Licensed by VAGA, New York, NY.

5.4 REMBRANDT VAN RIJN (1606–1669) Study for the Group of the Sick in "The Hundred Guilder Print" Reed and quill pen, wash, 45/8 × 43/8 in. Photograph by Walter Steinkopf. Staatliche Museen Preussischer Kulturbesitz, Kupferstichkabinett, Berlin.

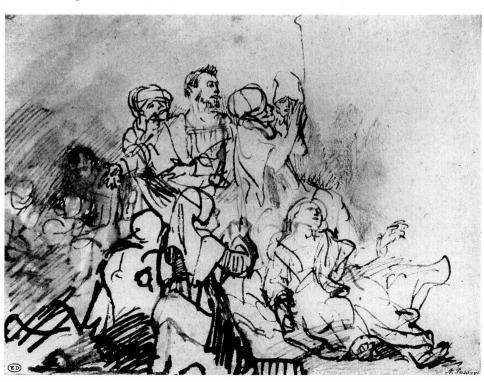

visual themes at work. Here, *all* the marks, shapes, and masses they suggest as well as every value, direction, and rhythm cooperate in building the drawing's dominant organizational idea: a large pyramidal configuration. This great triangular shape is the culmination of the many smaller triangular shapes in the work. Each of the figures, to varying degrees, suggests the triangular shape of the group; each carries the seed of the dominant organizational strategy.

A second design theme, the rich curvilinear rhythms that coil through the group, animates and further units the figures. Note that some of these curvilinear lines participate in forming the smaller triangles, as in the headdress of the boldly drawn kneeling figure in the foreground—the fusing of themes. A third system of circular shapes and forms provides still another visual theme that takes our eye into and around the group, giving us the sense of these figures as forms in space. Note how firmly Rembrandt builds this pyramid, the boldest lines and tones at its base. Note, too, that he creates a path between the near and far sides of the group. The path seems illuminated, as if some force is about to come among them. The figures, looking up, add to the sense of an impending activity moving leftward.

A visual theme can be a certain mode in the treatment of an element, a way of using, say, line or value. The rippling action of the lines in Figure 5.2 is such a theme; the more mechanical lines in Figure 5.3 is another.

Not unlike a musical theme, a visual thematic idea appropriate to the subject matter occurs to the artist, and its essential character is repeated in variations that serve to weave the work together and magnify its expressive point. Each theme, through its subtle variants and in contending with counterthemes, creates tensions and energies in the drawing of a formal kind; that is, of a purely abstract nature. And as we shall see in the following chapter, a drawing's expressive character emerges as much from these abstract activities as from its representational meanings.

Although sensitive to a figure's placement on the page, the design of many figure drawings does not reach out to engage the entire surface of the sheet. Often, it is concentrated in the figure itself. In Rembrandt's drawing, however, the shape surrounding the group actively contributes to the drawing's ordered visual condition (and consequently, to its expression). The background tones and the suggestion of a column help establish the sense of space, its two triangular wings echo the pyramidal theme, and its relatively small scale adds strength to the group's forms and actions by making them appear almost too energetic to be contained in so small a format. Had the background been smaller, the drawing would have been too crowded, the forms choked by the tight enclosure;

had the background area been larger, much of the drawing's power would have been dissipated.

Villon's Study for a Washerwoman (Fig. 5.5) is a clear example of visual themes that are held to the figure itself. Again, a dominant theme envelops the entire image. It is a system of intersecting diagonals that cascades down the figure. We feel these diagonal thrusts moving downward for two reasons: First, each of the bold diagonal marks appears to have been begun at its top and drawn downward, the lines and tones growing darker as they descend; and second, as Denman Ross points out, our eyes tend to move in the direction of diminishing intervals.² Here, the crisscross of diagonals occurs more frequently in the drawing's lower section. This intensifying zigzag activates the figure's gesture and, by its recurring role, unifies the image. A second theme that treats shapes in a harsh triangular manner is also at work, lending a crisp angularity to the woman's movements while it conveys the texture of her attire.

As these drawings show, in a good organizational system, all parts interrelate through various visual kinships and contrasts, every mark participating in the drawing's particular systems of ordered thematic actions. And as we saw in Rembrandt's and Villon's drawings, there is usually more than one visual theme at work. The kinds of visual themes possible are, of course, limitless. We have been examining some rather evident ones. Others can be very subtle. Consider, for example, in Villon's drawing, the inversion of the shape of the hair in the tones that define the breasts and several folds in the dress.

Further, a good design reveals an order of visual importance, a hierarchy of its visual themes. Without such a hierarchy, Rembrandt's pyramid and Villon's cascading diagonals would be lost amid the confusion of competing systems; we would be unable to decide, or even to see, what organizational and expressive meanings the artist intended.

Still another necessary condition for good design is the balancing of its parts on the page. Balance occurs when a drawing's measurable components of scale, shape, mass, value, position, and so forth as well as its abstract forces—that is, its expressions of weight, movement, tension, and rhythm—achieve a distribution of elements and energies that conveys a state of stability. This stability is based on visual activities that check and regulate each other—a system of compensations that suggests mutual restraint rather than immobility. In a balanced drawing, we sense equilibrium in both the physical and visual weight of the forms and in the behavior of the visual forces.

² Denman Ross, *On Drawing and Painting* (Boston: Houghton Mifflin Co., 1940), pp. 75–79.

5.5 JACQUES VILLON (1875–1963)

Study for a Washerwoman (Etude pour une blanchisseuse) (1902)
Graphite and black ink wash on paper, 381 × 255 mm (15 × 10 in.).
Gift of Louis Carre. Courtesy, Museum of Fine Arts, Boston. 64.732/

© 1999 Artists Rights Society (ARS), New York/ADAGP, Paris.

Drawings without a balanced resolution of parts and energies cannot hold together. With weight and movement unchecked, forms and forces break loose; isolated, floating, or falling parts and movements in conflict overwhelm any other aspects of order in the image. In the confusion and disorder of imbalance, abstract and figurative meanings are also lost, the chaos of conflicting and ambiguous visual clues making it impossible to sort out these meanings. In figure drawing, the repose and tranquility of a reclining figure can be shattered by a hovering dark tone, placed to appear about to fall; by unchecked diagonals that slide the figure down toward a corner of the page; or by any other element or energy that remains unstabilized in either its depictive or dynamic function. The balanced governing of forms and forces is necessary not only because we instinctively react with unease to a state of disequilibrium, but because the clarity of a drawing's total expressive content depends on its balance.

Implicit in the foregoing is that all good design is *unified*. In a well-ordered drawing, the harmony and cohesion of the parts and thematic actions, the artist's consistency of intent, and the manner of execution—his or her style of handling—all work together in a unity of visual (and expressive) purpose. All good drawings appear as a single piece, having an ultimate oneness. Despite the often powerful visual exchanges between their contrasting parts, they convey a sense of necessity and belonging, qualities vital in making an expressively sensible image.

But the artist must be mindful of a danger inherent in the search for unity. In art, the opposite of the chaos of visual anarchy is the monotony of visual rigidity and sameness. When the desire to organize an image leads to its overstabilization, when it is too rigidly interlocked by similarities, the results—being obvious in their sameness—are dull. A chessboard is certainly a unified design, but a boring one. In a good design, unity is achieved by the governing of contrasts: utilizing their contrapuntal behavior to emphasize certain passages, enriching the visual interplay of the marks, and balancing the image, as well as by the congenial merger of similarities. A good design always depends on variety, on the presence of stabilized differences, to keep from being excessively harmonized.

In drawing, then, to design is to compose content in a visual syntax that communicates clearly. And the requirements of a good design—the interplay, hierarchy, balance, and unity of a drawing's parts and dynamics—are met by our ability to perceive relationships. As Delacroix put it, "What does it mean to compose? It is the power to associate . . ."

When artists look about, they tend to see line, shape, scale, value, volume, color, texture, position, and direction in various relationships. They have come to understand that these measurable properties

of the things we all see have no visual meanings for drawing until they are related to other like or unlike properties in the things around them. Artists also know that these relationships need not be recorded only as seen; that by selecting those which support their goals and subordinating all others, they can make visual associations that form a complete statement of intent. Henry James once observed that "universally, relations stop nowhere, and the exquisite problem of the artist is eternally but to draw, by a geometry of his own, the circle within which they shall happily appear to do so."3 In a good design, then, the "circle," the field of energy within which relationships work, exhibits a sense of self-contained order, one in which we do not want to add or remove anything.

A sensitive design begins, as Delacroix observed, with the ability to associate, to make estimates, comparisons, and judgments about the similarities and differences in a subject's physical and dynamic actualities. The artist translates these perceptions into visual terms by means of the visual elements.

The element of color, because it is only an occasional participant in drawing and is generally cast in the role of a supporting player, is not discussed here in depth, but references to color appear throughout the text. However, a few general observations are in order. Color is a great modifier of the other elements, as the difference between viewing a black and white and a color television set makes clear.

Color is a powerful agent of volumetric and spatial clarity, lending emphasis to mass and space and to what is located near and far through its warm and cool hues. For example, a form meant to be located in the front plane of the pictorial field will do so more convincingly if it shows a warm color such as yellow, orange, or red; a form meant to be located far back in the spatial field will be more likely to do so if it is a cool color such as blue or green.

Color can make unlike parts relate, as when a book and a hat are similar in hue, or it can make like parts contrast, as when two books or hats are strikingly different in color. For this important reason, color is also a powerful agent of design, introducing connections and contrasts that help organize and enliven a work. Finally, color is capable of amplifying a drawing's mood by its cheerful, somber, or other character; therefore, it is a powerful agent of expression, as well.

Although a thorough exploration of the visual elements, more appropriate to a basic drawing book,⁴

³ Henry James, *Prefaces* (1907–1909), ed. Roderick Hudson.

⁴ See Nathan Goldstein, *The Art of Responsive Drawing*, 4th ed. (Upper Saddle River, N.J.: Prentice Hall, 1992), chap. 8.

is not attempted here, it is necessary to discuss these tools in more than a passing way to see some of their limitless relational possibilities.

THE VISUAL ELEMENTS

The six elements we will examine more fully are *line*, *value*, *shape*, *volume*, *space*, and *texture*. Of these, line and value enjoy a special importance inasmuch as the other four elements are made by one or the other or by their combined use. Of these two elements, line is the more universally used in drawing, the more direct and versatile, the element most at the heart of drawing. Indeed, the completely tonal drawing, resembling a photograph in its absence of line, is relatively rare. Nevertheless, value used alone can produce powerfully effective images, as can be seen in the conté crayon drawings of Seurat (see Fig. 6.19).

Marie Laurencin's *Self-Portrait* (Fig. 5.6) is a fine example of a drawing developed almost exclusively with tone, in this case, applied by charcoal and pencil. More typically, though, whether in dry or fluid

media, values in drawing are made by hatched strokes that collectively create the various tones we see, even when the use of value in a work exceeds that of line. The function of space will receive further attention when we examine the energies of the elements in action. This elusive element, which gives visual meaning to the location of all the other elements, cannot be directly examined, for space has no meaning outside the context of the elements that create and interrupt it.

Line

As an element, line refers to more than drawn lines. Boundaries or edges of shapes and forms, even when established by rough washes of ink tones, function as lines of separation from adjacent shapes, values, forms, or spaces. The long axis of a shape or form is also seen as a line phenomenon. The curve in a bending torso or an eyelid is a directed linear action. The long axis of the head may lie on a different line from that of the neck. Often, the long axis of even a complex form, or an axis running through several forms

5.6 MARIE LAURENCIN

Self-Portrait (1906)

Pencil on paper, $8^5/8 \times 6^3/4$ in. $(21.9 \times 17.1 \text{ cm})$. The Museum of Modern Art, New York. Purchase. Photograph © 1999 The Museum of Modern Art, New York/© 1999 Artists Rights Society (ARS), New York/ADAGP, Paris.

turned in differing directions, may still be a simple straight or curved line.

In Figure 5.2, a gently curved "line" runs downward from the figure's head to the left knee. And in Figure 5.5, the long axis of the woman's draped body, from head to feet, is vertical, despite the zigzag directions of the figure's parts. Such "lines" run through groups of shapes and forms that may differ in scale, value, texture, and substance; they may do so even when shapes and forms are separated from each other by considerable amounts of space. Indeed, the shape of a space separating solids can also participate in their linear arrangement. People "line up" for tickets to the theater; furniture may be "aligned" in straight or curved arrangements; and a model's extended arm may be "in a line with" the top (line) of a bureau across the room.

Matisse's Girl with Tulips (Jeanne Vaderin) (Fig. 5.7) demonstrates all these types of invisible line. In addition to the behavior of the artist's drawn lines, some of which course through forms or state the main visual theme (a large triangular arrangement similar to that of Fig. 5.4), there is the linear effect of the dark shape of the hair, important to the drawing's design strategy. Note how the shape's projection on the figure's right side is restated by the action of the lines that constitute the figure's right arm. Note, too, how similar the shape of the hair is to the shapes of the light gray turtleneck blouse, the upper body, the leaves, and the flowerpot. All these edges, and the forceful way in which they are drawn, produce a bold, rhythmic line play that envelops the entire configuration. Additionally, we sense lines not actually drawn, as in the large curved sweep of the two arms and the shoulders. By repeating lines that define the location of the arms and torso, Matisse causes lines to suggest movement in the figure.

Although lines do not exist in nature—do not surround forms and spaces—they are the most direct and visually logical means for conveying descriptive, dynamic, and expressive matters, which makes line an excellent means for searching out a subject's gestural behavior. We see this in Creti's *Studies for Jacob Wrestling with the Angel* (Fig. 5.8). The artist uses an animated line to express the energetic action of these groups of figures. In so doing, he extracts the linear action and order of these interacting figures to reveal that they wrestle at the abstract as well as the representational level; these swirls of interlacing lines not only describe, but they also enact the figures' energetic activities.

Line is capable of suggesting differing moods and even speeds. In contrast to Creti's spirited calligraphy, the line in Kuhn's *Seated Woman* (Fig. 5.9) is, for the most part, slow, easygoing, and largely restricted to

defining edges. Instead of using lines to act out strong rhythmic movements, Kuhn restrains their speed and assigns them the task of suggesting the figure's graceful resting forms. But the artist's interest in using line to accent the subject's shape state—the two-dimensional arrangement and nature of its formsmakes him hold back from suggesting heavy, limpid forms; the figure and the legless chair seem almost weightless. To underline the drawing's dominant line quality, Kuhn alters the character of some of the lines of the chair, speeding them up in a series of bold scallops. He also reinforces his two-dimensional theme by a pattern of dots and broad ink strokes. Both systems rise to the surface of the page, activating the design on the picture plane as well as in space. In this way, the artist calls our attention to the element of space as simultaneously existing in two- and threedimensional terms—as interspace and field of space.

Kuhn's knowledge of structure and anatomy is evident in the line's volume-informing delineations. Although an impression of weighty mass is intentionally subdued, the few lines used to define the figure tell a good deal about its essential structure and anatomy. Indeed, one of the more appealing qualities of this drawing is the large amount of abstract and representational content conveyed with such an economy of line. There are no unnecessary embellishments and no "unemployed" lines—each mark has a function in the drawing's depictive and dynamic states.

Lines can take on different functions simultaneously. In Kuhn's drawing, lines in the hair are both textural and structural, shape-making lines define planes and direction, other lines in the drapery suggest texture, and so on. Lines can be sorted into several broad categories, but all lines either function in more than one way or can alter their role and character along their course. A line begun as a gentle caress may end up as a furious slash.

As discussed in Chapter 2, structural lines, diagrammatic lines, and delineating or contour lines can impart a wide range of dynamic qualities. Each of these types of line may be primarily investigative, descriptive, or declarative in function, but each will always convey other qualities. Diagrammatic, structural, and contour-line functions can be seen in Michelangelo's Studies of Nude and Draped Figures (Fig. 5.10). Diagrammatic lines, such as those in the right arm and drapery of the female figure (back view), underline most of the structural lines that more fully model the forms. Instead of using a pronounced, independent contour line, Michelangelo delineates forms by massing or darkening structural lines as they approach edges, only occasionally reinforcing an edge by a short segment of contour line. These darker

5.7 HENRI MATISSE (1869–1954)
 Girl with Tulips (Jeanne Vaderin) Issy-les Moulineaux (early 1910).
 Charcoal on buff paper, 28³/4 × 23 in. (73 × 58.4 cm).
 The Museum of Modern Art, New York. Acquired through the Lillie P. Bliss Bequest.
 Photograph © 1999 The Museum of Modern Art, New York/© 1999 Succession H. Matisse, Paris/Artists Rights Society (ARS), New York.

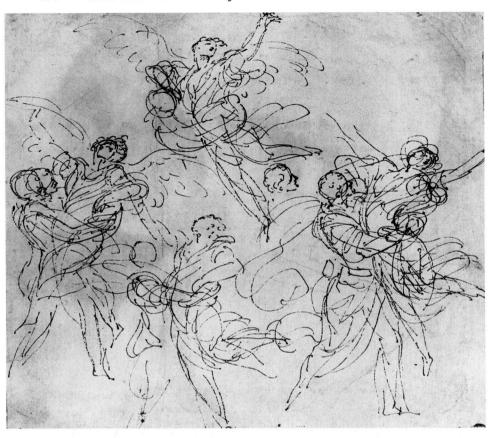

5.8 DONATO CRETI, Italian (1671–1749)
Studies for Jacob Wrestling with the Angel
Pen and brown ink, 21.6 × 24.3 cm.
The Art Museum, Princeton University.
Gift of Nathan V. Hammer. 1959-34.

5.9 WALT KUHN, American (1880–1949) *Seated Woman*

Pen, brush and ink on paper, H: $13^{13}/16$ in., W: $16^{1}/16$ in.

The Metropolitan Museum of Art, New York, Rogers Fund, 1955. (55.117).

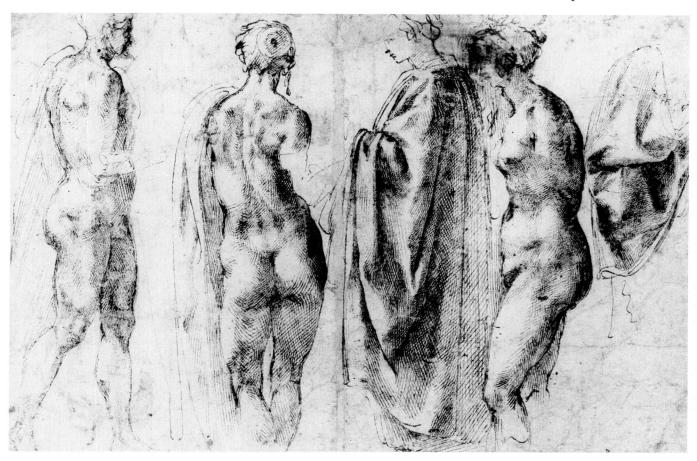

5.10 MICHELANGELO BUONARROTI (1475–1564) *Studies of Nude and Draped Figures* Pen and ink, $18^{3/8} \times 15^{1/4}$ in. Musee Conde, Chantilly Photographie Giraudon.

declarative segments are sometimes used to emphasize the weight of a part, to show the effect on the figure's surface of inner anatomical forms, or to amplify a visual theme of periodic, rhythmic curves.

Some lines, although they may function in various descriptive ways, are of an animated and curvilinear, or *calligraphic*, nature. They more strongly call attention to their own abstract activity as well as to their representational roles. Such lines are often bold and emotive, as can be seen in Lachaise's *Back of a Nude Woman* (Fig. 5.11), where the calligraphy takes on an oriental elegance. Often, artists strongly attracted to the animated action of line show a variety of calligraphic treatments in a single drawing, as in Oldenburg's *Stripper with Battleship: Preliminary Study for "Image of the Buddha Preaching"* (Fig. 5.12). But calligraphic lines—lines *inherently* active and seemingly aware of each other in their abstract in-

terplay—can be less flamboyant and more fixed on objective depiction, as in Derain's *Ballerina with Raised Arm* (Fig. 5.13).

Hence, in figure drawing, the calligraphic line, even the most expressively ornate kind, has its depictive duties to perform, just as the most descriptively motivated lines have abstract and expressive obligations to the drawing's dynamic state. In the best figure drawings, every kind of line is, to one degree or another, engaged in depicting and enacting, and thus in expressing.

A calligraphic attitude to line animates the forms in Rembrandt's *Esau Selling His Birthright to Jacob* (Fig. 5.14). Although we can discern diagrammatic, structural, and contour lines, all are activated by an energetic play of movements and rhythms between the often diagonally situated planes, forms, and tones that have calligraphic overtones. Every line serves several needs at once. For example, the bold hatched

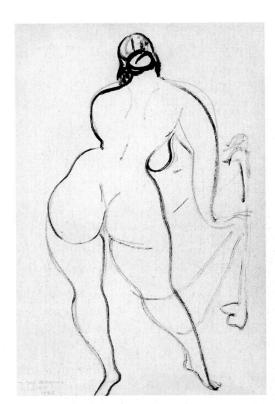

5.11 GASTON LACHAISE (1882–1935)

Back of a Nude Woman (1929)

Pencil, quill pen, India ink and brush wash, $17^3/4 \times 12$ in. Courtesy of The Brooklyn Museum, gift of Carl Zigrosser. 38.183.

5.13 ANDRE DERAIN

Ballerina with Raised Arm (n.d., ca. 1925?) Charcoal on cream-white laid paper, $24^{1}/2 \times 19$ in. (sheet),

 $2^{1}/2 \times 17$ in. (image).

Santa Barbara Museum of Art, Gift of Wright S. Ludington/
© 1999 Artists Rights Society (ARS), New York/ADAGP, Paris.

5.14 REMBRANDT VAN RIJN (1606–1669)

Esau Selling His Birthright to Jacob

Reed and quill pen, and wash, 7³/₄ × 6³/₄ in.

© British Museum.

lines of the tablecloth, while essentially diagrammatic and structural in function, are, in the context of the other lines of the drawing, strenuously calligraphic as well. Rembrandt strengthens some contours, such as those defining the arms of the two figures, to gain both dynamic and representational clarity. The bridge formed by these arms spans the two halves of the drawing, a link that bolsters both the drawing's design and its dramatic impact. Note how structurally informing are the calligraphic lines of Esau's turban and boots. In this drawing, despite the rich variety of line—the range in their value, width, texture, and length—all lines interrelate strongly. They "call" to each other, creating a cohesive order at both the abstract and figurative levels.

As Rembrandt's drawing demonstrates, descriptive lines can sometimes be so emotive in their calligraphy, and expressive lines can be so descriptive, that

they cannot be defined as being predominantly one or the other. But many artists prefer lines that plainly disclose a dominant attitude, whether structural or calligraphic. In whatever way we use line, a recognition of its versatility of function and character is important in learning to command this seemingly simple but potent element.

Value

The second element, value, also offers a broad range of functions and relational possibilities. As we have seen, value is sometimes a byproduct of hatched lines and is often an important consideration in modifying the character of lines in drawings we would regard as purely linear. For example, while Figure 5.11 is clearly linear, the variations in the value of the lines play several important visual roles. Lachaise uses

pure black to suggest both weight, as in the shoulder and breast, and the dark tone of the hair. Gray lines, some of them very faint, permit him to indicate forms farther away, delicate drapery, and subtle anatomical notations. Such changes in the tone of the lines help him suggest space as well as form.

Areas of tone, whether produced by hatched lines, washes, or broad chalk strokes, create shapes. These shapes, when they function as planes, can produce volumes, and by the way the tone is applied, various textures can be suggested. Such shapes of tone are often so fused or subtly graduated in value that their essential configuration is obscured, as in Figure 4.82. But in Daumier's Head of a Woman (Fig. 5.15), the shapes of tone are distinct enough to serve as a useful example of their volume-creating ability. By grouping all of the many values of his subject into four tones, Daumier also strengthens the sense of an ordered arrangement of values on the picture plane. These patches of value, in addition to their descriptive function, enact a playful abstract theme of variously toned and often curved shapes that seems to revolve

5.15 HONORE DAUMIER (1808–1879) *Head of a Woman*Black conde crayon, $6 \times 7^{1/4}$ in.
Photo R.M.N./Musee du Louvre, Paris.

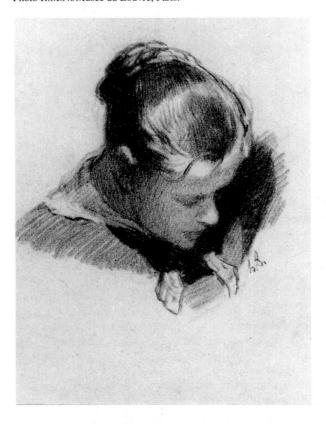

on the page. Note the differing tones and textures and the clarity of the planes that model the form of the hair and forehead, the most structurally developed passages in the drawing.

Value, then, can exist in line, shape, mass, and texture. It is also an efficient and forceful means of representing both two- and three-dimensional space, as demonstrated in Degas's monotype *Woman Wiping Her Feet near a Bathtub* (Fig. 5.16). A sense of atmosphere envelops the figure. This is suggested by gently modulated gray tones and by the contrasting flash of white at the upper left corner. This contrasting value holds its place in space because it suggests daylight streaming in through a far window and because it is strongly overlapped by the bending figure. Two-dimensionally, the values are arranged into a design that consists of three interrelated visual themes. By squinting at Degas's drawing, you may be better able to see the following tonal activities.

The first consists of the blocky shapes surrounding the figure, whose widely differing values serve to call attention to themselves as tones on a flat surface. But they are related by a rough sameness in scale, by their encircling action, and by a subtle tendency to aim toward the center of the page—like blunted arrowheads. Some touch the figure and some are overlapped by it. A second tonal theme forms a large, dark, inverted U-shape composed of the figure's legs and buttocks. It is repeated by a thinner, light gray shape fitted over the first, formed by the woman's arm and back. At the open end of the dark shape are flashes of light tone at either ankle that associate with the longer oblique light tones to either side of the legs and with the large white shape at the upper left corner. A third tonal system forms an inverted Y-shape that reaches across the entire page, incorporating the oblique light tones of the towel and the bathtub rim as the arms of the inverted Y, its central stem being the vertical, dark, draperylike shape that extends to the figure's back. These three tonal themes are interdependent and complementary. As we look at the drawing, first one and then another of these themes emerges, each graciously subsiding to allow the next its turn at our attention—yet all working together to form a unified, pulsating tonal design.

Degas's drawing shows us that values, like color, can make unlike things relate. Tonally, the white towel and the bathtub rim, despite being far apart spatially and quite different as objects, are visual first cousins. Although their oblique orientation and shape are roughly similar, it is their intense white tone that seals the visual bond. Similarly, the woman's hair and slippers associate through value.

Value's ability to make dissimilar parts relate and similar ones contrast is an important compositional device. It is a means by which to guide the viewer's visual tour of the image and to balance and unify the work. In Demuth's *Clowns* (Fig. 5.17), the dark legs of the lower figure are more easily associated with the dark tones above him than with the lightly toned legs of the standing figure. A similar visual bond is formed by the standing clown's head and the two pompons of his coat, while the relationship of the two heads is re-

duced by their visual contrast. But note how color associations, as well as tonal ones, enrich the drawing's dynamic activity (Plate 5).

Picasso relies heavily on value to establish the two-dimensional design in his etching *The Painter and His Model* (Fig. 5.18). Reading from left to right, large vertically oriented shapes of light and dark tones alternate until they come together and "fragment" in

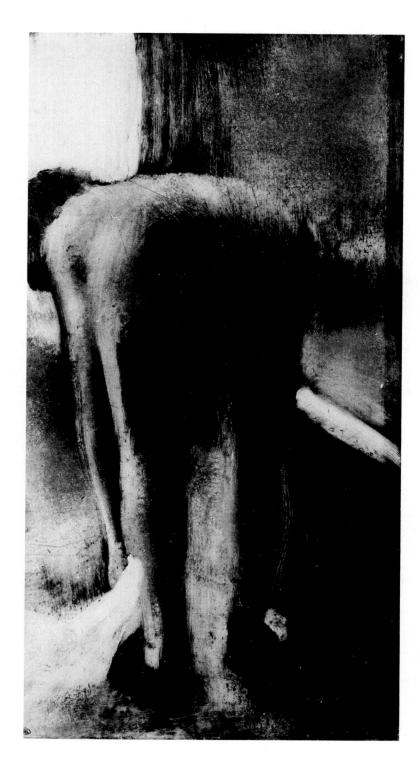

5.16 EDGAR DEGAS (1834–1917) *Woman Wiping Her Feet near a Bathtub* Monotype, 17³/₄ × 9³/₈ in. Photo R.M.N./Musee du Louvre, Paris.

5.17 CHARLES DEMUTH, American (1883–1953) *Clowns*

Water color and pencil on paper, $7^{1/2} \times 11$ in. The Metropolitan Museum of Art, New York. Bequest of Charles F. Ikle, 1963. (64.27.6).

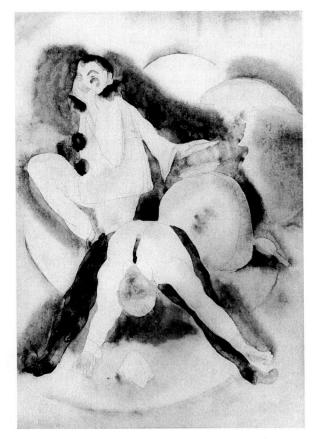

5.18 PABLO PICASSO (1881–1973) The Painter and His Model (Le Peintre et Son Modele) (1964) Aquatint and drypoint, 32.5 × 47.5 cm (2⁵/8 × 18¹/2 in.). Lee M. Friedman Fund. Courtesy, Museum of Fine Arts, Boston. 65.937/© 1999 Estate of Pablo Picasso/ Artists Rights Society (ARS), New York.

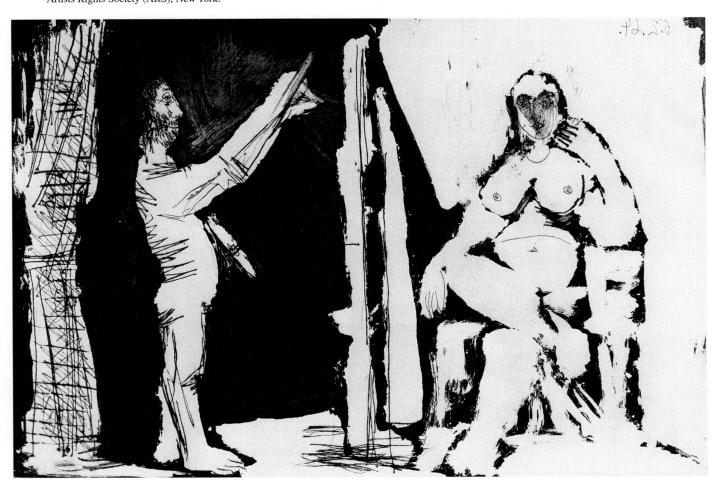

the drawing of the seated figure. Picasso intentionally makes the figure-ground relationship between the nude and her surroundings complex and ambiguous; it acts as an engaging visual counterpoint to the steady beat of the black and white vertical shapes that precede it.

Picasso uses the same value to associate the painter's upraised arm with the easel and with the diagonal edge of the background beyond the easel, and he further relates arm and easel by aiming them at the upper center of the page. Note that the shape on the far left and that of the painter's figure are similar in shape, direction, value, and texture. Both shapes, however, are related to the background surrounding the painter by the dark-toned shape behind the painter and by the texture of the rest of the dark background. Thus, Picasso uses texture to overcome the strong value contrasts among these shapes. To relate opposing elements in some way, whether by a similarity in texture, shape, scale, direction, or value, is a sound design practice. When some element or part of a drawing finds no visual relationship with other elements or parts in the work, it becomes isolated from the rest of the drawing.

In addition to its potency as a relational force, value is an important structural tool (as we saw in Chapter 2) and is the necessary means of establishing both the local tone and illumination of forms. As a structural tool, value can carve the boldest masses or the gentlest nuances of terrain, as demonstrated by Tiepolo's *Fantasy on the Death of Seneca* (Fig. 5.19). Here, broad washes of tone forcefully construct major masses, while smaller mounds and hollows are suggested by the undulating edges of these broad washes and by small incisive daubs of tone.

The impression of an intense light bathing this scene is strengthened by the artist's consistency in darkening all planes turned away from the light source. Except for a few passages, such as the black mask or the dark-haired boy, Tiepolo does not identify the local tones of the figures and objects depicted; the impression of brilliant light would have been reduced had he done so. Strong light and the dark shadows it produces make local tones difficult to see.

The danger in selecting a light source strong enough to overtake local tones is that it may produce a rather theatrical effect or one in which the requirements of illumination intrude on structural and spatial clarity. Tiepolo avoids this by showing (in three values) many of his subject's major planes. Figure 5.20 shows a contemporary artist's successful use of the same method.

But in the gentle light, Rembrandt's *Self-Portrait* (Fig. 5.21) permits both local tones and subtle modeling to be easily seen. In this sketch, Rembrandt man-

ages to utilize value's organizational, structural, and textural abilities and to describe both the inherent tone of a part and the effects of light falling on it. Note that all of the drawing's tones, and the subtle movements that enliven the image, are made by lines massed in various densities. The beret, the collar, and the thin band of tone representing the jacket, in creating graceful variations on a horizontally oriented lazy S-shape, move gently across the top and bottom of the page, forming rippling brackets to frame the stilled head.

That values can imply visual action is further demonstrated by Katzman's *Byron Goto* (Fig. 5.22), where dark, sometimes curved wedges of tone, as in the chair back, trouser folds, head, and shadowed regions of the figure, move in a forceful way. There is movement, too, in light wedges, such as the large wedges of the trousers and the smaller ones of the arms and hands (as well as in the several light-tone wedges of negative space). Katzman's vigorous handling of the chalk strokes adds to the energy of these actions; even the gray tone on the right side of the background is activated by its shape and "scribbled" treatment.

Shape

In examining line and value, we have, of course, been discussing the other elements as well. After line and value, shape is one of the most omnipresent elements in drawing. Indeed, when we begin a drawing, the size and shape of the surface chosen represent our first shape judgment, and that choice will influence all our subsequent decisions.

The use of line for shape-making purposes is universal. Children and adults alike naturally form images by denoting, and at the same time separating, their constituent parts by line boundaries. A circle represents a head, ovals represent the eyes and ears, and so on. What is generally unrecognized by the beginner is that drawn shapes simultaneously produce other shapes, namely, the shapes of the remainder of the page and those which result from subdividing existing shapes. To put it another way, in drawing shapes, we also create the shapes of the spaces between and around the drawn images. Shapes create shapes.

To understand the overall shape organization of a drawing, it is important to recognize these two distinct types of shape. *Figure*, or a positive shape, is a shape formed or enclosed by line or tone and representing either a tangible thing or a segment of a thing—the presence of substance—of "somethingness." *Ground*, or a negative shape, denotes an area that separates or surrounds a figure shape. The ability

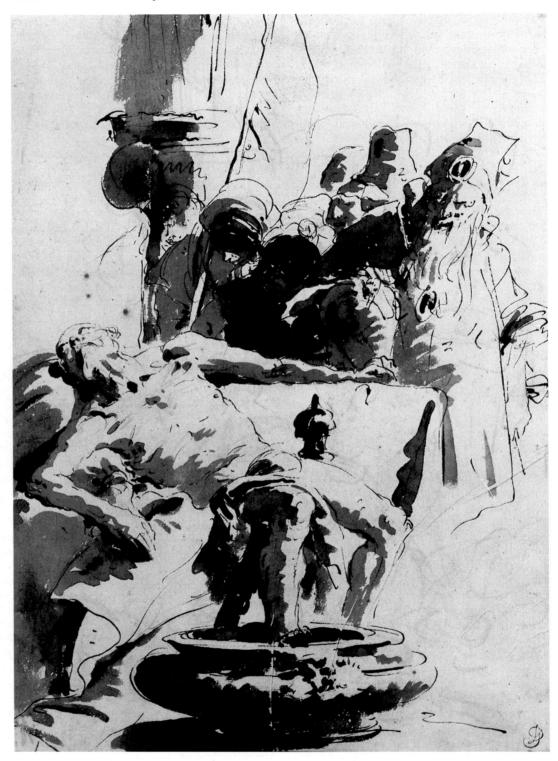

5.19 GIOVANNI BATTISTA TIEPOLO, Italian (1696–1770) *Fantasy on the Death of Seneca* (ca. 1735–1740)
Pen and brown ink with brush and brown wash, over black chalk, on ivory laid paper, 34×24 cm.
Helen Regenstein Collection. 1959.36. Photograph © 1998, The Art Institute of Chicago. All Rights Reserved.

5.20 JAY BROOKS *Figure* Conte crayon, 24 × 36 in. Courtesy of the artist.

to perceive objectively the visual properties of these two types of shape in our subjects enables us to make better depictive and design judgments about *all* the shapes that subdivide our page.

As an aid to more objective measurement, whether of the location, direction, scale, or contour of shapes, most artists find it helpful to reverse their figure–ground impressions as a means of "proving" the accuracy of their observations. For example, viewing Figure 5.23, if we concentrate on seeing the shape actualities of the spaces that separate the arms from the torso and the large wedge shape created by the location of the legs and if we actually try to draw those shapes, we discover important facts about the location, direction, scale, and contour of the arms,

torso, and legs. Furthermore, such occasional reversals of figure–ground impressions help us see the two-dimensional nature of our subject's parts and of the spaces among them, enhancing our appreciation of the dynamic possibilities inherent in the subject's shape state.

Responses influenced by this kind of "reverse seeing" are evident in Figures 5.16 and 5.17. In the Degas drawing, as we have seen, intentional shape ambiguities endow most of the shapes with both positive and negative functions.

These drawings show that figure-ground relationships may be reversed to good advantage. They also suggest some of the characteristics by which figure and ground are determined: Small shapes and over-

5.21 REMBRANDT VAN RIJN (1606–1669) **Self-Portrait** (ca. 1637) Red chalk (Benesch 1973 437), .129 \times .119 (5 1 /8 \times 4 3 /4 in.). Rosenwald Collection, Photograph © 1998 Board of Trustees, National Gallery of Art, Washington, D.C. 1943.3.7048.

 $\begin{array}{ll} \textbf{5.22} & \textbf{HERBERT KATZMAN} \ (1923-) \\ \textbf{\textit{Byron Goto}} \ (1974) \\ \textbf{Sepia chalk}, \ 72 \times 48 \ \text{in}. \\ \textbf{Courtesy of Terry Dintenfass, Inc. in association} \\ \textbf{with Salander-O'Reilly Galleries, LLC, New York.} \\ \end{array}$

lapping ones usually appear to be figural; large or overlapped shapes appear as ground. In virtually every instance, figure shapes are active. They assert themselves and demand our attention. Ground shapes are less active. They occupy those places on the page that figure shapes "permit." By reversing the characteristics of figure and ground shapes, the sense of three-dimensional space is reduced, and the two-dimensional spatial relations of the drawing's elements are increased.

Desnoyer's Getting Dressed (Fig. 5.24) demonstrates something of this reversal as well as some other ways by which subduing figure-ground cues can heighten a drawing's two-dimensional impact. The artist brings the shape of the checkered floor forward by stressing its convex edges where it meets the bureau. Convex edges are a characteristic we tend to associate with figural parts; concave edges go with ground parts. In some places, as in the bureau on the left, the shaded modeling suggests concave drawers, while the lines dividing the drawers show them to be convex. In other places, as in the light-gray wedge shape that touches the shoe of the seated figure, the artist avoids overlapping, thereby making it uncertain which shape is nearer. Then, too, by making that wedge shape light instead of dark, he further denies us a three-dimensional effect, for the shape is, of course, a cast shadow created by the pitcher. Some parts are shown as transparent or interpenetrating, another effective way of reducing the impression of volumes in space. The artist avoids modeling some forms, sometimes omitting even their shape boundaries, or he aligns various edges to imply that shapes in near and far positions in the room are on the same plane in space. This occurs with the line that marks the midline of the standing figure's legs, continues along the pitcher, and becomes the upper edge of the aforementioned wedge shape.

All these interruptions of figure—ground cues, and the artist's emphasis on sharply defined edges throughout, emphasize the drawing's two-dimensional design. Although the sense of masses in space is restrained to permit the shape-oriented design to assert itself, both considerations are compatibly integrated.

All shapes, of course, are produced by line, value, or by a combination of both. They can, as we have seen, stand for "thing," denote "empty" interspaces, or possess an ambiguity that suggests both figure and ground at the same time. As Figure 5.18 shows, they can be textured, change value within their boundaries, or be plain and unvarying. Shapes can be hard-edged, as in Figure 5.24, but they can also be somewhat unfocused, as in Figure 4.103. Shapes can be geometric or organic. They can be closed or open. Closed shapes are those entirely encircled by line, composed of tone,

or by linear and tonal shapes arranged to form an enclosure. Open shapes are those showing breaks in the linear or tonal enclosure. For example, in Figure 5.18, the shapes denoting the seated woman and her immediate surroundings all show avenues of access to neighboring shapes.

Nor does calling attention to shapes necessarily diminish a drawing's volumetric and spatial clarity. Avishai's *Untitled*, *I* (Fig. 5.25) is a sharply focused image in which both figure and ground shapes, while they function efficiently in their three-dimensional

5.23

5.24 FRANÇOIS DESNOYER (1894—) La Toilette (Getting Dressed) (1941) Pencil and chalk, 6³/4 × 8¹/4 in. Musee National d'Art Moderne, Paris/Reunion des Musees Nationaux.

5.25 SUSAN AVISHAI (1949–) *Untitled, I* Colored pencil. Courtesy of the artist.

5.26 GUISEPPE CESARI (1560/68–1640) *Studies for a Flagellation of Christ* Red and black chalk, $7^7/8 \times 6^1/8$ in. Cooper-Hewitt National Design Museum, Smithsonian Institution/Art Resource, NY. Friends of the Museum Fund. 1938-88-7071.

roles, also join to form a well-organized two-dimensional pattern.

Except for circles, squares, pentagons, and other shapes whose boundaries are more or less equidistant from their centers, all shapes suggest movement in the direction of their long axis. Even those few shapes that do not inherently imply movement will take on the directions and movements of the shapes they relate to. For example, one or more circular shapes aligned with various other shapes will be oriented in whatever direction the group of shapes takes.

As noted in Chapter 2, all masses have shape. Even the most complex pose imaginable, no matter how foreshortened and interlaced the forms may be, has its own silhouette. The ability to see a form's actual shape is necessary to draw its foreshortened state objectively. For Cesari to draw the foreshortened torso in his *Studies for a Flagellation of Christ* (Fig. 5.26), he had to do more than piece together its form units; he had to see (or envision) its general shape state. Although his drawing does not dwell on "shape-

ness," underlying these forms are the artist's shape judgments. A confirmation of the search for shape early in the drawing's development can be seen in the unfinished sketch in the lower right. Here, Cesari relies on shapes to establish the basic design and disposition of the drawing's forms.

Many artists, recognizing shape as a potent agent of design, emphasize it in preparatory sketches for works in other media. Poussin's *Drawing for the Rape of the Sabines* (Fig. 5.27) illustrates shape's importance in the artist's organizational conception in this preparatory sketch for a major painting. By imagining a strong light source, the artist creates a pattern of dark shapes that sometimes envelops more than one figure. Establishing these inherently animated light and dark shapes enables Poussin to examine and further plan the role of shape's contribution of energy to the dramatic action scene he will paint. Poussin's drawing makes it clear that planes, the basic building unit of masses, are shapes at various angles in space.

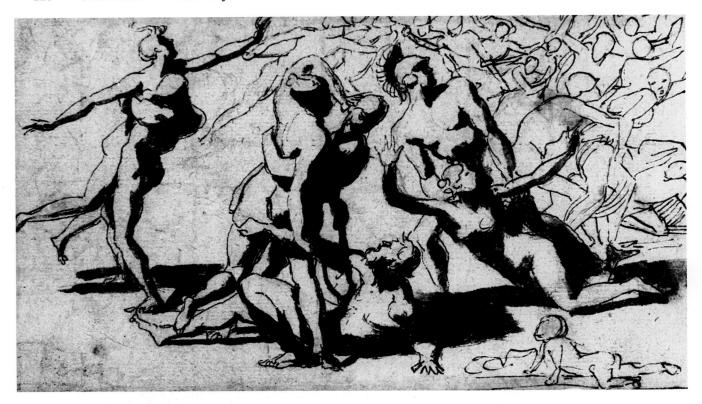

5.27 NICOLAS POUSSIN (1594–1665)
 Drawing for the Rape of the Sabines
 Pen and wash over black chalk, 4¹/₄ × 3¹/₈ in.
 The Royal Collection © Her Majesty Queen Elizabeth II.

Volume

A drawing's shapes, then, like its lines and values (and textures, as we shall see), all function both twoand three-dimensionally. In doing so, they give twodimensional-design meanings to volumes in threedimensional space. In Chapter 2, we discussed
volume as the goal of the structural factor and examined the means by which its impression on a flat surface is achieved. Here, we will consider the design
functions of volume, noting in particular what effects
a volume's scale, value, weight, and position in space
(and on the drawing's picture plane) have on a drawing's design. And just as the two-dimensional aspects
of space were necessarily touched on in discussing
line, shape, and value, so will its three-dimensional
aspects emerge in examining volume.

In drawing, all volumes suggest two kinds of weight: real weight (the sense of gravitational pull on a solid mass) and visual weight (the sense of forces acting within and on a mass for the purpose of calling attention to it, stabilizing it, or relating it to other

forms or shapes in the pictorial field). A single diagonal line drawn on a blank page produces a sense of tension, imbalance, and a striving for a more stable position. Similarly, the drawing of a tilted volume will also produce tension and imbalance that we feel as visual rather than actual weight. Unlike physical weight, the visual weight of volumes in a drawing can pull in any direction, depending on their shape and location and on their relation to each other and to other elements in the work. Visual weight has to do, as much as anything else, with eye appeal—with the importance of a volume's visual behavior in the design. In Figure 5.24, some of the forms, such as the standing figure and the bureau and lamp to the left, pull upward.

Visual weight (which will be more fully examined later, when its effect on all the elements can be discussed together) always influences our understanding of a volume's design function. Although it is a more evident force in drawings that suggest little physical weight (Fig. 5.24), visual weight is still a factor in more realistic drawings.

For example, in *Three Studies of a Young Negro* (Fig. 5.28), Watteau creates both two- and three-dimensional balance by the location, movement, scale, and value of his subject's volumes. The three studies are arranged to form a triangle that exists both two- and three-dimensionally.

Two-dimensionally, the position of the figures creates an inverted Y-shaped space between the heads, whose symmetry and centrality impart a stable pivot point around which they seem to rotate in a counterclockwise direction. Partly for representational reasons (the heads face counterclockwise), the direction of the rotating action is strongly influenced by the

"swing" of the large wedge and by the rhythmic actions illustrated in Figure 5.29.

Three-dimensionally, Watteau's design strategy depends just as much on this enveloping, circular action. In the same way as a rotating disk will remain balanced but tilt to one side when stationary, these forms achieve balance by their revolving action. If we were to disregard their dynamic behavior and try to see these volumes as static, we would notice that their collective disk is fixed at an unstable angle. Seen this way, the figure on the left leans precariously toward the other two, and the position of the head seems arbitrary—the drawing seems fragmented and unstable. It

5.28 ANTOINE WATTEAU (1684–1721) *Three Studies of a Young Negro*Red, black, and white chalk, gray ink washes, 95/8 × 105/8 in. Photo R.M.N./Musee du Louvre, Paris.

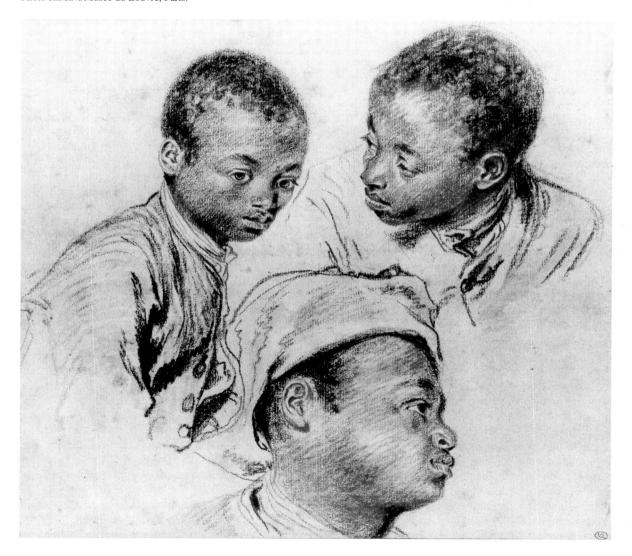

5.29

is their common motion that creates a stable threedimensional balance. The three heads "need" each other to achieve this. Individually, they fall in different directions, but collectively, they compensate each other's diagonal thrust and achieve equilibrium. Note how subtly Watteau resolves the problem of the structurally explicit and weighty heads on the more generalized and fading bodies. By gradually decreasing the clarity and value of the draped forms, he avoids disembodying the heads. At the same time, he takes advantage of the looser handling in the drapery to reinforce the overall rotation and to impart a sense of open space between the figures.

The sense of deep space, made more convincing by the "road" formed by the shoulders, accommodates the three figures in a way that further bolsters the drawing's two-dimensional design. Seen this way, the large wedge stops just short of the sheet's left and right boundaries, avoiding isolated triangles of space at each of the four corners.

As this analysis illustrates, masses, like all other elements, suggest movement. They do so by the physical and visual nature of their parts and functions, that is, by the nature of all their structural properties and dynamic activities. A volume's degree of action is largely determined by its depictive and visual weight, by its relational condition with other elements in the design, and by the artist's manner of expressing it. A form securely balanced and patiently rendered will appear less energetic than the same form tenuously balanced and spontaneously drawn.

The volumes in Watteau's drawing move at a

moderate pace, slowed somewhat by the easy pace of the handling and by the thorough modeling of the heads that makes them at once independent from, and united with, the main design theme of rotation. We can enjoy the drawing of each figure separately, but we are always aware of their interdependence.

In contrast, the volumes in Rembrandt's *Head of an Oriental with a Dead Bird of Paradise* (Fig. 5.30) undulate and whirl with furious energy. The strong downward pull of the head's physical and visual weight is increased by the lively climbing action of the scarf, which coils and "springs" on the turban, adding its mass and weight to the head. Furthermore, by making the scarf intensely energetic, Rembrandt suggests that its crescendo of action in the turban—its wild swirls—cannot be contained there. He therefore provides an avenue of release through the head, beard, and arm by repeating the scarf's swirling actions in these forms.

Rembrandt's placement of the figure on the page also tends to heighten the downward pull on the turbaned head, but for other reasons. The downward movement is necessary to establish balance in a configuration otherwise too tilted and located too far down in the lower right corner of the page. And the means for this counterbalance, in addition to the scarf's contribution, are present in the downward-aiming arrowhead shape formed by the turban, the bearded head, and the hand. Rembrandt further emphasizes the physical weight of the scarf-laden turban by placing a deep shadow on its underside. To give the downward-moving thrust a visual anchor and

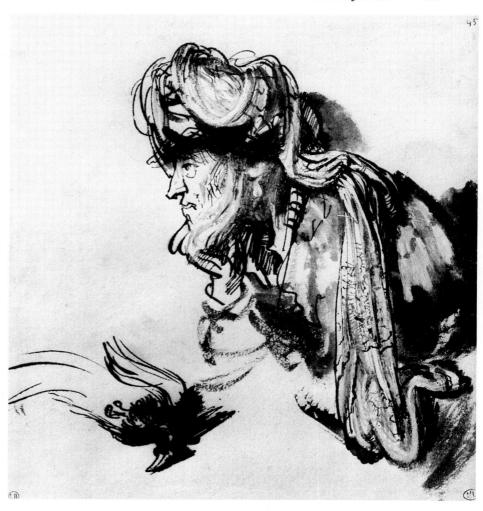

5.30 REMBRANDT VAN RIJN (1606–1669)
Head of an Oriental with a Dead Bird of Paradise

Pen and bistre washes, some gouache, $4^{5}/8 \times 4^{3}/8$ in.

Photo R.M.N./Musee du Louvre, Paris.

goal, he places the dead bird enticingly close to the arm, thus extending the downward movement into it by providing a dynamic, if not an actual, connection. Whenever a very small space separates any two or more parts, we "see" them as connected. This phenomenon is referred to as *closure*.

In the hands of a knowledgeable artist, the impression of volume can survive strong attempts at its suppression. In Parker's *Reclining Nude* (Fig. 5.31), the volumes are almost overwhelmed by the artist's insistence on shape, yet they still suggest broad structural and even anatomical facts. They do so because the blocky planes and simplified contours are neither arbitrary nor naive. They are intentional, sensitively chosen responses that amplify a particular design theme that concentrates on shape. Parker's understanding of structure and anatomy makes these changes count. Note in the limbs that the planes conform to anatomical fact. The planes are simplified and strive toward rectangularity, but they are not willful distortions.

Because physical weight is an incidental quality here, Parker relies more on visual weight to establish balance. Although the hair, being more convincingly modeled than other parts, does suggest a degree of real weight, it is mainly the dark tone and bold shape of the hair that counterbalance the figure's location on the left side of the page. Notice that the artist further decreases the sense of physical weight by suggesting the figure's upward movement by the principle of closure. In being thus held to the top of the sheet, the figure seems almost weightless.

At the opposite extreme, the design theme of Goodman's *Reclining Nude at Window #1* (Fig. 5.32) is based mainly on the figure's physical weight, although visual weight plays an important role here, as we shall see. Because we bring to this drawing our prior knowledge of the weight of a human figure, we know that the great weight of the figure's unseen legs (increased by the figure's slightly downward tilt toward the lower right corner, where forms are felt to be

5.31 ROBERT ANDREW PARKER (1927–) Reclining Nude

Ink and water color washes, 8 × 9 in.

Collection of Christopher Parker. Courtesy of the artist.

heaviest) demands the compensating physical weight the artist emphasizes in the figure's upper body. He does this by several means: by the downward flow of the mass of black hair; by the more fully modeled forms of the head and upper body; by the downward flow of these forms as expressed in the breasts and the straight lower contours of the arm, back, and thigh; and by the bold value contrasts and large expanse of dark tone on the drawing's left side. All these devices signify physical weight. But to give the required weight to the drawing's left side, Goodman places the fast-moving vertical lines that define the window frame at just the right place to add visual weight where it will do the most good.

Volumes, then, can vary greatly in the impression of solidity—from the sculptural clarity of forms by Goodman to the teasing ambiguity of those by Parker. Some artists, however, utilize volume's ability (usually in tonal drawings) to be "lost and found" as a design device. In Moore's *Women Winding Wool* (Fig. 5.33), volumes vary widely in the clarity of their mass and edge, creating some passages of monumentality and some of mystery. By regulating clarity, Moore dramatically accentuates the subject's essential de-

sign: the action of the large horizontal figure eight enveloping the two upper halves of the figures and the pulsations of the light tones in the two lower halves.

Texture

Texture designates several visual phenomena. Generally, it is used to describe the tactile nature of a material; we speak of the texture of hair, skin, cement, or silk. In drawing, the term also applies to the visual characteristics of the drawn marks. The texture of charcoal lines differs greatly from pen-and-ink lines. Additionally, the texture of the surface drawn on influences the textural character of the image. For example, a pen or pencil drawing made on glossy paper will show a different surface texture than when these materials are used on rough-grained paper.

We can also distinguish textural differences among marks made with the same medium. The texture of the ink lines in Figures 5.8, 5.9, and 5.10—their density on the page and the nature of their calligraphy—differ strongly from each other. In a similar way, texture also refers to the density of other elements on the page. The shape textures of Figures 5.24

5.32 SIDNEY GOODMAN (1936–) Reclining Nude at Window #1 Ink, $8^1/2 \times 12$ in. Courtesy Terry Dintenfass, Inc. in association with Salander-O'Reilly Galleries, LLC, New York.

and 5.27 are quite different. Texture also defines the visual repetitions of patterns, such as plaids or stripes, and is often extended to include the massing of any group of forms that are similar in nature. Fingers intertwined, a cluster of folds or creases, or a pileup of ballplayers or boulders all exhibit different visual textures. The figure's textures include more than those of hair and skin; some artists interpret the figure in a way that emphasizes the texture of its surface forms, as Tintoretto does in his *Study for a Group of Samson and the Philistines* (Fig. 5.34). Millet's Study for *Man with a Wheelbarrow* (Fig. 5.35) demonstrates several of the aforementioned aspects of texture in drawing. Additionally, it shows how texture can serve to regulate the similarities of like and unlike things.

By describing the texture of the leaves, Millet unites all the leaf clusters, whatever their differences in value, shape, scale, and position. In using diagonal lines to suggest the texture of the contents of the barrow, he strengthens the contrast between the shaded portion of the hay and the shaded wooden sides of the barrow. Those diagonal lines serve more than textural interests. By their tilt, they "reach" for the point of the large curving mass of leaves, creating a visual tension that carries their common arc through the figure. The direction also restrains the unity of the collective dark tone of the doorway and the loaded wheelbarrow, which would otherwise have been isolated in their similarity. Note that nowhere does a material's texture overtake its volume. How often, in student drawings,

5.33 HENRY MOORE Women Winding Wool (1949)
Crayon and watercolor on paper, 13³/4 × 25 in. (34.8 × 63.6 cm.).
Collection, The Museum of Modern Art, New York.
Gift of Mr. and Mrs. John Pope in honor of Paul J. Sachs.
Photograph © 1999 The Museum of Modern Art, New York.

is the mass of, say, the head lost in the concentration on the texture of the hair and skin! In such drawings, textures seem to rise to the surface of the page, conflicting with the sense of structural masses in space. That this need not occur is amply illustrated in Van Dyck's *Head of an Apostle* (Fig. 5.36).

But when a two-dimensional design is to be emphasized, it may be desirable to permit textures to come to the surface. Manet's *Jeanne (Spring)* (Fig. 5.37) communicates the airy, active feel of his subject by a profusion of differing textures. All alike in their energetic and lacelike nature, they unite in forming an almost page-filling design. Their unity is reinforced by the visual counterpoint of the drawing's few black and white shapes. Manet makes the forms of the figure and those of her surroundings less structurally insistent and emphasizes the textures, creating a design that functions well in either its two- or three-dimensional sense.

Manet's attitude toward the textural effects of his medium differs markedly from that of Millet or Van Dyck. The latter are less concerned with the virtuosity of their media than Manet, who delights in making the pen and brush produce a sparkling surface "fabric." Villon, in his etching *Kneeling Nude* (Fig. 5.38), is even more unswerving in his concentration on the

texture of the etched lines. He produces a system of mechanical cross-hatched lines whose shapes and textures are as pronounced as their values. Villon's persistent texture suggests that the lines do not actively express forms, but rather that they obligingly halt to permit an edge or a value to occur. But to avoid too rigid a result, Villon provides some line and texture variety. A secondary system of seemingly curved edges resulting from straight-line hatchings (there are no curved lines in the drawing) creates gentle, even sensual, forms and at the same time establishes a texture composed of undulating shapes and edges.

Differing textures intensify each other. Whether it is the texture of the medium itself, of a material, or of a decorative pattern, textures oppose and enhance each other to produce visual contrasts that can play important organizational and expressive roles. In Diebenkorn's Seated Woman, No. 44 (Fig. 5.39), the texture of the crayon lines in the background not only continues the upward-directed motion of the figure and chair but intensifies the impact of the stark white shapes of the floor. Likewise, the floral design of the dress, an oasis of rich organic activity in the drawing's otherwise more austere pattern of shapes, gives meaning to those shapes. We sense the artist's involvement with the play of these unadorned shards that make up the

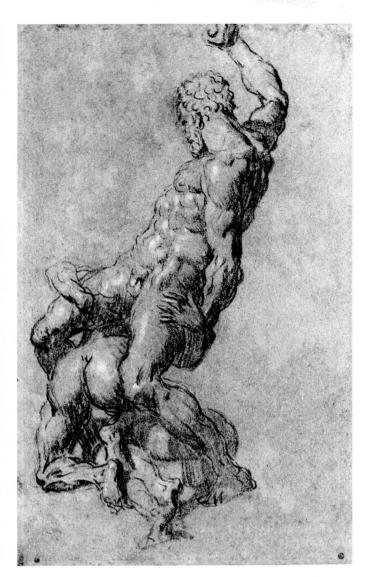

5.34 JACOPO TINTORETTO (1518–1594) Study for a Group of Samson and the Philistines Charcoal heightened by white on blue paper. Musee Bonnat, Bayonne, France.

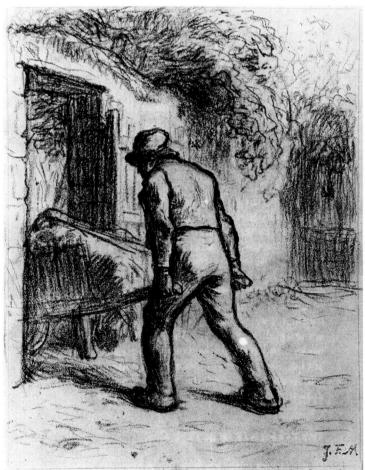

5.35 JEAN FRANÇOIS MILLET (1814–1875) *Study for Man with a Wheelbarrow* (1855–6) Black conté crayon on wove paper, 15.2 × 11.1 cm (6 × 4³/8 in.).

Gift of Martin Brimmer. Courtesy, Museum of Fine Arts, Boston. 76.442.

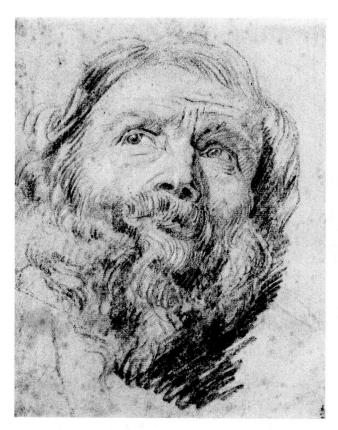

5.36 ANTHONY VAN DYCK, Flemish (1559–1641) *Head of an Apostle* Black and white chalk on white paper, $10^{1/2} \times 8^{1/16}$ in. The Metropolitan Museum of Art, Gift of Mr. and Mrs. Janos Scholtz, 1952. (52.214.4).

figure's forms and those of the chair, wall, and floor. The floral pattern, in its contrast to them, both clarifies and relieves this play among the shapes.

In discussing the elements, we have already seen some of the visual energies at work: Direction, closure, and weight are all powerful relational forces. Although we concentrated on the various manifestations of each element and some of the ways each element might relate to others of its kind, we also observed some relational actions among different elements. To understand better how such energies issue from, and act on, elements, we now examine the various ways in which elements form the visual bonds that integrate a drawing's figurative and dynamic content.

THE ELEMENTS IN ACTION

In every drawing, each of the elements participates in several relationships at the same time. Indeed, line

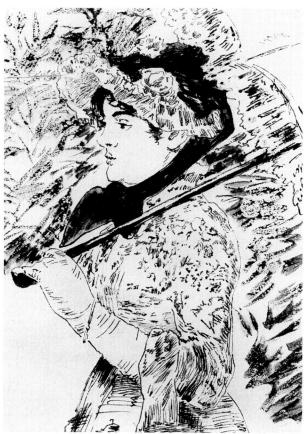

5.37 EDOUARD MANET, French (Paris, 1832–1883, Paris)
Jeanne (Spring) (ca. 1881–1882)
Pen and brush and black ink on albumen photographic paper,
31.3 × 21.2 cm. actual.
Courtesy of the Fogg Art Museum, Harvard University Art Museums.
Bequest of Grenville L. Winthrop 1943.872.

and value, being what the other elements are made of, are always active in the visual behavior of those elements. And because the shapes, masses, textures, and spaces they give rise to are engaged in visual activities with one another, a single line or tone may be shunted onto several tracks of visual association that will carry its kinships with other elements far across the pictorial field.

All visual relationships generate energies that suggest movement, or a striving for movement.⁵ A sensitivity to movement, to any kind of motion, weight, or change, is not only at the heart of what stimulates the artist toward compositional balance and unity; it is also a matter of vital concern to each of us as we function on a daily basis. We instinctively react to real motion or change because such activity may

⁵ Rudolf Arnheim, *Toward a Psychology of Art* (Berkeley and Los Angeles: University of California Press, 1972), pp. 75–89.

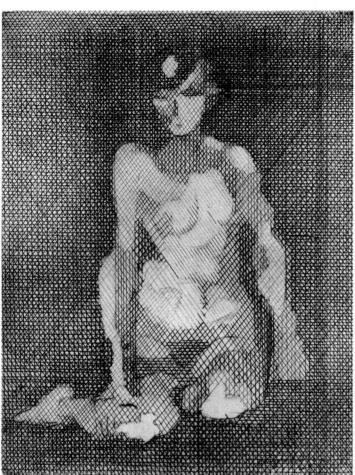

5.38 JACQUES VILLON (1875–1963)

Kneeling Nude (1930)

Etching, $8^{13}/16 \times 6^{7}/16$ in.

Photograph courtesy of the Boston Public Library, Print Department/ © 1999 Artists Rights Society (ARS), New York/ADAGP, Paris.

5.39 RICHARD DIEBENKORN (1922–1993)

Seated Woman No. 44 (1966)

Watercolor, charcoal, gouache, crayon, $30^{1/4} \times 23^{1/2}$ in. University Art Museum, State University of New York at Albany. Gift of the Faculty-Student Association and President Evan K. Collins to the Fine Arts Study Collection, University at Albany. State University of New York.

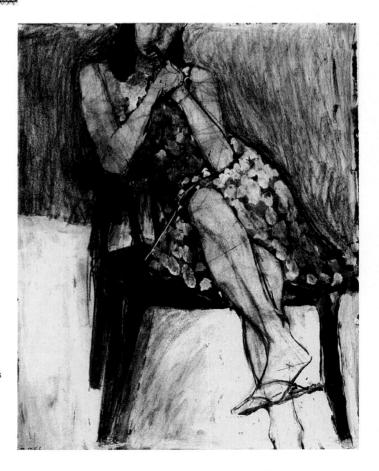

spell danger or opportunity. Such a stimulus in our field of vision automatically attracts our attention. Like the kitten or the housefly, we find that movement demands attention. So deeply engrained is this response in humans that even the illusion of motion or change attracts our attention. We respond to the visual forces in a work of art with interests that have deep roots in our psyche.

Some kinds of energy are discernible even within a single element. For example, some lines, according to their character and route in a drawing, move quickly, as in Figures 5.8 and 5.11. Other lines move slowly, as in Figure 5.9. The same is true for shape; the oval, for example, suggests leisurely movement; a triangle implies faster motion as it chases its point. And an even gradation of value or size seems to change faster than a modulation that occurs by abrupt differences of degree.

But other energies are generated only between like elements: The visual impact and action of a large shape's size and movement depend for their meaning on their relation to the scale and behavior of other smaller shapes, and even on their relation to the page. A shape will appear larger on a small format, as in Figure 5.36 where the rugged head seems all the more imposing because of the small scale of the picture plane. An arm, a leg, a drapery fold, and a tree trunk may all be related in a work if the artist emphasizes the rhythm of their common S-shaped movement. Figures 5.4 and 5.8 show how strongly a drawing's shapes may relate through such rhythmic actions.

Relational energies can be grouped in several ways. This discussion takes into account the important influences that the representational actions of the figure and its surroundings have on a drawing's abstract order. Because of the simultaneity of the various energies interacting in most relationships—the relational "chords" that strike our senses—any attempt at classifying such interdependent activities invariably fails to account for some phenomena too elusive and ineffable to be snared in print. All such classifications are really more convenient than defensible. They attempt to identify broad types of visual energy to heighten our awareness of the rich dynamic life possible in drawing. And, although some actions, tensions, and energies elude any system of grouping, comprehending the nature of the many forces that can be described is the best route to apprehending those that cannot.

To understand the nature of these visual forces, we must understand the term *movement* in its broader sense, as *any kind of action or change*. In addition to the obvious movements of direction, as when we draw a figure standing *up* with its arms hanging *down*, there are other motions that are not determined by the long axis of an element or of an identifiable form. We

sense movement when groups of lines, shapes, or volumes relate by a gradual increase or decrease in their scale, value, texture, or density on the page.

The degree of energy of such movements is suggested by the gradient of change within or between relating elements: by the collective shape and directional thrust of the group, by the force with which it ascends to domination in the design, by the number of visual steps involved in the change, and even by the vigor or delicacy of the artist's handling.

For example, in Matisse's Dancer Resting in an Armchair (Fig. 5.40), a system of circles radiates upward from the center of the page. Their similar shape and behavior and their gradually increasing scale and spread provide a strong common movement. A bold contrasting movement is seen in the downward rush of straight lines and shapes that gradually diverge from the center of the figure. We sense all these to be moving down, not up, because of (1) the visual need for "release" from the weight of the legs and lower torso, (2) the weight of the tilted rectangular shapes, and (3) the suggestion of gravitational pull on the skirtlike folds. Note that Matisse unifies these totally opposing shapes and movements by making the collective behavior of their antagonistic thrusts form one radiating burst of energy.

These two strong actions, the billowing up of circular elements and the rushing down of straight elements, gain energy by the number of participants and the simplicity of their action. However, they are held in check by even stronger forces, namely, the bold forward thrust of the figure and the curved movements of the arms and legs. By placing the figure on top of the system of overlapped shapes that surrounds it, Matisse creates a series of forward-moving shapes that push the figure toward us, and by their bold and simple contours, the limbs swing around in strong arcs.

Some kinds of relational energy, such as visual weight, physical weight, or tension (to be discussed), suggest that movement is either necessary or imminent rather than occurring. Others, such as location or those concerning various types of similarity or contrast, will, produce motion or a striving for motion, depending on their context in the drawing. But the dynamics of *direction, rhythm,* and *handling* are those most endowed with the sense of movement.

Direction

We sense directed action when one or more elements move on straight or varied paths toward an intended point on or beyond the picture plane or move forward or backward in a field of depth. Such movements usually suggest visual or physical weight. The forms of the human figure, being for the most part tapered, can

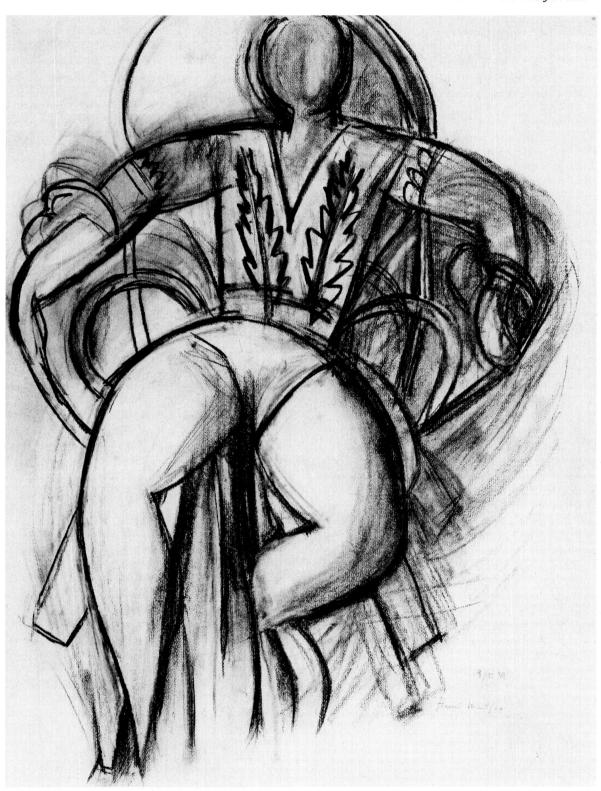

5.40 HENRI MATISSE (1869–1954)

Dancer Resting in an Armchair (1939)

Charcoal on wove paper, 63.9 × 47.8 cm.

The National Gallery of Canada, Ottawa. Purchased, 1967/

© 1999 Succession H. Matisse, Paris/Artists Rights Society (ARS), New York.

be shown as moving with vigorous speed toward specific points as in Degas's drawing (Fig. 5.16) or as in Diebenkorn's work (Fig. 5.39). Seeing the Diebenkorn work in color (Plate 7) adds another system of directional thrusts. Now, the light and dark warmtoned shapes, "sorted out" from among the cool-toned ones, generate movements between themselves that contrast with the less active thrusts of the cool shapes, a distinction largely absent in Figure 5.39. Long lines, edges, shapes, and volumes, especially when their course follows simple straight or curved paths (Fig. 5.40), make for stronger movement.

When changes in value or texture agree with the direction of a shape or volume, the speed of those elements is increased. For example, in Figure 5.35, the downward-curving movement of the great mass of leaves above the wall gains energy by changes in the value's gradation and the texture's increased animation. Both changes occur along the same direction as that of the shape of the leaves. Again, in Figure 5.21, the force of the beret's movement to our right is heightened by the texture's loss of clarity and the value's lowered tone.

Thus, textures, values, and even interspaces have directional motion. Blurred elements move faster than sharply focused ones, and the movement of any element can be slowed or checked by other elements that overlap or intersect it.

Rhythm

Most clearly observed in the repetition of similarly directed movements among lines, shapes, or volumes, rhythm is produced by a recurrence of similar characteristics of any kind among the elements. A certain pace in the grouping or density of the elements, a recurring texture or degree of tonal change, or a discernible pattern or treatment among like elements all produce rhythm. It can be sensed among unlike elements when their sameness in direction, formation, or handling is strong enough to withstand their contrasting identities and functions. For example, in Figure 5.17, round or half-round lines, shapes, and volumes -whether large or small, light or dark, near or far all suggest rhythm by their curved basis. The more often a rhythm is reinforced, the stronger is its movement (see Figs. 5.2, 5.30, 5.36, and 5.40). One aspect of this relational energy—the rhythmic accents in lines, as in Figures 5.2, 5.5, and 5.8, or in shapes, as in Figures 5.17 and 5.18—overlaps the next category.

Handling or Character

The stylistic or idiosyncratic accents and cadences of lines, tones, and shapes are a powerful source of moving energy. The artist's "handwriting"—the deliber-

ate, playful, delicate, or vigorous treatment of the elements—can make unlike elements relate, as in Figure 5.14, where diverse parts exhibit the unifying stamp of the artist's particular manner of execution. Like things can be made to contrast when, for purposes of variety, design, or expression, the style is varied, as in the figures of Figure 5.20. Partly a matter of neuromuscular coordination and partly the result of one's temperamental and creative attitude, the artist's handling creates a kind of visual meter that sets a certain speed among the elements and the forms they constitute. For example, in McKibbin's Female Figure, Back View (Fig. 5.41), there is a brisk animation that contrasts with Kuhn's more deliberate pace in Figure 5.9. One factor in the energetic fluency of McKibbin's use of line is the periodic emphasis of the darker segments. Not only do these bolder passages clarify structural facts, but they also create a visual meter that relates various parts of the figure. These darker segments heighten the lines' energy, some of which is sensed as a quality of the figure itself.

Handling is to some degree always influenced by the nature of the medium and the tools used in drawing. These materials not only affect the range and character of the marks but, because of their various traits and limits, even influence the kinds of observations the artist makes. Had Kuhn used chalk and McKibbin ink, each drawing would have been changed in more than surface texture. The different options that these two media offer would have influenced what the artist looked for and what he did about it.

Location and Proximity

The relational energies of location and proximity are produced by the association of like or unlike elements according to their position on the picture plane or in a field of depth. Elements equally distant from the horizontal or vertical center of the page may relate in their sameness of location. For example, in Figure 5.18, the dark and light halves of the background relate in part because they evenly surround the figures and roughly divide the page. Clusters of elements may relate by their density if surrounding elements differ markedly in scale, value, texture, or direction, as in Figure 5.19. Here, the entire group of shapes, forms, lines, and so forth above the outstretched arm of Seneca, in addition to the many other relational activities within it, is related by the density of its components. Connections based on location and proximity are strong visual forces. Symmetrically located parts form the strongest bonds.

Subdivision

In any grouping of integrated elements, subgroups will form because of similarities in shape, value, tex-

5.41 ALEX MCKIBBIN (1940–) Female Figure, Back View Black chalk. Collection of Ms. Lucinda Walser. Courtesy of the artist.

ture, or any other properties that distinguish them from the parent group. For example, in Figure 5.4, the darker lines in the lower left side of the page pull away from the lighter ones surrounding them; they still belong to the larger group of lines but form a discernible subgroup. Again, in Figure 5.40, the large circle behind the figure and the circles below each arm, while maintaining their visual union with all the other circular lines, shapes, and interspaces, form a subdivision. They do so by virtue of their more complete roundness and because they are symmetrically arranged. Often, such subdivisions gain enough independence to relate to elements or other subdivisions quite far away. In Figure 5.5, the three or four darkest strokes on the dress call to the similarly dark strokes of the hair.

All elements, as noted earlier, can (and usually do) form several links simultaneously. For example, in Figures 5.19 and 5.39, strong values create large light and dark shapes—"super shapes"—from the many smaller shapes. These large shapes exist inde-

pendently of any ties to one particular volume; they form their own abstract relationships. But the smaller shapes, although "recruited" into these super shapes, continue to function in forming volumes, disclosing directions, rhythms, and so on.

Elements, then, relate to each other in various combinations based on their similarities and contrasts with other elements. The texture and value of lines, the shape and value of volumes, and the texture and value of shapes are all characteristics that determine how elements will associate with one another. Of course, when color is present, still other relationships occur. Additionally, they will relate according to visual functions such as direction, rhythm, weight, or tension and according to scale, handling, and proximity.

Visual Weight

As mentioned earlier, all elements possess visual weight on the picture plane. Thick lines and dark val-

ues weigh more than thin lines and light values, large shapes and interspaces weigh more than small shapes, and pronounced textures are visually more weighty than subtle textures. Although, as noted earlier, such weights can press in any direction, in many drawings, visual weight, like physical weight, is resolved by being balanced seesaw fashion on either side of an imaginary vertical fulcrum in the drawing's center (Figs. 5.4, 5.14, 5.16, and 5.18).

Directional energies are often the driving force behind visual weight. In Figure 5.15, the wedge composed of the neck, neckerchief, and shoulder throws its weight to the side instead of downward. Similarly, the left shoulder and the dark cast shadow swing upward, their weight aimed for the upper right corner of the page. The shapes and tones of the hair provide a third grouping of elements whose visual weight goes toward the top of the page. These forces modify the physical weight and seem to keep the image secure in its location. Again, in Figure 5.11, the visual weight of the thick lines in the head makes for its stronger upward thrust.

Although directed movement usually accompanies the action of visual weight, the latter, being in part a matter of eye appeal—of visual attraction in the drawing-is present even when elements convey little or no direction. In Figure 5.18, the large dark shape of the background has a strong sense of visual weight but not of direction. More often, however, these two relational forces are seen working together, each intensifying the visual impact of the other. Whether we see a single element or a large segment of a drawing as primarily suggesting direction or visual weight largely depends on its context in the design. For example, the bold and animated drawing of the woman's hair in Schiele's Seated Woman (Fig. 5.42) emphasizes the head's upward thrust; direction is stronger than visual weight. However, in the delicately drawn clasped hands, it is visual weight, not movement, that calls our attention to this part of the drawing. But note that these two parts, aligned vertically, give this drawing's rhythmic calligraphy a much needed stabilizing effect.

Tension

Tension is an ever-present characteristic of other energies such as direction, location, handling, and both visual and physical weight. As used here, tension describes a sense of elements threatening change, striving to meet or repel each other or to alter their shape or location. When two or more elements or parts of the same element are so arranged as to almost touch, we feel their striving to complete the union. Likewise, when elements or whole parts of a drawing

are directed away from each other, we sense their desire to move further apart. Arrangements in which the directional forces are ambiguous or in conflict also produce tension between the components—a sense of standoff between antagonistic energies. Thus, the two ends of a C-shape, if not too far apart, strive to complete the interrupted circle we feel the shape intends to be. Similarly, the five or six wedges of a star shape strive to pull away from their common base, each moving in the direction it points to, while their common base strives to hold them to itself. Lines formed into an H-arrangement suggest that whether we see the two vertical bars as attacking or retreating, the horizontal bar prevents their doing either and creates a pulsating tension of forces pulling and pushing.

In our need to understand the visual condition of

5.42 EGON SCHIELE (Austrian, 1890–1918) **Seated Woman (Sitzende Frau)** (1918) Black crayon, $18^{11}/_{16} \times 11^{13}/_{16}$ in. $(47.5 \times 30.0 \text{ cm.})$ 58.1.252. The Ackland Art Museum, The University of North Carolina at Chapel Hill, Burton Emmett Collection.

whatever we see, we feel tension in any arrangement that only weakly hints at its essential form state or that contains ambiguous visual cues; instinctively, we want to resolve our perceptions into some comprehensible order. Just as our anxiety subsides when we see a parachutist touch down safely, so does our unease at viewing a drawing of a falling figure subside when we find a basis for its stability within the design. This stability neither completes nor neutralizes the act of falling. Indeed, it underscores the drama of the event by showing it against the backdrop of the drawing's total order. But it also prevents the act from causing the design itself to fall. When what fills our field of vision is *itself* in collapse, particular falling parts within it have less meaning. The figurative action in well-designed drawings never overwhelms their abstract order.

In Figure 5.27, the three groups of struggling figures in the foreground suggest a tenuous but balanced tripod. The artist makes the action of each group more powerful by joining their visual forces and, by showing their various falling states within the context of a stabilized design, gives them greater expressive impact. Here, strong tensions work to bring the groups together. Diagonal directions, in departing from the inherent stability of vertical and horizontal directions, produce tensions. There is in this drawing a high degree of motion and tension in the attraction and repulsion among the diagonally placed elements and in the groupings they make. Note the absence of a single vertical or horizontal "pedestal" of tone beneath them, helping stabilize the design. In Figure 5.26, tension is experienced in the large figure's limbs. They strive (as do the arms of the star shape) to pull away from each other, but are checked by their collective balance on the page and by the roughly equal tensions in all directions that cancel each other's thrusts. Ambiguous tensional forces are felt in Figure 5.33. The wedges formed by the bent arms, the directional thrust of the figures' weighty hips, and the downward slope of the laps all produce tensions—a striving to pull away from each other. At the same time, the link of the wool thread, the dark tone enveloping both figures, and the design's pronounced symmetry all produce tensions that pull the two halves of the drawing together. The result is a tension-filled confrontation—a balance based on mutual restraint.

The participants in a tensional conflict of any kind suggest a charged field of energy between them; they seem aware of each other. It is as if such lines, textures, masses, directions, or values do battle with each other for supremacy. For example, in Figure 3.26, the large white drape and the large black tone vibrate with tension as they contend for dominance. It is mainly the figure's leg "invading" both of these

contrasting areas that keeps them from tearing the composition apart.

A single element may also contain tension within it, as do the C, H, and star shapes or as exists in any element that takes more than one direction. Volumes, especially those of the figure, suggest tension when inner parts press against their container of skin, as in Figure 5.34, or pull against each other, as in Figure 5.26, or when their structures show strong interjoinings and multiple directions. The artist's handling can increase or decrease the force of a tension by emphasizing its aggressive or gentle nature.

A drawing's tensions, then, arise as much from the activities of the elements as from the imagery they produce. They exist in both the most tender and the most turbulent works. In a broader sense, a drawing's tensions are aspects of its expressive nature. Tensions can be of a warring or a playful sort, but being a natural phenomenon of the effect that elements have on each other, they make their appearance early in a work and must be considered a given factor in drawing.

Figurative Influences

The physical requirements of representational forms in a given context act as a strong modifier of the relational bonds that have been discussed. For example, a drawing of a figure leaning on a fern will not appear balanced because of what we know about the structure and weight of both forms, though in formal visual terms such an image may be faultless. Replacing the fern with a cane will balance the figure in its representational sense but may cause the design to collapse. To prevent this, we must compensate for the cane's weak two-dimensional properties-its slight visual impact—in the design. We may choose to increase its directional energy; we may join it in various strong rhythms or tensions; we may place larger objects around it; we may strengthen its contrasts of value or texture with other parts of the drawing; or we may combine several of these steps or turn to still others. For while the cane has the physical strength to support the figure, we must give it the visual strength to support the design.

As this example suggests, a drawing's two- and three-dimensional design must make visual sense at both the abstract and representational levels. The more convincingly forms suggest recognizable objects and activities, the more their various identities, locations, and directions in space influence a drawing's balance. Representational subject matter, unless drawn with a regard for its two-dimensional condition, always weakens more than the order on the picture plane; it also diminishes its own expressive function.

In Figure 5.14, a sensitive interplay exists between figurative and abstract needs and between twoand three-dimensional ones. Rembrandt avoids splitting the design in half by softly fusing Esau's draped figure and the tablecloth and by aligning the tablecloth's top and bottom edges with those of Esau's belt and coat fringe. This horizontal band creates a broad and subtle introduction—a visual prelude—to the dynamic action of the two arms. The scene's dramatic import would have been far weaker if the link between the two figures had been only their clasped hands. Note how many lines and values are directed to those hands. Note, too, that Rembrandt relies more on visual weight than on physical weight in his drawing of the table. Its presence is necessary to counter the weight of the standing figure. Had he made so large a form physically heavy, he would have weighted the drawing too much on the right.

Again, the design of Figure 5.19 discloses a knowing interplay of abstract and figurative order. Tiepolo's drawing, like Rembrandt's, relates two separate groupings of forms. A system of diagonal motions zigzags through the figure of Seneca and the nearby group. Tiepolo places a drape's dark shadow in alignment with Seneca's left lower leg and creates a large trapezoid out of his arms and the same dark shadow. Here, our appreciation of the weight and direction of Seneca's limp figure is essential to the drawing's design. Seneca's visual weight alone is too slight to provide the counterthrust necessary to balance the visual and physical weight of the nearby figures, as we see if we turn the drawing upside down. Tiepolo reinforces the sagging figure's weight by introducing the drape on the left, the direction and modeling of which add visual weight toward the lower left corner of the page. But it is our sense of gravity's downward pull on the figure that completes the drawing's equilibrium. Note that Tiepolo emphasizes abstract actions to underscore physical inaction. The furled drape, the insistent swirls of the cornice, and the curves of the drapery and the pottery all serve to accentuate the stillness of death.

EXAMPLES OF RELATIONAL ACTIVITIES IN THE FIGURE

In examining the elements and energies of drawing, we may seem to have drifted far from our earlier considerations of structure and anatomy. But in fact, we have only been discussing another kind of structure and anatomy: that of the figure's dynamics. Like its physical counterpart, the dynamic "anatomy" of the figure is a given aspect of figure drawing, and it is present in any observed or invented pose. How these

two anatomies will interact is, of course, determined by our perceptual understanding and our intent, but neither can be disregarded if our figure drawings are to have both dynamic and representational life.

Although the relational activities in drawings that concentrate on the figure are often active mainly within the boundaries of the figure's image, such activities are still understood in relation to the page. Therefore, the location of a single figure on the page still requires sensitive compositional judgment.

The way Degas has placed the figure in his Dancer with a Bouquet Taking a Bow (Fig. 5.43) reveals a fine balance of two- and three-dimensional considerations. Although some might question the visual necessity of the head touching the edge of the page, the integration of two- and three-dimensional weight throughout the drawing establishes a balance within the image and between image and the page. Degas, anticipating the visual and physical weight of the large bouquet, places the figure well to the left of center. To have located the dancer farther to the right would have tilted the scale to the right side and would have cramped the bouquet in the lower right corner of the page. To further lighten the load on the right side, Degas barely suggests the dancer's left leg and simply omits the skirt covering it. Sensing the need for still more weight on the left side of the page, Degas strengthens the edges of the limbs and the costume on that side, giving them more visual weight. Even so, when we turn the drawing upside down, the bouquet retains its visual dominance. But right side up, our response to the figure's physical weight adds just enough force on the left to balance the drawing on the page.

Of course, Degas could have easily balanced the bouquet by making the figure more structurally solid, and thus heavier, but that might have reduced the sense of the subject's graceful agility. Then, too, this is one of a number of quick preparatory sketches. Partly notation, partly exploration, such drawings are complete when the simplest expressive order of a particular arrangement of forms yields promising ideas. Note some other forces working to convey the dancer's physical balance: A fanlike rhythm relates the arms, skirt, and bouquet in a way that poises the figure's right arm and the bouquet in a tension for balance. These energies, and the animated handling, make us experience the dancer adjusting to keep her balance.

In Villon's drypoint Standing Nude, Arms Upraised (Nu Debout Bras en L'Air (Fig. 5.44), an even stronger tension exists in the placement of the figure's arms. We feel their imminent movement downward and expect them to swing back up on the other side of the page. Villon suggests this in several ways. First, the arms themselves carry a heavy burden of visual as

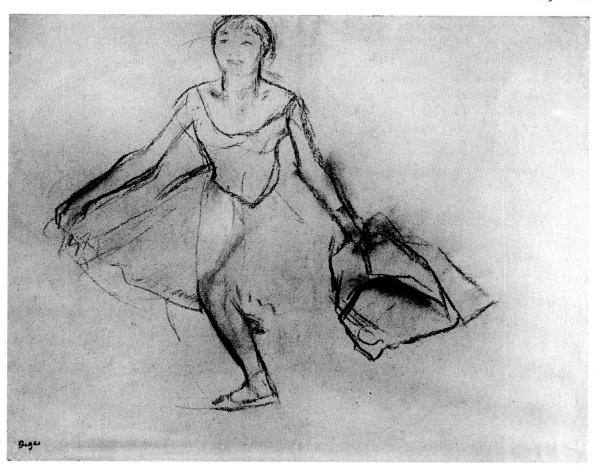

5.43 EDGAR DEGAS (1834–1917)

Dancer with a Boquet Taking a Bow
(Danseuse au bouquet satuant) (ca. 1878)

Charcoal on pine paper, 460 × 600 mm (18¹/8 × 23⁵/8 in.).

Gift of H. Walter Child. Courtesy, The Museum of Fine Arts, Boston. 20.840.

well as physical weight. Notice that Villon models their form with solid black areas instead of the lighter hatching used throughout most of the rest of the figure. In the context of an otherwise nearly symmetrical design, we sense that diagonally placed forms of much weight are striving for a location more consistent with the rest of the design. Second, what we know about human forms helps us recognize that the arms are swinging, not reaching. A reaching action engages the entire body, but here, the figure is almost at attention and turned away from the direction of the arms' motion. Without the assistance of the rest of the figure, such a movement is understood as a single "frame" in a sequence of positions that make up the swinging motion. Third, the figure's location in the center of the page, in making the counterswing possible, makes it more necessary. Last, Villon's modeling of the figure strongly hints at movement—teases us with diagonally drawn structural lines that suggest the back and forth swing. Even some lines on the left side of the page beckon the arms downward.

Villon's knowledge of anatomy provides him with a basis for establishing visual relationships that support his design theme without violating essential structural truths. For example, the directions of the lines modeling the legs, in their diagonal rush toward each other, not only reinforce the theme of motion but also accurately describe the angle of the major curved planes of those forms. In fact, throughout the drawing, the modeling simultaneously conveys the artist's design theme and the figure's structural and anatomical generalities. Strong visual bonds of direction,

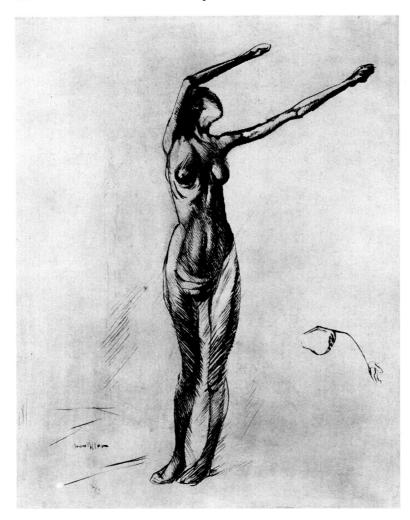

5.44 JACQUES VILLON (1875–1963)

Nu Debout, Bras en L'Air (Standing Nude,
Arms Upraised) (1909)

Drypoint, 21³/₈ × 16⁵/₈ in.
Lee M. Friedman Fund. Courtesy,
Museum of Fine Arts, Boston. 61.613/

© Artists Rights Society (ARS),
New York/ADAGP, Paris.

rhythm, tension, and figurative behavior weave these forms into a single animated gesture.

But appealing visual activity does not always require such visible evidence among the elements. Sometimes, as in Anderson's Variant on Ingres' Figure Odyssey (Fig. 5.45), forces work in a more concealed way. Here, the artist calls our attention to a circular motion enveloping the figure by making fine adjustments in the clarity and visual dominance of various forms. The shadow cast by the figure's right upper arm, the contour of the back, and the plane of the underside of the right upper leg, in being subtly darker than surrounding lines and tones, unite to form a half-circle. The directions of the left upper leg and left forearm complete the circle. Anderson continues the rotating movement by aligning the thumb of the upraised arm with the edge of the figure's right trapezius muscle. Note that he subdues the impression of volume in the right lower arm and the lower legs; he even makes their shapes more open and draws them more lightly. Emphasizing these forms would have impeded the rotating motion.

A second visual theme is based on a "family feeling" among the drawing's shapes. The artist discreetly refines the contours to accentuate a system of S-curves and sharpens the tips of shapes to emphasize their pointed endings. The resulting pattern of delicately fashioned arrowhead shapes creates graceful darting motions between parts of the figure and the interspaces formed by the torso, arms, and legs. Note the reversed but similar shapes of the space enclosed by the figure's left arm, breast, abdomen, leg, and the shape bordered by the drape and legs. In the figure, sharp-pointed shapes, such as those of the left breast and right leg, relate to the surrounding interspaces, unifying and enlivening this seemingly straightfor-

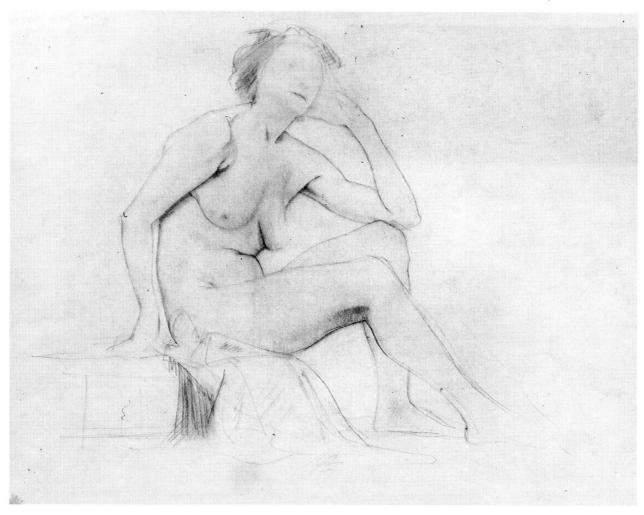

5.45 LENNART ANDERSON (1930–) *Variant on Ingres' Figure Odyssey* Pencil, $10^3/8 \times 15^1/2$ in. The Salander O'Reilly Galleries, LLC, New York. Photo by Geoffrey Clements/Licensed by VAGA, New York, NY.

ward drawing. Thus, the associations made by subgroups of line and shape lend graceful abstract meanings to graceful representational ones.

Anderson is sensitive to three-dimensional design matters. While he takes care to preserve the design of the picture plane, he also organizes the forms in space, varying the weight and focus of lines and values to call our attention to various points in space. For example, in subduing the clarity of the head and in stressing the curve of the shoulder girdle, he gives the rotating action a three-dimensional basis as well as a two-dimensional one. And in strengthening the values in places such as the armpits and waist and in occasionally darkening segments of the contour, he not

only heightens our understanding of the location of the forms in space but also creates a spatial beat of such points of emphasis.

Here, as in all good representational drawings, figurative energies influence abstract energies, and vice versa. We tend to regard the drape as having less visual impact, not only because it is lightly indicated but because in the context of the design it has little physical weight. Likewise, the rotating motion gains force where the torso adds its own weight to the action.

Just how influential the known properties of the figure can be is demonstrated in Palma's *Half-Length Male Nude Seen from the Rear* (Fig. 5.46). Here,

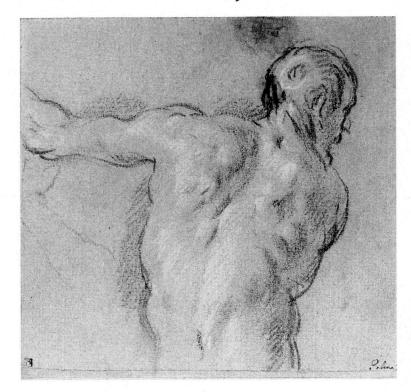

5.46 JACOPO PALMA (called Palma Giovane), Italian (1544–1628)

Half-Length Male Nude Seen from the Rear

Black and white chalk on blue-green prepared paper, 19.3 × 19.9 cm.

The Art Museum, Princeton University.

Gift of Frank Jewitt Mather, Jr. 1951-35.

some of the answering thrust to the direction of the extended arm is effectively carried by the direction of the man's gaze to the right. Palma's drawing also shows how useful a knowledge of anatomy is in providing and sustaining inventive responses to the figure's actions. Knowing the skeleton and muscles of the back enables Palma to accentuate those inner forms that enhance the force of the figure's twisting action. For example, to emphasize the torsion in the neck and head, Palma produces a system of reversed C-curves throughout the figure. In contrasting with the turn of the head, they amplify the force of its twist. The artist stresses the curves of the scapula and the muscles on and around it to begin the arm's leftward movement well inside the torso. The wavelike turnings of the arm's contours suggest the leftward force of the "storm" gathered at the scapula and, even beyond, in the curves of the ribs and contour of the right side.

In addition to the aforementioned gaze to the right, the only other major force that counterbalances the image's powerful leftward motion is the slight rightward arc of the torso itself. One enormous C-curve, its physical weight neutralizes the visual weight of the rest of the design. All the categories of relational energy are present even in this "simple" preparatory sketch. And although the energies provided by direction, rhythm, visual weight, and figurative influences dominate, those of handling, location,

subdivision, and tension play important supporting roles.

In the sixteenth-century Persian drawing *Portrait* of a Noble Lady with an Elaborate Headgear (Fig. 5.47), a different system of relational energies gives prominence to rhythms, handling, and location. Lines and shapes produce gracefully flowing rhythms whose elegance is reflected in the sure and fluid handling. Some lines, such as those of the shoulders, elbows, and knees, form a subgroup of large, simple curves; others relate by their smaller scale and by the action of the line clusters they are a part of, as do the lines of the radiating folds. The shapes achieve equilibrium by congenially answering each other's gentle movements. Nowhere do lines and shapes move unaware of the actions of their neighbors.

Three-dimensionally, too, there is a deliberate elegance among the volumes. Note the downward force of the two arms in contrast to the monumental rise of the figure's left leg. These moves and countermoves among the volumes occur leisurely, almost in slow motion, and they contrast with the faster movements in the drapery and headdress. By its location in the image, the figure's left arm takes on the necessary visual and physical weight to balance the drawing's heaviness on the left. It does so by gaining force from the downward flow of the headdress and by overhanging the empty area of the lower right corner of the page.

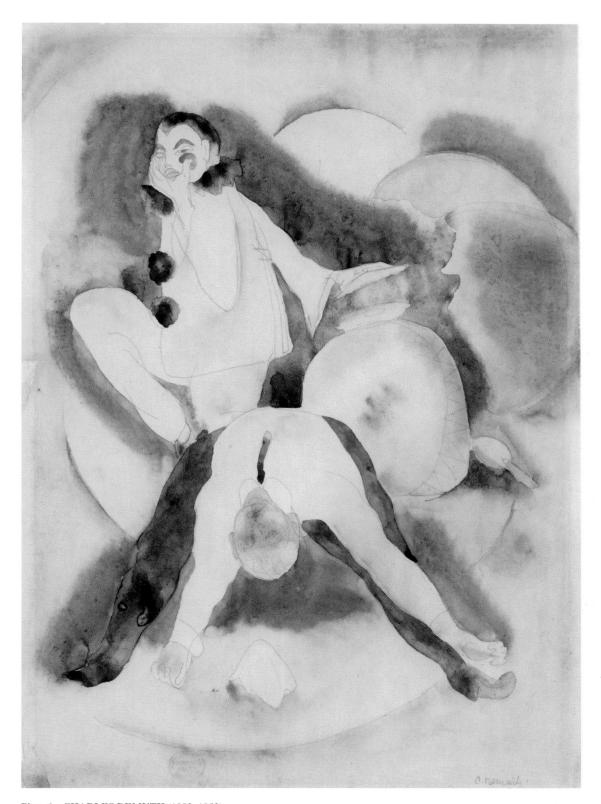

Plate 6 CHARLES DEMUTH (1883–1953)

Clowns

Watercolor and pencil on paper, H.: 7¹/2 in. × W.: 11 in.

The Metropolitan Museum of Art,

Bequest of Charles F. Ikle, 1963. (64.27.6)

Photograph © 1992 The Metropolitan Museum of Art.

Plate 7 RICHARD DIEBENKORN (1922–)
Seated Woman, No. 44 (1966)
Watercolor, charcoal, gouache, crayon, 30¹/4 × 23¹/2 in.
Gift of the Faculty-Student Association and President Evan K. Collins to the Fine Arts Collection, The University Art Museum,
State University of New York at Albany.

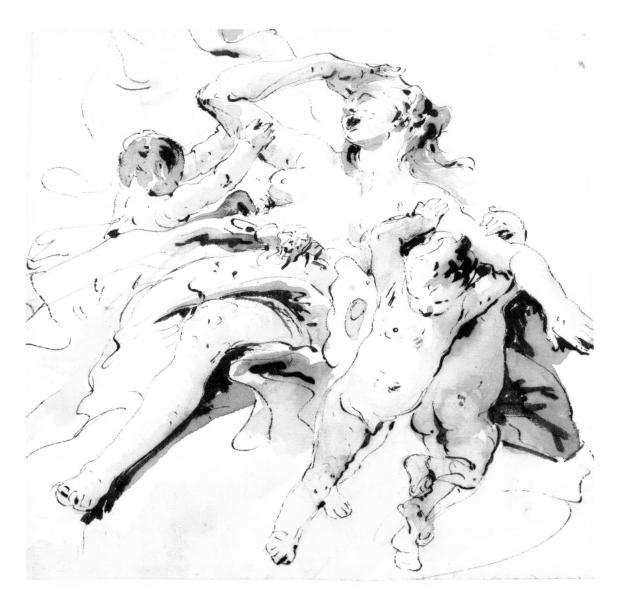

Plate 8 GIOVANNI BATTISTA TIEPOLO (1696–1770) Psyche Transported to Olympus Pen and brown ink, brown wash, over black chalk, on paper, H.: $8^3/4$ in. \times W.: $8^{11}/16$ in. $(22.3 \times 22.0$ cm). The Metropolitan Museum of Art, Rogers Fund, 1937. (37.165.20) Photograph © 1992, The Metropolitan Museum of Art.

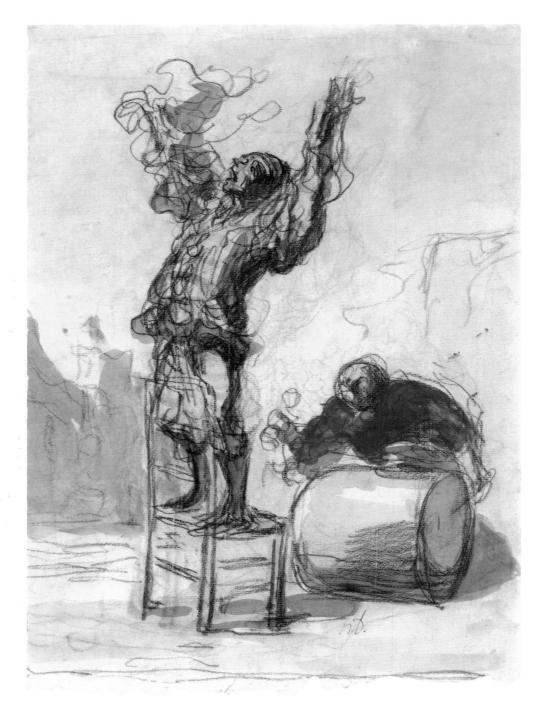

Plate 9 HONORE DAUMIER (1808–1879) Street Show (Paillasse)

Black chalk and watercolor on laid paper,

H.: $14^3/8$ in. \times W.: $10^1/16$ in. $(365 \times 255$ mm).

Signed (in ink, lower right): H.D. Photograph © 1992 The Metropolitan Museum of Art The Metropolitan Museum of Art, Rogers Fund, 1927 (27.152.2).

5.47 PERSIAN DRAWING, SAFAVID PERIOD (end of 16th century)

Portrait of a Noble Lady with an Elaborate Headgear

Brush and ink, $7^5/8 \times 5$ in.

Photo R.M.N./Musee du Louvre, Paris.

Note how well these forms, despite the simplicity of their structure and the absence of tonal modeling, suggest convincing volumes. Such an economical statement of solid, graceful masses conveys the artist's sound grasp of structural and anatomical essentials as well as a penetrating sensitivity to dynamic order. Although these forms are insistently stylized—as much the result of convention as of personal response—they reveal a conviction and eloquence that no convention of figure drawing can provide (or suppress).

For some artists, the abstract visual forces take on the fury of a storm. For them, creating a figure's living presence has little to do with surface niceties or refined adjustments of value or proportion. In their drawings, vigorous graphic energies become the visual equivalents of those which animate the living figure. But their drawings, while more intuitional than deliberate, are never unreasoned or arbitrary. There is, in fact, as compelling a necessity in the ordering of the marks as there is in the most consciously arranged image. Naturally enough, their drawings tend to show strong direction and handling energies.

This is clearly the case in Kokoschka's *Half-Length* of a Reclining Woman (Fig. 5.48). Unlike the drawings already examined in this section, where to varying degrees forms suggest energies, here we feel that energies "consent" to imply forms—that is, the real subject matter is the behavior of visual forces of the image, not the physical behavior or character of the model. Although the best exponents of figure drawing always contend with the interacting factors of structure, anatomy, design, and expression, each artist evolves a personal formulation of these considerations. Kokoschka's solution places structure and anatomy in subordinate roles, making them the servants of an expressive design. He does this not out of indifference to the figure's fixed,

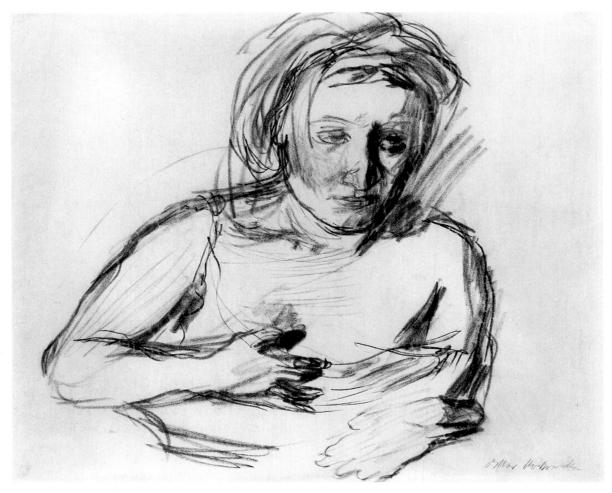

5.48 OSKAR KOKOSCHKA, English Born Austrian (1886–1980)

Half-Length of a Reclining Woman (c. 1931–1932)

Red chalk on cream wove tracing paper, 45.1 × 55.5 cm.

Margaret Day Blake Collection, 1945.1. Photograph © 1998, The Art Institute of Chicago. All Rights Reserved/© 1999 Artists Rights Society (ARS), New York/Pro Litteris, Zurich.

measurable aspects, but because his main interest is in evoking its more vigorously dynamic aspects.

Here, urgently racing lines and values seem only partially concerned with depictive tasks. In sweeping across forms, in leaping from one edge to another, they reveal how energetically the artist responds to the subject's clues for such actions. In addition to the almost frenzied pace of the handling, Kokoschka makes effective use of various other devices that speed up visual motion.

He avoids sharply focused shapes and forms, simplifies their contours, omits surface details, and gives the entire configuration a tension-producing tilt to the right side. Only in the head, the focal point of many of the drawing's moving forces, do these devices abate somewhat, permitting a more structured

and objective treatment. Strong rhythmic actions heightened by blurred edges and by the furious manner of drawing the hair, the various hatchings, and the folds in the dress further add to the expression of energy. Because the elements are all strongly engaged in motion, we sense tensions throughout the drawing. Each line and value strives for change or continuance, each form only tenuously occupies its space on the page; the woman's hair and hands never really settle into any one position. Yet Kokoschka gives us a stabilized design. Despite the drawing's violent calligraphy and action, no directional thrust remains unchecked. In fact, the image suggests an arrangement approaching symmetry.

In Kollwitz's stormy *Mother and Dead Child* (Fig. 5.49), everything suggests motion. There is

5.49 KATHE KOLLWITZ *Mother and Dead Child* (1903) Charcoal, black crayon and yellow crayon on heavy brownish paper, $18^3/4 \times 27^1/2$ in. (47.6 × 69.8 cm). Signed, lower right; notes in the artist's hand, lower left. Private collection, Courtesy Galerie St. Etienne, New York/© 1998 Artists Rights Society (ARS), New York.

movement in the mother's clutching of her child, in the mother's crossed legs, as well as in the forceful handling of the charcoal. There is even movement in the limp body of the child draped across her mother's lap. Smaller movements animate the drawing's smaller forms. The artist intensifies the energies that strong directions and rugged handling generate by making the image fill the sheet. There is a tensional strain on the boundaries of the page by the strong force of mainly diagonal movements. The same drawing in a larger pictorial field would lose some of its visual and expressive impact.

ANATOMY AS AN AGENT OF DESIGN

In Chapters 3 and 4, some references were made to the role that anatomical considerations play in stimulating dynamic activities. Here, we will examine several drawings to see how such activities may be generated by a figure's surface anatomy.

Cézanne, in *Rowing Man* (Fig. 5.50), establishes a rhythm composed of long diagonal hills and valleys that accentuate the figure's straining forward thrust. Especially clear in the center figure, the rhythm is formed by the teres major, the external oblique, the pectorals, the thoracic arch, and the midline furrow of the rectus abdominus muscles. Cézanne's lively treatment of these swelling forms produces a strong sense of physical and abstract action. To achieve this rhythm, Cézanne not only stresses the volume and rhythmic action of these surface forms but also subdues or omits others.

In Ingres's sheet of studies (Figure 5.51), the examination of surface anatomy is clearly more of a motive than an obligation to representational imagery.

5.50 PAUL CÉZANNE (1839–1906) *Rowing Man*Pencil, 8⁷/8 × 11⁵/8 in.

Museum Boijmans-Van Beuningen, Rotterdam. Photo by A. Frequin.

Ingres delights in emphasizing bony landmarks at the elbow, wrist, hip, knee, and ankle. And in the figure's contours, he slows the line down to experience each muscle's influence on the surface forms. In doing so, the entire page takes on the energy of these sensual undulations. Note the rhythmic arrangement of the various parts he set out to study.

In Michelangelo's Studies for "The Punishment of Aman" for the Sistine Chapel (Fig. 5.52), we find a probing examination of the surface changes that bone, cartilage, and muscle provide, with some forms additionally exaggerated or even invented. In the torso, Michelangelo enlarges or exaggerates the clarity of the flank pads and surrounding forms, the serratus muscles, the thoracic arch, the ribs, and the muscle bundles of the pectoralis major. In fact, an interesting characteristic of Michelangelo's figure drawings is

that he usually shows each muscle in a state of contraction, revealing its swelled form. In the legs, he emphasizes the form of the rectus femoris, even suggesting different constructions for this muscle in each leg; in the left leg, he shows the adductor group with the clarity it would have only in the flayed figure.

By these anatomical changes, Michelangelo creates a different kind of rhythm from the fast-moving one in Cézanne's drawing or in the less exhaustive study by Ingres. We sense a pulsating ripple in the Michelangelo, both visual and physical—a constant rise and fall of small surface forms. Instead of enhancing directional movement, as in Ingres's study, this rhythm slows down the figure's vertical thrust. This occurs because the human eye hunts for and examines change of any kind. The eye is a rover, constantly searching for visual problems to solve. Simple

structures, rhythms, and textures are quickly understood and as quickly dismissed. But when the eye encounters complexities, it slows down to explore them. We might be quickly bored by the easy structure and pattern of a new picket fence, but we are more likely to dwell on an old, battered, and irregular fence, finding its deviations of form, value, and direction more visually engaging. So does the figure of Aman make us pause to study the always interesting changes in its surfaces.

That the same anatomical forms can initiate and serve an endless variety of relational activities is seen in Boccioni's *Reclining Male Nude* (Fig. 5.53). Here, the artist subordinates the sense of volume to concentrate instead on the shapes of the torso's surface forms. A pattern engages shapes formed by groups of large and small muscles in movements against each other, creating two-dimensional tensions that parallel those produced by the pressure, strain, and weight of the muscles themselves. Boccioni, in simplifying

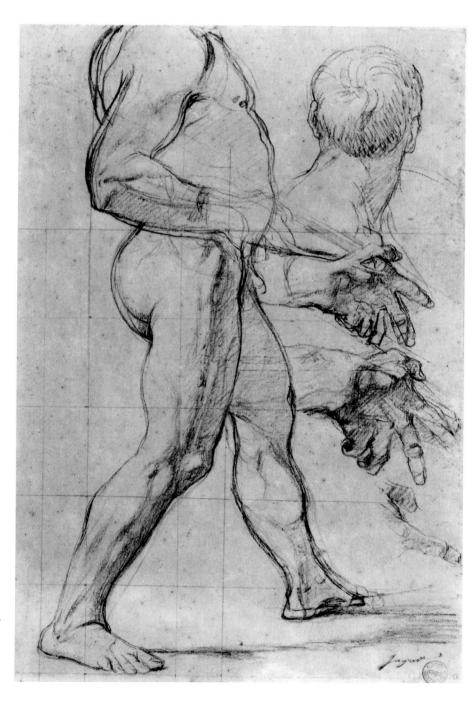

5.51 JEAN-AUGUSTE-DOMINIQUE INGRES (1780–1867)

Etude pour "Le martyre de Saint Symphorien"
Bayonne, Musee Bonnat NI 981 95 CN 7428.
Photo RMN/R. G. Ojeda.

these contending knots of shape, stresses straight and curved lines that reinforce the drawing's twodimensional design as well as the rigid and supple condition of the forms. In responding to the figure's anatomical and dynamic condition, Boccioni finds solutions that enhance the drawing's representational and abstract meanings. A subject's particular arrangement always contains the seeds of its creative solution, to be nurtured in accordance with each artist's expressive intent.

Boucher suggests the vitality and power of the sea god in *Study of a Triton* (Fig. 5.54) by a large dia-

5.52 MICHELANGELO BUONARROTI (1475–1564)
Studies for "The Punishment of Aman"
for the Sistine Chapel
Chalk, 16 × 8¹/4 in.

© The British Museum.

5.53 UMBERTO BOCCIONI (1882–1916) *Reclining Male Nude* (ca. 1909–10) Pencil, 11⁷/8 × 7¹/2 in.
The Lydia and Harry Lewis Winston Collection, Mrs. Barnett Malbin, Birmingham, Michigan.

mond shape composed of the figure's arms and by a system of diagonals and wedges—shapes and directions well suited to suggest energy and motion. Strong rhythms emerge from the repetition of these angular shapes and counteracting directions, urged on by Boucher's aggressive treatment. But it is his sound grasp of structure and anatomy that provides the basis for many of these powerful abstract actions. Throughout the figure, bone, muscle, and the form units they make furnish the artist with plenty of visual ammunition for these dynamic exchanges. For example, in the left arm, the wedge shape of the deltoid digs hard into the biceps and triceps below. At the same time, they

counter with a pincerlike swing under the deltoid and, at their opposite end, mount their own assault on the supinators at the elbow.

Among the forms of the chest and back, muscles overlap and interlace aggressively; in the arrangement of the hands, the blocklike fingers echo the vigorous energy of the hair. As in Kokoschka's similarly energetic drawing (Fig. 5.48), Boucher stabilizes the visual energies among the parts and in the figure's overall surge to the left by using an essentially symmetrical design and by investigating great visual and physical weight in an overhanging arm. Here, too, a rotating action envelops the forms. This action, along

5.54 FRANÇOIS BOUCHER (1703–1770)
Study of a Triton (1748–1753)
Black chalk, with stumping with traces of red chalk, heightened with white chalk and traces of graphite, on tan paper, 22.1 × 27 cm. Helen Regenstein Collection. 1965.240 recto. Photograph © The Art Institute of Chicago. All Rights Reserved.

with Boucher's use of swelling curves, keeps the drawing's angularities from appearing too brittle or harsh.

Surface anatomy, even if only of the most general kind, can continue to guide associational bonds, as Hiroshige's *Two Women Playing* (Fig. 5.55) indicates. The contours of the robes that describe the backs of the two women, in addition to providing visual parentheses that unite these figures, take some of their graceful flow from the nature of the forms they cover. These contours, especially the one on the left, supply us with a surprising amount of information about the figure's anatomy. In that contour, we can locate the beginning of the gluteal muscles, sense the absence of any obstruction to the robe's fall until the gastrocnemius muscle, and follow the edge of the lower leg to the ankle. Additionally, it describes the oblique and tapering nature of the supporting right leg.

THE FIGURE AND THE ENVIRONMENT

In the best drawings of the figure in an environment, the figure is always an integrated component of the design. Whether it is dominant in the drawing or represents only a small part of it, the figure, at least in its formal, visual sense, fully relates with other segments of the drawing and is part of a consistent visual syntax. It can be thought of as part of a large still life, interior, or landscape design—a form among other forms. To think of it in this way is not to disregard the figure's singular nature and importance; on the contrary, by integrating the figure and its surroundings to create a greater unity, we enlist the environment's differing character as a visual foil against which the figure's unique qualities and meanings can have even greater visual and expressive impact.

Treating the figure in a distinctly special way

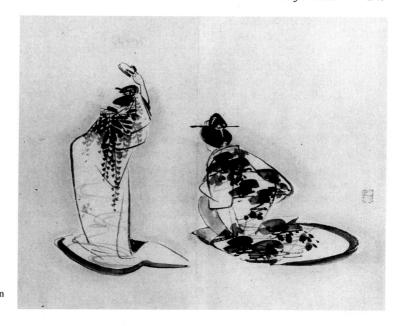

5.55 ANDO HIROSHIGE (1797–1858) *Two Women Playing*Ink and watercolor, $10^{7/8} \times 6^{5/8}$ in.
Courtesy of the Freer Gallery of Art, Smithsonian Institution, Washington, D.C. 04.357.

only isolates it from its surroundings, weakens the drawing's unity, and obscures the very meanings that such special attention endeavors to express. Too often, beginners who include the model's surroundings lavish attention on the figure at the expense of its environment, unaware that the figure's representational and dynamic meanings depend on a visually logical and consistent integration of the *entire* subject. As we have seen, the figure can come alive with little or no surrounding support. However, when other forms are part of the design, no matter how abbreviated and vague their treatment, they must relate to the figure's forms.

Such an attitude is evident in Thiebaud's *Man on Table* (Fig. 5.56), where there is more space and emphasis given to the severe form of the table and its harsh black shadow than to the limp figure on it. In fact, the drawing's ominous meaning is amplified by this tactic. Note how well the artist establishes the foreshortened arm; note, too, the daring transition from the fully modeled upper body to the ghostlike legs.

In Fishman's *Reclining Figure* (Fig. 5.57), the cascade of drapery reenacts the fall of the figure's forms, adding to the artist's emphasis on the look and feel of weighty mass giving in to gravitational pull. Although the figure dominates the scene, the integration of human and drapery forms through similarities of movement, contours, and handling creates an animated dynamic state that gives the drawing its strong expressive force. Note that the darkest tone, on the woman's head, occurs where it can have the strongest

effect: at the end of the tumble of forms. Like a stone falling into a pool, the head seems to have produced the "ripples" suggested by the layers of drapery surrounding it.

Hopper, in his preparatory Study for East Side Interior (Fig. 5.58), builds a classical grid of vertical and horizontal units. Shapes and values, lines and volumes all conform to a checkerboard alignment in which the seated figure participates. At first glance, the figure does not attract much attention. That is commanded by the strong, bright shape of the window, made even more visually attracting by its dark frame and by its alignment with the chair below it, adding to the window's vertical motion. To the left, the dark picture on the wall echoes the window's shape, while throughout the drawing other vertical directions and light-toned shapes relate with the window, further strengthening its visually compelling power. The window attracts these shapes; even the sewing machine strives to move to the right.

Only a few areas that contrast with the drawing's hard geometry seem to resist the window's magnetism. The globe on the far left, the curved chair, the woman's head, and a few dark shapes in the lower left corner emerge as a secondary visual theme of organic shapes and forms that begin to command attention. Once this system is recognized, we also sense that the figure's central location, added to the curvilinear units encircling it, give the figure a unique visual power. Additionally, her sharp glance toward the window and the slight leftward tilt of the torso, in re-

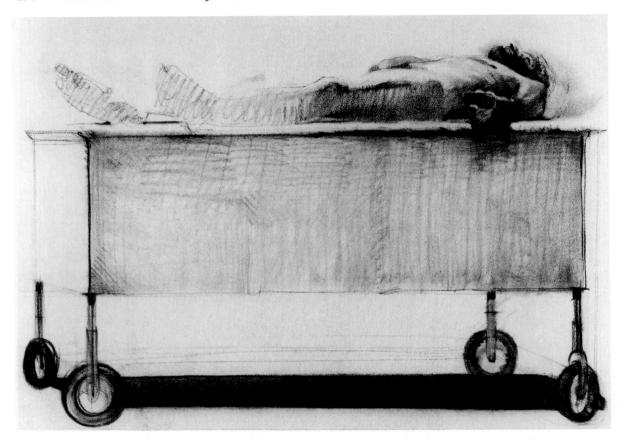

5.56 WAYNE THIEBAUD *Man on Table* (1978) Charcoal on paper, $22^{1}/4 \times 30$ in. Courtesy of the artist.

vealing both physical and visual resistance to the window's attracting force, heighten her importance in the design. Hopper, by firmly integrating the figure in the design, establishes a visual unity that can bear the gradually accumulating attention and importance that her location, form character, and human gesture command. To have given her more prominence in scale, value, or "finish" might have destroyed the drawing's unity and the visual activities that support the artist's physiological statement. Our appreciation of her living presence, of the sudden gesture that suggests an unseen interruption, depends on the abstract and representational context in which we find her.

In a similar vein, the seated figure in Rembrandt's *The Artist's Studio* (Fig. 5.59) is *found* to be important rather than announced as such. She occupies an even smaller portion of the design than does the figure in Hopper's drawing and, in strictly visual terms, seems even more consistently regarded as an object.

Far from emphasizing the figure's visual impact, Rembrandt almost camouflages her forms. He does this by matching the light tone of her torso with that of the nearby wall and the darker tone of her skirt with the shadowed areas surrounding it. Additionally, he makes the forms surrounding the figure more structurally assertive, draws them in a more rugged manner than he does the figure, and further restrains her visual impact by having the chair overlap her back while minimizing the effects of the figure's forms overlapping her surroundings. The overall effect makes the figure something of a visual rest area between the more vigorously handled segments on either side.

As in Figure 5.58, Rembrandt's organizational strategy is also based on a pattern of vertical and horizontal lines and shapes. An overall light tone softens the grid of rectangular shapes that appears throughout the drawing; even the woman's torso and the direction of her bent legs suggest conformity to this gridlike

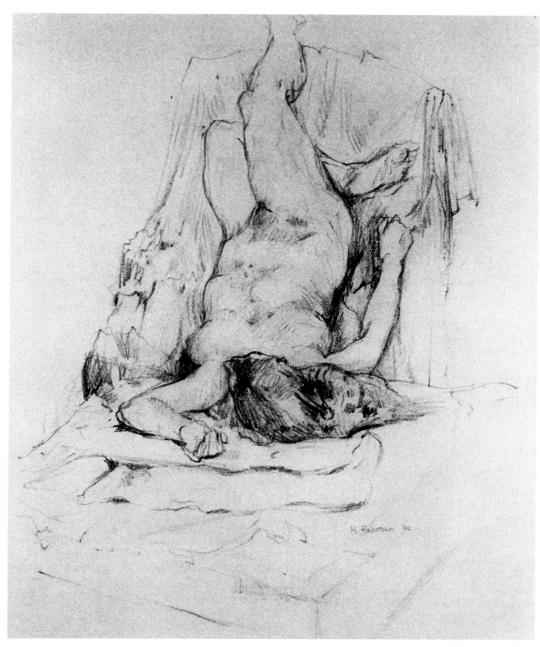

5.57 HARRIET FISHMAN Reclining Figure (1990) Black chalk, 18 × 24 in. Arkansas Arts Center.

pattern. But although completely integrated in the design, she is not a minor component in its order. In fact, despite her small scale and quiet visual behavior, she is the keystone of the design. Rembrandt reveals her dynamic role as subtly as he defines her figurative role.

The long diagonals of the easel at the far left, by contrasting with the drawing's many vertical and horizontal movements, create the need for some answering diagonal. This is provided by the figure's lower arm and leg and by the long lines of the fireplace behind her. By making the seated figure take part in

5.58 EDWARD HOPPER (1882–1967)

Study for East Side Interior (1922)

Conte crayon and charcoal on paper, 815/16 × 111/2 in. (22.7 × 29.2 cm.).

Collection of Whitney Museum of American Art, New York.

Josephine N. Hopper Bequest. 70.342. Photograph Copyright © 1998:

Whitney Museum of American Art.

both the grid and the diagonal movements, Rembrandt makes her location and form necessary links in the design.

Another diagonal connects the windows to the figure. This results from the alignment of the circle in the window on the right, the staggered corners of the two dark shapes on the wall, and the woman's head. Rembrandt further strengthens the figure's relational play with the windows by giving them a common value and vertical—horizontal orientation on the page. And in reserving the drawing's strongest

value contrast for the figure and the nearby dark tone below the table, Rembrandt provides still another means of *indirectly* calling attention to the seated woman. In creating this quiet interior scene, he does more than describe the small light-bathed figure resting in a corner of the large studio. By abstractly conveying the importance of this small and subtle segment of the design, Rembrandt deepens our comprehension of her human significance in a large inanimate setting.

In Castiglione's Pan and Syrinx, with a River

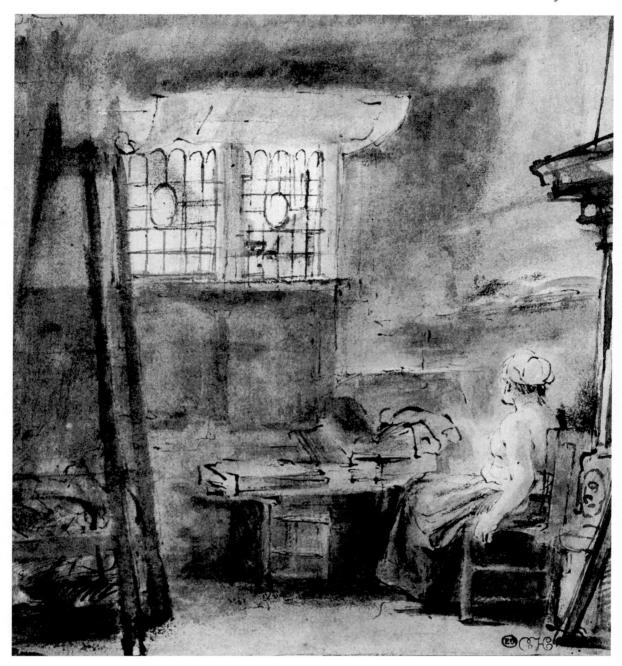

5.59 REMBRANDT VAN RIJN (1606–1669) *The Artist's Studio* Pen and ink with wash, touched with body color, 8×7^3 /s in. Ashmolean Museum, Oxford.

God (Fig. 5.60), the dominance of the five figures is assured by their horizontal alignment in the foreground, as is their integration in the drawing's organization. This is accomplished by Castiglione's undulating brushwork, which treats figures and foliage in

the same fluent manner, and by his emphasizing a sameness of direction between parts of the figures and the background. For example, the diagonal tilt of the tall grasses on the left side is repeated in the arms and legs of the three larger figures; it is seen

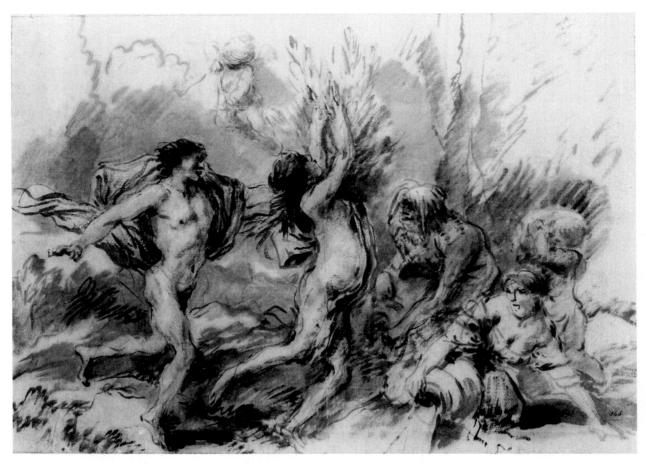

5.60 CASTIGLIONE

Pan and Syrinx, with a River God

V & A Picture Library.

again in the tree trunks, foliage, and elsewhere in the drawing.

The observant reader may have noted that in earlier discussions of balance, as here, the problem is often that elements to the right of center seem to weigh more than comparable elements to the left of center. That we do judge parts on the right to have more weight can be easily proven if we examine any of the drawings in this book by holding them up to a mirror. While the reasons for this phenomenon are obscure, it is nevertheless universal, a given condition of perception that we must take into account in establishing a balanced resolution of forces.⁶

Beginning art students, struggling to make their figure drawings come alive, may sense some of the figure's underlying structure. They will sooner or later recognize the need to understand anatomy and will always have known, even as children, that the human figure can convey a limitless range of expressive meanings. Yet most beginners have never seriously considered the abstract forces released by the elements which, in paralleling the order, vitality, and motion of living organisms, fertilize the image and give it life. Developing an awareness of the dynamic cues in the subject and of the means of translating them into ordered, expressive graphic terms is essential to creating figure drawings that *enact* and *evoke* as well as define.

⁶ Another strange phenomenon is that we regard a part located high on the picture plane as weighing more than if it were located lower. For a useful discussion of the experiencing of visual weight, see Rudolf Arnheim, *Art and Visual Perception* (Berkeley and Los Angeles: University of California Press, 1969), chap. 1.

SUGGESTED EXERCISES

Unless otherwise indicated, the following exercises are not restricted to any particular medium or size and have no time limits. But because they vary widely in purpose, give some thought to choosing a medium and size suitable to the nature of each exercise. In each, establish a design strategy based on visual ideas that originate in the subject. That is, let the pose and the character of the forms suggest the placement on the page, the size of the image, and the major visual activities and themes. In each of the following drawings, whatever the particular goals, remember that you are always trying for a balanced and unified resolution of the elements and energies.

- Working from a model, make the following drawings of the same pose:
 - a. A gestural line drawing, somewhat in the calligraphic and rhythmic nature of Figures 5.2, 5.4, and 5.8. Emphasize directions and a strong sense of animation.
 - b. A deliberate, continuous line drawing, somewhat in the manner of the contour line used in Figure 5.9. Rely on shapes rather than on a profusion of lines, and stress the subject's two-dimensional aspects.
 - c. A volume-informing line drawing which may include a moderate amount of hatching. Intentionally emphasize physical weight in establishing balance.
- 2. Working from a model and using an erasable medium such as vine charcoal or soft graphite, restrict your drawings to values only. The values may be formed by groups of lines, but avoid explaining edges or folds by lines only. Include the model's immediate surroundings. If you wish, apply a moderately dark tone to your paper before you begin to draw and use an eraser as well as your charcoal or graphite to establish the tonalities. Your goal is to suggest movement within values and through their shape and handling. This drawing need not include the entire figure. In general, promote a bold, aggressive handling, as in Figure 5.22.
- **3.** Working from a model, make the following drawings of the same pose:
 - **a.** Using Figures 5.17 and 5.18 as rough guides, draw the model in a manner that intentionally creates figure–ground ambiguity.
 - b. Using Figure 5.19 as a rough guide, draw the model in a manner that creates strong light and dark tones. Be sparing in your use of line; try instead to make values establish the forms. For this drawing, you may wish to use artificial light to produce strong value contrasts.
- 4. Working from a model, make the following drawings of the same pose:
 - a. A drawing that subdues the sense of volume and relies mainly on visual weight for balance.

- b. A drawing that emphasizes a strong sense of volume and relies mainly on physical weight for balance.
- 5. Working from a draped model in an environment and using Figure 5.37 as a rough guide, make a pen, brush, and ink drawing that relies on texture as a major means of organizing the design.
- 6. Using Figure 5.61 as your model, draw a free adaptation of these forms as they might look in the living model. Although your drawing will not show the figure in the flayed state, emphasize the textural character of the muscles, as in Figure 5.34.
- **7.** Using either Figure 5.62, 5.63, or 5.64 as your model, make the following two drawings:
 - **a.** With Figure 5.40 as a rough guide and by inventing any environment necessary, interpret the model for its design possibilities in similarly energetic terms.
 - **b.** With Figure 5.48 as a rough guide and by inventing any environment necessary, use pen, brush, and ink to establish a drawing that conveys a similarly powerful sense of motion among the elements.
- **8.** Using Figure 5.44 as a rough guide, invent a pose that suggests the figure's imminent movement. Do this through the pose, the modeling, and the handling.
- **9.** Using Figure 5.24 as a rough guide, invent a two-figure composition in an interior or exterior setting that emphasizes shape, texture, and value and that aims at a strongly two-dimensional image.
- **10.** Using either Figure 5.62, 5.63, or 5.64 as your model, make the following two drawings:
 - **a.** Using Figure 5.22 as a rough guide, make a chalk drawing in which the medium's texture plays an active role in the drawing's movement and energy.
 - b. Using Figure 5.33 as a rough guide, make a drawing in which the figure's forms are "lost and found" in a dark background.
- 11. Make the following two self-portraits:
 - a. With chalk or graphite on a sheet no larger than 14 × 18 in. and using Figure 5.36 as a rough guide, make a drawing that fills the page. The structural lines that model the forms should also function to balance the design on the page.
 - **b.** Using Figures 2.16 and 2.22 as rough guides and working actual size, make a "drawing" using small cut and torn shapes of white, light gray, and dark paper to represent the planes. Do not use more than three degrees of gray for this collage and think of it as a mosaic process. Try to convey a sense of volume, shape, and value order.
- 12. Rework or redraw two or three of the exercises done for Chapter 4, freely interpreting the forms to emphasize rhythmic movement among the muscles.

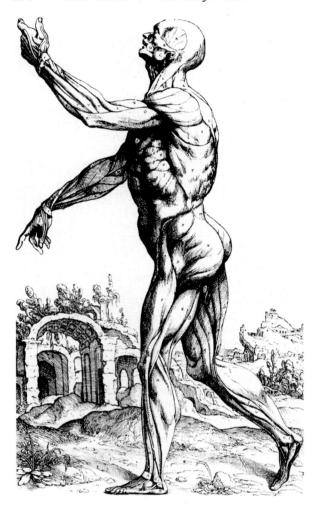

5.61 ANDREAS VESALIUS (1514–1564) *Plate 25 from "De Humani Corporis Fabrica," Book II* Engraving.
Courtesy of the New York Academy of Medicine Library.

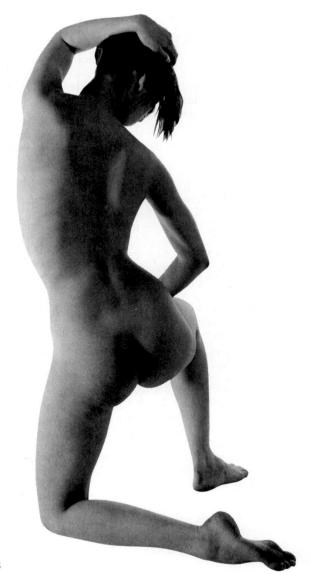

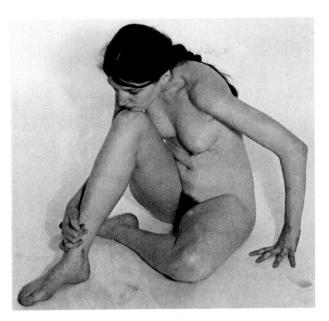

5.63

- **13.** Working from a model arranged in an interior or exterior environment, make the following three drawings:
 - **a.** A drawing in which the figure is almost camouflaged by value, shape, and placement among the surrounding objects, as in Figures 5.58 and 5.59.
 - **b.** A drawing in which one or more figures are dominant but strongly integrated in the design, as in Figure 5.60.
 - c. A drawing that may stress or subdue the importance of the figure in the design but that is strongly animated, relying on strong actions and directions, as in Figures 5.32 and 5.54.
- 14. Using Figure 5.12 as a general guide, invent on one large sheet a group of three or four sketches. Each should contain one or more figures in a setting or situation of your own devising. Each sketch should show, as does Figure 5.12, a variation of arrangement and design on your selected theme and should be placed on the page to contribute to the overall balance and unity of the picture plane.

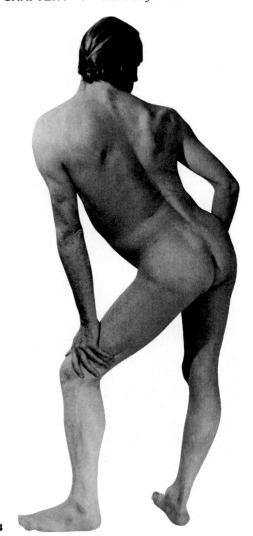

15. Working from a clothed model in any environmental setting and using Figure 5.39 as a rough guide for its emphasis on shape and texture, make a drawing (with any combination of media) in which shape and texture are dominant characteristics. Consider using "cutoffs" of the figure, as in Figure 5.39, and emphasize the drawing's picture-plane activities rather in its three-dimensional conditions.

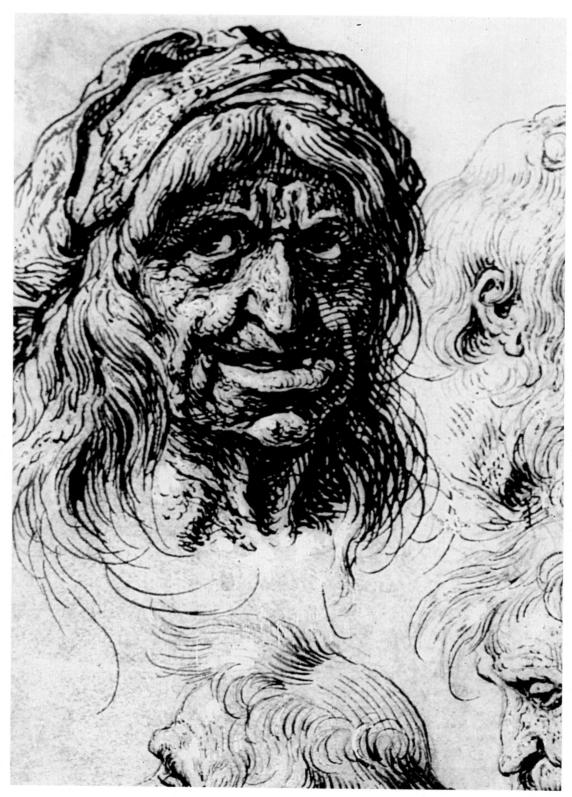

6.1 JACOB DE GHEYN II (1565–1629)
Study of Four Heads (detail)
Pen and ink over charcoal, white chalk highlights.
Teylers Museum, Haarlem.

6

The Expressive Factor

The Emotive Content of Figure Drawing

SOME GENERAL OBSERVATIONS

In Chapter 5, we observed that a drawing's design and expression emerge largely from the same phenomena: the visual dynamics that form the drawing. That these two factors are interwoven is evident in the expressive nature of the terms that describe most of the relational categories. Direction, rhythm, handling, weight, and tension suggest types and degrees of moving, attracting, repelling, pulsating energies, and strivings for change among the parts of a drawing. In responding to these visual activities, we *experience* their differing behaviors. We cannot help but react to these abstract and representational thrusts, stresses, weights, and tensions with a *felt* appreciation of their force.

A drawing's design reflects more than a conscious plan. Artists rely on intuition and feelings as much as on intellect to shape their images. If the design is the mind's strategy, that strategy is influenced by subconscious as well as conscious feelings that the mind initiates and by emotive qualities in the subject and in the emerging drawing. Thus, the resulting energies within and among a drawing's marks do more than function in their formal and depictive roles. They allude to psychological and spiritual states that we can apprehend and that enable a drawing to express, instead of only describe, the artist's responses to hu-

man events and attitudes as well as to things and places.

The artist's feelings, his or her psychological state during the act of drawing, largely determine the nature of the image. Our reality is shaped by our moods. The same pose can strike happy and melancholy artists differently. In a positive mood, artists may see in the figure's pose an affirmation of life's beauty and a reflection of their own good feelings, and this identification is bound to be mirrored in their drawings. The unhappy artist feels the bitter contrast between the figure's vitality and his or her own inner sadness, and this, too, is echoed in the work.

In the best drawings, we can sense a prevailing mood: Daring or decorum, rage or reflection, sorrow or sensuality pervade these drawings because such feelings were at work within the artist. These moods are conveyed by the form as well as the content. The lines and tones that express playfulness are not those of pathos, and the energies of anger are unlike those of joy. It is through these emotive marks that drawings take on universal significance. Such qualities raise a drawing out of its time and place and make the image a symbol that holds meanings for any society at any time.

We even experience emotive meanings in drawings that seem to focus more on formal visual issues

and seem less expressively motivated. Cambiaso's enthusiasm for structure (Figs. 2.5 and 2.33), Desnoyer's thoughtful explorations of two- and three-dimensional space (Fig. 5.24), Manet's spirited play with texture (Fig. 5.37), and Moore's engrossment with monumental form (Fig. 5.33) are all deeply felt expressions, each conveyed by elements, actions, and handling that reveal these attitudes.

Expression, then, should be understood as issuing from more than the emotional or psychological state of the figure's representational situation; it is a quality also inherent in the subject's forms and the marks that make them. Because both meanings of the term are important in figure drawing, they must not only complement but reinforce each other. In drawings where they conflict, we sense an uncertainty of purpose, a confusing ambiguity of expressive cues. A drawing of a fist can express power, threat, avarice, confidence, or fury. Without some emotive clues beyond the depiction, the fist is only described; it can be identified but not clearly experienced.

If drawings are to convey some expressive meaning, the artist must first experience this meaning in what is observed or envisioned. As the poet Horace observed, "If you wish me to weep, first you must grieve." But in contemplating the expression of a model, the artist searches for more than outward physical manifestations of a mood or event. He or she also searches for the figure's essential rhythmic and structural characteristics, because they reveal those dynamic properties by which the artist can evoke the figure's expression in ways that mere description cannot.

This is why so many artists begin their drawings by establishing the figure's gesture. By temporarily disregarding the figure's smaller surface effects and details and by seeing its arrangement of forms as *one expressive system* and not a collection of separate parts, the artist perceives the figure's essential masses, abstract activities, *and* mood (Figs. 5.49 and 6.2).

The best figure drawings begin with a grasp of generalities that excite the artist's imagination and end with those necessary specifics demanded by the original excitement. The artist's adherence to an original theme tells him or her when the drawing is complete—when the interpretation of the subject's important physical, psychological, and dynamic conditions is present in the work. And this must be done by deduction, not induction—by proceeding from the general to the specific. To reverse this process and draw each segment sequentially, bit by separate bit, does not allow for perceptions that uncover the general structural, human, and abstract conditions of the figure as a *whole*—perceptions vital to its figurative as well as evocative state.

Among the most common results of such a piecemeal approach are unintentional distortions in proportions and in the location of parts and the loss of the relational activities necessary to a drawing's balance and unity. To begin with details is to end with an unrelated collection of them, for details greedily devour essentials and strongly resist an integration of the figure's forms into a system of organized expression.

But if expression is largely conveyed by the character of the drawing's abstract and structural condition and, consequently, by the artist's handling, it is also, and importantly, a product of the subject's recognizable state. Facial expressions, physical actions, and the event in which the figure takes part (that is, the storytelling aspects of the subject matter) strongly affect the drawing's expression. However, as noted earlier, these two sources of expression must be mutually supportive. A precise and delicate rendering of a figure drowning would suggest a conflict between form and content. We do not shout our whispers or scream quietly.

A kinship between the dynamic and representational aspects of expression is demonstrated in the detail from de Gheyn's Study of Four Heads (Fig. 6.1). The artist does more than skillfully denote the physical expression of an old woman's grimace. Her fearful disquiet is carried in the rapid lines of the hair and in the gnarled and nervous lines of the face, in the abrupt changes of value, and in the tortuous shapes and forms of the head and bonnet. The intensity of her gaze is heightened by the circular movements around the eyes and throughout the head. By rhythmically repeating lines in the hair, bonnet, face, and neck, de Gheyn endows the image with a nervous vibrancy. Visual tensions abound, reinforcing the anatomical tensions in the strained features. The unusual contrast of the fixed gaze and the animated abstract movements, the latter due in part to the forceful handling, adds to her expression of anxious displeasure.

Kollwitz's *Death, Mother and Child* (Fig. 6.3) is a moving evocation of love and death. The hands that embrace the child's head hug with a tender intensity born in the abstract nature of ruggedly carved arcs enveloping gently rounded forms. The intimacy between the mother and child is revealed in the subtle fusion of their faces and in the tender sensuality of the modeling that continues across them. The drawing's strong horizontal and vertical directions are given contrast only by the diagonal movements of the ghostlike arms that grip the child.

Form and content work together in Abeles's *Black Camasol*, *Black Evening* (Fig. 6.4), evoking a bleak mood. The woman's lonely isolation is amplified by the stark white shapes of the background and

6.2 KUNIYOSHI Sketch for Kakemono-e of Tkiwa Gozen Ink on paper, $9^{7/8} \times 22^{7/16}$ in. Collection, Rijksmuseum voor Voldenkunde, Leiden, Netherlands.

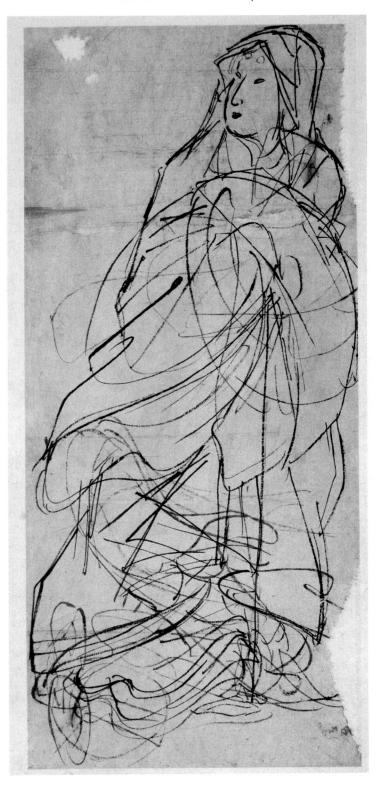

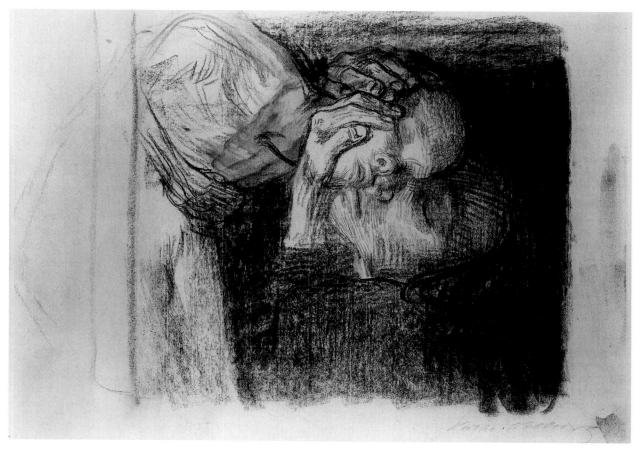

6.3 KATHE KOLLWITZ (1867–1945) **Death, Mother and Child** (1910)

Charcoal on laid Ingres paper (Nagel 605), .480 × .633 (18⁷/8 × 24⁷/8 in.).

Rosenwald Collection, Photograph © Board of Trustees, National Gallery of Art, Washington, D.C. 1951.16.60.

by their contrast with her ruggedly modeled forms. As in Kollwitz's drawing, a major visual theme is the system of mainly vertical and horizontal directions. But the weighty head, the supporting arm, and the figure's drooping left hand depart from the drawing's grid scheme, calling attention to the figure's body language. A second visual theme creates a large circular movement that begins with the curving chair, arcs across the shoulders, and sweeps down the figure's left arm to begin again. This, too, brings our attention to the head and supporting hand. This theme further magnifies the woman's isolation and mood through the contrast of the image's inner tensions and movements with the relentless emptiness of its surroundings.

As the foregoing examples make clear, drawings

made with a desire to realize with feeling an observed or envisioned expressive state must call on those dynamic forces that can evoke that state. Without some caring involvement, we lack a basis for selecting and organizing those abstract and figurative clues essential to expression. Drawings developed without some expressive goal, whether that expression is to be found only in the character of the drawing's relational life or in the interplay between the expressive forces in the subject and in the elements, are like rudderless boats; they move in no certain direction and drift according to the winds of chance.

This should not be understood as a license for unbridled self-expression. Creative expression records the artist's experience of a subject's visual and spiritual condition. We learn about the artist's ability to

6.4 SIGMEND ABELES (1934—) **Black Camasol, Black Evening**Charcoal pencil, 23 × 30 in.

Collection of Terry Shaneyfelt, Brookline, Massachusetts.

feel and intuit by how effectively he or she conveys the figure's expressive meanings, not merely those of the artist. Using the figure only as a springboard for an emotional high dive makes the drawing's real subject the artist, not the model. But a conscious concern with self-expression can easily turn into an essentially nonvisual emotional binge that does not really get at the subject's abstract and human condition. To do that, we must first be open and responsive to what we confront and draw our conclusions plainly.

As noted earlier, expressive meanings are revealed not only by the figure's structural nature but also by the means used to model the forms. De Gheyn's spirited calligraphy, Kollwitz's gentler strokes, and Abeles's rugged fluency disclose something of the drawing's psychological tone. Even in drawings that do not convey strong human emotions, the artist's interpretation and treatment of the subject will convey a particular expressive attitude.

The nonchalant pose in John's *Nude Study* (Fig. 6.5) could as easily have suggested melancholy, monumentality, or furious motion. Imagine what

Michelangelo, Degas, Kollwitz, or Matisse might have done with this pose. John's responses lead him to the harmonious cadence of the curvilinear edges and volumes; he extracts their easygoing, rhythmic lilt. Hair and limbs, lines and tones all move along in playful accord, all support the artist's interpretation of the figure as imbued with voluptuous form and movement. But the visual and expressive potentialities of most poses are great enough to support a wide range of interpretations. Michelangelo would probably have found monumentality here; Degas a unique blend of sensuality and classicism; Kollwitz a poignant sentiment; and Matisse a spirited and subtle play between two- and three-dimensional matters.

Physical weight can be a strong agent of expression, as in Ingres's *Study for the Portrait of Louis-François Bertin* (Fig. 6.6). Ingres bolsters the figure's implacable stance by a pose that stresses both the sitter's considerable bulk and a stable arrangement of his forms. There is strength and resolution in the large U-shaped curve of the two arms, reinforced by the similarly curved chair back and the figure's

6.5 AUGUSTUS EDWIN JOHN (1879–1961)

Nude Study (ca. 1906–07)
Red chalk, 9 × 11⁵/8 in.

The Metropolitan Museum of Art, Rogers Fund, 1908 (08.227.20)/© 1999 Artists Rights Society (ARS), New York/DACS, London.

legs. These grand curves, by the large spaces and forms they envelop, also suggest bigness, substantiality, and stability. Such abstract expressions of assertive solidity amplify the sitter's determined stance and gaze.

Too often, the beginner relies on the model's facial expression to convey the mood, but as Ingres demonstrates, a mood is best imparted through the entire image. Notice that Ingres, in drawing the small active forms of the tousled hair and clawlike fingers, adds subtle psychological insights and visual counterpoints of scale that further emphasize the sitter's imposing bulk and personality.

THE INHERENT EXPRESSION OF THE ELEMENTS

We have said that in addition to the emotive content of the subject's figurative situation, there is the emotive character of the drawing's elements. Such characteristics evoke recollections and insights about movements and energies that we feel as expressions of various kinds. In Chapter 5, we discussed the inherent visual nature of the elements and saw how each mark either adds to or detracts from a drawing's balance and unity. We were interested in the differing functions and energies of the elements for order-forming purposes. Now it only remains to point out that these differing abstract activities also carry emotive content and that indifference to this emotive content also diminishes meaning.

Every drawn mark can be felt as well as seen. A boldly drawn curve representing a downturned mouth with lips pressed together contains the force of the mouth's frowning expression to a far greater degree than the same curve drawn hesitantly. Additionally, the curve, in relating to the boldness of other lines and tones, becomes part of a larger system of expressive elements that further support the emotive force of the frown. But if the curve is to express discontent, we must, as Horace advised, first experience that discontent. It must be part of our perception. The most careful description of a figure's forms cannot communicate what felt lines and tones can evoke. Accuracy

6.6 JEAN AUGUSTE DOMINIQUE INGRES, French (1780–1867) *Study for the Portrait of Louis-François Bertin* (1766–1841) Chalk and pencil on pieced paper, H: 13³/₄, W: 13¹/₂ in. The Metropolitan Museum of Art, Bequest of Grace Rainey Rogers, 1943. (48.85.4)

without ardor results in a spiritless rendering of surface effects.

In neglecting to support what is seen with what is there to be felt, the beginner's lines and tones still continue to express; they convey indifference or inhibition in the presence of the figure's expressive energy. Such drawings may be accurate inventories of forms, but the forms fail to come alive because they lack an expressive incentive. Lebrun had in mind this failure to feel when he observed that all too often "in teaching, we neglect to sponsor passion as a discipline. The only discipline we teach is that of the deadly diagram supposedly to be fertilized later by personal experience. Later is too late."

Each of the elements can enact a broad range of expressive actions. Line, tones, and shapes can suggest fast or slow movements; they can seem playful, threatening, nervous, sensual, stately; they can relate with other elements to form reassuring or uneasy states of balance in a drawing. Even the elements we use to make a diagram or a doodle suggest their inherent and distinctly different expressive personalities.

When de Gheyn changes his expressive goal, his use of the elements changes also. In Figure 6.7, the expressive behavior of the elements in the three views of an old man's head are more rhythmic, gentler, and the illumination less harsh; the tonal changes are more gradual; the shapes friendlier and less gnarled than those of the woman's head.

An important consequence of using the emotive power of the elements to reinforce figurative themes

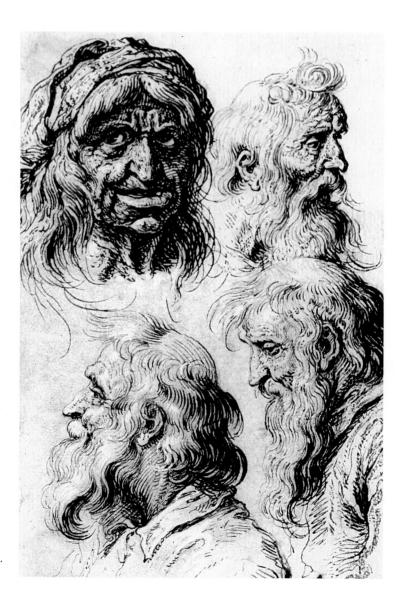

6.7 JACOB DE GHEYN II (1565–1629)Study of Four HeadsPen and ink over charcoal, white chalk highlights.

Teylers Museum, Haarlem.

¹ Rico Lebrun Drawings (Berkeley and Los Angeles: University of California Press, 1961), p. 25.

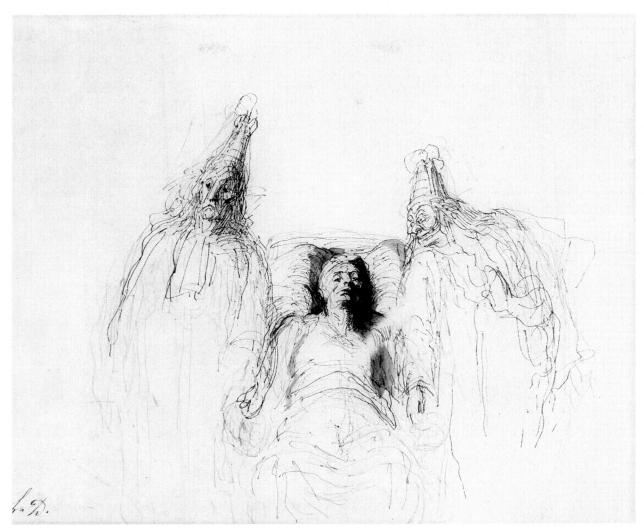

6.8 HONORE DAUMIER (1810–1879) *The Imaginary Invalid*Pen and black and grey ink and grey wash over black chalk, 128/16 × 13⁷/s in.
Yale University Art Gallery.
Bequest of Edith Malvinia K. Wetmore.
Photograph by Joseph Szaszfai.

is that the best artists make the elements perform as metaphors that deepen or transcend these themes, as the foregoing examples have shown. Sometimes the event represented is enigmatic and can only be understood by experiencing the behavior of the elements. For instance, the faint, quivering lines in Daumier's *The Imaginary Invalid* (Fig. 6.8) suggest the tremulous unease of the patient and of the two strange attendants. Symmetrical and delicate at first glance, the drawing's agitated lines and the single shock of dark tone surrounding the patient's head begin to alert us to the scene's quiet nightmare, which grows in terror while we watch.

By way of an interesting contrast to Daumier's deceptively light and gentle treatment, Aronson's *Rabbi III* (Fig. 6.9), dark and seemingly brooding, is a statement of tranquil introspection, and the dominant behavior of the elements supports that theme. The stable monumentality of the shapes and forms, the unchanging tone of the background, the gentle transitions of tone in the head, the figure's centrality, and its union of physical and visual weight all attest to an enduring serenity. The sudden burst of black strokes, harshly carving planes, and hollows intrude like blows while they strengthen the forms.

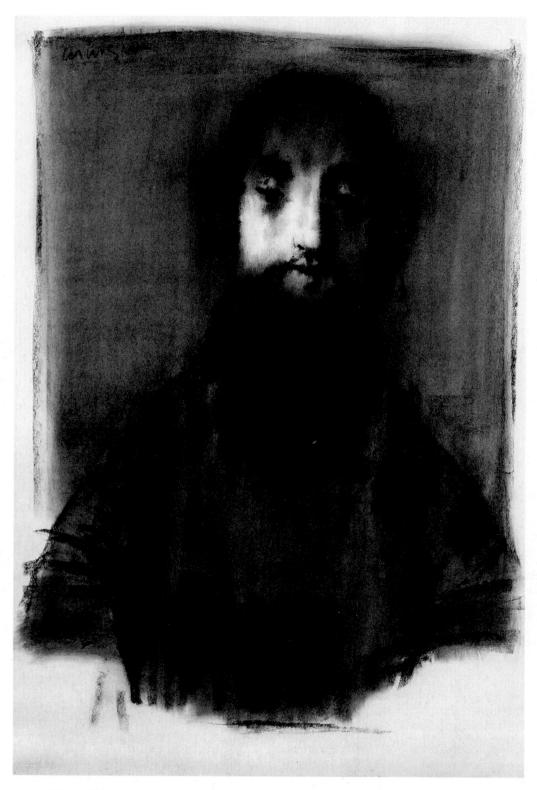

6.9 DAVID ARONSON (1923–) *Rabbi III* (1964) Brown chalk, 40×26 in. Gift of Arthur E. Vershbow, Benjamin A. Trustman, Samuel Glazer and Dr. Earl Stone. Courtesy, Museum of Fine Arts, Boston. 64.2017.

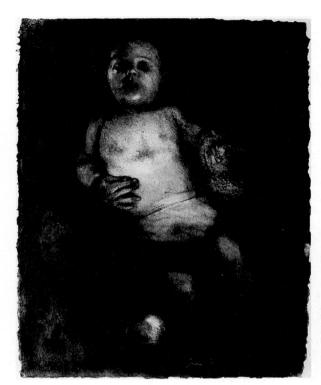

6.10 JIM DINE (1936–) **Second Baby Drawing** (1976)

Charcoal, pastel, and pencil, on paper, $39^7/8 \times 31^1/8$ in. $(101.4 \times 79 \text{ cm.})$. Collection, The Museum of Modern Art, New York. Gift of Lily Auchincloss. Photograph © 1999 The Museum of Modern Art, New York.

6.11 WALT KUHN (1880–1949)

Study for "Roberto" (1946)

Black ink and opaque white paint on reddish-tan wrapping paper,

Sheet: $17^3/8 \times 10^{1/4}$ in.

Charles Henry Hayden Fund.

Courtesy, Museum of Fine Arts, Boston. 61.938.

6.12 JULIE SAECKER SCHNEIDER *Away From Me, if Possible* (1984) Graphite pencil, 29 × 23 in. Courtesy of the artist.

But if the dark tone in Aronson's drawing speaks of introspection and strength, the tones in Dine's *Second Baby Drawing* (Fig. 6.10) suggest a more ominous mood. The hard-to-define background (is the child's lower body submerged?), the sudden, harsh light, the child's questioning expression, and the clawlike, moving left hand all create an uneasy and expectant situation.

The dynamic power of the elements in Kuhn's Study for "Roberto" (Fig. 6.11) abstractly augments the power described in the hefty forms of the resting acrobat. Similar to Aronson's drawing in its stability and implications of perseverance, Kuhn's drawing suggests a sense of raw strength and confidence by the rugged nature of the elements. There is nothing facile about the man or the handling; both are straightforward expressions of inherent vigor. That expressive intent can dramatically alter form and handling is evident in comparing Kuhn's drawing of a seated woman (Fig. 5.9) with this powerful work.

Even though this discussion focuses on the expressive power of the elements, do not think that a realistic technique must necessarily forsake strong expressive meanings. Schneider's drawing (Fig. 6.12) clearly demonstrates that this need not be the case. Here, the convolutions and tensions in the tangle of forms find a degree of release in the "escaping" extended arm of the male figure, an action that abstractly illustrates the drawing's title.

DISTORTION

Since responsive figure drawings are the result of analysis, empathy, emphasis, and intent, they are, strictly speaking, all distortions of human forms. All carry the stamp of our impressions, our imagination, and our idiosyncrasies. But sometimes an artist's interpretation demands changes that drastically alter human proportions, forms, or textures. In the best figure drawings, these more obvious changes are never the product of impulsive fancy or private symbolism; rather, they are attempts at philosophical or psychological assertions that cannot be expressed in more objective figurative modes.

Often, such drawings show the figure used metaphorically. De Chirico, in *Il Condottiere* (Fig. 6.13), creates an image that may be a man becoming a still life or a still life becoming a man. Either way, the drawing offers intriguing considerations. Of particular interest is the artist's insistence on a considerable amount of specific anatomical fact. Note the highly altered but still discernible clavicles, pectoralis muscles, abdominal muscles, and flank pads. In the figure's left

6.13 GIORGIO DE CHIRICO (1888–1978)

Il Condottiere

Pencil, 12³/8 × 8¹/2 in.

Staatliche Graphische Sammlung, Munich/

© Estate of Giorgio de Chirico/Licensed by VAGA, New York, NY.

leg, there are even suggestions of the adductor group and of the rectus femoris and vastus muscles.

The term *still life* takes on a grim meaning in Peterdi's engraving *Still Life in Germany* (Fig. 6.14). The artist's emphasis on the intricate system of muscles, tendons, and veins in these brutalized and withered extremities implies his disgust with those who would destroy such magnificence. Peterdi distorts these broken forms to magnify the suffering and evil that are his theme, but he draws them with the care and precision of a medical illustrator. This deliberate emphasis on details and textures—on a relentlessly sharp focus—beckons us to consider the causes of such destruction with the same patient concern.

The forms in Lebrun's Lone Great Mutilated Figure (Fig. 6.15), though largely unidentifiable, not only evoke the character of human forms but convey a sense of anguish and tragedy through their struggling interactions and because of their rough-hewn struc-

6.14 GABOR PETERDI (1915–) Still Life in Germany (1946) Engraving, Plate $12 \times 8^7/8$ in. Edition: 3/30. The Brooklyn Museum of Art. Gift of the artist. 59.209.1.

ture and the harsh light that strikes them. The background's dark tone, the cast shadows, the medium's texture, and the impassioned handling all intensify the expressive mood.

In Tchelitchew's *Study for "The Crystal Grotto"* (Fig. 6.16), the forms of the skull undergo a metamorphosis that suggests landscape and cave formations. The double-exposure effect, especially evident in the facial bones, creates a strong vibrating motion, strengthening the sense of a change in subject matter. But even such a subjective interpretation of the cranial forms reveals the artist's authoritative understanding of anatomy.

Sometimes, though, distortions mainly involve changes in contour and scale relationships, as in Shahn's *Gandhi* (Fig. 6.17). Here, the artist exaggerates the thin legs, the conical form and length of the draped torso, and size differences between parts of the figure. The results evoke the stately and ascetic nature of the great Indian leader.

In Grosz's *Circe* (Fig. 6.18), distortion crosses over into metamorphosis in the animal head of the figure on the right to underscore Grosz's rage at social inequities. The artist's caustic satire is in evidence everywhere; in the pasty, pinched, and sagging forms of the female figure, in the debonair pose of the pigfaced man, and in the mocking nature of the lines and tones that whip, cut, splash, and stain.

THE EXPRESSIVE ROLE OF THE MEDIUM

As the preceding drawings show, the intrinsic character and range of the materials used in drawing have a

6.15 RICO LEBRUN (1900–1964)

Lone, Great Mutilated Figure

Black ink with wash and charcoal on cream wove paper, $39^{11}/_{16} \times 28$ in.

Worcester Art Museum, Worcester, Massachusetts. 1962.20.

6.16 PAVEL TCHELITCHEW (1898–1957)
Study for "The Crystal Grotto" (1943)
Pen and brush and ink on paper, 14 × 11 in.
(35.6 × 27.9 cm.).
The Museum of Modern Art, New York.
Gift of Mr. and Mrs. Sam A. Lewisohn.
Photograph © The Museum of Modern Art, New York.

decided influence on a drawing's emotive nature. By their range of textural effects, their erasable or permanent nature, and their adaptability to different uses, they always affect the artist's handling and even the kinds of judgments he or she will make. For example, the reed pen cannot easily produce the gradual tonal changes that are natural to the sable brush. An artist working with the pen may avoid such gradations of tone but may search out reasons for including them when using the brush.

The effect of different media is evident when we compare Degas's treatment of the figure drawn with chalk (Fig. 2.50) with a similar figure done in an ink monotype (Fig. 5.16). Degas takes advantage of chalk's dry, abrasive character to create masses and light effects with blunt strokes and subtle blendings. Using ink, which in the monotype technique can be removed as easily as applied, he models the forms by broad swipes of a brush or cloth, stressing their shapes and directional speed rather than their structure, as in Figure 2.50.

Had Tchelitchew used a soft graphite pencil and Schneider a brush and ink, each would have been restricted by their medium from making many of the linear and tonal judgments we see in their drawings. But each would no doubt have gone on to discover what their medium *could* produce. Their meanings might have been as successfully conveyed, but not often by the same graphic strategies.

The mood of some drawings seems to depend on the particular medium used. When this is the case, considerations concerning its use are nearly as important as factors of structure, anatomy, design, and ex-

6.17 BEN SHAHN (1898–1969)
Gandhi (ca. 1964)
Ink and watercolor on paper, 21³/4 × 43 in.
The Arkansas Arts Center Foundation Collection:
Given in memory of Esther and David Kempner
by their daughter, Eleanor Freed, 1983. Accession #83.6/
Estate of Ben Shahn. Licensed by VAGA, New York, NY.

6.18 GEORGE GROSZ (1893–1959)

Circe (1927)

Watercolor, pen and ink, and pencil on paper, 26 × 19¹/4 in. (66 × 48.6 cm.).

The Museum of Modern Art, New York. Gift of Mr. and Mrs. Walter Bareiss and an anonymous donor (by exchange). Photograph © 1999 The Museum of Modern Art, New York/© Estate of George Grosz/Licensed by VAGA, New York, NY.

pression. The stately solemnity of Seurat's *Seated Boy with Straw Hat* (Fig. 6.19) owes something to the medium's compatibility with the artist's interest in monumental forms. Seurat, in selecting a paper with a pronounced grain and by using the side of a conté crayon stick, utilizes the textural properties of both to create the gentle play of broad tones that expresses their quiet grandeur.

It would be far more difficult to obtain these results with a harder chalk on less grainy paper. But such materials are exactly suited to Michelangelo's fascination with the drama inherent in the powerful inner tensions and pressures among the bones and muscles pressing against the figure's surface (Fig. 6.20). And Schiele's need for a more sensual and spontaneous expression of rhythmic shapes, lines, and tones leads him to use several media (Fig. 6.21).

All good drawings exhibit a congenial rapport between meanings and media. But an overdependence on the powers of a medium to convey our intent may cause the medium to dictate the results instead of enhancing them. Such drawings often provide a showy display of facility that makes their dominant expression an exhibition of technical cleverness, not a statement of felt responses based on something encountered or imagined.

EXAMPLES OF EXPRESSION IN FIGURE DRAWING

Here, we will examine more ways in which the expressive meanings of a drawing's figurative state can be made stronger by the expressive character of its abstract behavior. The range of options for doing this is limitless. Yet these few examples may suggest something of the inventive freedom possible and encourage us to be more trusting of our intuitive responses. Our gut reactions to a subject's essential

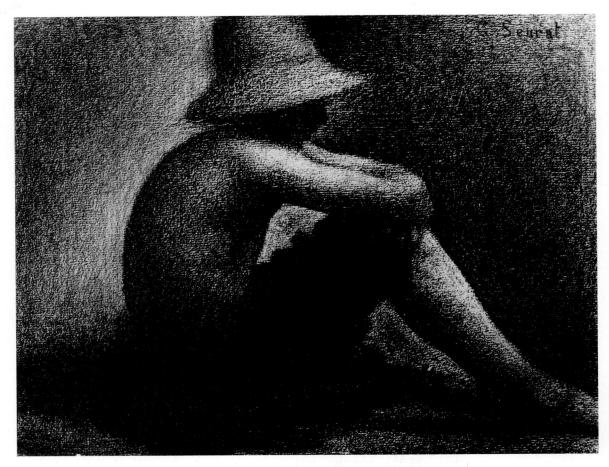

6.19 GEORGES-PIERRE SEURAT (1859–1891)

Seated Boy with Straw Hat (1883–1884)

Black conté crayon, 9½× 12¾s in.

Yale University Art Gallery. Everett V. Meeks, B.A. 1901, Fund.

6.20 MICHELANGELO BUONARROTI (1475–1564) Study of Adam in the "Creation of Adam" in the Sistene Chapel Chalk on tan paper, $9^5/8 \times 15$ in. © The British Museum.

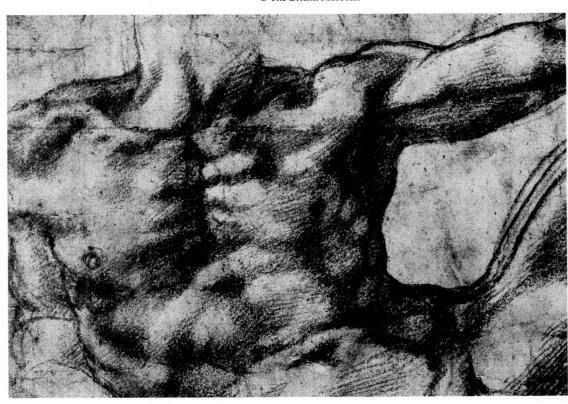

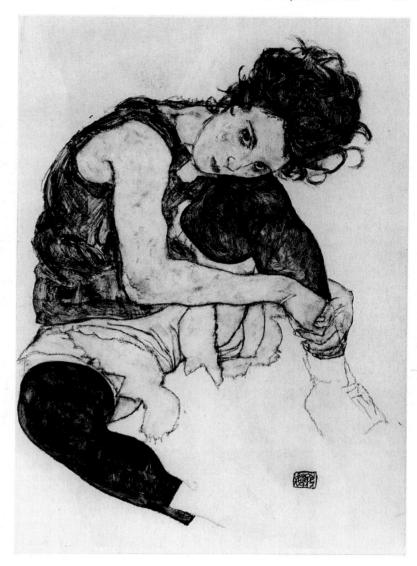

6.21 EGON SCHIELE (1890–1918) Sitting Woman with Legs Drawn Up (1912) Oil sketch.
National Gallery, Prague.

character, in the first moments of seeing or imagining it, usually carry the key to how we should draw it. Overediting and censoring our original impression may make us lose sight of (or surrender) our initial response to the subject. This occurs when structural, anatomical, textural, or other demands divert us from our initial motivation and purpose, or when our second thoughts force us to resist or even withhold personal responses in favor of a more realistically "correct" image or to make our approach conform to some admired manner or style.

Had Rosa, in his envisioned image (Fig. 6.22), backed off from the fervor that is at the heart of his drawing, it would not move us as it does. Rosa magnifies the force of St. George's lance by avoiding any other straight direction. In the context of the scene's

roiling turmoil, the lance's diagonal vector strikes with fatal power. The artist goes after the violent action of man and beast, and the furious whorls, slashing lines, and splashing tones express this. Observe, though, that despite this furious treatment and the figure's suit of armor, important physical landmarks are still noted, as in the arms, abdomen, and legs. Note, too, that our eye moves along the serpent's body toward the tail, where we partake in the swift thrust of the lance to its target.

The emotive power of Lebrun's *Figure in Dust Storm* (Fig. 6.23) benefits from the rhythmic lines, the vague and lost edges, the delicate and light-toned values that model the forms, and the substantiality of the forms above and below the fast-moving tone that obscures part of the figure. The strong motion energies of these subtly stated elements and the overall diagonal movement of

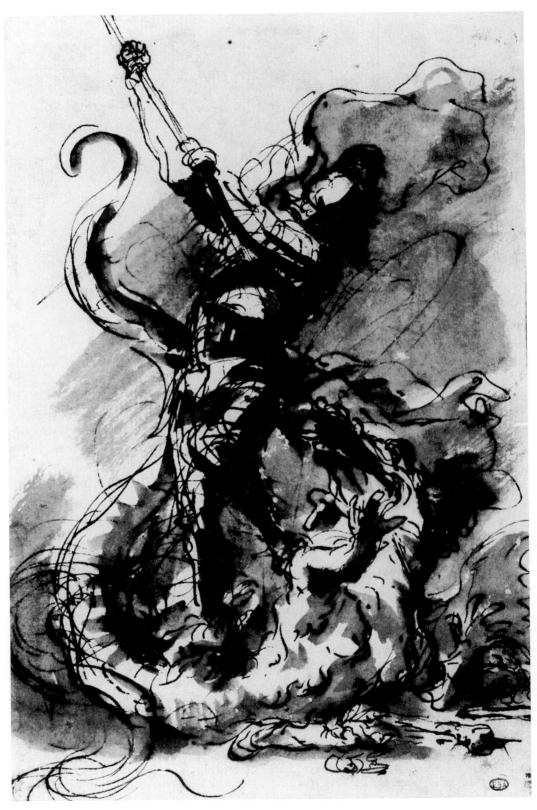

6.22 SALVATORE ROSA (1615–1673) St. George Slaying the Dragon Pen and ink, watercolor, $9 \times 5^{7}/8$ in. Ecole Nationale Superieure des Beaux-Arts, Paris.

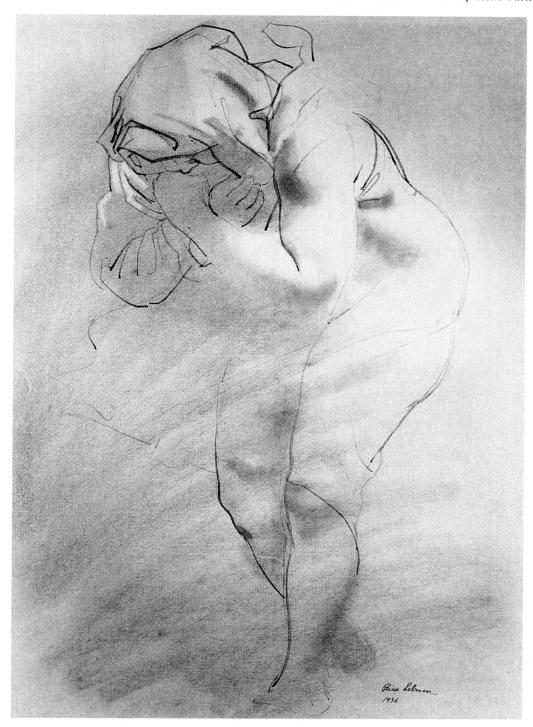

6.23 RICO LEBRUN (1900–1964) Figure in Dust Storm (1936) Ink and charcoal on paper, $24^{3/4} \times 17^{7/8}$ in. (sheet). The Santa Barbara Museum of Art. Gift of The Honorable Mr. and Mrs. Robert Wood Bliss. 1958.1.

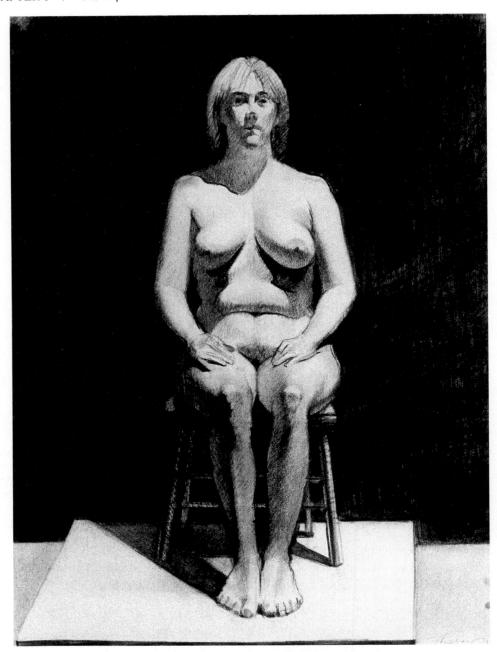

6.24 WAYNE THIEBAUD *Dark Background* (1976)

Charcoal, 30 × 22 in.

Courtesy of the artist.

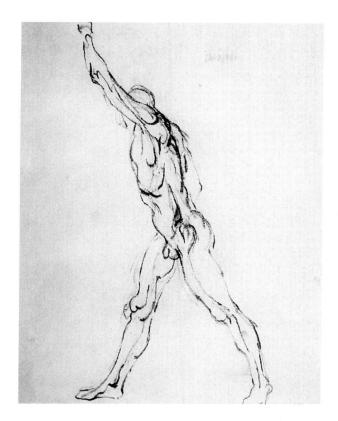

6.25 LLOYD LILLIE (1932–) *Male Figure, Side View* Pencil, 9¹/₈ × 14 in. Courtesy of the artist.

the forms give the drawing's representational theme the added force to make us feel the figure's struggle against the wind and dust. Notice how the contrast of the harsher linear treatment of the head and arms bolsters the impression of the force of the windswept dust.

Thiebaud's stark image (Fig. 6.24) generates its expressive force in the contrast between the stilled, seated figure and the ominous darkness broken by a harsh shaft of light. That light is almost aggressive in the strong shadows it casts and in its relentless revelations of the figure's forms. Is the sitter a willing or resigned participant? Is the image benign or wrathful? Sometimes a drawing's expression is in the form of a question. The viewer provides the answer.

The power of the anatomical factor as an agent of expression is well illustrated in Lillie's vigorous *Male Figure, Side View* (Fig. 6.25). Here, the artist's gestural attack is pressed beyond the point where it might serve as an underdrawing to guide and enliven more fully realized forms. Instead, the figure's action and the powerful relational energies that express that action are the drawing's chief purpose. Each of the four factors is intensely active and interacting with the others. The lines that develop the structure simultaneously clarify the anatomy and, by their animated but ordered calligraphic behavior, convey an expres-

sive design that supports the representation of a rugged but graceful figure.

Even when the figure is draped, anatomical considerations can continue to play an important expressive role, as we see in Zuccaro's *Study of a Man Seen from Behind* (Fig. 6.26). The artist's interest in the figure's powerful action is strengthened by the straining action of the lower half of the body, revealed beneath the drapery. Zuccaro also reinforces the figure's action by establishing folds in some areas and stretching the cloth taut elsewhere. But it is the lively system of lines, shapes, and forms that, in being equally active at the abstract level, gives us the *feel* of the action. Here, everything curls and spirals, evoking a sense of the figure's turning action.

But in Watteau's *The Old Savoyard* (Fig. 6.27), all is stilled. The figure has paused, balanced between the case on his back and the container suspended from his neck. The stable nature of the elements—the tenuous but balanced standoff between their various movements—matches the checked action of the figure. Watteau has drawn the figure in a position that suggests the man has just stopped walking or is about to start. At the abstract level, the physical and visual weights, the canceling out of diagonal lines, the stable and unstable shapes, the alternately vigorous and gen-

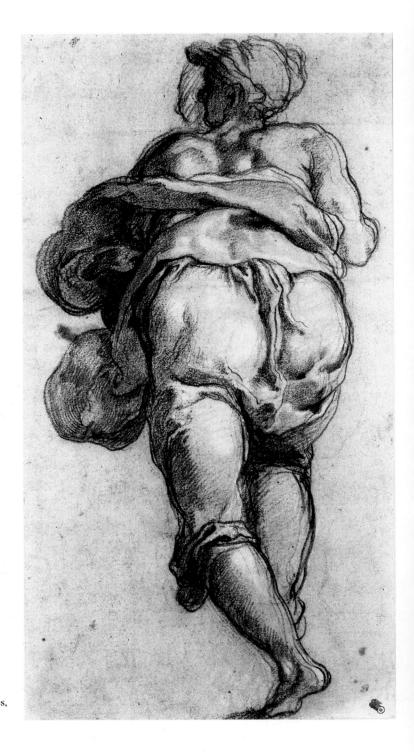

6.26 TADDEO ZUCCARI (1529–1566) **Study of a Man Seen from Behind (recto)** (ca.1555)

Red chalk heightened with white on laid paper, approximate .344 × .183 (139/16 × 73/16 in.).

Aolsa Mellon Bruce Fund, Photograph © 1998 Board of Trustees, National Gallery of Art, Washington, D.C.

tle handling, and the fluctuation between bold and subtle tonalities all suggest a barely maintained truce between actions just ended or about to begin. By creating tensions among these balanced but contradictory forces, Watteau supports a psychological tension in the figure that is summarized in his facial expression: a blend of resolution and introspection.

In Watteau's drawing, the suspension of the figure's action is subtle. But the suspension of such actions can be riveting, as in Figure 6.24 and in Goodman's *Ann and Andrew Dintenfass* (Fig. 6.28). The rigid pose of the figures and the artist's insistence on straight lines and angular turnings are added to the near symmetry of the design (a tactic that often pro-

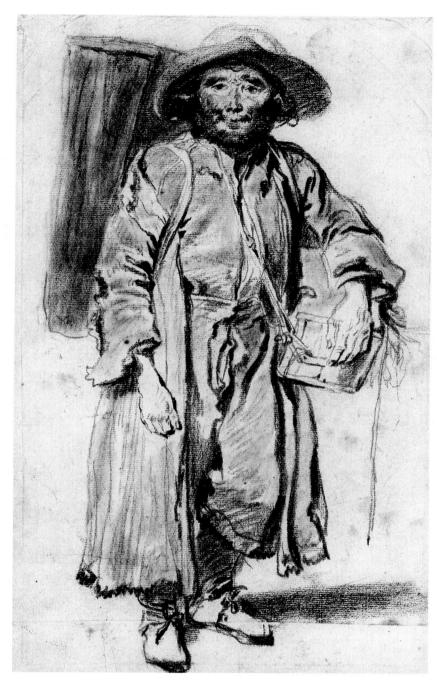

6.27 ANTOINE WATTEAU, French (1684–1721) *The Old Savoyard*

Red and black chalk, with stumping, on buff laid paper, laid down on cream wove card, laid down on cream board, 35.9×22.1 cm. Helen Regenstein Foundation, 1964.74. Photograph © 1998, The Art Institute of Chicago.

motes feelings of solemnity or stillness) and the polarizing of the values into a severe grid of mostly black and white shapes. The mood of the resulting image, heightened by the sitters' looking our way, is one of tension and confrontation in a frozen moment. There is psychological tension between the sitters in their "together but alone" positions and between them and the viewer; we are made to feel like intruders. There is visual tension between the figures' large

U-shaped arrangement and the design's gridlike compositional structure and between the stability of the grid and a system of diagonal vectors that generates a radiating energy. Notice that Goodman's sound understanding of the figure's structure and anatomy is evident through the draped forms, despite the harsh and angular modeling.

But because so many visual relationships suggest movement, it is natural enough that the expressive

6.28 SIDNEY GOODMAN (1936–)

Ann and Andrew Dintenfass (1971)

Charcoal, 27 × 32¹/2 in.

Courtesy of Terry Dintenfass, Inc., in association with Salander-O'Reilly Galleries, LLC, New York.

meanings of many figure drawings are principally rooted in the figure's physical actions. For example, Tiepolo's Psyche Transported to Olympus (Fig. 6.29) is, aside from its mythological comment, an expression of figures in flight. Movement is at the very core of this drawing, and each free-flowing line and tone expresses action. Fast-moving shapes and rhythms, the sparse but volume-informing modeling, and the drawing's diagonal rush across the page help us experience these figures as being in flight rather than falling. Note how the configuration's main movement from the lower left to the upper right of the page is countered by an implied diagonal running from the upper left to the lower right of the page. Note, too, how the warm-toned ink washes (Plate 8), lending an air of sunlight, add to the drawing's expressive force.

In another Rosa drawing, *Witches' Sabbath* (Fig. 6.30), the moving action sweeps through the entire configuration, enveloping both figures and specters. The nightmarish scene is conveyed by a serpentine coil of skeletons and beasts winding slowly upward in a mutually reinforcing blend of frenzied lines and fearful apparitions. Rosa skillfully designs the large rib cage to "urge" the spiral upward and relates it to the curling smoke throughout the drawing.

The sense of tension and movement among compressed forms can produce a strong feeling of constrained energy. In Picasso's etching *Minotaur, Drinking Sculptor, and Three Models* (Fig. 6.31), the moving rhythms among the figures, the confined arms and legs, and the artist's suggestion of their great weight impart a feeling of accumulated energy capable

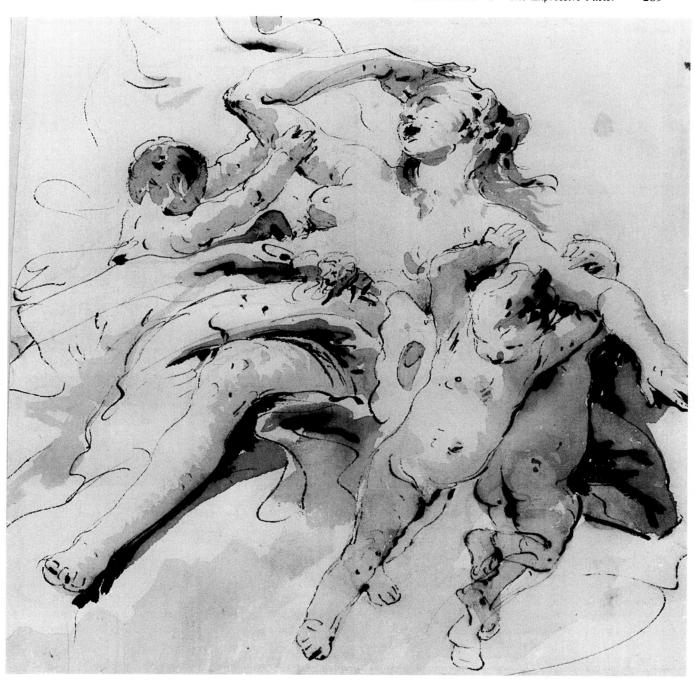

6.29 GIOVANNI BATTISTA TIEPOLO, Italian (1696–1770) *Psyche Transported to Olympus* Pen and brown ink, brown wash, over black chalk, $8^3/4 \times 8^3/4$ in. The Metropolitan Museum of Art, Rogers Fund, 1937. (37.165.20).

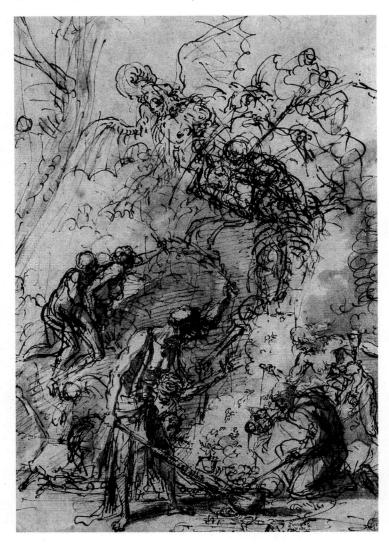

6.30 SALVATOR ROSA (1615–1673) Witches' Sabbath
Pen and brown ink, brown wash, 27.2 × 18.4 cm.
The Metropolitan Museum of Art, Rogers Fund, 1912. (12.56.13)

of an explosive change. There is a similar feeling of pent-up force in the crowding of the five heads, in the large bent leg, coiled as if about to spring free, and in the hatched tones that seem too vibrant for the shapes they are confined in. These conditions create strong visual tensions throughout the work, intensified still more by the forceful nature of the lines. The tactile sensuality evident in many of the contours and in the emphasis on physical weight, as well as the intimacy of the poses, suggests the drawing's psychological tone.

Duchamp's famous painting *Nude Descending a Staircase*, *No.* 2 (Fig. 6.32) is a well-known example of the expressive power of movements that can emerge from the relational interaction of the elements. The intensity of movements is due largely to the high degree of similarity among the directions, shapes, sizes, and locations of the fig-

ure's severely abstracted but still identifiable parts. Even in this highly subjective interpretation of human forms, a sound knowledge of anatomy underlies the image: Clavicles, pectoral and gluteal muscles, pelvic forms, and even a faithful set of human proportions help us identify with the figure's energetic descent.

We have seen that a drawing's expression is revealed not only by the depictive matter but by the abstract, dynamic character of the elements, in the pace and temperament of their interplay, in the artist's "handwriting," and even in the uses of media. Expression is as much a part of the drawing's design as the design is a key to the drawing's expression.

But some intangible quality remains that eludes analysis: Some spirit or state—a presence—that we sense giving life and universality to the best figure

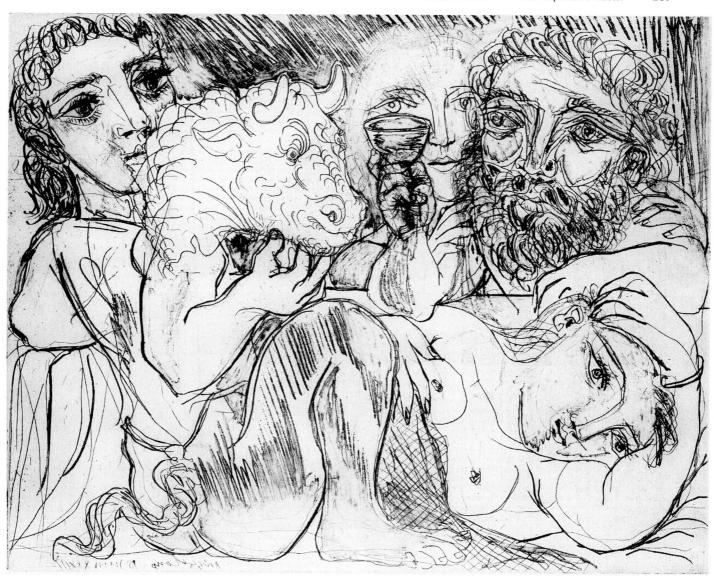

6.31 PABLO PICASSO (1881–1973) Minotaur, Drinking Sculptor, and Three Models (Minotaure, buveur et femmes) (1933) Etching, 11¹¹/₁₆ × 14¹/₂ in. Lee M. Friedman Fund and Gift of William A. Coolidge. Courtesy, Museum of Fine Arts, Boston. 63.1022/ © 1998 Estate of Pablo Picasso/© 1999 Estate of Pablo Picasso/Artists Rights Society (ARS), New York.

6.32 MARCEL DUCHAMP (1887–1968) *Nude Descending a Staircase, No. 2* (1912)

Oil on canvas, $37^3/4 \times 23^1/2$ in.

Courtesy The Philadelphia Museum of Art. Louise and Walter Arensberg Collection/© 1999 Artists Rights Society (ARS), New York/ADAGP, Paris/Estate of Marcel Duchamp.

6.33 REMBRANDT VAN RIJN (1606–1669) Woman Seated, in Oriental Costume Brush, pen and ink, $7^{7/8} \times 6^{3/8}$ in. Photograph by Walter Steinkopf. Staatliche Museen Preussischer Kulterbesitz Kupferstichkabinett, Berlin.

drawings remains as mysterious as those forces that give life to the figures themselves. Perhaps it is the result of a critical degree or pitch of dynamic activity or of a crucial blend of the artist's intellectual, intuitive, and subconscious responses and intentions. Certainly, it demands the interaction of the four factors we have been examining. Though indefinable, its absence in a drawing leaves the image somehow unrealized. But if this quality cannot be isolated, one fact about it is certain: No matter how faintly or obliquely sensed, an honest acceptance of our own interests and responses, although no guarantee of its presence, is an essential condition for achieving it.

The shadowy and moving expression of Rembrandt's *Woman Seated, in Oriental Costume* (Fig. 6.33), emerging from the harmony between the depiction and the dynamics, seems imbued with this impalpable quality of "rightness" and life. The drawing's unself-conscious nature, in revealing that Rembrandt's paramount concerns were to inquire, experience, and respond, suggests that approaching figure drawing with a desire to know, instead of to show, may lead to that mysterious presence that transforms knowledge and skill into art.

SUGGESTED EXERCISES

Unless otherwise indicated, there are no time limits on the following exercises, and they may be drawn to whatever scale and with whatever medium you require. Where necessary, you may combine media.

The nature of these drawings will demand your entire commitment to the depictive and abstract emotive theme concerned in each. Although summoning up feelings on demand is difficult, perceiving the structural and dynamic possibilities in each of the observed or imagined figures is fundamental to good drawing. Being aware of these possibilities will help you gain insights about the subject's expressive condition and about the means to convey it. Indeed, one of the main challenges in these exercises is to have the drawing's expression come through the elements as well as the figural depiction.

- 1. Working from the model and using a large sheet of paper, draw fifteen to eighteen small, 1-min. action poses. These drawings may be no more than 2 in. high. Using Figures 5.8 and 6.25 as rough guides, emphasize the rhythms of inner forms as well as edges and suggest the general structural nature of the forms. Next, using these sketches as models, make the following three drawings:
 - a. Select any three or four of these action poses and combine them in a drawing that suggests battle or some other aggressive state, adjusting the poses to conform to this theme. Your treatment of the figures, and the choice and use of the medium selected, should advance the idea of combat or struggle (see also Fig. 5.27).
 - b. Select any three or four of these action poses and combine them in a drawing that suggests flight or any rhythmic and dancelike actions, as in Figure 6.29. Again, handling and medium should be compatible with your theme.
 - c. Select any four or five of these action poses that will support an action theme of your own choosing.

Use any medium or combination of media that will help express your feelings about the event you have selected.

- 2. Working from one or more models or using a mirror, make the following three drawings of heads in which the facial expressions are reinforced by the character and behavior of the elements:
 - a. Someone shouting happily or excitedly.
 - **b.** Someone scowling or frowning.
 - c. Someone sleeping.
- **3.** Working from the model, make two drawings *of the same pose* that could serve as illustrations for:
 - a. A mystery story.
 - b. A love story.
- 4. Working from the model, make two drawings of the same pose, using a different medium for each. For example, the first drawing might be done in pen and ink and the second with the side of a conté crayon stick. Extract those abstract and figurative qualities in the model that the medium can more easily produce. That is, allow the medium to influence what you say about the model in each drawing.
- 5. Working from the model, any photos in this book, or your own earlier drawings, make three drawings that suggest the figure's metamorphosis into:
 - a. A feline animal.
 - **b.** A tree.
 - c. A machine.
- **6.** Working from the model and using Figure 6.15 as a rough guide, make three comparably abstracted drawings to suggest:
 - a. Melancholy.
 - **b.** Joy.
 - c. Anger.

- 7. Using Figures 6.3, 6.9, and 6.19 as rough guides, make the following largely tonal figure drawings based on your imagination:
 - a. One figure carrying another.
 - b. Two or three figures dancing.
 - c. A sleeping or dead figure.
- Using Figure 6.26 as a rough guide, invent a drawing of a comparably draped figure performing some strenuous physical act.
- Referring to the muscle illustrations in Chapter 4 (or in any other source), invent a drawing of a flayed figure lifting a heavy object, such as a rock.
- **10.** Using Figure 6.32 as a rough guide, invent the following two drawings:
 - a. A ballet dancer in motion.
 - b. Two wrestlers in action.
- 11. Using 6.14 as a rough guide, make your own "still life" of human forms, not necessarily as a horror show,

- but to suggest Peterdi's general theme or any other expressive idea.
- 12. Using Figure 6.18 as a rough guide, make a drawing that uses a moderate degree of metamorphosis to underscore some social or political theme. Grosz's drawing should not dictate your drawing style but only suggest a degree of distortion and metamorphosis.
- 13. Using Figure 6.31 as a rough guide, invent a drawing of several figures in some comparably compacted arrangement which suggests constrained energies.
- 14. Using Figure 6.30 as a rough guide and referring to the anatomical illustrations in Chapters 3 and 4 (or in any other source), invent a drawing that conveys your version of a "witches' Sabbath."
- **15.** Working from the model and using Figure 6.24 as a rough guide, make several drawings in which the elements and the handling activate passive resting poses.

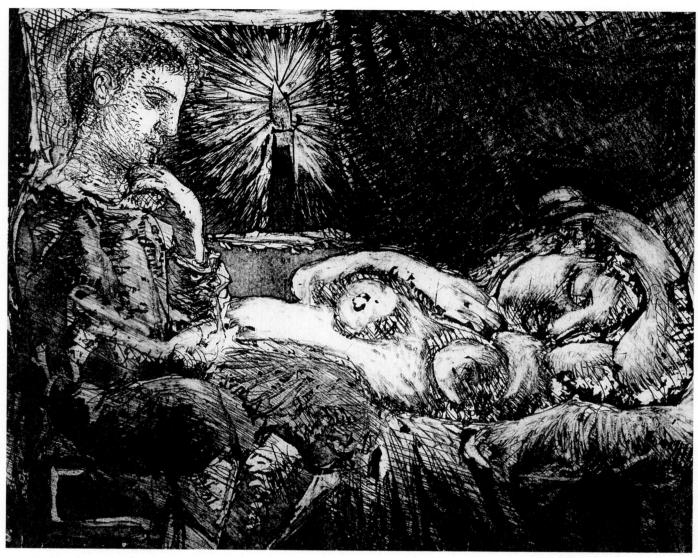

7.1 PABLO PICASSO, Spanish (1881–1973)

Boy Watching Over Sleeping Woman by Candlelight (1934) (detail)

Etching and aquatint, 93/8 × 113/4 in.

Lee M. Friedman Fund. Courtesy, Museum

of Fine Arts, Boston. 63.1018/© 1999 Estate of Pablo Picasso/

Artists Rights Society (ARS), New York.

The Factors Interacting

Some Examples

DIFFERING FORMULAS

The central theme of this book involves the high degree of interdependence and mutual support among the factors of structure, anatomy, design, and expression. We have seen that the measurable factors of structure and anatomy are as deeply interlaced with the dynamic factors of design and expression as they are with each other and that each factor has both figurative and abstract functions. As we examined each of these factors, we saw some examples of how they function in their own sphere and how they assist the function of the other factors.

Earlier, too, we saw that all artists formulate some personally necessary hierarchy of importance for the roles these factors will play in their drawings. In this section, we will examine some of these "prescriptions" for their usage. We understand a drawing not only by the ways in which the factors interact but by their order of importance in the image.

In Ricci's Man Between Time and Death, Evoking Hope (Fig. 7.2), forms emerge from the swarm of spirited lines, the excited calligraphy "permitting" the depiction rather than the demands of the depiction permitting some calligraphic play, as in Dürer's An Oriental Ruler Seated on His Throne (Fig. 7.3). Dürer insists on a precise articulation of each plane and volume, of each tassel and jewel. Further, he constructs a

more formal and stilled design than does Ricci. In emphasizing the subject's volumetrics, Dürer makes the structural factor dominant; in arranging them symmetrically, he calls our attention to the two-dimensional aspects of the drawing's design. This accent on structure and symmetry, however, is not developed without an appealing calligraphy of its own. But it is clear that Dürer's intentions demand steady ranks of structurally oriented lines, whereas Ricci counts on the flutter of numerous agitated hatchings to reinforce the drama of the life-or-death discourse.

Very little of the surface anatomy is directly visible in Dürer's drawing, although it is more solidly present than in Ricci's drawing. But Ricci's use of anatomy is expressively compatible with the rest of the emotionally charged drawing. Hope's classical simplicity, Time's heroic ruggedness, the man's idealized head and entreating stance, and Death's "incorrect" but expressively effective "body" are well cast in their parts and feelingly drawn to impart the character and role of each of the participants in the event.

The contrasting goals of these two drawings are reinforced by their very different design strategies. Ricci calls on powerful rhythms and diagonal movements, on animated figurative motion, and on a spontaneous handling. Dürer's method depends on a careful canceling out of movements, the stability of vertical and horizontal axes, a motionless figure, and

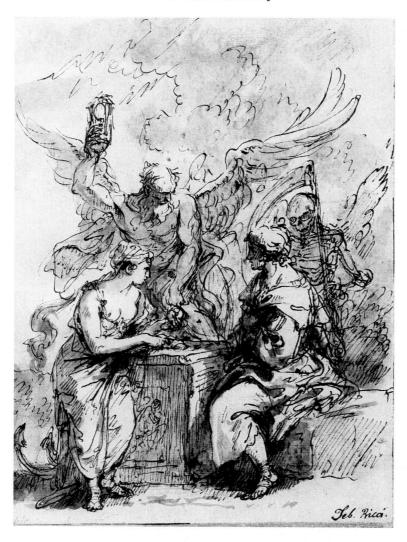

7.2 SEBASTIANO RICCI, Italian (1659–1734) *Man Between Time and Death Evoking Hope* Pen and brown ink, gray wash, over black and red chalk, $10^3/4 \times 7^3/4$ in.

The Metropolitan Museum of Art, New York. Rogers Fund, 1967. (67.65)

a more deliberate handling. Each relies on a contrapuntal device to intensify the main emotive character of his image: Both the stable block in the center of Ricci's swirling forces and the swirling sash in the center of Dürer's stabilized forces serve to reinforce (and provide some visual relief from) the drawing's dominant expressive attitude.

Although Ricci emphasizes dynamic matters and Dürer measurable ones, each drawing reveals a sensitivity to qualities in the other. We are all the more delighted in the amount of quiet but playful rhythmic activity at work throughout the Dürer because we see it in the context of the drawing's rigid symmetry. Likewise, we are all the more relieved to find the stabilizing forces within the Ricci because they keep the forceful energies from running wild. Note in the Dürer the unsymmetrical but balancing results of the long sword on the left against the dark tones on

the right and, in the Ricci, the steadying function of the rough symmetry between the two figures in the foreground.

In a more daring abstract invention, Cambiaso's Male Nude on Horseback (Fig. 7.4) departs from his more structured and geometric approach to forms to create a whirlwind of action. Responding to the oval format as well as to the forms of his subject in this action-filled scene, Cambiaso relies on curvilinear lines and animated, interweaving shapes. Here, everything is in a state of turbulent motion. The drawing's equilibrium is tenuous: We no sooner react to the visual and physical weight pulling the man downward to the left than we realize he is being wrenched toward the right by the downward action of the horse. Led down to the meeting of the horse's legs and head, our eyes are drawn upward by the fanlike burst of directions in that area; we can then follow any of several routes

7.3 ALBRECHT DÜRER, German, (1471–1528) *An Oriental Ruler Seated on His Throne* (ca. 1495) Pen and black ink, .306 × .197 (12 × 7³/4 in.). Ailsa Mellon Bruce Fund, Photograph © 1998 Board of Trustees, National Gallery of Art, Washington, D.C. 1972.22.1.

7.4 LUCA CAMBIASO, Italian (1527–1585)

Male Nude on Horseback Brown ink on tan antique laid paper, folded and pricked all over, 29 × 25 cm. actual. (13³/₈ × 9³/₄ in.). Courtesy of the Fogg Art Museum, Harvard University Art Museums. Bequest of Austin A. Mitchell 1969.112.

back onto the mainstreams of directional energy. The longer we examine this drawing, the greater our sense of being hurled about in a whirlpool.

The contour lines, although forceful in their actions, are delicately stated and almost weightless. Further, the gracefully energetic rhythms that course through the drawing act as modifiers of the impression of solid masses in space. These effects, in calling our attention to the drawing's two-dimensional life, reveal the artist's fascination with the drawing's dynamics on the picture plane. These felt and sophisticated extractions from the raw material of man and horse, by their insistence on energetic line and shape patterns, show the factors of design and expression to be dominant in the artist's strategy for conveying the event.

But structure and anatomy, although secondary, actively participate in the drawing's lively animation. Notice how economically Cambiaso conveys struc-

tural conditions. His ability to summarize complex forms to reveal their more nearly geometric state helps us better understand the basically ovoid form of the head, the cylindrical basis of the extremities, and the construction and interjoining of smaller form units in both the man and the horse. These interjoinings are especially clear in the man's arm and legs and in the horse's head. Cambiaso's incisive treatment of structural matters adds to the drawing's energies and thus to its expression.

Cambiaso balances anatomical considerations with the drawing's dynamic nature. He screens these as selectively as he does the structural clues, including only those necessary to establish a convincing figure and to emphasize its action. The artist's sound grasp of anatomy is evident in how much is conveyed about bone and muscle in the few lines given to these details. For example, the nine or ten lines of the figure's upper arm suggest the deltoid and its insertion

point, the contour of the lateral head of the triceps as well as some of that muscle's tendonous lower portion, the olecranon process, a hint of the supinators, and the body and insertion of the biceps. Note the equally economical and informed drawing of the knees and how clearly the anatomical differences of their various positions are explained. Despite their anatomical function, these lines never "forget" to take part in the spirited nature of the handling and design. Nor does the figure's powerful musculature fail to benefit from the strong energies that course through it, contributing to the drawing's expressive character.

By comparison, de Gheyn's *Boy Seated at a Table with a Candle and Writing Tools* (Fig. 7.5) is immediately more structurally oriented. Not unlike Dürer's "recipe" for using the four factors, de Gheyn's greater stress on a warmer, more vigorous use of line and his lesser concern with details give this drawing a stronger sense of spontaneity and movement. But if de Gheyn is less precise than Dürer,

he "carves" the forms more insistently than Cambiaso and does so in an appealing, tactile way also seen in the head of the Oriental in Dürer's drawing. But while Dürer reserves this more sensually tactile attitude for the head and some few other passages, de Gheyn models all the forms by lines that feelingly ride on the surfaces. De Gheyn's unrelenting desire to experience even the figure's unseen forms is what makes him draw the figure's clothed forms in a way that convincingly suggests the presence of the torso and arms. In the Dürer drawing, however, the artist's fascination with details of the drapery makes him occasionally lose the figure beneath it. Indeed, it is only Dürer's emphasis on a decorative formality—on an image as much symbolic as alive—that keeps the figure's occasional disappearance from becoming an inconsistency in the drawing. De Gheyn is more concerned with the spirit than with the letter of a form. This is apparent when we compare the hands in both drawings. In Dürer's, the hands are structurally lucid but without

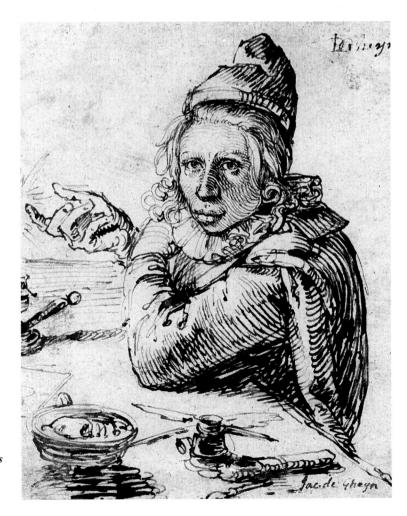

7.5 JACOB DE GHEYN II (1565–1629) **Boy Seated at a Table with a Candle and Writing Tools** Pen and iron-gall ink on brownish paper, $5^{1/4} \times 4$ in. Yale University Art Gallery. New Haven, CT. Library Transfer. Photo by Joseph Szaszfai.

the enveloping rhythm and animation of the hand in de Gheyn's.

A subtle visual theme organizes de Gheyn's drawing. In addition to the diagonal of the table canceling out the opposing diagonal of the boy's upper arm, a system of small units forms an encircling beat that moves around the page. The extended hand, the objects below it, the bowl in the lower left corner, the objects nearby, the collar overhanging the cloak, and the hat all take part in this revolving beat. Of these, the bowl in the lower left corner is an especially important component in the design. Its visual and physical weight provide that extra bit of leverage necessary to keep the design from being too heavy on the right. Note, too, how the vertical fold of the cloak joins the bent arm and the gesturing hand in forming an extended N-shape whose direction moves to the left, additionally weighting the drawing on that side.

Although the drawing's emotive force is not a dominant matter for de Gheyn, the artist shows obvious pleasure in modeling the forms. The boy's gentle, earnest spirit is harmoniously interwoven with the spirited mood that issues from the drawing. These moods do not seem imposed by the artist's desire to emphasize either state; we feel them because he did, and his empathy with the subject comes across to us through the interplay of the factors.

An even stronger mood imbues Tiepolo's etching *Head of a Young Black Man* (Fig. 7.6). Like Dürer and de Gheyn, Tiepolo relies on the structural factor, but here the lines do more than feel out the changing terrain. An overall texture of generally wavy lines, in addition to explaining the subject's topography, creates a soft, almost impressionist atmosphere. These lines produce tones that bathe the forms in a gentle light, intensified by the flash of sunlight on the sleeve of the figure's left arm.

By gently graduating values and avoiding strong contrasts between them, Tiepolo evokes an atmosphere of hushed restraint that supports the figure's introspective mood. The overall feeling of quiet contemplation is reinforced by the circular movements of the design. These make the figure appear to withdraw inward. Tiepolo locates the figure at the far end of what we sense to be a cone of motion. By making the shapes, textures, and value contrasts of the cloak and arms more visually active in their overall impact and in their revolving action than the forms further back, the artist makes us aware of the distance separating us from the young man's head and torso. Tiepolo further bolsters both the conical swirl and the mood by reducing the value contrasts and the clarity between the forms further back. Both the tone of the background, in approaching that of the light side of the head and of the cape on the figure's right side, and the tone of the

tunic, in approaching the tones of the scarf and the dark side of the head, help strengthen the figure's physical *and* psychological retreat.

Pronounced textures tend to muffle the structural clarity of forms and of surface anatomy; structural clarity tends to force its way through a textural web. These are not conflicting ideas but mutually supportive ones. The etching's texture depends on these precise structural explanations simply because it needs something to be textured *for*—some reason for changing value and pattern. And were the forms less fully realized, they would be buried under such prominent textural activity. Likewise, these strongly carved forms, while needed to come through the texture, would lose some of their emotive character if stripped of this softening atmosphere.

As Tiepolo's etching indicates, structural considerations can lead the way to subtle and moving expressive states. And as all the drawings examined thus far illustrate, an understanding of anatomy provides a rich source of stimulating dynamic responses that serve other factors. Even in Dürer's drawing, where anatomy has such a small role, the design of the facial forms is consistent with the design of the surrounding segments and may even have stimulated his solution to the design of the beard and the headdress. In fact, except for Figure 7.4, all the examples thus far in this chapter show little of the figure itself. But in each (except here and there in the Dürer), the drawing of the drapery shows that the artist is well aware of the nature of the forms below; it continues to influence each drawing's design and expression as well as the forms we do see.

This is again evident in a contemporary drawing similar in arrangement to Tiepolo's. Abeles's New Year's Eve, 1978 (Fig. 7.7) utilizes a number of the same tactics we find in Tiepolo's etching, such as the circular orientation of the forms, the averted glance, and the use of textured passages (especially in the background) to create the psychological tone of the work. Again, introspection and withdrawal are expressed by the curved arms, one hand resting on the other, but the head is the focal point in the design. As in our earlier examples, we are convinced of the figure's presence beneath the heavy layers of drapery. We can tell that the figure's left leg is crossed on the right one, we can locate the woman's left elbow, we can discern the form of the breasts and shoulders, and we can even note that despite the heavy clothing the figure is lithe.

Furthermore, in Abeles's drawing, there is an emphasis on shape similar to the prominent role of shape in the Tiepolo. Here, too, the structural factor is an important theme in its own right, yet it also lends to the drawing's design an engaging system of triangular

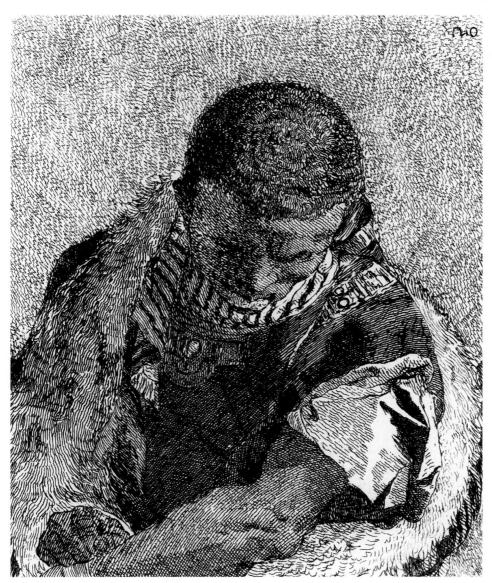

7.6 GIOVANNI DOMENICO TIEPOLO, Italian (1727–1804) *Head of a Young Black Man* (1770)

Etching, 2nd state, $5^3/4 \times 4^9/16$ in.

George R. Nutter Fund. Courtesy Museum of Fine Arts, Boston. 54.974.

shards. These result from the planar nature of the coat, but the artist continues to expand this triangular theme throughout the work. The large shapes of the coat, collar, and chair all hint at their triangular basis; even the darkened background is composed of two large triangles.

Again, in Vespignani's Girl in Bed—Graziella (Fig. 7.8), little shows of the figure itself. But the

artist's understanding of its masses beneath even these thick layers of bedding assures us of their presence. Where we do see the forms themselves, Vespignani reveals his mastery of anatomy in suggesting so much of their structure by volume-informing contours and a very economical selection of lines within those contours. The only lines inside the contours of the hand are those few that describe the metacarpal heads and

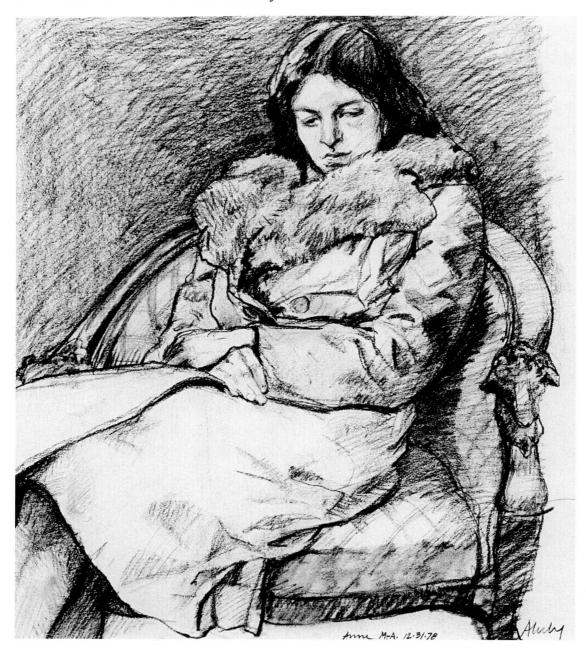

7.7 SIGMUND ABELES (1934—)
 New Year's Eve, 1978
 Charcoal.
 Collection of June and Jess Gangwer, Madbury, New Hampshire.

some folds in the fingers and those that mark off important planar junctions. Even in the head, where the artist restricts his observations to facial features, the drawing of those features triggers strong clues about the planes of the rest of the head.

Although Vespignani's gentle drawing is expressively the opposite of Cambiaso's (Fig. 7.4), they both

show a similar concern with contours that sets them apart from the more structurally insistent artists discussed earlier. The absence of swarms of structural lines carving masses in space clears the picture plane for other visually expressive events.

In this drawing, Vespignani's emotive theme is the tranquillity of the resting figure. Almost every-

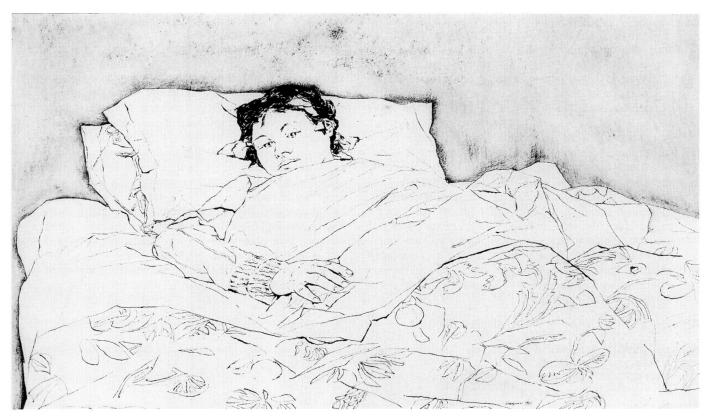

7.8 RENZO VESPIGNANI, Italian (Rome, 1924—) *Girl in Bed—Graziella* (1953)
Black ink and wash (blotted?) on cream wove paper, 52.7 × 89.5 cm. actual. (20³/4 × 35¹/4 in.).
Courtesy of the Fogg Art Museum, Harvard University Art Museums. Bequest of Meta and Paul J. Sachs 1965.431/© Renzo Vespignani/ Licensed by VAGA, New York, NY.

thing shown is in a state of surrender to gravity. The girl's limp forms accommodated to the pliant bedding suggest their unseen substantiality by the mattress bending under her weight and by the folds radiating from beneath her head and arm. The folds of the sheet and the patterned blanket "give in" to their own weight or, where they are supported by the figure, adhere to her forms with little resistance. Only a few folds in the bedding try to hold themselves up, a half-hearted attempt that only underscores the easy yielding of the rest of the drawing's forms.

Tranquillity is also implied by the pearly tone and soft texture of the wall, by the emphasis on horizontality (which includes the shape of the page), and by the grand "landscape" of the bedding. By giving the figure and her immediate surroundings the same white tone, Vespignani further stresses her visual harmony with the surroundings. Only the dark tone of the girl's hair breaks the visual silence of the drawing's peaceful mood, calling attention to her quality

of gentle introspection—the psychological as well as the visual center of attraction.

Another design theme directly uses the structural considerations of the forms. If we cover all but the lower fourth of Vespignani's drawing, the patterned coverlet appears to lie flat on the picture plane. When we expose only the lower half of the drawing, the arm and the mound of the legs are clearly volumetric. But they are minor masses when compared to the more formidable volumes in the upper part of the drawing. By this ordered increase of forms in scale and substance, Vespignani creates a uniting pattern of growth that gives each mass a necessary part in expressing it.

This concept of a work growing toward some crescendo of form is more frequently seen in drawing than we might at first suppose, as a glance at the many drawings reproduced in this book shows. Figures 1.6, 2.37, 4.12, and 6.9 are some examples of drawings that culminate in strong mass clarity at one place in the configuration.

Such a strategy guides Polonsky's *In Sleep* (Fig. 7.9). Instead of forms growing more substantial as they move back in space, here they do so as they move toward the right side of the page, building to an imposing group of heavy forms on that side. Polonsky balances the drawing by the counterweights of the upper torso's blocklike mass bearing down on the lower left side of the page and by the direction of the head, lower arm, and pillows, which also aim for the lower left corner. Additionally, the figure's arm, drawn to imply ample weight, echoes the bend in the torso, adding emphasis to the torso's downward pull to the left.

The artist, in emphasizing the subject's shapes, calls our attention to the dynamics of the picture plane. Here, the soft, rounded wedges of the shapes of the arm and the pillows, moving with the force inherent in long wedgelike shapes, assist the expression of pliancy. This creates an image that is relaxed in surrender to weight and gravity yet imparts an engaging sense of rhythmic action.

Note that Polonsky, like Vespignani, is led by his emotive theme of limp weight to the use of undulating contour lines that convincingly suggest the essential nature of the masses. Structure and anatomy are also enlisted in serving the drawing's expression. Because the lower arm must suggest weight, Polonsky gives it a cylindrical simplicity and weights its lower end by bold strokes that emphasize the olecranon process; because the hand must work at gripping the pillow, he suggests the metacarpal heads and a generally more bony mass. Again, in the head, the girl's relaxed right side is simplified, but her compressed left side is more structurally stated.

As we have seen, artists who are sensitive to the total behavior of a subject's forms extract those qualities that will clarify the subject's narrative condition. What they select, omit, emphasize, and alter as well as the character of the marks themselves are determined by their largely intuitive sense of what is necessary to convey their interpretation. Thus, the artist's

7.9 ARTHUR POLONSKY (1925–) *In Sleep*Brush and ink, 22 × 28 in.
Courtesy of the artist.

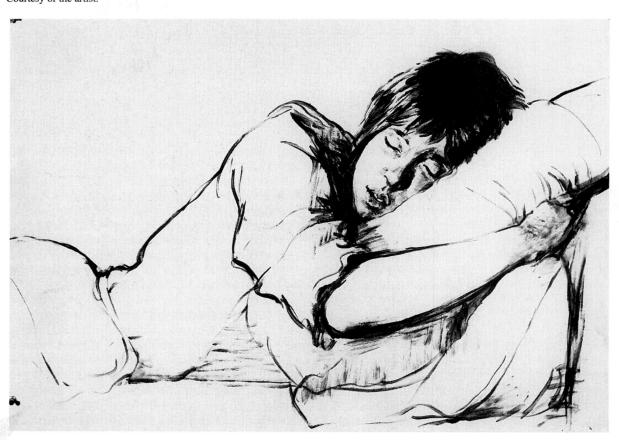

interpretive purpose determines the importance of the role each of the four factors will play. When Polonsky draws a sleeping girl, the drawing's movements and mood are both temperate, and the handling is moderately paced. But when he confronts a different subject, his perceptions and feelings lead him to a different formula.

In Polonsky's *Portrait of J. G.* (Fig. 7.10), more directed action is more expressively insistent. The structure and anatomy, although they play important roles, are more subordinated to the abstract forces of this spirited image. The handling is far bolder, the shapes more animated, and the values more aggressively stated and active. Polonsky's response to the powerful energy inherent in the subject's forms leaves little time (or need) for structural or anatomical nuances. Instead, it demands (logically enough) that he

convey these converging forms with an immediacy and vigor that match the subject's character.

Rothbein's Seated Woman, Leaning (Fig. 7.11) depicts little physical action yet evokes a sense of turbulent dynamic and emotive force. The design and handling suggest both repose and disquiet. The forceful relational energies hovering on the brink of balance produce tensions which, in their uneasy equilibrium, impart the same unsettled mood that we sense in the figure's gesture and expression.

There is tension between the figure's tilt to the left side of the page and the counterthrust to the right side by the massive dark tone on the arm and torso, between the harshly contrasting values and the gently revolving movements, and between the alternating passages of broad and precise handling. These tensions create abstract visual sensations that reinforce

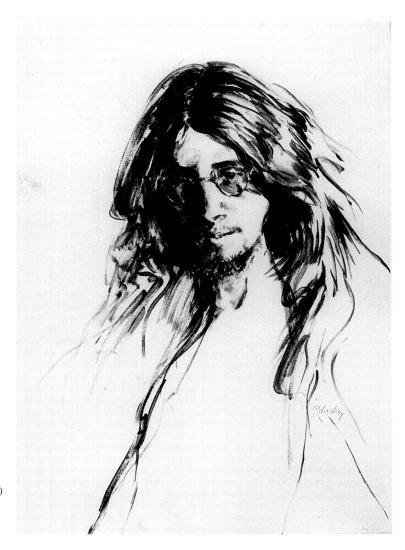

7.10 ARTHUR POLONSKY (1925–) *Portrait of J. G.* Brush and ink, 28×22 in. Courtesy of the artist.

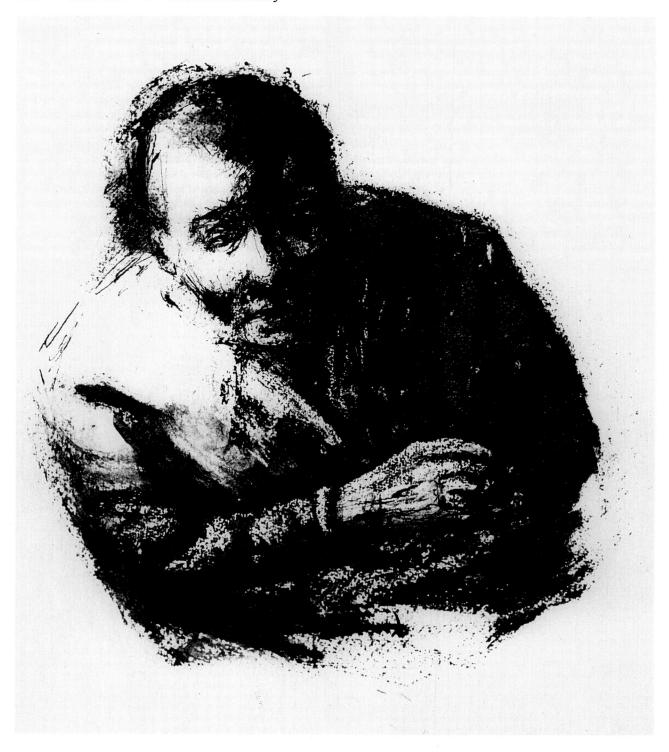

7.11 RENEE ROTHBEIN (1924–) Seated Woman, Leaning
Pen, brush, and ink, $9 \times 11^{1}/4$ in.
Courtesy of the artist.

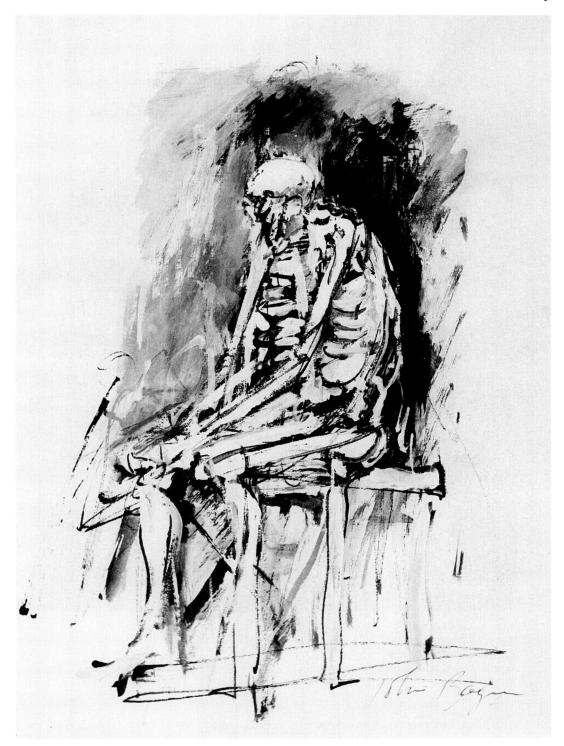

7.12 JOHN BAGERIS (1924—)
 Seated Skeleton II
 Sepia and black ink, white gouache.
 Collection of Mrs. Lucy Stone, Cambridge, MA. Courtesy of the artist.

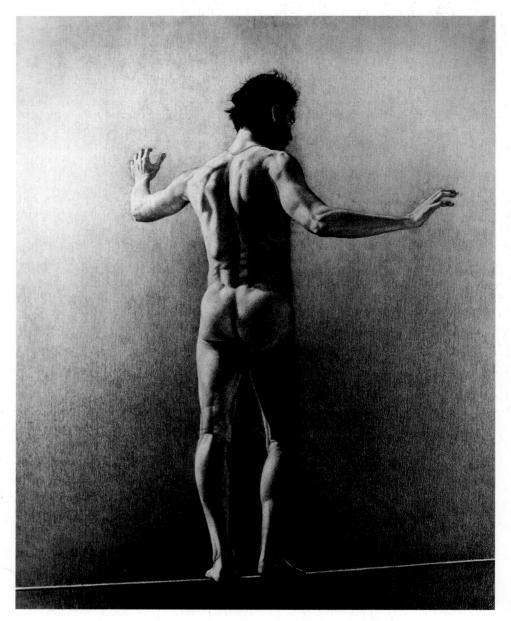

7.13 JAMES VALERIO
Tightrope Walker (1981)
Pencil on paper, 29 × 24 in.
Courtesy of George Adams Gallery, New York.
Photo: eeva-inkeri.

the figurative sensations. Both are assertive *and* tentative—the woman's enigmatic gesture hovers between curiosity and apprehension, between reaching out and withdrawing.

These broadly conceived forms, carved by a strong light source, impart a weighty monumentality that adds force to the struggle between the physical weight on the left side and the visual weight on the right. And in the weathered terrain of the head and hand, as well as in the knowing shapes and structure of the figure's draped parts, the artist reveals her knowledgeable control of anatomy. Although the dominant property of Rothbein's drawing is its expressive impact, this expression clearly emerges from the interaction of all the factors.

Bageris's Seated Skeleton II (Fig. 7.12) is a varia-

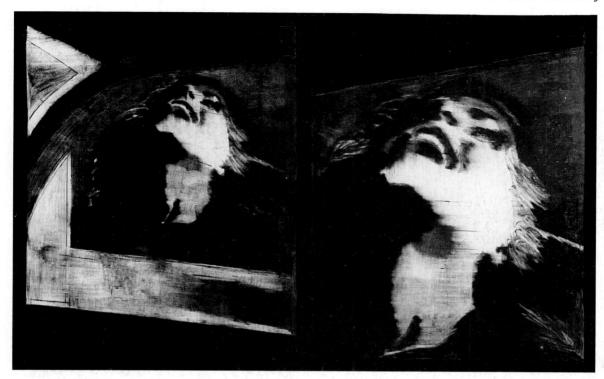

7.14 JAMES GILL (1934—)
Laughing Woman and Close-Up (1964)
Crayon on oak-tag board, 28½ × 45 in. (72.5 × 114.4 cm).
The Museum of Modern Art, New York. Eugene and Clare Thaw Fund.
Photograph © The Museum of Modern Art, New York.

tion of the theme in Figure 3.58. Here again, the artist creates a frenzied but ordered swarm of dark and light strokes whose movements animate the background and chair as well as the skeleton. These powerful spasms and strivings for change are all the more provocative because they issue from a seated and supposedly lifeless subject. Indeed, an important part of the drawing's expressive theme is the ominous energy of the subject, which threatens to explode the image despite the several stabilizing vertical and horizontal directions and its "still life" nature. Note that Bageris wisely subdues structural considerations to intensify the subject's abstract condition and that he imbues each line, shape, and tone with an almost unbearable urgency. Such a bold utilization of the skeleton as an agent of expressive design requires more than a passing familiarity with its design and construction; we are not likely to see or intensify the energies of forms we know little about.

Valerio's *Tightrope Walker* (Fig. 7.13) shows anatomy and structure to be equally important considerations in this enigmatic image, but the drawing's design and expression are hardly less strongly stated.

Here, Valerio balances more than the figure. He carefully balances the few forms and values that make up the image and, in creating a gentle play of light upon the figure and background through delicately nuanced value changes, gives the scene a feeling of expectancy and quietude that is in accord with the tightrope walker's concentration.

Gill's Laughing Woman and Close-Up (Fig. 7.14) uses an unusual rhythm idea. In addition to the shapes and values that, by their active and spontaneous character, support the expression of laughter, the artist repeats and enlarges the woman's head, further reinforcing the beat of laughter. But in the brooding nature of the surrounding tones, in the allusions to strange apertures and movements, and even in the figure's advancing toward us, Gill implies an ominous undertone. Note that the throat is drawn in conformity with anatomical fact but is illuminated in a way that produces a particularly animated shape, thus enacting the vibrating movements of laughter. Note, too, how the design strategy has the heads and their gray, windowlike "containers" moving to our right, while the overall bulletlike shape of the configuration rushes to

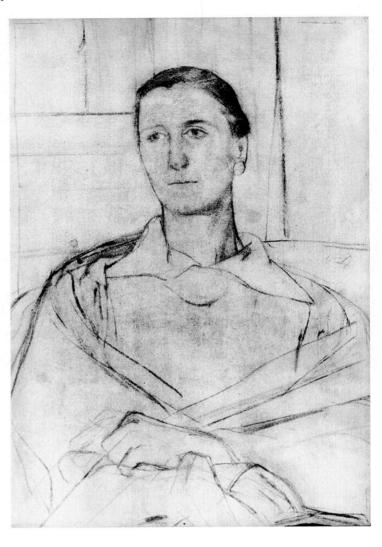

7.15 LENNART ANDERSON (1930–)
Portrait of Mrs. Susan Peterson
Charcoal.
Courtesy of the artist/Licensed by VAGA, New York, NY.

our left. Gill's contrasting of the organic form of the head with the more mechanical, angular forms and spaces surrounding it further emphasizes the animation of the laughing woman.

But contrasting the figure with more angular forms can serve other purposes. In Anderson's *Portrait of Mrs. Susan Peterson* (Fig. 7.15), the blocky divisions of the background only directly state what is hinted at in the figure, where rectangular and triangular shapes underlie every part. Here, a major visual theme is the sensitive adjusting of overt and covert pure forms. The artist integrates the strongly modeled form of the head with the rest of the design by its location, direction, and underlying blocklike shape. Note how the winglike character of the woman's collar is echoed in the hands and in the grand spread of her shawl. These passages of fluttering action, contrasting with the generally more stately character of

the drawing's expressive mode, keep the image from seeming either brittle or stilled.

This is yet another example of a drawing that gathers itself together to culminate in a strongly modeled form—in this case, the head. This idea is carried through in part by the changing role of structure and anatomy, which grow more explicit in the drawing's upper half.

Picasso's etching Boy Watching Over Sleeping Woman by Candlelight (Figs. 7.1 and 7.16) shows a complex interweaving of the four factors that shifts in emphasis from a strong use of structure on the left side of the page to a more two-dimensional ordering of the forms on the right side. But Picasso takes care to make this a subtle transition. He further unifies the design by the enveloping dark tones and by rhythms, such as the C-shaped curves that relate all the arms and hands. In addition, he knits the image together by

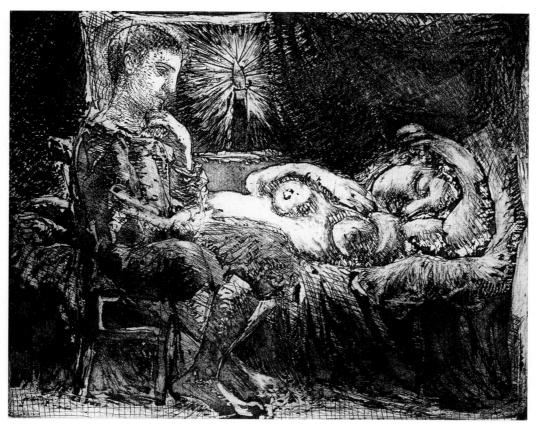

7.16 PABLO PICASSO, Spanish (1881–1973) *Boy Watching Over Sleeping Woman by Candlelight* (1934) Etching and aquatint, $9^3/8 \times 11^3/4$ in. Lee M. Friedman Fund. Courtesy, Museum of Fine Arts, Boston. 63.1018/© 1999 Estate of Pablo Picasso/ Artists Rights Society (ARS), New York.

arranging shapes and forms that call to each other across the page. This occurs with the shape of the boy's head and that of the window behind him in their association with the spherical and blocky forms of the woman and the pillow. Picasso establishes an expressive need for this shift in emphasis from more structured forms on the left to more shape-oriented forms on the right. The boy's enigmatic but protective character is strengthened by the substantiality of his forms, just as the woman's state of deep sleep is enhanced by the rhythm of her more abstracted and shape-oriented forms.

The etching's mood is both hushed and troubled. The harsh light of the candle, the sly shifts from three- to two-dimensional stresses, and the changing level of clarity all suggest a strange, dreamlike state. The very active role of textures also adds to this mood. In their rich abstract play, the textures call our attention to a degree of dynamic activity that belies

the quietude of the depiction. Picasso's formula results in an image that pulsates between representational and abstract readings. We cannot disregard the unusual life in either the depiction or in the dynamic means used to establish it.

The anonymous Bolognese artist who drew *A Burial Scene* (Fig. 7.17) reveals a similar sensitivity to the visually expressive forces that, in activating a representation, intensify its psychological meanings. The artist utilizes several important strategies that amplify the mood of this mysterious event. By placing all the figures and the darkest tones low on the page and by clarifying the structure of the lower-placed forms more than those higher up on the page, the artist strengthens the dramatic impact of the scene by focusing our attention on the corpse's interment. The artist emphasizes the sagging body's weight (and destination) by blending the cast shadows of the corpse and the nearby figures with the dark tone of the tomb

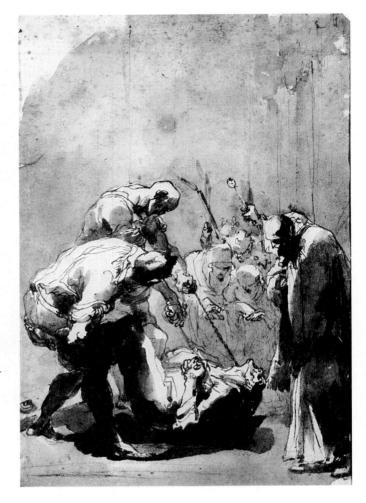

7.17 Italian, Emilian, Bolognese (17th Century)
A Burial Scene
Brown ink and brown wash over black chalk on off-white antique laid paper, 22 × 15 cm. actual.

Courtesy of the Fogg Art Museum,
Harvard University Art Museums.
Bequest of Charles A. Loeser 1932.248.

opening, thereby adding a strong visual weight to the lowering action.

Some of the more discreet touches that add to the drawing's disquieting mood are the taut ropes that serve as a visual foil for the curvilinear and animated forms, the extended hands of the figures in the background that seem to urge the body downward, and the upthrust of the corpse's mouth and chin—a last visual and human "protest" to the downward actions. Note how effectively the artist uses the overhead light source to emphasize some parts and hide others. The artist further stimulates the figurative and abstract actions and mood by exaggerating the curvilinear rhythms of the surface anatomy and the drapery, giving them a nervous vibrancy.

Giving great visual and physical weight to a drawing's lower portion serves a different purpose in Katzman's *The Studio* (Fig. 7.18). A large, slightly curved, and downward-flowing movement envelops the entire sheet. Here, everything gains force and

weight as we proceed downward. Values darken, masses grow bolder in modeling, and handling grows more forceful. Only the model's counterturning arc and lighter tone prevent these forces from running off the page. In fact, her forward-thrusting leg and foot lead us to move upward to start the action over again. This image-filling strategy calls our attention to the seated model, thus matching the attention shown by the artist in the drawing. Here, the four factors interact, as they do in Picasso's etching, by shifting from shape-oriented design considerations in one place to more structurally realized masses in another. Again, the transition is gradual.

Tiepolo's arrangement of the four factors in his *Error and Falsehood* (Fig. 7.19) places the bold moving actions of strong directions and rhythms ahead of even figurative energies. Not unlike Cambiaso (Fig. 7.4), Tiepolo relies on a stormy two-dimensional design to activate the image. As this exploratory sketch for a painting shows, most artists first approach a vi-

7.18 HERBERT KATZMAN (1923–) *The Studio* (1976) Sepia chalk, $67^{1}/2 \times 48$ in. Courtesy of Terry Dintenfass, Inc., in association with Salander-O'Reilly Galleries, LLC, New York. Photo by Geoffrey Clements.

7.19 GIOVANNI BATTISTA TIEPOLO (1696–1770) *Error and Falsehood* Pen and brown ink, brown wash over black chalk, $7^5/8 \times 10^1/8$ in. The Pierpont Morgan Library, New York (IV, 136)/Art Resource, NY.

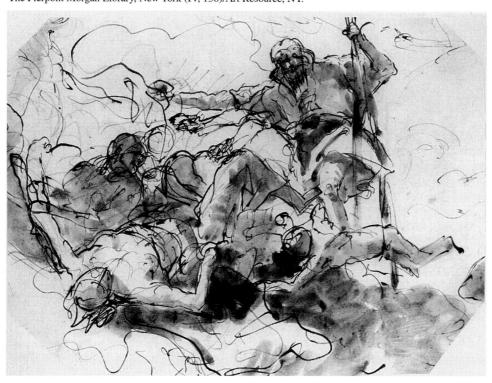

7.20 PHILIP PEARLSTEIN (1924—) *Male and Female Models on Greek Revival Sofa* (1976)

Watercolor on paper, 29¹/₂ × 41 in. (74.9 × 104.1 cm.).

Collection of Whitney Museum of American Art,

New York. Purchase, with funds from the Louis and

Bessie Adler Foundation, Inc., Seymour M. Klein, President, and the National Endowment for the Arts. 77.6. Photo by Geoffrey Clements. Photograph © 1998:

Whitney Museum of American Art.

sual challenge with a concern not for its representational specifics but for its dynamic essentials. And although this is a preparatory work, it is a complete graphic statement. Expressive design considerations are dominant, but structure and anatomy—their broad masses and bold surface undulations adding fuel to the drawing's powerful actions—are inventively interacting concepts.

Here, all the elements are in a state of strong agitation, but they compensate each other's actions to produce an orderly pattern of forces. Despite all the visual commotion generated by a clashing of diagonal and zigzag movements, an encircling system of arms embraces the actions, and on its periphery, encircling clouds reinforce this containing device. On the right, the vertical thrusts of the standing figure and the staff he holds produce a needed visual weight to counterbalance the drawing's overall movement toward the lower left corner. Thus, for all the excitement of the elements and the handling in this spontaneous sketch,

the artist is in control of the image, which communicates the fallen figures' troubled ferment.

Although Pearlstein's Male and Female Models on Greek Revival Sofa (Fig. 7.20) is more deliberately drawn and developed further than Tiepolo's quick sketch, there is a strong similarity in the underlying design structure. Once again, a system of diagonal and zigzag movements is the dominant theme. But unlike the Tiepolo, where such energies amplify the action of the figures, here they animate a scene we know to be stilled. As in the Tiepolo (and for the same reason), an encircling band of shapes (the couch and blanket) contains the strong diagonal thrusts of the figures' parts. Pearlstein's knowledge of anatomy is evident, and if the basic structure of parts is less than clear in places, it is compatible with the artist's flattening as well as forming parts to call attention to visual events on the picture plane.

The contrasts of an active abstract state, but a stilled depictive one, and a high degree of realism, but

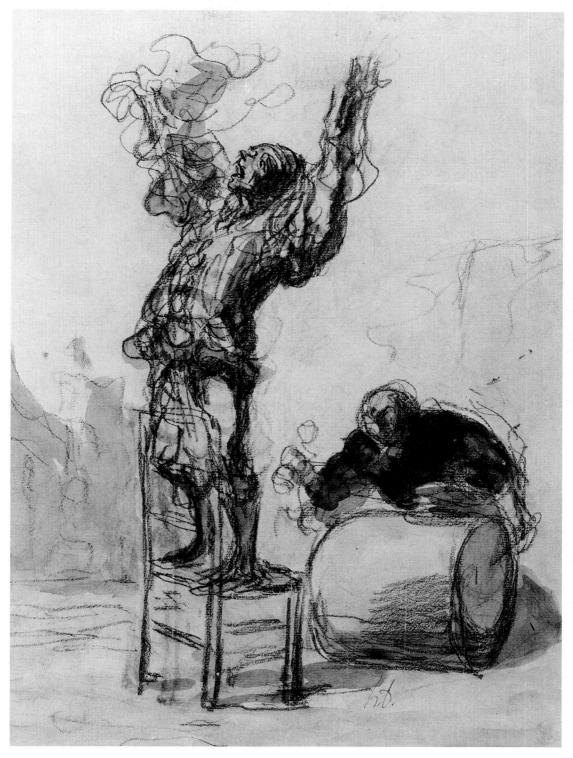

7.21 HONORÉ DAUMIER, French (1808–1879) A Clown Charcoal and watercolor, $14^3/8 \times 10$ in. $(36.5 \times 25.4$ cm.). The Metropolitan Museum of Art, Rogers Fund, 1927. (27.152.2).

a flattening of many forms, reflect the contrast in the drawing's expressive tone, where a rather intimate portrayal of a nude couple is dehumanized by the many cutoffs, including, most important, the heads.

But strong directed energies, especially when drawn in an urgent manner, as in the Tiepolo, are an effective means of suggesting the physical action of figures. In Daumier's A Clown (Fig. 7.21), we cannot resist seeing the arms of the clown as energetically flailing, just as we know the bent figure to be drumming. Daumier, a master of designing with strong shapes of tone, here arranges the pale tone on the left, the clown's deeper tone, and the strong dark tone of the drummer in a manner that creates space, variety, and balance. Nor are the white shapes merely places that are "left." Notice that the large white segment of the background on the left echoes the general wedgelike shape of the clown, while at the same time leading us into the configuration. Note, too, that the white area separating the two figures is shaped almost into an imitation of the clown's left arm and lower body, only exaggerated and enlarged. Both of these background shapes, in aiming toward the clown's feet (as does the drummer's right arm), bring us to the necessary starting point for viewing the clown and experiencing his impassioned motions; our eyes rise up the figure to the waving arms in the same way that we sense the arms' thrashing action to have begun in the clown's feet; that is, the strongly active gesturing involves his entire body.

Viewed in color (Plate 9), sparse but effective color notations serve to reinforce the drawing's emotive meaning. Such expressive eloquence would hardly be possible in a carefully rendered drawing of the subject. Here, as in Tiepolo's drawing, design and expression are the dominant factors, but structural clues clarify and strengthen the configuration (note the strong dark-toned plane that explains the clown's left side). Even anatomical information is provided to help find our way along the clown's figure. The essential form of the clown's feet and legs, the general heft and arched state of the torso, and the expressive drawing of his head all reveal a sure grasp of anatomical facts.

McGarrell's lithograph *Elephant Bathers 1* (Fig. 7.22), even busier in design than Tiepolo's or Daumier's drawings, creates almost the opposite emotive effect. In contrast to their furious calligraphy, McGarrell's lines are more deliberate and frequently hatched. Likewise, his tones are less shifting and fluid, his shapes more sharply defined. Instead of serpentine or diagonal movements of great force, McGarrell stresses horizontal and subtle diagonal motions. By an almost cubist criss-crossing of directions, he keeps all other directions from generating any strong-moving force.

McGarrell's surrealistic theme requires these less turbulent forces and feelings. This troubled and equivocal scene—half snapshot, half dream—needs the fragmented shapes and passages of ambiguity between figure and ground to impart a sense of anxiety and even of quiet terror. The artist achieves this by carefully integrating changes in perspective and scale, by concealing figures among matching values and open-ended shapes, by using subtle metamorphic occurrences (as in the animallike head of the figure at the lower left corner), and by camouflaging interspaces separating groups with veils of tone or overlapping and undefinable forms. The artist further merges vision with reality by teasing suggestions of figures and animals forming in unexpected places: White shapes on the table at the right suggest a small upright animal on a figurelike group of shapes; behind the basketball player (whose ball suggests a skull), a reclining figure appears in a textured area, which, may be read as clouds or waves because of the shifts in perspective. Hatched lines sometimes clarify and sometimes obscure forms; similarly, surface anatomy occasionally denoted objectively is sometimes distorted or obscured.

The resulting mood of this densely filled image in which forms are lost and found, lucid and dreamlike, finds support at the abstract level of its order. The interjoining shards of small shapes and tones canceling out strong movements, the often carefully stated textures and patterns returning us to the picture plane, the ambiguities of figure—ground associations, the overall windblown nature of the drawing, and the temperate pace of the handling all hint at the same ineffable feeling of anxious expectancy.

Sheeler's *Nude Torso* (Fig. 7.23), using the closeup view so favored by some artists and photographers in creating numerous "cutoffs" of forms (as in Fig. 7.20), introduces fresh possibilities for organizing familiar matter in ways that allow for new metaphors and new expressions. Here, Sheeler treats the figure as landscape: An image of barren dunes, hillocks, and valleys competes with the figure's fertile forms, just as a pattern of lines and values on the picture plane competes with the impression of massive volume and space.

THE PATHOLOGIES OF FIGURE DRAWING

Although there are comments throughout this book on various failings and errors in figure drawing, we will now examine briefly some of the more common ways in which our practices may stray from the great realm of good drawing.

We have seen that the differing ways the four factors may combine are virtually limitless. Although the drawings we examined are hardly an extensive sampling of such combinations of usage, they show that in every master drawing no factor is left unregarded and no factor is elevated to a level of importance that excludes a consideration of the other factors. No figure drawing can bear such an isolating attention to any one factor and survive as a system of organized expression.

Without the governing influences that the interacting factors impose on each other, any of them can be disengaged from the rest and made foreign to the image they were meant to dominate. An overconcern with structure can become a tedious fixation on measurement and mass as ends in themselves. Although an acute analytic sensitivity to the structural nature of any form is nothing less than crucial—we simply can-

not draw anything whose essential construction we do not understand—an obsessive fascination with structural matters reveals an attitude that holds drawing to be no more than a kind of pretend sculpture. At best, a figure constructed without the contributions of the other factors remains only a report on the container the living figure comes in.

An overbearing concern with anatomy quickly deteriorates into a slavish faithfulness to physiology. While a knowledge of anatomy is essential for a keen understanding of a figure's structural and dynamic possibilities, an overbearing concentration on the figure as merely a machine produces only a thorough inventory of its parts.

7.22 JAMES McGARRELL (1930–) *Elephant Bathers 1* (1962–63) Lithograph, 22¹/₄ × 30¹/₈ in. Gift of the International Graphic Arts Society. Courtesy, Museum of Fine Arts, Boston, 67.1168.

7.23 CHARLES SHEELER, American (1883–1965)
Nude Torso (1903–1922)
Graphite on white ivory wove paper,
laid down on off-white paper, 11.5 × 16 cm.
Friends of American Art Collection, 1922.5542. Photograph © 1998,
The Art Institute of Chicago. All Rights Reserved.

An exclusive interest in design soon becomes an intellectual exercise, a kind of visual chess game. Instead of the birth of a graphic organism that, like the real organism, has an equivalent structure, order, and temperament, the results of runaway design considerations—with design as an end in itself—are, at most, clever sensory entertainment. More frequently, such works seem self-consciously novel and contrived.

As noted in the previous chapter, a concentration on expression as an end in itself quickly becomes a mainly nonvisual and self-indulgent emotional fling. Such drawings do not really tell about the artist's felt responses to an observed or envisioned figure, but only show a kind of vague free-association statement stimulated by some general aspect of the figure. The real subject remains the artist's psyche. But creative expression is not a retreat from reason or order. It is an attitude that, while directing what the eye should search for, is still open to receiving stimulation from

the subject's objective state. Thus, it is the force that both generates perceptions and, in containing much of what constitutes the artist's "screen" of intent, largely directs the filtering of all his or her perceptions. The best exponents of figure drawing always transmit the subject's message as well as their own.

I wrote elsewhere, "A good drawing not only succeeds in stating the artist's intention, but does so in ways we regard as forthright, economical, organized, and compelling. When a drawing fails to meet one or more of these criteria, the fault is always in some kind of discontinuity of spirit, inquiry, design, or commitment." But when these criteria *are* met, when we feel a drawing has given us a strong and satisfying experience, we feel such a work to possess a certain energy

¹ Nathan Goldstein, *The Art of Responsive Drawing*, 4th ed. (Upper Saddle River, N.J.: Prentice Hall, 1992), chap. 11.

and spirit—a kind of "life." Indeed, it is the sense of vitality, of aliveness, that is at the heart of the great symphony, poem, or novel. Like living organisms, our visual ones require a healthy interworking of their parts and concepts if they are to come alive.

Regarding our figure drawings as organisms that roughly parallel many of the qualities and frailties of living organisms creates a useful analogy. It helps us see how important all of a drawing's components are to its artistic well-being. It also alerts us to the need for "diagnostic objectivity" if we are to analyze and adjust our creative efforts in ways that will really matter to the quality of our work. Toward this end, the following discussion is designed to help you better analyze various "ailments" that might otherwise go undetected.

Because our subject is the figure, we will make only passing references to problems that may exist in drawings of other subjects and concentrate more on defects having to do with the figure itself. As just noted, such defects are traceable to some kind of discontinuity—a break—in a drawing's main visual or expressive manner. We should, however, bear in mind that what may be a failing in the context of one drawing may be an important function in another. In other words, a certain change, condition, or emphasis is right or wrong in relation to the rest of the drawing and not in relation to any established conventions. What follows, then, is not based on any particular aesthetic ideology but rather on universal principles of balance, clarity, and unity of a drawing's figurative and dynamic conditions.

Perceptual Defects

- 1. The Sequential Approach. The single most common problem in drawing the figure (or anything else) is the beginners' tendency to draw in a piecemeal fashion. Typically, the figure is drawn by starting with the head, followed by the neck, followed by the upper torso, then the lower torso, and so on until the feet are drawn. At no time are these sequentially drawn parts examined to determine how the proportions, directions, or locations of these forms relate to each other, although the answers to these important questions are all visible in the posing model. This approach of collecting parts in isolation also blinds the beginner to the gestural character of the pose, making the resulting work no more than an accumulation of unrelated segments.
- 2. Prior Knowledge. This is the tendency (especially in difficult foreshortened passages) to draw what we know about the figure instead of what we actually see before us. It is the result of what may be called "lazy vision," a reluctance to make a demanding commitment to those analytic practices that sort out and clar-

- ify objectively the figure's various turnings, shapes, and tones. When prior knowledge replaces sensitive inquiry, cliché replaces perception.
- 3. Isolated Parts. If, as the old saying has it, "The whole is greater than the sum of its parts," then any part that fails to integrate with the others in an image prevents this important whole from forming. This can occur even in the drawings of the highly gifted, as seen in a preparatory sketch by Bastien-Lepage (Fig. 7.24), where the figure's left foot has grown in importance (and even in size) to the detriment of the drawing as a whole. This work, one of a number of drawings submitted by the artist to the jury for the awarding of the Prix-de-Rome, the highest accolade of the École des Beaux-Arts, contains a faint inscription near the bottom, penciled in by one of the jurors: "pied trop fort" (too strong a foot).
- 4. Contour Dependence. This originates in the mistaken belief that contours or outlines are the chief means of, and ultimate solution to, good drawing. This notion stems from the conviction that only lines describing the limits of forms or areas can adequately show a subject's volumetric and spatial character. This reluctance to leave the "safety" of the delineating edge to model the interior regions of the figure's forms makes such drawings appear ghostlike. When interior modeling does occur, the use of single lines to suggest foreshortened planes and other changes in terrain produces "scars" on the white shapes of the interior rather than a convincing impression of undulating surfaces, which can only be established by changes in value. Such an overdependence on line is often seen in gesture drawings, where it is the figure's essential action and mass that should take precedence, and not merely its edges. Gesture drawings are not fast contour drawings. A frequent characteristic of an overbearing reliance on contour is the sameness of the width and character of the (often) long and lifeless lines, resulting in forms that seem shaped out of wire. Such drawings reveal a fear or confusion about the use of value to establish edges and model form. But we should not confuse the reluctance to let go of line with the intentional and effective use of it, as in Figures 2.47 and 7.4.
- 5. Surface Detail. While the degree of surface detail is a matter of personal preference and can produce impressive results, some drawings show an overbearing emphasis on such effects, generally at the cost of a part's basic structural clarity. Often a symptom of the sequential approach to drawing, this problem suggests an inability to analyze and extract the figure's essential planes and masses. Seasoned artists know that if the subject's larger planes and values are well understood, not many of the lesser ones are needed

7.24 JULES BASTIEN-LEPAGE (1848–1884)
Figure Study for "Annunciation to the Shepherds"
(L'Annonciation aux Bergers) (1875)
Pencil and black chalk on faded blue paper,
12¹/₈ × 9⁷/₁₆ in. (30.8 × 24.0 cm.).
Cincinnati Art Museum. Gift of Frank Duveneck. 1915.215.

unless a high degree of realism is the goal. An overabundance of surface niceties and a scarcity of convincingly structured volume suggest that unselective scrutiny, not analysis, is at work.

6. Unconvincing Volume and Space. When not due to an overemphasis on surface detail or a weak grasp of structural matters, the weak impression of volume and space is often the result of timid or uncertain modeling. Sometimes such drawings show a weak range of values, often only a few small, light tones, as occurs when a photograph is removed too early from the developing tray.

Sometimes the problem has to do with the intimating nature of the subject. Students who are able to model the form and space of a still life or landscape with authority balk at applying their analytic skills to the figure. Its unique importance seems to make them feel that it must be approached differently. The human figure *is* of very special importance, but like the landscape and still life, it is made up of shapes, planes, tones, and textures that must be assessed objectively if our figure drawings are to possess the ring of truth. In figure drawing (as in all other spheres), seeing

things as they are is a prerequisite to choices and changes for the better.

7. The Wooden Figure. Another common problem for the beginner is the tendency to make final drawing statements right from the start of a drawing, bypassing a search for the model's gestural character. A common symptom of such drawing is the parallel nature of the lines or edges of the figure's forms. Arms and legs seem cut from board. This also suggests an overcaution about error. Ironically, the concern over making mistakes—of making a mess—has probably ruined more drawings than anything else. Fear of moving freely on the page makes it nearly impossible to match the energies in the posing figure with energies in the drawing. Such overcaution is not satisfying for the artist. And when we do not enjoy the act of drawing, we can be sure the viewer will not enjoy the results. In good, responsive figure drawing, there is safety only in sensitive perceptions and judgments and in confident responses.

8. Tonal "Anemia." This defect can be seen in tonal drawings as a fear of using large and dark areas of

value, even when it is evident that the drawing's volume and space, composition, or expression require them. Such drawings often seem faded, hesitantly toned, and smoky. They suggest that the several functions of value are not well understood. Sometimes, beginning a tonal drawing on a toned surface (either tinted paper or one that is given a coating of charcoal or graphite) is helpful for overcoming a reluctance to use bold, dark values for modeling form, for giving the impression of illumination, or for organizational and expressive purposes.

9. Mannerisms. These are false flourishes generally intended to emulate the authoritative, economical, and multiply engaged lines and tones of master artists. Drawings afflicted with this defect usually convey little or nothing more about the figure than vague generalities. Often symptomatic of a superficial grasp of analytic skills, such drawings are ambiguous about volume and space and have a breezy, rather than knowing, air. At best, they are only "promissory notes"; at worst (and more frequently), they are merely flashy pretensions that allude to a fluency and understanding the artist does not possess.

There are, of course, numerous other ways in which faulty perception affects figure drawings. Some problems can be solved by at least a general knowledge of anatomy. For example, beginners often draw heads too large but hands and feet too small. Often, the legs are drawn too short for the body and are shown as emerging from the *bottom* of the torso and descending to the ground in a *straight* line. They do neither.

Other problems can be solved by a knowledge of the principles of perspective. The figure's forms, however special to us, are subject to the laws of perspective, and knowing which of a posing model's forms are located above your eye level and which lie below it is a useful start in applying these principles.

Organizational Defects

1. Rendering. Such drawings show a great interest in accurate depiction—in illustrative fact—but not much interest in dynamic matters. The results often show fussy embellishments of parts but little to hold the parts together. Without the enlivening and unifying effects of dynamic relational play, such drawings seem always labored and lifeless. The problem is not that there has been too much attention paid to the naturalistic aspects of the figure drawing; rather, not enough attention has been brought to bear on those abstract energies that would bring the image to life. Accurate representation and energetic graphic invention are not mutually exclusive. The more thoroughly objective a drawing's imagery becomes, the greater

the demands on our ability to organize the marks that make the image.

- 2. Lack of Unifying Movement. The stilted, piecemeal appearance of drawings made with little or no regard for the moving energies that can animate and unify any group of human (or other) forms we may see is usually traceable to a sequential approach to drawing. But the directional and rhythmic forces at work among the parts of the figure are perhaps the most evident quality of our subject. They may best be returned to our drawings by studying gesture drawing and by examining further the issues dealt with in Chapter 5.
- 3. Random Shifts between the Second and Third Dimension. Such an inconsistency (as with any other in drawing) indicates the absence of an overall dynamic theme—an uncertainty about the drawing's purpose or goal. Many drawings do show integrated transitions of emphasis between two- and threedimensional phenomena, as in Picasso's and McGarrell's drawings (Figs. 7.16 and 7.22), where integrated shifts in emphasis occur between events on the picture plane and events among the figure's forms in space. But a random coming and going of volumetric and spatial clarity indicate the absence of a single frame of reference—of one "voice" in a drawing. When elements in one part of a drawing convey mass and space and those in another do not, there must be some comprehensive design strategy that justifies and unites these parts.
- 4. Faulty Placement. An indifference to the figure's location on the page suggests an innocence about what constitutes the most fundamental feature of good design—balance. We have seen that a drawing's design consists of the configuration and the page. The impact of imbalance on the viewer caused by a visually illogical placement of the figure often overrides the drawing's intended impact. An image that is itself stable, when placed badly on the sheet, becomes part of an unstable design.
- 5. The Divided Drawing. This is the result of strong divisions of the picture plane by lines, values, or shapes that isolate one part of a drawing from another and destroy the unity of the design. But such divisions, when they are overcome by other unifying forces, are a frequent device in drawing. In figure drawing, the problem often arises when there are two figures shown, each threatening to isolate itself from the other. The problem can be solved in numerous ways. In Figure 4.81, Boucher solves it by making one figure overlap the other; in Figure 4.95, unity is achieved by the sameness of the pose; in Figure 5.18, Picasso uses strong shape, value, and directional similarities to weave the work together; in Figure 5.33,

Moore fuses the two figures by blending dark values; and in Figure 7.20, Pearlstein intersects diagonal movements and the encircling band that the couch and patterned blanket provide. In drawing, any runaway dynamic force can be corralled by other stronger forces.

These are only some of the ways our drawings may fail to balance and unite. Any faltering in organizational matters suggests a need to further examine the dynamics of visuality that are, after all, a given condition of making marks on a bounded flat surface. This is not to suggest that figure drawings must be stridently dynamic. Some drawings show dynamic energies of a subtle and delicate kind, as in Figures 1.16 and 1.29. But delicacy is not timidity: It is a special kind of caring about nuance and inflection, a style of expression, and as such, an affirmation of intent. Timidity is only a style of evasion.

Expressive Defects

1. Expressive Blandness. This weakness suggests an overconcern with depiction and narrative interests as well as an innocence about harnessing those dynamic and intuitive forces that make our drawings interesting to others. But even this blandness is expressive. The viewer senses the absence of impulses that both empathy and intuition provide. When artists do not risk commitment to what is there to be sensed, they can only record what is there to be measured. Their drawings reveal this hesitancy.

All arts teachers are familiar with the conscientious student drawing that carefully avoids responses to the figure's dynamic potentialities. At one time, most art academies insisted on just this kind of disciplined concentration on measurable matters. But such drawings often were superfical and lifeless. Drawings that avoid the moving energies that create the graphic equivalent of life *are* lifeless. However, sensitively observed drawings of a highly realistic kind can be very impressive when the artist takes into account a subject's moving energies, as Figure 7.13 demonstrates.

2. Anecdotal Drawing. When the artist is concerned more with storytelling—with some emotional, narrative aspect of the subject (whether social, political, historical, or religious)—than with a fusion of narrative and abstract forces that would animate and unify the image and actually strengthen the narrative expression, the resulting work is more literary than visual. Any storytelling message can be a valuable property of any drawing, but it should never diminish the inventive and responsive depth of the work.

3. *Influenced Drawing*. The problem here is that the influenced drawing usually lacks the conviction and daring—the sense of necessity—present in the drawings it was influenced by. I am not referring to drawings that show a faint, residual influence of a particular artist, era, or style. Artists who by temperament and aesthetic disposition find that they share a point of view with that of a colleague, master, or stylistic period may well reflect some superficial similarities. But their work is essentially original if it is not limited by, or imitative of, the influencing works. It is hardly uncommon for some artists, and among them some of the best, to expand on or even to develop new concepts stimulated by the innovations of others. After all, in being artists ourselves, it is natural to search out "kindred visual spirits" among other artists, past and present, just as in our social lives we search out friends who strike us as "our kind." In both cases, influences occur. In both cases, our understanding, our abilities, and ultimately, our freedom to be ourselves is increased.

But strong influences block the emergence of personal responses. An adopted manner is usually an imitation of a technique rather than a concept—it is a show of another's idiosyncrasies. Whichever it is, its presence always prevents the development of genuine originality. But the student who begins to trust and respect his or her own responses to drawing the figure soon finds a satisfying creative freedom that imitation will never provide.

4. Conflicting Meanings. We find this defect in works that fail to convey a consistent visual attitude, mood, or handling. The freedom of response to a subject, and to its equivalent state on the page, does not extend to arbitrary changes in attitude toward the subject or to its manner of presentation within the same drawing. For example, in a figure drawing that is primarily structural and tonal, deciding to draw one leg in a strictly linear and calligraphic manner is a pronounced inconsistency. More frequently, students will draw the figure in one mode and the background in another (and usually with far less involvement or care).

Conflicting expressive meanings are not uncommon in student drawings. They often result from experiencing the many new ideas and challenges that a good program of art study provides. But conflicting interests and meanings violate one of the most fundamental requirements of any art form: to communicate a single point of view in a clear way. This is not to say that multiple meanings are impossible in drawing. In the example just given, both tonal and linear ideas can be compatible in the same image if an interest in both is made an integral and recurring theme of the drawing's expressive order.

Conflicting meanings may sometimes result when the figurative expression is at variance with the expressive nature of the handling and design. For example, in a drawing of a figure engaged in some strenuous or dramatic action, a delicate, precise handling and a design that stresses the tranquillity of horizontal directions might weaken or even contradict the figure's action.

Beginners preoccupied with the seemingly unmanageable number of considerations involved in drawing need to know that all these factors eventually begin to come together and work for the student almost automatically. Then it will be important to recognize that perceptions and methodologies are servants that perform best when the strongest demands are made of them. And the demands of a sensitive, analytic, and empathic eye, inquiring and organizing in a personal way, create original style. Style, in fact, indicates the key to our priorities—it reveals both temperament and intention. Therefore, a search for style is not only futile; it is beginning at exactly the wrong end. It is your goals that shape your style. Style, then, is not arbitrary, not chosen; it is inherent in our nature and purpose.

THE ROLE OF MEDIA IN EXPRESSION

In the preceding chapter, we observed that when the expressive order of a drawing depends on the nature of the medium, the medium is nearly as important as the four factors in perceiving and responding. We must now extend our examination of the interacting factors to include some observations and examples of the role of the materials, especially when they strongly affect the image. We will also briefly consider the needs of the emerging drawing. For in addition to the skills and interests we bring to the act of figure drawing, and besides the subject's supply of measurable and dynamic data, the drawing as it forms makes suggestions of its own. And finally, because we want our drawings to say what we mean them to, we will examine some drawings to see why the intent to arrive at a particular goal is the necessary point of entry into figure drawing, even though our perceptions, materials, and the needs of the merging drawing always influence our intent.

As noted earlier, all good figure drawings show a congenial alliance between the artist's intentions and the medium's character. When we find that a medium exerts a strong influence on our handling and judgments, its value for us is determined by our ability to adapt the medium to our purposes or adjust our goals to take advantage of the medium's properties.

When Rembrandt uses the etching needle, he ac-

cepts the restrictions it imposes on the broad, calligraphic manner of his drawing style (Figs. 5.1, 5.14, and 5.21). But because he responds to the needle's linear precision and delicacy, the fine weave and textural range of its tonalities, and even its restrictions on a more aggressive handling, he adjusts his goals away from the more spontaneous manner of his drawings in ink, wash, or chalk and accepts etching's challenge to be especially resolute and direct.

In his etching *Three Heads of Women, One Asleep* (Fig. 7.25), although he does little to relate these three studies beyond their sensitive arrangement on the page, Rembrandt chooses to tell about subtle tonal and surface changes, textures, and light effects. He does so not as an end in itself but as clues to the moods of the three women. For example, the sleeping head is securely held, not only by the dependably sturdy hand but by the "cushion" of crosshatched lines which, in completing the circle begun by the woman's hat, adds to our appreciation of the weight of the head relaxed in sleep.

Though an etched line is difficult to alter or remove, Rembrandt still begins to draw each figure with free lines that search out movements, rhythms, shapes, and major planes and masses. Note that in drawing heads, Rembrandt does not concentrate on the eyes, nose, and mouth, but is equally attentive to all of the head's forms.

In Tiepolo's pen and wash Standing Man in a Cap and Cape, His Left Arm Partly Raised (Fig. 7.26), the materials assist the artist in grasping the passing gesture of the model. Although such a pose might be as successfully captured in several other media, none can move with the speed and vitality of the quill or steel pen. Nor can they produce the range of tones from near white to pure black as easily as can washes of ink and watercolor. The speed of execution that Tiepolo's pen lines make possible not only reinforces the expression of the old man's sudden gesture but conveys the trembling inflections of his momentary stance and of the drapery's fluttering action. Likewise, the immediacy of the broad washes suggests the moving nature of the figure's gesture.

But these lines and tones do more. They deftly establish important structural and anatomical conditions, note textures and local tones, and illuminate the forms in a strong light. Notice how well the line of the hat's brim explains the form of the head, how the corrugator muscles affect the structure of the forehead, and how the sinewy muscles of the lowered arm expend effort. Tiepolo convinces us of the presence of the figure's forms beneath the heavy drapery—he even manages to tell us about the deltoids and the man's left knee and that at the ankle the medial malleolus is higher than the lateral one.

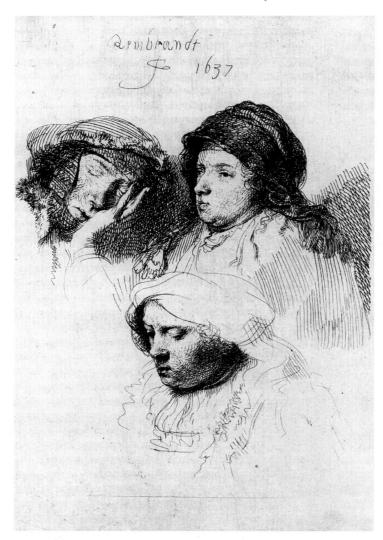

7.25 REMBRANDT VAN RIJN (1606–1669) *Three Heads of Women, One Asleep* (1637) Etching, second state, $5^{1}/2 \times 3^{3}/4$ in. (142 × 97 mm). Gift of the Estate of Lee M. Friedman. Courtesy Museum of Fine Arts, Boston. 58.1051.

This is all stated with an ongoing interest in the dynamic nature of the forms and in their collective action, strengthened by the fast-moving cadence of the medium. In stressing the upward expansion and growing substantiality of the figure, from its tremulous beginning at the feet to the monumental finale of the upper body, Tiepolo adds even greater force and spirit to the expressive gesture of the old man's head and arm.

The especially harmonious interplay between the artist's needs and the medium's character earns our immediate appreciation in Kollwitz's charcoal drawing *Self-Portrait, Drawing* (Fig. 7.27). Unlike Tiepolo's drawing, this image is difficult to imagine being formed by any other medium. Charcoal, which is simply carbonized wood, has the sooty, velvety texture so necessary to Kollwitz's suggestions of atmosphere; it makes us see the figure as through a veil of

tone. The artist's interest in a delicate modeling of powerful forms is aided by the ease with which charcoal can change in value from whispered light tones to mellow dark tones. Few other media will respond as readily to such demands.

Like Tiepolo's drawing, Kollwitz's depicts a figure in action. Because the hazy nature of charcoal enables even the darkest tones to fuse with surrounding tones, Kollwitz is able to express the vigorous movements of the extended arm with vigorous movements in the broad strokes that rush up and down along it. This sudden flurry of intense activity is so expressively necessary and so well integrated in the design that we accept it as an inventively effective strategy.

Kollwitz securely anchors this furious departure from the drawing's otherwise delicate tonal activity in

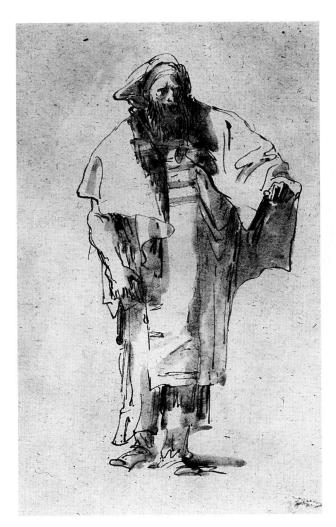

7.26 GIOVANNI BATTISTA TIEPOLO, Italian (1696–1770) Standing Man in a Cap and Cape, His Left Arm Partly Raised Pen, brown ink and gray brown wash, 22.5 × 13.9 cm. The Art Museum, Princeton University. Bequest of Dan Fellows Platt, Class of 1895. 1948-862.

several ways. At the sleeve, the vertical strokes enacting the arm's movements are blended with the tone and direction of the lower arm. All along the arm, the strokes roughly suggest the sleeve's folds, and one stroke falls exactly at the bend of the arm, further integrating itself with the arm. Another dark stroke corresponds to the contour of the torso, and the few bold strokes on the torso relate in direction to the lighter ones all across the chest. Furthermore, by beginning a fanlike spread of directions with the foreshortened drawing board (convincingly suggested by a single line!) that extends across the page, the broad strokes on the arm form a necessary part of that dynamic action. As insurance, the artist defines the arm's shape in

the lighter underdrawing and even allows it to stand free of the broad strokes in the area below the elbow.

Kollwitz moves easily from structural to dynamic matters. In the hand, the fingers are deftly summarized, the artist's knowledge of anatomy guiding the solution; but in the darkened palm, structure gives way to lines and tones that evoke, rather than delineate, the squeezing together of the muscle and skin—we feel the force of the grip on the charcoal stump.

This drawing, too, reveals the characteristic noted earlier and so often seen in master drawings: the avoidance of an overall sameness of structural or dynamic emphasis. Note how this drawing seems to begin faintly, reach an intense pitch of activity, and then subside. Had Kollwitz continued to develop the forms of the back of the head and of the torso, not only would the drawing's present balance have been sacrificed, but its emotive force would have been dissipated. Here, the grand U-shaped sweep of the entire configuration and the developed forms of the face and hand unite to heighten the drawing's dramatic impact.

It is, of course, impossible to point to those places in a completed drawing where lines and tones exist (or are absent) because the drawing, as it formed, demanded such conditions. The sensitive artist responds to three considerations in the act of drawing: (1) his or her temperamental and creative interests in general and the intentions for the drawing under way; (2) the subject's measurable and dynamic actualities and potential for stimulating creative ideas; and (3) the emerging drawing's needs for further development and integration of the four factors, and *its* creative potentialities—the hints and ideas that the still malleable image suggests.

Did Kollwitz add the broad strokes along the arm because she intellectually or intuitively planned to, because the folds in the observed sleeve suggested them, or because the drawing needed something bold to enliven it and pull it together? Perhaps these strokes exist for all three reasons. Again, did she refrain from further developing the back of the head by prior intent, because the gray tone of the hair blended with the tone of the wall, or because the drawing's expressive order advised against it? All we can say with any certainty is that some, and perhaps much, of the drawing was determined by its own visual and expressive requirements.

IN CONCLUSION

That finished drawings are the result of a three-way conversation between artist, subject, and drawing in progress—what can be dubbed a trialogue—is, of course, more immediately apparent in more subjective

7.27 KATHE KOLLWITZ (1867–1945) Self-Portrait, Drawing Charcoal on brown laid Ingres paper (Nagel 1972 1240), . $477 \times .635 (18^3/4 \times 25 \text{ in.})$. Rosenwald Collection, Photograph © 1998 Board of Trustees, National Gallery of Art, Washington, D.C.

works or when the subject is envisioned rather than observed. Figures 7.2, 7.14, and 7.16 did not appear in the mind's eye of the artists, complete in every detail, needing only to be transferred to paper, line by line. A general vision and intent were there, unfocused and tentative—something far less than the realized drawing yet more than an impulse; but these drawings were resolved by negotiations between the artist, the subject, and the emerging drawing. Of course, such negotiations occur in drawings made in the presence of the model. The model's expressive needs also help shape the final result as many of the drawings in this book show.

Bloom's *Autopsy* (Fig. 7.28), drawn in his studio after having attended a number of autopsies, bridges the categories of subjects observed and those envisioned. Here, too, we feel the drawing was formed partly by the artist's response to *its* visual and expressive needs as well as to his own remembered observa-

tions and creative purposes. Indeed, the harmonies, contrasts, balance, and unity of any drawing, if they are to avoid looking arbitrarily imposed or only weakly managed, must evolve from an ongoing awareness of the drawing's strengths, weaknesses, and possibilities at every stage of its development.

Bloom's drawing also demonstrates how powerfully the nature of the abstract activities can influence our reaction to a depiction. The drawing of the cadaver, despite its dissected state, is strangely lyrical, its forms seemingly windblown. Its graceful rhythms impart a transcendental air to the forms that provide a surprising contrast with the disagreeable nature of the event itself. But there is something instantly unpleasant in the outstretched arms placed on the cadaver. The rush of those arms, their clawlike fingers, and because they end within the page, their ghostly quality are conveyed by their directed energy, shape, and treatment, all of which are *inherently* aggressive. In

7.28 HYMAN BLOOM (1913–) **Autopsy** (1953) Sanguine crayon on pale green paper, $54^1/2 \times 37^1/2$ in. (138.4 × 95.3 cm.). Collection of the Whitney Museum of American Art, New York. Purchase 54.55. Photograph by Geoffrey Clements. Copyright © 1998: Whitney Museum of American Art.

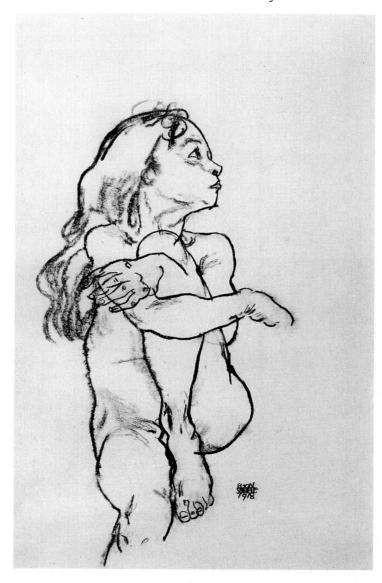

7.29 EGON SCHIELE (1890–1918) Seated Nude Girl Clasping Her Left Knee (1918) Charcoal, $18^{1/8} \times 11^{5/8}$ in. The Metropolitan Museum of Art, Bequest of Scofield Thayer, 1982. (1984.433.293).

contrast, the forms of the dissected corpse, by virtue of their graceful flutter, gentle tonal changes, and delicate treatment, seem far less forbidding than do the extended arms performing the autopsy.

In the best figure drawings, the artist's intent—a blend of excitement and curiosity about the visual and expressive actualities and possibilities issuing from a particular subject—determines the overall character of the drawing. Although the subject and the emerging drawing provide important information and counsel and create demands and opportunities that must be considered, their influence should serve to regulate and strengthen intent, but not divert or overrule it.

Once a drawing is under way, the temptations to "alter course" are often great, especially when we at-

tempt something just beyond our reach. Sometimes we do not perceive certain possibilities until the drawing is well advanced, possibilities that might be interesting (or promise a less demanding conclusion) but are far from our intended goal. Sometimes the drawing takes on unintended characteristics that beckon us to some other (often commonplace) conclusion. And sometimes the medium itself begins dictating to us. The artist must have both discipline and faith in his or her original theme to steer clear of such diversions. This does not mean that one cannot pursue an interesting creative possibility which may lead to a more inventive result. Indeed, ideas that germinate in one drawing should be nurtured in subsequent drawings. But allowing the drawing or the medium to take com-

mand is a serious surrender of control that often leads to poor results.

Bloom is faithful to his theme. The consistency of the drawing's traits and mood, the character and harmonious interplay of its elements, and its balance and unity attest to the artist's unvarying faith (and enthusiasm) in his theme, a theme conceived in an especially engaging integration of the four factors.

As we observed in Chapter 1, the frank declaration of a particular point of view is central to the art of figure drawing (and of course, to any work of art). It is also central to originality. Too often, the beginner in search of a point of view confuses novelty with originality. Novelty may result from originality, but it should never be pursued for its own sake. Genuine originality, the kind that makes images come alive, begins with the effort to respond honestly to our interests and our perceptions. And each perception increases our emotional, intellectual, and intuitive involvement with the subject, with our emerging work, and with our theme, thereby creating a state of receptivity in ourselves that enables our responses to become increasingly more personal, more insistently ours, and thus original. Genuine originality is the natural result of genuine caring. As Kenneth Clark has observed, "Facts become art through love, which unifies them and lifts them to a higher plane of reality . . ."2

Schiele's intent and perceptual acuity are both apparent in *Seated Nude Girl Clasping Her Left Knee* (Fig. 7.29). His candid satisfaction in the tactile experiencing of the forms *and* in the calligraphic play of the lines is revealed in the nature of the lines. Not only do these interacting directional thrusts, textures, speeds, and tensions among the lines fail to conflict with Schiele's sensual theme, but they support it—their abstract expressive nature amplifies the psychological tone of the artist's search of the forms.

In Matisse's *Nude* (Fig. 7.30), expressive interests are more structurally than sensually motivated, and the dynamic nature of the elements is more forcefully active in volumetric and directional behavior than in tactile behavior. In contrast to Schiele's varied and lively, but leisurely, contours, Matisse's are almost entirely comprised of C-shaped segments that race boldly on counterchecking, volume-informing, and shape-enclosing functions. As in Schiele's drawing, the elements' figurative and abstract roles complement rather than compete with each other. Although these two drawings are roughly similar in their figurative sense, they are very different in temperament and

Likewise, Rembrandt's Female Nude Reclining with Arm Raised (Fig. 7.31) shows a complemental play of figurative and abstract activities among the elements. Less calligraphically active than Schiele's drawing and less structurally insistent than Matisse's, Rembrandt's drawing nevertheless conveys qualities of calligraphic play and structural clarity that go beyond the others in economy, conviction, and the level of dynamic life. Furthermore, in embracing both of these challenges, he succeeds in an interweaving of the four factors that shows each equally active. This is not to suggest that such a formula is intrinsically superior (though it is perhaps more demanding), but to point out that all four factors can be abundantly active at the same time.

Here, facts and inferences about structure and anatomy tell us a great deal about both, and the drawing's design and expression are alive with energies and meanings at both the abstract and figurative levels. Note, for example, in the upraised arm, that the single line which establishes the broad plane of the lower arm simultaneously performs the following additional functions: (1) it defines the contour of the lower arm from the olecranon process to the lower ending of the ulna, explaining the bony nature of each and also defining the base of the plane of the back of the hand; (2) it relates, either by its position, length, or hooked endings, to numerous other lines throughout the drawing; and (3) by its energetic thrust and rugged character, it reveals its own emotive force as well as the physical effort of the arm's gesture. In this drawing, virtually every mark "earns its keep" by equally advocating all four factors. Joseph Conrad's comment on the art of writing is just as applicable to drawing: "A work that aspires, however humbly, to the condition of art should carry its justification in every line."3

In these three drawings of the female figure, each artist is determined to convey his aesthetic and humanistic intent and is led to a necessarily different formulation of the factors and thus to an original graphic invention. Were these three artists to have exchanged models, each would have responded to a different hierarchy of perceived actualities and implications, and the result in each case would be inventive and personal. In fact, were every artist shown in this book to have drawn these three poses, we would have

theme. Both were begun and sustained by the artists' deeply felt responses to perceptions "programmed" and guided by intent. In both, conditions in the forming image and those set by the medium played important roles in determining their final resolution.

² Kenneth Clark, *Landscape into Art* (New York: Transatlantic Arts, Inc., 1961), p. 16.

³ From the preface to *The Nigger of the Narcissus*.

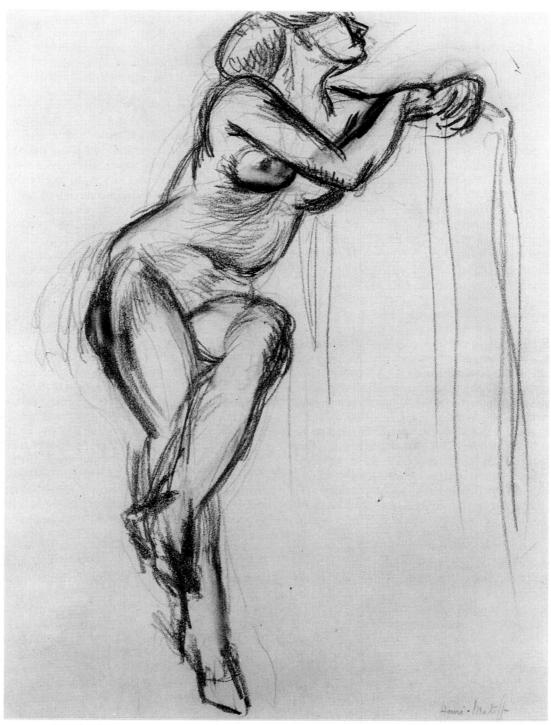

7.30 HENRI MATISSE, French (1869–1954)

Nude (ca. 1905)

Watercolor on paper, H: 5³/4 in., W: 9⁵/8 in.

The Metropolitan Museum of Art, Alfred Stieglitz Collection, 1949 (49.70.5)/© 1999 Succession H. Matisse,

Paris/Artists Rights Society (ARS), New York.

7.31 REMBRANDT HARMENSZOON VAN RIJN (1606–1669) *Female Nude Reclining with Arm Raised* (c. 1665) Pen and brown ink, with brush and brown wash, on tan laid paper, 23.2 × 18 cm.

Margaret Day Blake Collection, 1947.464. Photograph © 1998,

The Art Institute of Chicago. All Rights Reserved.

had that many different creative expressions. What yours would be, or can become, depends on your perceptual skills, on your temperamental interests and the insights they provide, and on your recognition of the interacting nature of the four factors.

If figure drawing is to be seriously approached as art, it cannot be regarded as an imitative or even a simplifying process. It is the felt ordering of form relationships that simultaneously refer to the figure and to a system of expressive order that reinforces, and is in turn reinforced by, the representational aspects of the drawing.

If we understand the term *representation* to mean the depiction of a subject's essential outer and inner self—its fundamental physical and spiritual character—then selective realism and selective subjectivity, in asserting these essentials, share a basic interest in the profound perceptual, dynamic, and transcendental qualities that nature and life suggest. These necessary qualities do not come from either infatuation or mere observation of reality. They yield only to analysis, knowledge, order, and empathy.

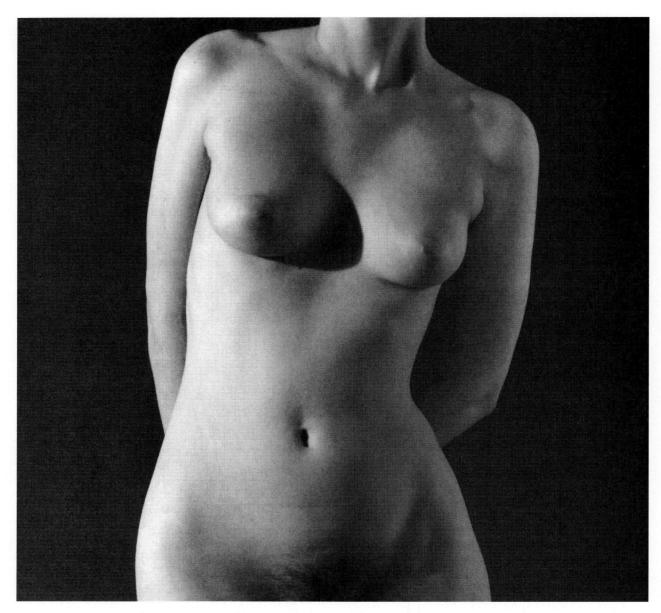

A Gallery of Visual Resources

To draw the figure well, we need to study and draw the figure often. The photographs in this chapter (along with those throughout the book) are for readers wishing to see more examples of at least some of the structural, anatomical, and other material examined in Chapters 2 through 6, as they manifest themselves in the living figure. Readers may wish to use some of these photos as models for various exercises in the text. In the absence of a model, readers may want to work from these photos to put into practice ideas, information, and ideally, inspiration they have acquired in reading the text and seeing its many outstanding examples of figure drawing.

Although drawing from photographs is a far cry from being in the presence of the live model, it is still preferable to not drawing at all. There are, however, a few considerations to hold in mind:

1. Values: The photograph does not record the number of subtle value changes in a subject that our eyes see when we look at the subject. Instead, the photograph groups several similar values into one, creating a somewhat different pattern of toned shapes. While this sometimes has the effect of simplifying the distribution of values on the subject, it can also lead to a more harsh lighting of the subject than is actually the case and to a misreading of its structure. It is best,

therefore, to understand the values in the photograph as only a general guide to be expanded on as the drawing develops.

- 2. Monocular vision: The camera has only one "eye." When we cover one of our eyes and look around, we see what a camera sees. We then see less "around" a form than does the camera. Although this difference is less when subjects are placed further away, it can cause nearby subjects to appear a little flatter than they actually are. The solution to this problem is to concentrate more on creating convincingly realized volume and space in the drawing and not merely making an accurate recording of the photograph's contours, which would be different if the camera had two eyes.
- 3. Hardening: Partly because of the above and partly because the edges in most photographs are easier to see than the values and planes that give the illusion of volume and space, there is a tendency to emphasize edges rather than the clues that lead to mass and solidity. At such times, we need to discipline ourselves to rely less on contours than on what we can see or recall about the form's structure.
- 4. Distortion: Sometimes a photograph shows distortions in the proportion and shape of a sub-

ject's parts. For example, in Figure 8.36, the size of the right foot is slightly larger than it should be. The solution lies in being mindful that such distortions can occur and making adjustments wherever necessary.

Despite these sometimes vexing problems, drawing from photographs, if combined with drawing from life, gives useful information about the four factors of figure drawing this text has examined. I hope the photographs here and throughout the text do just that.

8.2

332

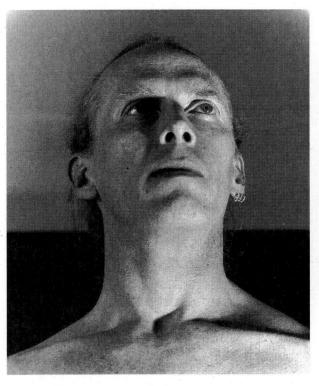

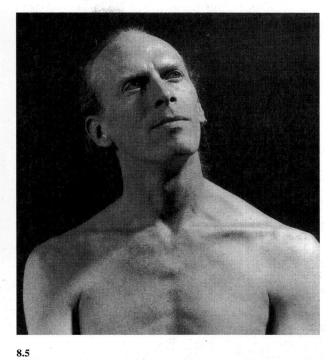

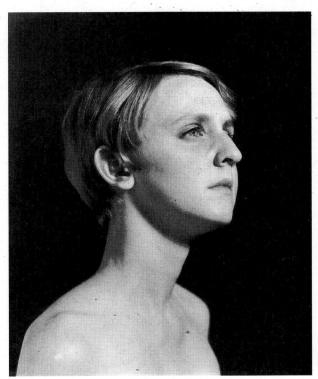

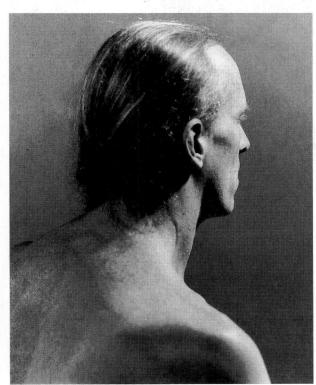

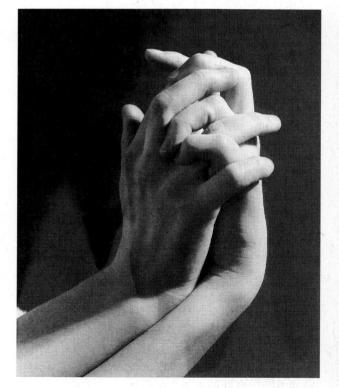

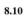

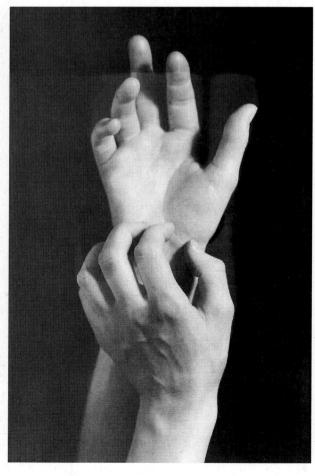

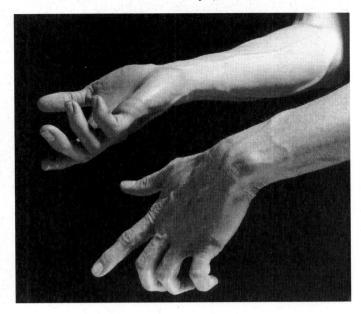

8 11

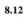

8.15

8.17

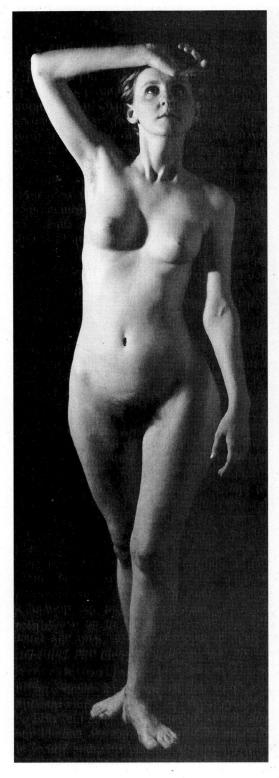

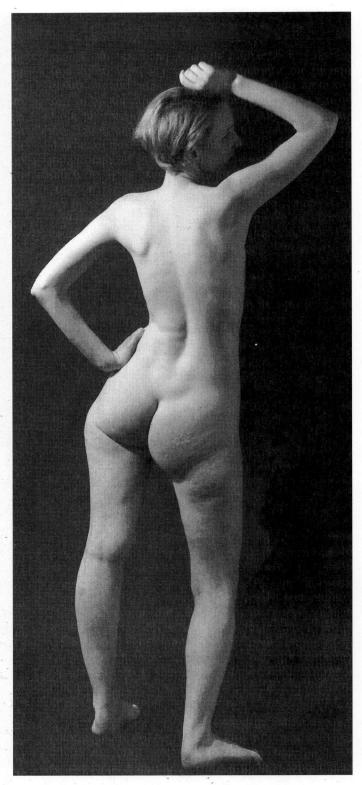

8.20

8.21

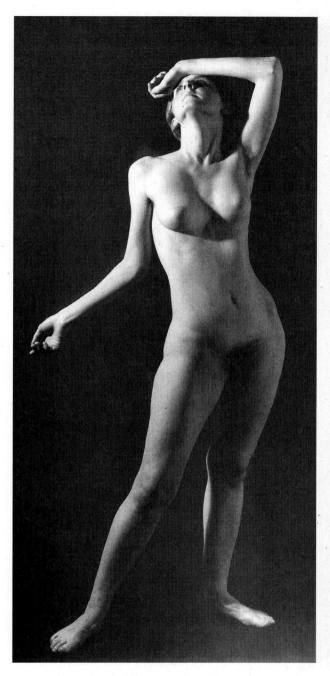

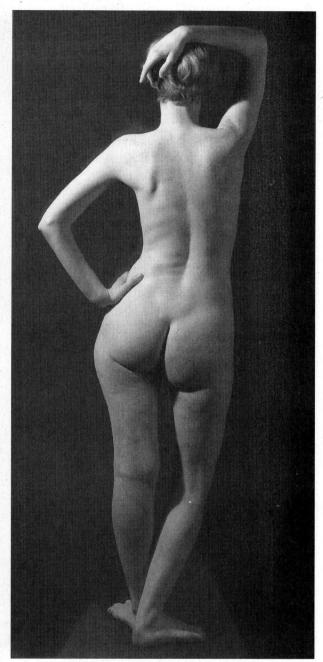

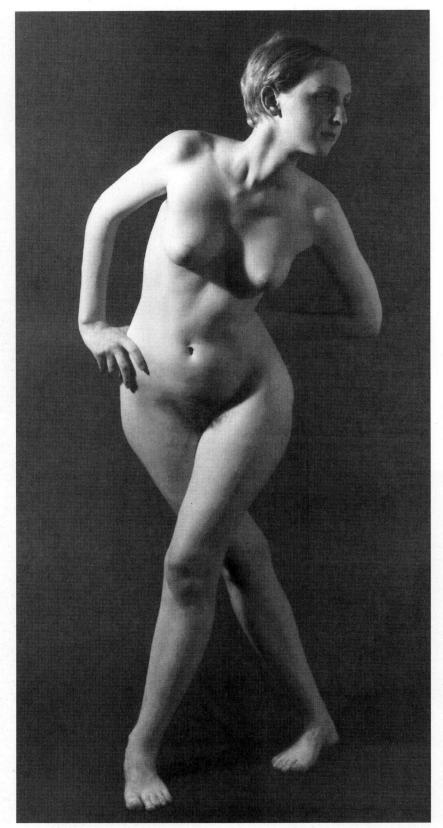

8.28

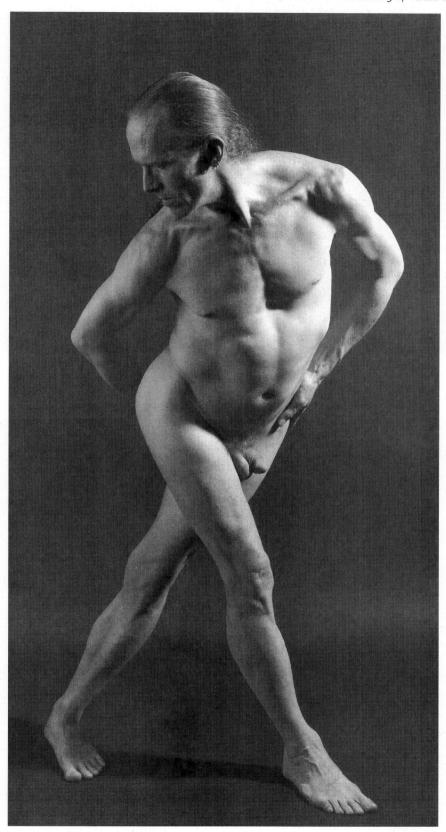

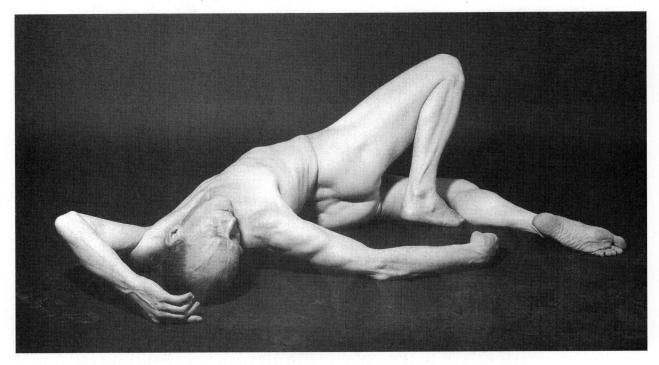

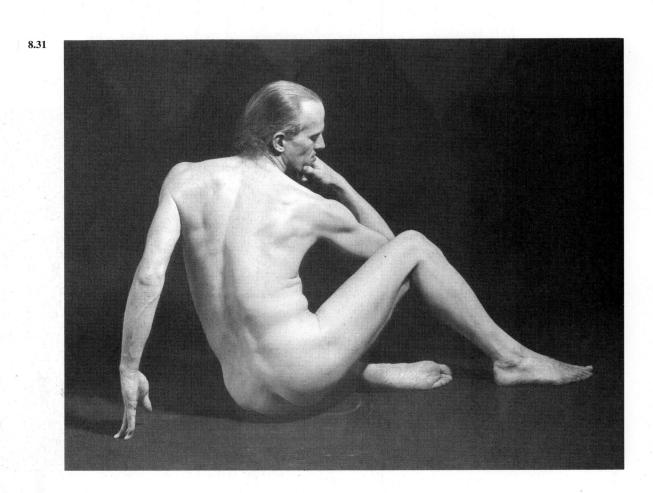

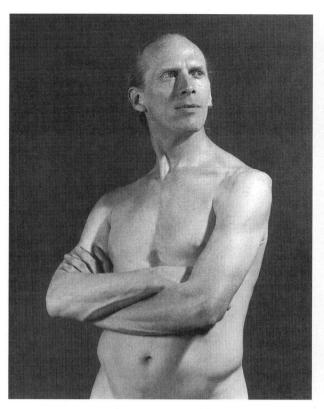

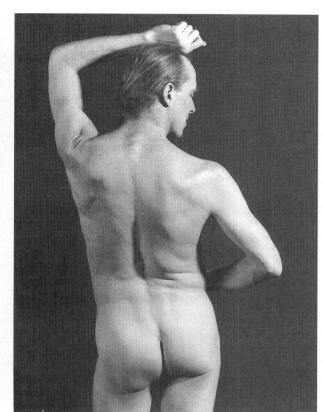

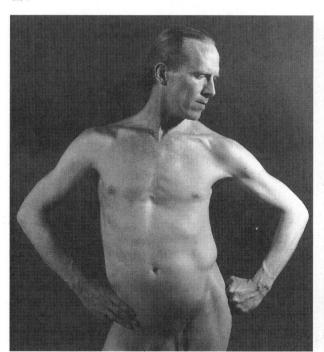

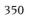

8.38

Bibliography

GENERAL TEXTS

- Anderson, Donald M. Elements of Design. New York: Holt, Rinehart and Winston, Inc., 1961.
- **Arnheim, Rudolf.** Art and Visual Perception. Berkeley and Los Angeles: University of California Press, 1974.
- **Arnheim, Rudolf.** *Toward a Psychology of Art.* Berkeley and Los Angeles: University of California Press, 1972.
- Bertram, Anthony. 1000 Years of Drawing. London: Studio Vista Ltd., 1966.
- **Blake, Vernon.** The Art and Craft of Drawing. London: Oxford University Press, Inc., 1927.
- Bro, Lu. A Studio Guide. New York: W. W. Norton & Company, 1978.
- Chaet, Bernard. The Art of Drawing. New York: Holt, Rinehart and Winston, Inc., 1970.
- Clark, Kenneth. The Nude. New York: Pantheon Books, 1956.De Tolnay, Charles. History and Technique of Old Master Drawings. New York: H. Bittner & Co., 1943.
- **Edwards, Betty.** *Drawing on the Right Side of the Brain.* Los Angeles: J. P. Tarcher, Inc., 1979.
- Eisler, Colin. The Seeing Hand. New York: Harper & Row, Publishers, 1975.
- Goldstein, Nathan. The Art of Responsive Drawing, 5th ed. Englewood Cliffs, N.J.: Prentice Hall, 1999.
- Hale, Robert Beverly. Drawing Lessons from the Great Masters. New York: Watson-Guptill Publications, 1964.
- **Hayes, Colin.** *Grammar of Drawing for Artists and Designers.*London: Studio Vista Ltd., 1969.

Vanderpoel, John H. The Human Figure. New York: Dover Publications, 1958.

ON ANATOMY

- **Barclay, Jeno.** Anatomy for the Artist. London: Spring Books, 1960.
- Berry, William A. Drawing the Human Form. New York: Van Nostrand Reinhold Company, 1977.
- Cody, John. Visualizing Muscles. Lawrence: University Press of Kansas, 1990.
- **Goldfinger, Eliot.** *Human Anatomy for Artists.* New York: Oxford University Press, 1991.
- **Hatton, Richard G.** *Figure Drawing.* New York: Dover Publications, Inc., 1965.
- **Oliver, Charles.** *Anatomy and Perspective.* New York: The Viking Press, 1972.
- **Peck, Rogers S.** Atlas of Human Anatomy for the Artist. New York: Oxford University Press, 1951.
- **Perard, Victor.** *Anatomy and Drawing,* 4th ed. New York: Pitman Publishing Corporation, 1955.
- **Richer, Paul.** Artistic Anatomy, trans. Robert Beverly Hale. New York: Watson-Guptil Publications, 1971.
- Royce, Joseph. Surface Anatomy. Philadelphia: F.A. Davis Co., 1965.
- **Schider, Fritz.** An Atlas of Anatomy for Artists. New York: Dover Publications, Inc., 1957.
- **Thomson, Arthur.** A Handbook of Anatomy for Art Students. New York: Dover Publications, Inc., 1964.

FOR ANATOMICAL MATERIALS

For Functional Model (skeleton reproduced on page 116) The Johns Hopkins University Press Baltimore, Maryland 21218

Kilgore International 172 W. Chicago Street Coldwater, Michigan 49036

Medical Plastic Laboratory Gatesville, Texas 76528

Ward's Natural Science Est. Ltd. Box 1712 Rochester, New York 14603

ON PERSPECTIVE

Ballinger, Louis. *Perspective, Space and Design.* New York: Van Nostrand Reinhold Company, 1969.

Burnett, Calvin. *Objective Drawing Techniques.* New York: Van Nostrand Reinhold Company, 1966.

James, Jane H. Perspective Drawing: A Directed Study. Englewood Cliffs, N.J.: Prentice Hall, 1981.

Watson, Ernest W. How to Use Creative Perspective. New York: Reinhold Publishing Co., 1960.

ON MEDIA AND MATERIALS

Dolloff, Francis W., and Roy L. Perkinson. How to Care for Works of Art on Paper. Boston: Museum of Fine Arts, 1971.

Watrous, James. The Craft of Old Master Drawings. Madison, Wisc.: University of Wisconsin Press, 1957.

Index*

A

Abductor digiti minimi, 164 Abductor pollicus longus, 147, 148 ABELES, Sigmund: After Her Eye Operation, 127, 129 Black Camasol, Black Evening, 260, 262, 263 New Year's Eve, 1978, 296-97, 298 Abstract character of drawings, 5 Acetabulum, 92, 98 Achilles' tendon, 161, 162, 163, 164 Acromiun process, 86, 90 Adductor digiti minimi, 164 Adductor group, 157, 159 Adductor longus, 163 Adductor magnus, 159, 161, 163 After Her Eye Operation, Abeles, 127, 129 Alar cartilages, 127, 128 ALBERS, Josef, Self Portrait, 49, 50 ALBINUS, Bernard: Muscles, Back View, 168

Muscles, Front View, 166

Muscles, Side View, 167 Skeleton, Back View, 106 Skeleton, Front View, 98, 106 Skeleton, Side View, 106 Allegorical Figure of a River God, Cézanne, 37, 39 Allegory of Death, de Gheyn II, 78 An Actor in His Dressing Room, Rembrandt, 67, 69, 70 Anatomical factor, 5 design and, 243-48 muscles, 123-95 skeleton, 79-120 Anatomical Studies, Montelupo, 98 Anatomy of the External Forms of Man, The, Plate 2, Fau, 158 Anatomy of the External Forms of Man, The, Plate 3, Fau, 90-91, 94 Anconeus, 147, 148, 149, 150, 152 ANDERSON, Lennart: Portrait of Mrs. Susan Peterson, 306 Variant on Ingres' Figure Odyssey, 238, 239 Andy Warhol, Neel, 71, 74 Angel of Death, Rothbein, 108, 109 Ann and Andrew Dintenfass, Goodman, 280-81, 282 Antihelix, 127, 128 Antitragus, 127, 128

Arm bones, 91, 95-98

^{*} Page numbers in boldface indicate the location of illustrations.

Arm muscles, 143–54

Arms, Study of, Da Gheyn II, 143, 146

Arms and a Man's Face, Studies of, Rubens, 151, 152

ARONSON, David, Rabbi III, 267, 268

Artist's Studio, The, Rembrandt, 250–52, 253

Atlas, 87

AUTIO, Rudy, Girl with Dog, 31, 32

Autopsy, Bloom, 322, 323, 324

AVISHAI, Susan, Untitled, I, 217, 218

Away from Me, if Possible, Schneider, 269, 270

Axis, 87

\boldsymbol{B}

Bacchus and Ariadne, Poussin, **70**, 70–71 Back of a Nude Woman, Lachaise, **8**, 24, 207, **208**, 209–10 Back View of Male Figure, Herron, **48**

BAGERIS, John:

Seated Skeleton I, 111, 112

Seated Skeleton II, 303, 304-5

Band of Richer, 157, 159, 162, 163

BARNARD, George Grey, The Struggle of the Two Natures in Man, 193

BARNET, Will, Figure and Cat, Study for Dusk, 198, 199

BAROCCI, Federico:

Studies of Legs and a Foot for St. Sebastian in the Genoa Crucifiction, 159, **160**

Bathsheba Receiving David's Letter, Rubens, 62, 63, 64, 66

Battle of Nudes, Pollaiuolo, 10, 11

Bearded Oriental in a Turban, Half Length, Rembrandt, 5, 6

BELLOWS, Kent, Four Figures Set Piece, 32

Biceps, 136, 146, 147, 148, 150, 152, 153

Biceps femoris, 156, 157, 159, 161, 162, 163

Bird Catcher, The, de Gheyn II, 71, 72

BISHOP, Isabel, Nude Bending, 37, 41

Black Camasol, Black Evening, Abeles, 260, 262, 263

BLOOM, Hyman:

Autopsy, 322, 323, 324

Nude Old Woman, 64, 66

Seated Figure, 108

BOCCIONI, Umberto:

Male Figure in Motion, (towards the Left), 190, 191

Muscular Dynamism, 142, 144

Reclining Male Nude, 245-46, 247

Bolognese School, A Burial Scene, 308

Book of the Dead of Ta-Amen, Ptolemic Period, 8, 9

BORGHESE, From Salvage's "Anatomie du Gladiateur Combattant," 80, 81, 103, 170, 171

BOUCHER, François:

Nude Children (Amorini), 172, 173

Reclining Nude, 172, 175

Seated Nude, 53, 55

Study of a Triton, 246-47, 248

Boy Seated at a Table with a Candle and Writing Tools, 295, 296

Boy Watching Over Sleeping Woman by Candelight, Picasso, **290** (detail): 306, **307**

Brachialis, 146, 147, 148, 150, 152

Breasts, 135, 137

BROOKS, Jay, Figure, 213, 215

Burial Scene, A, Bolognese School, 308

Byron Goto, Katzman, 213, 216

C

Calcaneus, 99, 100, 164

Calligraphic lines, 207-9

CAMBIASO, Luca:

Hercules, 179, 179-80

Male Nude on Horseback, 292, 294, 295

Resurrection and Ascension, 57, 58

The Conversion of St. Paul, 34 (detail); 35, 36, 38

Canine fossa, 82

CANUTI, Domenico Maria, Study of a Dead or Sleeping Man, 12, 14

Capitulum, 91, 95

Cardinal Borjia, Velázquez, 84, 85

Cardinal John Fisher, Holbein the Younger, 126

Carolingian Illumination, Portrait of St. Gregory, 10

Carpal bones, 96, 97

CASSATT, Mary, The Coiffure, 22, 23

CASTIGLIONE, Pan and Syrinx, with a River God, 252–53, **254**

Cervical vertebrae, 84, 85, 86, 87

CESARI, Guiseppe, Studies for a Flagellation of Christ, 219

CÉZANNE, Paul, 35

Allegorical Figure of a River God, 37, 39

Rowing Man, 243, 244

Cheselden's "Osteographia" or "The Anatomy of the Bones," Plate XXXVI, 116

Christ on the Cross, Study for a, Michelangelo, 139, 140

Circe, Grosz, 271, 273

Clark, Kenneth, 1, 70

Clavicle, 86, 90, 135, 136, 139

CLOSE, Chuck, Phil/Fingerprint II, 27, 28

355 Study of Four Heads, 258 (detail); 266 Closure, defined, 223 The Bird Catcher, 71, 72 Clown, A, Daumier, 311, 312 "De Humani Corporis Fabrica," Book I, Plate 10 from, Clowns, Demuth, 211, 212 Vesalius, 84, 85 Coccvx, 84, 85, 86, 87 "De Humani Corporis Fabrica," Book II, Plate 25 from, Coiffure, The, Cassatt, 22, 23 Color, 202 Vesalius, 256 Concha, 127, 128 DE KOONING, Willem, 1 Two Women III, 25, 27 Conversion of St. Paul, The, Cambiaso, 34 (detail); 36, 38 DELACROIX, Eugene, 20 COPLEY, John Singleton, Henry Earl of Bathurst, 131 Coracobrachialis, 152, 153 Two Nude Studies, 19, 28 DEL SARTO, Andrea, Red Chalk Drawing, 2, 3 Coracoid process, 90, 153 Deltoid, 134, 136, 139, 148 Coronoid process, 82 Corrugator, 125 DEMUTH, Charles, Clowns, 211, 212 DERAIN, André, Ballerina with Raised Arm, 207, Cranium, 80, 82, 83 "Creation of Adam" in the Sistine Chapel, Study of Adam for, 208 Design factor, 5 Michelangelo, 7, 12, 28, 35, 273, 274 anatomy and, 243-48 CRETARA, Dominic: overview, 197-203 Seated Figure, Back View, 41, 44, 45, 49 visual elements, 203-28 Sheet of Studies of the Female Figure, 60, 61 CRETI, Donato, Studies for Jacob Wrestling with the Angel, relationships between/among, 228-43 DESNOYER, François: 204, 206 Getting Dressed, 217, 218, 220 Cricoid cartilage, 131, 133 Desperate Man, Dürer, 36-37, 38, 45 Cross-contour lines, 47-48 Crucified Haman, Studies for, Michelangelo, 60, 134, 135 DICKINSON, Eleanor, Study of Hands, 2, 4 "Crystal Grotto, The," Study for, Tchelitchew, 271, 272 DIEBENKORN, Richard, 1 Seated Woman, No. 44, 226, 229 Diggers, The, Millet, 70-71, 71 DINE, Jim, Second Baby Drawing, 269, 270 Direction, 230, 232 D Distortion, 270-71 Douris, 9 Dancer Resting in an Armchair, Matisse, 230, 231 Drapery, Study of, Leonardo da Vinci, 66, 67 Drawing for the Rape of the Sabines, Poussin, 219, Dancer with a Bouquet Taking a Bow, Degas, 236, 237 DAUMIER, Honoré: DUCHAMP, Marcel, Nude Descending a Staircase, No. 2, A Clown, 311, 312 284, 286 Head of a Woman, 210 DÜRER, Albrecht: The Imaginary Invalid, 267 An Oriental Ruler Seated on His Throne, 291, 293 Dead or Sleeping Man, Study of a, Canuti, 12, 14 Desperate Man, 36-37, 38, 45 Death, Mother and Child, Kollwitz, 260, 262 DE CHIRICO, Giorgio, Il Condottiere, 270 DEGAS, Edgar, 7 Dancer with a Bouquet Taking a Bow, 236, 237 Nude Woman Standing, Drying Herself, 22, 23 E Russian Dancer, 71, 72 Standing Nude Woman, Back View, 143, 145 Ear, surface forms, 127, 128 Study of a Nude for "The Sorrows of the Town of Orleans," East Side Interior, Study for, Hopper, 249-50, 252 21, 22 Ectomorphic type, 134 Woman Wiping Her Feet near a Bathtub, 210, 211 Elephant Bathers I, McGarrell, 312, 313 DE GHEYN II, Jacob:

Environment, figure and, 248-54 Epicondyles, 91, 95, 96, 99

Erector spinae, 141, 142, 143

Epictetus, 9

Boy Seated at a Table with a Candle and Writing Tools,

Studies of Four Women at Their Toilet, 52-53, 55

295, 296

Study of Arms, 143, 146

ERLEBACHER, Martha Mayer, Male Back, 49, 52 Error and Falsehood, Tiepolo, 308, 309, 310 Esau Selling His Birthright to Jacob, Rembrandt, 207, Étude pour "Le martyre de Saint Symphorien," Ingres, 243-44, 245 Expressive defects, 318–19 Expressive factor, 5 distortion and, 270-71 examples in figure drawing, 273, 275-87 inherent in elements, 264-70 media and, 271-73, 319-21 overview, 259-64 Extensor carpi radialis brevis, 147, 148, 150 Extensor carpi radialis longus, 146, 147, 150 Extensor carpi ulnaris, 147, 148, 150, 152 Extensor digiti minimi, 147, 148, 149, 152 Extensor digitorum, 147, 148, 150 Extensor digitorum brevis, 164 Extensor digitorum longus, 156, 157, 159, 162, 164 Extensor hallucis longus, 156 Extensor pollicus brevis, 147, 148 Extensor pollicus longus, 148, 149 External oblique, 136, 137, 139 Eye, surface forms, 126, 127 Eye level, 57-60

F

FALK, Peter, Reclining Figure, 108, 110 Fall of the Damned, Rubens, 172, 174 Fantasy on the Death of Seneca, 213, 214 Fat, skin and, 172, 173, 174, 175 FAU, J., Dr.: The Anatomy of the External Forms of Man, Plate 2, 158 The Anatomy of the External Forms of Man, Plate 3,

90-91.94 Female Figure, Back View, McKibben, 232, 233 Female Nude Asleep, Rembrandt, 37, 38, 42, 45 Female Nude Reclining with Arm Raised, Rembrandt, 325,

Femme Couchee (Saskia Sick in Bed), Rembrandt, 15 Femur, 98, 99 Fibula, 86, 98, 99, 162 Figurative character of drawings, 5

Figurative influnces, 235-36 Figure, Brooks, 213, 215

Figure, environment and, 248-54

Figure and Cat, Study for Dusk, Barnet, 198, 199

Figure in Dust Storm, Lebrun, 275, 277 Figure of Christ, A Study for, Rubens, 137 Figure of Christ on the Cross, Study for, Rubens, 14, 15 FISHMAN, Harriet, Reclining Figure, 249, 251 Flagellation of Christ, Studies for a, Cesari, 219 Flank pad of external oblique, 136, 137, 139, 141, 157, 161, Flexor carpi radialis, 147, 148, 152

Flexor carpi ulnaris, 147, 148, 150, 152, 153 Flexor digitorum, 147, 152, 153 Flexor digitorum longus, 157, 159, 161, 163 Foreshortening, structural aspects of, 54, 57-61 Form units, 46

Four Figures Set Piece, Bellows, 32 Four Heads, Study of, De Gheyn II, 258 (detail); 266 Four Women at Their Toilet, de Gheyn II, 52-53, 55 From Salvage's "Anatomie du Gladiateur Combattant," Borghese, 80, 81

Frontal bone, 82 Frontalis, 125 Front View of Female Figure, Herron, 48 Frugal Repast, The, Picasso, 111

G

Gandhi, Shahn, 271, 272 Gastrocnemius, 157, 159, 161, 162, 163 GÉRICAULT, Theodore, Study for one of the Figures in "Raft of the Medusa," 5, 56 Getting Dressed, Desnoyer, 217, 218, 220 GIACOMETTI, Alberto, Trois Femmes Nues, 29-30, 30, GILL, James, Laughing Woman and Close-Up, 305, Girl in Bed-Graziella, Vespignani, 297-98, 299 Girl with Dog, Autio, 31, 32 Girl with Tulips, Matisse, 204, 205 Glenoid fossa, 89, 90 Gluteus maximus, 139, 141, 159, 162, 163, 165 Gluteus medius, 136, 141, 157, 158, 162, 165 GOLDSTEIN, Nathan, Reclining Figure, Foreshortened View, 57, 59, 60 GOLUB, Leon, Standing Figure, Back View, 108, 109 GOODMAN, Sidney: Ann and Andrew Dintenfass, 280-81, 282 Model on Draped Table, 91, 95 Reclining Nude at Window #1, 223, 225 GOYA, Francisco Jose de, Not (in this case) either, 16, 18, 24, 101 Gracilis, 157, 159, 161, 163

357

Great trochanter, 86, 98, 99, 139, 141, 161, 162 I Greek art, 8-10 GROSZ, George, Circe, 271, 273 Il Condottiere, De Chirico, 270 Group of Samson and the Philistines, Study for a, Tintoretto, Iliac crest, 86, 89-90, 92, 161, 163 225, 227 Ilio-tibial band, 141, 157, 159, 161, 162 GRÜNEWALD, Matthias, Portrait de Margarethe Preiewitz, Imaginary Invalid, The, Daumier, 267 Infraspinatus, 137, 139, 141 GUERCINO, St. Joseph with His Flowering Staff, 53, INGRES, Jean-Auguste Dominique: Étude pour "Le martyre de Saint Symphorien," 243-44, Portrait of Mrs. John Mackie, 67, 68 Studies of a Man and a Woman for the "Golden Age," 46, H Study for the Portrait of Louis-François Bertin, 263-64, Half-Length Male Nude Seen from the Rear, Palma, 239, Three Studies of a Male Nude, 18, 19, 105, 107 In Sleep, Polonsky, 300, 301 Half-Length of a Reclining Woman, Kokoschka, 241, Ischium, 163 Hallucis longus, 157 Handling, 232 Hands, Study of, Dickinson, 2, 4 Head: J muscles, 124-26 surface forms, 126-31 Jacob Wrestling with the Angel, Studies for, Creti, 204, Head and Neck, Nadelman, 108, 109 Head of an Apostle, Van Dyck, 226, 228 Jeanne (Spring), Manet, 226, 228 Head of an Oriental with a Dead Bird of Paradise, JOHN, Augustus, Nude Study, 263, 264 Rembrandt, 222, 223 "Jupiter et Antioche," Study for, Watteau, 15-16, 17 Head of a Woman, Daumier, 210 Head of a Young Black Man, Tiepolo, 296, 297 Helix, 127, 128 Henry Earl of Bathurst, Copley, 131 Hercules, Cambiaso, 179, 179-80 K Hercules and Omphale, Primaticcio, 20, 21 HERRON, R.E., Dr.: KATZMAN, Herbert: Back View of Male Figure, 48 Byron Goto, 213, 216 Front View of Female Figure, 48 The Studio, 308, 309 Three Back Views of a Seated Female Figure, 74 Kneeling Nude, Villon, 226, 229 HIROSHIGE, Ando, Two Women Playing, 248, 249 KOKOSCHKA, Oskar: HOKUSAI, Katsushika, Wrestlers, 5-6, 7 Half-Length of a Reclining Woman, 241, 242 HOLBEIN, Hans, the Younger: Portrait of Joseph Hauer, 176, 177 Cardinal John Fisher, 126 Trudl Wearing a Straw Hat, 39-40, 42 Portrait of Anna Meyer, the Daughter of Jacob Meyer, 12, KOLLWITZ, Käthe: Death, Mother and Child, 260, 262 HOPPER, Edward, Study for East Side Interior, 249-50, Mother and Dead Child, 242, 243 252 Self-Portrait, Drawing, 320-21, 322 Horizon line, 57-60 Two Nudes, 90, 93 Humerus, 86, 89, 91, 95 Weinende Frau (Woman Weeping), 2, 5, 25 HUNTINGTON, Daniel, Skeleton Study, 113, 114 KUHN, Walt: Huyghe, René, 20 Seated Woman, 204, 206 Hyoid, 131, 133 Study for "Roberto," 269, 270 Hypothenar, 147, 150, 152, 153

Index

KUNIYOSHI, Sketch for Kakemono-e of Tkiwa Gozen,	Major planes, 40–41
261	Male and Female Models on Greek Revival Sofa, Pearlstein,
Kylix, Battle of Centaurs and Lapiths, 9, 10	310, 312
	Male Back, Erlebacher, 49, 52
	Male Figure, Seated, McKibben, 80, 81
7	Male Figure in Motion, (towards the Left), Boccioni, 190, 191
L	Male Nude on Horseback, Cambiaso, 292, 294, 295
	Male Torso, Seem from the Back, Michelangelo, 492
LACHAISE, Gaston, Back of a Nude Woman, 8, 24, 207,	Male Torso, Segantini, 47, 48
208, 209–10	Man and a Woman for the "Golden Age," Studies of a,
Lateral cartilage, 126, 128	Ingres, 46, 47
Lateral malleolus, 157, 161, 162, 164	Man Between Time and Death, Evoking Hope, Ricci, 291,
Latissimus dorsi, 135, 136 , 137 , 138 , 139 , 141 , 143	292
Laughing Woman and Close-Up, Gill, 305, 306	Mandible, 82
LAURENCIN, Marie, Self-Portrait, 203	MANET, Edouard, Jeanne (Spring), 226, 228
LEBRUN, Rico:	Man on Table, Thiebaud, 249, 250
Figure in Dust Storm, 275, 277	Man Seen from Behind, Study of a, Zuccaro, 279, 280
Lone Great Mutilated Figure, 270, 271	Manubrium, 86, 89
Running Figure, 189, 190	Man with a Wheelbarrow, Study for, Millet, 227
Three-Penny Novel, Beggars into Dogs, 108, 110	Masseter, 124, 125
Leg bones, 98–100	Mastoid process, 82
LÉGER, Fernand, Study of a Seated Female Nude, 71,	MATISSE, Henri:
73	Dancer Resting in an Armchair, 230, 231
Leg muscles, 154–72	Girl with Tulips, 204, 205
Legs, Orozco, 164	Nude, 325, 326
Legs and a Foot for St. Sebastian, Barocci, 159, 160	Nude Study, 46 , 48
LEONARDO DA VINCI:	Seated Nude with Tulle Blouse, 26, 27
Myology of the Lower Extremity, 161, 162	Two Sketches of a Nude Girl Playing a Flute, 183 , 184
Myology of the Shoulder Region, 12	Maxillae, 82
Study of Drapery, 66, 67	McGARRELL, James, Elephant Bathers, 312, 313
Levator scapulae, 133, 134	McKIBBEN, Alex:
"Libyan Sibyl, The," Studies for, Michelangelo, 89, 91	Female Figure, Back View, 232, 233
LILLIE, Lloyd:	Male Figure, Seated, 80, 81
Male Figure, Side View, 279	Media, expressive role of, 271–73, 319–21
Running Figure, 197, 198	Medial maleolus, 161, 163
Standing Figure, Back View, 185, 186	Mental protuberance, 82
Study of a Woman's Head, 83, 84	Mesomorphic type, 134
Line, 203–9	Metacarpal bones, 96, 97
Lips, surface forms, 127, 128	Metatarsals, 99, 100
Lobe, 127, 128	MICHELANGELO Buonarroti, 20-21
Local tone, 49	"Creation of Adam" in the Sistine Chapel, Study of Adam
Location and proximity, 232	for, 7, 12 , 28, 35, 101
Lone Great Mutilated Figure, Lebrun, 270, 271	Male Torso, Seen from the Back, 492
Lumbar vertebrae, 84, 85, 86, 87	Studies for the Crucified Haman, 60, 134, 135
	Studies for "The Libyan Sibyl," 89, 91
	Studies for "The Punishment of Aman" for the Sistine
	Chapel, 244–45, 246
	Studies of a Madonna and Child, 49, 51
M	Studies of Nude and Draped Figures, 204, 207
	Study for a Christ on the Cross, 139, 140
Madonna and Child, Studies of a, Michelangelo, 49, 51	Study for the Nude Youth over the Prophet Daniel, 178,
MAILLOL, Aristide, Young Cyclist, 193	179

Study of Adam in the "Creation of Adam" in the Sistine Northampton Madonna, Study for the, Moore, 71, 72 Chapel, 273, 274 Nose, surface forms, 126, 127 Not (in this case) either, Goya, 16, 18, 24 Middle Ages, 9-10 MILLET, Jean-François: Nude, Matisse, 325, 326 Nude and Draped Figures, Studies for, Michelangelo, 204, Study for Man with a Wheelbarrow, 225, 227 The Diggers, 70, 71 Nude Children (Amorini), Boucher, 172, 173 Minotaur, Drinking Sculptor, and Three Models, Picasso, Nude Descending a Staircase, No. 2, Duchamp, 284, 286 282, 284, 285 Nude for "The Sorrows of the Town of Orleans," Study of a, Model for the "Guiliano de Medici" of Michelangelo, Tintoretto, 46-47, 47 Degas, 21, 22 Model on Draped Table, Goodman, 91, 95 Nude Man Kneeling, A, Rubens, 141, 143 MONTELUPO, Raphael da, Anatomical Studies, 98 Nude Model, Whistler, 37, 40 MOORE, Henry: Nude Old Woman, Bloom, 64, 66 Study for the Northampton Madonna, 71, 73 Nude Sitting on Chair, Pearlstein, 80 Nude Study, John, 263, 264 Women Winding Wool, 224, 226 Mother and Dead Child, Kollwitz, 242, 243 Nude Study, Matisse, 46, 48 Movement, 230-36 Nude Torso, Sheeler, 312, 314 Nude Woman Standing, Drying Herself, Degas, 22, 23 direction and, 230, 232 figurative influences and, 235-36 Nude Youth over the Prophet Daniel, Michelangelo, 178, 179 handling and, 232 location/proximity and, 232 rhythm and, 232 subdivision and, 232-33 tension and, 234-35 O visual weight and, 233-34 Muscles: Occipital bone, 82 arm, 143-54 OLDENBURG, Claes, Stripper with Battleship: Preliminary head, 124-26 Study for "Image of the Buddha Preaching," 207, leg, 154-72 208 neck, 131-34 Old Savoyard, The, Watteau, 279, 280 overview, 123-24 Olecranon process, 86, 96 torso, 134-43 of ulna, 147, 150, 153 Muscles, Front View, Albinus, 166, 168 Omohyoid, 133, 134 Muscles, Side View, Albinus, 167 One of the Figures in "The Raft of the Medusa," Study for, Muscular Dynamism, Boccioni, 142, 144 Myology of the Lower Extremity, Leonardo da Vinci, 161, Géricault, 53, 56 Orbicularis oculi, 125, 126 Myology of the Shoulder Region, Leonardo da Vinci, 12 Orbicularis oris, 125 Orbit, 82 Organizational defects, 317-18 Oriental Ruler Seated on His Throne, An, Dürer, 291, N OROZCO, Jose Clemente, Legs, 164 NADELMAN, Elie, Head and Neck, 108, 109

NADELMAN, Elie, Head and Neck, 108, 109
Nasal bones, 82
Nazi Holocaust Series, Study for the, 25, 26, 32
Nearly Full-Length Figure of a Youth Pulling off His Shirt,
Rosa, 12, 13, 28
Neck muscles, 131–34
NEEL, Alice, Andy Warhol, 71, 74
Neolithic rock painting (facsimile), 8, 9
New Year's Eve, 1978, Abeles, 296–97, 298

P

Painter and His Model, The, Picasso, 211, 212
PALMA, Jacopo, Half-Length Male Nude Seen from the Rear, 239, 240
Palmaris longus, 147, 148, 152, 153

Pan and Syrinx, with a River God, Castiglione, 252-53, Planes: human form and, 40-45 PAPO, Iso, Standing Figure, 28, 29 interjoining of masses and, 45-49 Parietal bone, 82 PLATT, Michael, Sketchbook, 31, 32 PARKER, Robert Andrew, Reclining Nude, 223, 224 POLLAIUOLO, Antonio del, Battle of the Nudes, 10-11, PASCIN, Jules: Reclining Nude, 154, 155 POLONSKY, Arthur: Patella, 98, 99, 156, 162, 163 Portrait of J.G., 301 Patellar surface, 99 In Sleep, 300, 301 Pathologies of figure drawing, 312-19 PONTORMO, Jacopo da: expressive defects, 318-19 Sibyl, 102 organizational defects, 317-18 Studies for the Pietà, 141, 144 overview, 312-15 Popliteal fossa, 161 perceptual defects, 315-17 Portrait de Margarethe Preiewitz, Grünewald, 2, 3 PEARLSTEIN, Philip: Portrait of Anna Meyer, the Daughter of Jacob Meyer, Male and Female Models on Greek Revival Sofa, 310, Holbein the Younger, 12, 13, 14 Portrait of a Noble Lady with an Elaborate Headgear, Nude Sitting on Chair, 80 Persian drawing, Safavid Period, 240, 241 Pectoralis major, 134, 136, 139, 148, 153 Portrait of Felix Barré, Villon, 45, 48 Pectoralis minor, 136 Portrait of J.G., Polonsky, 301 Pelvis, 52 Portrait of Joseph Hauer, Kokoschka, 176, 177 bones of, 89-91, 92, 93, 94, 95 Portrait of Louis-François Bertin, Study for the, Ingres, Perceptual defects, 315-17 263-64, 265 Peroneus brevis, 159, 161, 162, 164 Portrait of Mrs. John Mackie, Ingres, 67, 68 Peroneus longus, 157, 159, 161, 162 Portrait of Mrs. Susan Peterson, Anderson, 306 Peroneus tertius, 164 Portrait of St. Gregory, Carolingian Illumination, 10 Persian drawing, Safavid Period POUSSIN, Nicolas: Portrait of a Noble Lady with an Elaborate Headgear, 240, Bacchus and Ariadne, 70, 70-71 Drawing for the Rape of the Sabines, 219, 220 Perspective, foreshortening and, 54, 57-61 Praxiteles, 9 PETERDI, Gabor, Still Life in Germany, 270, 271 Presentation in the Temple, Rubens, 28 Peter of Amiens before the Doge Vitale Michele, Veronese, PRIMATICCIO, Francesco, Hercules and Omphale, 20, 21 Pronator teres, 146, 147, 148, 152, 153 Phalanges, 96, 97, 100 Psyche Transported to Olympus, Tiepolo, 282, 283 Phidias, 9 Ptolemic Period, Book of the Dead of Ta-Amen, 8, 9 Philtrum, 127, 128 "Punishment of Aman," Studies for the, Michelangelo, Photographs, drawing from, 331-50 244-45, 246 PICASSO, Pablo, 1 Boy Watching Over Sleeping Woman by Candelight, 290 (detail); 306, 307 Minotaur, Drinking Sculptor, and Three Models, 282, 284, Q Study for the Painting "Pipes of Pan," 62, 64 The Frugal Repast, 111 Quadriceps femoris, 156, 157, 159 The Painter and His Model, 211, 212 Two Nudes, 27 Woman Seated and Woman Standing, 35, 37, 39 Picture plane, 26 R Pieta, Studies for the, Pontormo, 141, 144 "Pipes of Pan," Study for the Painting, Picasso, 62, 64 PIRANESI, Giovanni Battista, Two Studies of a Man Rabbi III, Aronson, 267, 268

Radius, 95, 96

Reclining Figure, Falk, 108, 110

Standing, His Arms Outstretched to the Left, 187,

189

Reclining Figure, Fishman, 249, 251 Reclining Figure, Foreshortened View, Goldstein, 57, **59,** 60 Reclining Male Nude, Boccioni, 245-46, 247 Reclining Nude, Boucher, 172, 175 Reclining Nude, Parker, 223, 224 Reclining Nude, Pascin, 154, 155 Reclining Nude at Window #1, Goodman, 223, 225 Rectus abdominus, 136, 137 Rectus femoris, 136, 139, 156, 157, 159, 162, 163 Red Chalk Drawing, Del Sarto, 2, 3 REMBRANDT van Rijn, 14-15, 20-21 An Actor in His Dressing Room, 67, 69 Bearded Oriental in a Turban, Half Length, 5, 6 Esau Selling His Birthright to Jacob, 207, 209 Female Nude Asleep, 37, 38, 42, 45 Female Nude Reclining with Arm Raised, 325, 327 Femme Couchee (Saskia Sick in Bed), 15 Head of an Oriental with a Dead Bird of Paradise, 222, 223 Seated Nude Woman, 186-87, 188 Self-Portrait, 213, 216 Study for the Group of the Sick in "The Hundred Guilder Print," 196 (detail), 198, 199 The Artist's Studio, 250-52, 253 Three Heads of Women, One Asleep, 319, 320 Woman Bathing Her Feet at a Brook, 15, 16, 101 Woman Seated, in Oriental Costume, 286, 287 Renaissance drawing, 11-14 Resurrection and Ascension, Cambiaso, 57, 58 Rhomboid, 141, 143 Rhythm, 232 Rib cage, 52 bones of, 86, 88, 89, 118 RICCI, Sebastiano, Man Between Time and Death, Evoking Hope, 291, 292 "Roberto," Study for, Kuhn, 269, 270 RODIN, Auguste: St. John the Baptist, 157, 159, 160 Study of a Standing Nude, 24, 25 ROSA, Salvator: Nearly Full-Length Figure of a Youth Pulling off His Shirt, 12, **13,** 14, 28 St. George Slaying the Dragon, 275, 276 Witches' Sabbath, 282, 284 Ross, Denman, 200 ROTHBEIN, Renee: Angel of Death, 108, 109 Seated Woman, Leaning, 301, 302, 304 Study for the Nazi Holocaust Series, 25, 26, 32 Rowing Man, Cézanne, 243, 244 RUBENS, Peter Paul, 20-21 A Nude Man Kneeling, 122, 123 (detail); 141, 143

A Study for the Figure of Christ, 137

Bathsheba Receiving David's Letter, 62, 63, 64, 66 Fall of the Damned, 172, 174 Presentation in the Temple, 28 Studies of Arms and a Man's Face, 151, 152 Study for the Figure of Christ on the Cross, 14, 15 Running Figure, Lebrun, 189, 190 Running Figure, Lillie, 197, 198 Russian Dancer, Degas, 71, 72

S

Sacral triangle, 141 Sacrum, 84, 85, 86, 87 Sartorius, 136, 156, 157, 159, 161, 162, 163 Scalenus, 133, 134 Scapula, 86, 90 SCHIELE, Egon: Schiele's Wife with Her Little Nephew, 2, 24-25 Seated Nude Girl Clasping Her Left Knee, 324, 325 Seated Woman (Sitzende Frau), 234 Sitting Woman with Legs Drawn Up, 273, 275 Schiele's Wife with Her Little Nephew, Schiele, 2, 24-25 Schneider, Julie Saecker, Away from Me, if Possible, 269, 270 Seated Boy with Straw Hat, Seurat, 273, 274 Seated Female Nude, Study of a, Léger, 71, 73 Seated Figure, Back View, Cretara, 41, 44, 45, 49 Seated Figure, Bloom, 108 Seated Nude, Boucher, 53, 55 Seated Nude, Valerio, 172, 173 Seated Nude Girl Clasping Her Left Knee, Schiele, 324, 325 Seated Nude with Tulle Blouse, Matisse, 26, 27 Seated Nude Woman, Rembrandt, 186–87, 188 Seated River God, Nymph with an Oar, and Putto, Tiepolo, 16, 17, 28 Seated Skeleton I, Bageris, 111, 112 Seated Skeleton II, Bageris, 303, 304-5 Seated Woman, Kuhn, 204, 206 Seated Woman, Leaning, Rothbein, 301, 302, 304 Seated Woman, No. 44, Diebenkorn, 226, 229 Seated Woman (Sitzende Frau), Schiele, 234 Secondary planes, 41, 45 Second Baby Drawing, Dine, 269, 270 SEGANTINI, Giovanni, Male Torso, 47, 48 Self Portrait, Albers, 49, 50 Self-Portrait, Drawing, Kollwitz, 320–21, 322 Self-Portrait, Laurencin, 203 Self-Portrait, Rembrandt, 213, 216

Semimembranosus, 156, 159, 161, 162, 163

Semitendinosus, 156, 159, 161

Septum, 126, 127 Serratus magnus, 135, 136, 137, 138, 139 SEURAT, Georges-Pierre, Seated Boy with Straw Hat, 273, SHAHN, Ben, Gandhi, 271, 272 Shape, 213, 215, 217-19 SHEELER, Charles, Nude Torso, 312, 314 Sheet of Studies of the Female Figure, Cretara, 60, 61 Shoulder girdle, bones of, 86, 90, 91 Sitting Woman with Legs Drawn Up, Schiele, 273, 275 Skeletal proportions, 101-5 Skeleton: as armature, 51-54 in figure drawing, 105-13 influence on surface forms, 79-80 overview, 79-80 views of, 80, 81, 86, 88, 94, 98, 108, 114, 116, 118, 119 Skeleton, Front View, Albinus, 98 Skeleton Study, Huntington, 113, 114 Sketchbook, Platt, 31, 32 Sketch for Kakemono-e of Tkiwa Gozen, Kuniyoshi, Skin and fat, 172, 173, 174, 175 Skull, 52 bones, 80-83 as unit of measure, 101-5 Soleus, 157, 159, 161, 162, 163 Sphenoid bone, 82 Spinal column, bones of, 84-86, 85, 86 Splenius, 133, 134 St. George Slaying the Dragon, Rosa, 275, 276 St. John the Baptist, Rodin, 157 St. Joseph with His Flowering Staff, Guercino, 53, 56 Standing Figure, Back View, Golub, 108, 109 Standing Figure, Back View, Lloyd, 185, 186 Standing Figure, Papo, 28, 29 Standing Man in a Cap and Cape, His Left Arm Partly Raised, Tiepolo, 319-20, 321 Standing Nude, Arms Upraised, Villon, 236-37, 238 Standing Nude, Study of a, Rodin, 24, 25 Standing Nude Woman, Back View, Degas, 143, 145 Sternohyoid, 133, 134 Sternomastoid, 131, 132, 139, 141 Sternum, 88, 89, 136 Stevens, Alfred, Two Studies of a Standing Figure, Back View, 49, 52 Still Life in Germany, Petardi, 270, 271 Stripper with Battleship: Preliminary Study for "Image of the Buddha Preaching, Oldenburg, 207, 208 Structural factor, 5, 35-77 foreshortening and, 54, 57-61 overview, 35-40

planar approach and, 40-49 supports and suspensions, 51-54 value and, 49, 51 Struggle of the Two Natures in Man, The, Barnard, Studio, The, Katzman, 308, 309 Styloid process, **82**, 91, **95** Subdivision, 232-33 Superciliary bone, 82 Supinator longus, 146, 147, 148, 150, 152 Surface forms: figure, 172, 176-90 head, 126-31

T

Talus, 99, 100 Tarsal bones, 99, 100 TCHELITCHEW, Pavel, Study for "The Crystal Grotto," 271, 272 Temporal bone, 82 Temporalis, 124, 125 Tendons, 123 Tension, 234-35 Tensor fascia latae, 136, 157, 159, 162 Teres major, 137, 139, 141 Teres minor, 137, 139 Texture, 224-28 Thenar, 147, 150, 152, 153 THIEBAUD, Wayne: Dark Background, 278, 279 Man on Table, 249, 250 Thoracic vertebrae, 84, 85, 86, 87 Three Heads of Women, Rembrandt, 319, 320 Three-Penny Novel, Beggars into Dogs, Lebrun, 108, Three Studies of a Male Nude, Ingres, 18, 19, 105, 107 Three Studies of a Young Negro, Watteau, 221, 222 Thyroid cartilage, 131, 133 Tibia, 86, 98, 99 Tibialis anterior, 156, 157, 159, 162, 163 TIEPOLO, Giovanni Battista: Error and Falsehood, 308, 309, 310 Fantasy on the Death of Seneca, 213, 214 Head of a Young Black Man, 296, 297 Psyche Transported to Olympus, 282, 283 Seated River God, Nymph with an Oar, and Putto, 16, 17, Standing Man in a Cap and Cape, His Left Arm Partly

Raised, 319-20, 321

Tightrope Walker, Valerio, 304, 305 TINTORETTO, Jacopo: Study for a Group of Samson and the Philistines, 225. Study of a Model for the "Guiliano de Medici" of Michelangelo, 40, 46-47, 47 Torso, muscles of, 134-43 Tragus, 127, 128 Trapezius, 131, 132, 136, 139, 141 Triceps, 146, 147, 148, 150, 152, 153 Triton, Study of a, Boucher, 246-47, 248 Trochlea, 91, 95 Trois Femmes Nues, Giacometti, 29-30, 30 Trudl Wearing a Straw Hat, Kokoschka, 39-40, 42 Tubercle, 127, 128 Two Nudes, Kollwitz, 90, 93 Two Nudes, Picasso, 27 Two Nude Studies, Delacroix, 19, 28 Two Sketches of a Nude Girl Playing a Flute, Matisse, 183, Two Studies of a Man Playing a Guitar, Watteau, 154 Two Studies of a Man Standing, His Arms Outstretched to the Left, Piranesi, 187, 189 Two Studies of a Standing Figure, Stevens, 49, 52 Two Studies of the Head of a Young Woman, Watteau, 129, 130 Two Women III, De Kooning, 25, 27 Two Women Playing, Hiroshige, 248, 249

\boldsymbol{U}

Ulna, **95**, **96** Ulnar crest, 149, **150**, **152** *Untitled, I,* Avishai, 217, **218**

V

VALERIO, James:
Seated Nude, 172, 173
Tightrope Walker, 304, 305
Value:
structure and, 49, 51
as visual element, 209–13
VAN DYCK, Anthony, Head of an Apostle, 226, 228
Variant on Ingres' Figure Odyssey, Anderson, 238, 239
Vastus lateralis, 139, 156, 157, 159, 161, 162

VELAZQUEZ, Diego, Cardinal Borjia, 84, 85 VERONESE, Paolo, Peter of Amiens before the Doge Vitale Michele, 20 VESALIUS, Andreas: "De Humani Corporis Fabrica, Book I." Plate 10 from, "De Humani Corporis Fabrica, Book II, Plate 25 from, VESPIGNANI, Renzo, Girl in Bed-Graziella, 297-98, 299 VILLON, Jacques: Kneeling Nude, 226, 229 Portrait of Felix Barré, 45, 48 Standing Nude, Arms Upraised, 236-37, 238 Study for a Washerwoman, 200, 201 Visual elements, 5 line, 203-9 relationships between/among, 228-36 shape, 213, 215, 217-19 texture, 224-28 value, 209-13 volume, 220-24 Visual resources, photographs as, 331–50 Visual weight, 220-24, 233-34 Volume, 220-24

Vastus medialis, 156, 157, 159, 163

W

Washerwoman, Study for a, Villon, 200, 201 WATTEAU, Antoine: Study for "Jupiter et Antioche," 15-16, 17 Study of a Young Negro, 49, 53 The Old Savoyard, 279, 280 Three Studies of a Young Negro, 221, 222 Two Studies of a Man Playing a Guitar, 154 Two Studies of the Head of a Young Woman, 129, 130 Weinende Frau (Woman Weeping), Kollwitz, 2, 25 WHISTLER, James McNeill, Nude Model, 37, 40 Witches' Sabbath, Rosa, 282, 284 Woman Bathing Her Feet at a Brook, Rembrandt, 15, 16 Woman Seated, in Oriental Costume, Rembrandt, 286, 287 Woman Seated and Woman Standing, Picasso, 37, 39 Woman's Head, Study of a, Lillie, 83, 84 Woman Wiping Her Feet near a Bathtub, Degas, 210, Women Winding Wool, Moore, 224, 226 Wrestlers, Hokusai, 5-6, 7

Xiphoid process, 86, 88, 89

Young Cyclist, Maillol, 193 Young Negro, Study of a, Watteau, 49, 53

Z

Zuccaro, Taddeo, Study of a Man Seen from Behind, 279,

Zygomatic arch, 82 Zygomatic bone, 82 Zygomaticus major, **125**, 126

1.